Curse your high flown Advertisements! A pretty
Jaunt I have had._ I saw the House to be sure_
and that was as much as I could do!_ But where
the Devil is the HANGING-WOOD you talk
so much about?

My Dear Sir be calm_____
fault_ you must have overlooked that
inestimable little Jewel the GALLOWS. on the
north side of the Paddock and if that is not
a HANGING WOOD_ I dont know what is.

The HANGING-WOOD.!
OR
A PALL-MALL-PUFF.!

CHRISTIE'S REVIEW
OF THE SEASON 1972

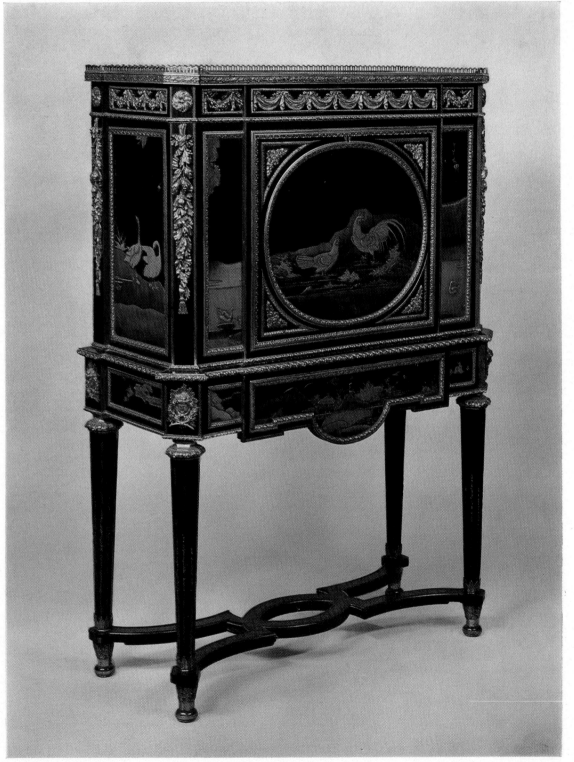

Highly important
Louis XVI black
lacquer secretaire à
abattant, by
M. Carlin, 33½ in.
(85 cm.) wide, 48½ in.
(123 cm.) high,
stamped M. Carlin
Sold 29.6.72 for
120,000 gns.
($312,500) on behalf
of the Trustees of
Lord Hillingdon

CHRISTIE'S REVIEW OF THE SEASON 1972

Edited by John Herbert

HUTCHINSON OF LONDON / ST MARTIN'S PRESS, NEW YORK

HUTCHINSON & CO (*Publishers*) LTD
3 Fitzroy Square, London W1
London Melbourne Sydney Auckland
Wellington Johannesburg Cape Town
and agencies throughout the world

ST. MARTIN'S PRESS, INC
175 Fifth Avenue, New York, NY 10010

First published 1972

*First published in the
United States of America in 1973*

*This book was designed and produced for
Christie, Manson & Woods by Hutchinson Benham Ltd.
It was set in 'Monotype' Baskerville 12 on 15 point,
and printed in England by Anchor Press Ltd, Tiptree, Essex,
with colour letterpress by Benham & Co Ltd, Colchester, Essex,
colour lithography by Flarepath Printers Ltd, St. Albans,
Hertfordshire, and binding by
Wm. Brendon & Son Ltd, Tiptree, Essex*

ISBN 0 09 114380 2 Library of Congress Catalog Number: 66–33358

CONTENTS

Foreword by Ivan Chance, Chairman *page* 9

The Hillingdon Collection by Hugh Roberts 12

Old Master paintings 17

Venetian view painters by William Mostyn-Owen 22

Buried treasure by Lady Dorothy Lygon 45

Dutch and English 18th- and 19th-century paintings 51

A memorable season for English pictures by Christopher Wood 57

Old Master and English drawings and watercolours 69

The Daniells in India and Africa by Huon Mallalieu 95

Old Master and Modern prints 103

Impressionist and 20th-century paintings and sculpture 113

Australian sales by John Henshaw 152

Jewellery 159

Silver 177

Objects of art and vertu, coins, icons and antiquities 205

Gold snuff-boxes by Hermione Waterfield 210

Books and manuscripts 239

John Gould and Samuel Curtis by Stephen Massey 240

Books of Hours by Frank Lissauer 249

'Read any good bibliographies lately?' by Cyril Connolly 256

Porcelain and glass 259

Christie's Italiana by Harry Ward Bailey 272

Chinese ceramics and works of art 287

The change in taste for later Chinese porcelain by Anthony du Boulay 302

Japanese and Tibetan works of art 309

Central heating and works of art by John Herbert 318

English, French and Continental furniture, clocks, works of art,
 rugs and tapestries 323

The furniture of the nomad by Oliver Hoare 382

Arms and armour 389

Modern sporting guns by Christopher Brunker 399

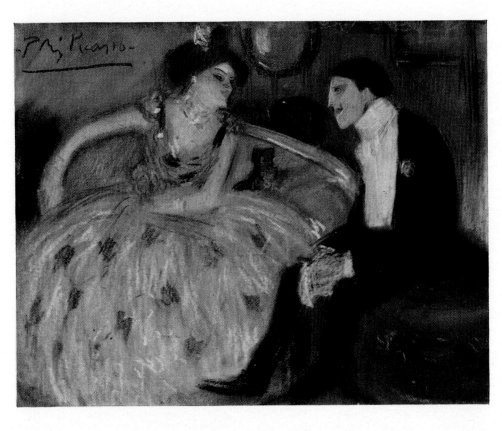

PABLO PICASSO: *Le boudoir*
Pastel, signed P. Ruiz Picasso
13 × 16½ in. (33 × 42 cm.)
Painted in Madrid in 1901
Sold 27.6.72 for 44,000 gns.
($120,120)
From the collection of Leo M.
Rogers

Wine 405

The wine year by Michael Broadbent, MW 406

Dolls, fans and dresses 413

Stamps 421

Postage stamps, philately and postal history by Robson Lowe 422

Veteran and vintage cars, models and steam locomotives, photographs
 and photographica 425

List of addresses 434

Acknowledgments 435

Index 438

The Hon Patrick Lindsay, who is in charge of the picture department, selling George Romney's painting of the Gower family for £147,000 ($382,200). The Romney was in our sale on June 23rd of English pictures which totalled nearly £1 million ($2,400,000)

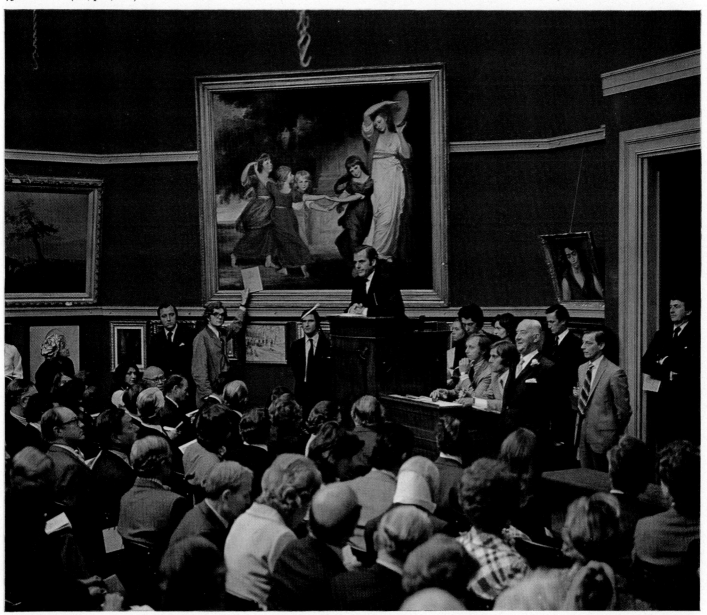

Mr Ivan Chance, the Chairman, auctioning the Leo M. Rogers Collection of Impressionist paintings, drawings and sculpture on June 27th. The 44 works sent from the United States were sold for £856,320 ($2,055,168). Sales of Impressionist and Modern British work totalled £5,231,447 ($13,634,522) during the season compared with £2,867,529 ($7,455,575) for 1970–71.

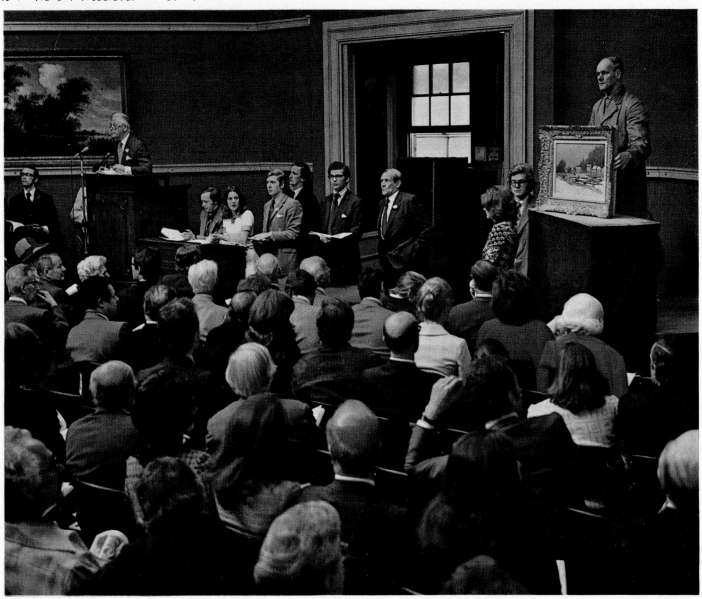

FOREWORD

BY IVAN CHANCE, *Chairman*

This has been a memorable year for the Fine Art Trade. It has been abundantly clear that London has remained the centre of this trade and it is only necessary to attend a major sale to appreciate the fact that the whole world, people of every creed and colour, collectors and dealers alike, come to London because they know that it is here they will find the major works of art, both in the salerooms and among the dealers. In spite of the fact that for the past hundred years the Jeremiahs have been deploring the 'loss of our national heritage' and complaining that 'the barrel has been scraped dry' there is, nevertheless, a vast store of major works of art in this country which is perhaps not surprising when one takes into consideration the fact that between the end of the seventeenth century and 1914 we were steadily expanding and with an enlightened and educated aristocracy were in a position to acquire from less fortunate countries those splendid pictures and works of art which in many cases still remain in the homes of the descendants of those who originally acquired them. But the major sales are not only made up of works of art from this country. A glance at the catalogues will show that collectors from North and South America, every country in Europe and even the Far East now consider that it is very well worth their while to consign their collections or individual works of art to London for sale.

The reason for London's pre-eminence is due to a variety of factors: firstly the intangible goodwill which comes from a trade which has established a reputation for knowing its own business; and, secondly, and most important, the lower rate of commission and the complete absence of any form of sales tax.

For the past year this trade has been carried on under the threat of near extinction had the full provisions of Value Added Tax come into force as originally envisaged in the Finance Bill. When this new tax was first brought to the attention of our trade it was obvious that in the way it was originally intended to apply it would have deterred overseas clients from consigning their works of art to London for sale because of the incidence of Value Added Tax on importation and on sales by both auctioneers and dealers. Apart from the obvious fact that this would have involved extra expense to the consignor, it would also have had a very bad psychological effect in as much as the London trade would no longer have been able to proclaim as in the past that sales of works of art by owners from abroad were free of all taxes.

A committee was therefore formed by representatives from the British Antique Dealers' Association, The Society of London Art Dealers, and Messrs Christie's and Sotheby's, under the chairmanship of Mr Anthony Lousada, a senior partner in a leading firm of City solicitors, and a former Chairman of the Tate Gallery with wide experience of the working of this market. It was emphasized from the start that the Fine Art Trade in no way wished to claim exemption from payment of this tax but that the method of tax should be revised so that overseas clients were not affected. This committee had numerous meetings with the senior officials of Customs and Excise and eventually an interview with the Chancellor. Finally an amendment was made to the Finance Bill which means that the import of pictures, sculpture, drawings,

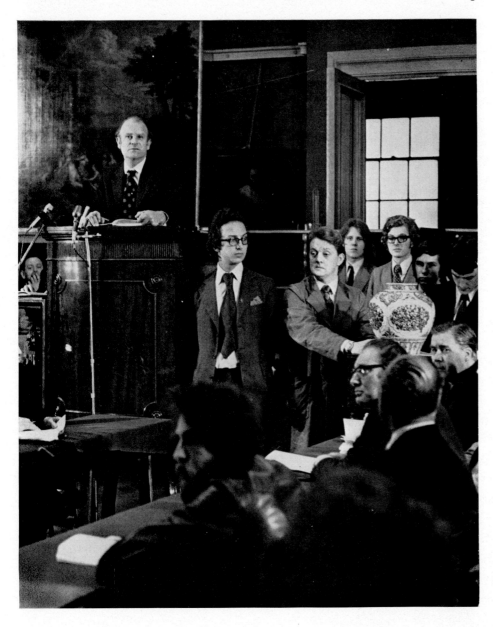

Anthony du Boulay, director in charge of the Ceramics and Oriental works of art department, selling the fourteenth-century blue-and-white vase for £220,500 ($573,300), the highest price ever paid at auction for any work of art other than a painting

silver, jewellery and other works of art over one hundred years old will be entirely free from Value Added Tax when sent for sale by residents outside the United Kingdom, whether dealers or private collectors; further no Value Added Tax will be charged on auctioneers' or dealers' commission payable by overseas residents. Within the United Kingdom the imposition of Value Added Tax on these works of art (which in this connection fall within the special scheme designed for them on the basis that they are 'second-hand goods'), will not be on the price of the individual item but on the dealer's profit margin, and the auctioneer's commission.

This has come as a very great relief to the Fine Art Trade and it is equally certain that the Treasury will not be the losers.

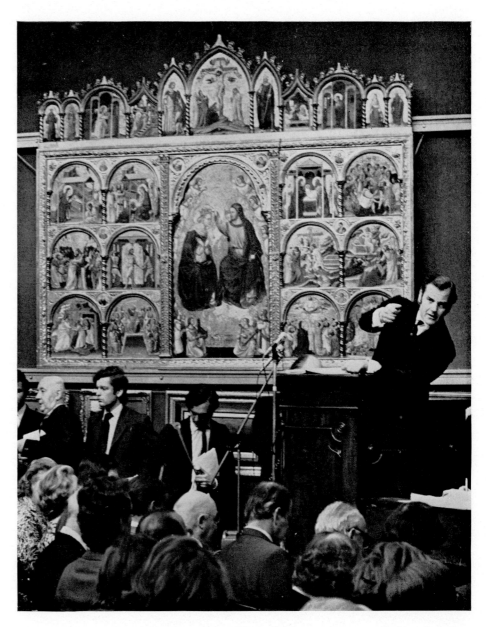

The Hon Patrick Lindsay auctioning the fourteenth-century polyptych by Guariento di Arpo, which was bought by the Norton Simon Foundation of California for £257,250 ($627,400)

The Hillingdon Collection

BY HUGH ROBERTS

The sales this season of pictures, furniture and works of art from the collection of Lord Hillingdon have focussed attention on one of the most important but equally one of the least known of the greater English nineteenth-century collections. Other collections of the same period – the Wallace and Jones collections for example – are well known and extensively studied. The Hillingdon collection, for the reason that it has remained privately owned, scattered among several family houses and was never exhibited *in extenso* before the various dispersals of the last forty years took place, is now known in its entirety only from the rare privately printed catalogues compiled for the first Lord Hillingdon in 1891. These invaluable documents record the whole extent of the collection at its peak when it was housed at Wildernesse Parke, Sevenoaks, and Camelford House, Park Lane, and justify placing it among the greatest assemblies of eighteenth-century French furniture and English portraits ever owned by one family.

The founder of the collection, Charles Mills, later the first baronet and a partner of the family banking firm of Glyn Mills & Co., was born in 1792. He was thus older by eight years than his rivals in the field of French furniture collecting, Richard Seymour-Conway, 4th Marquess of Hertford, and John Jones, both of whose collections, one at Hertford House the other at the Victoria and Albert Museum, were eventually bequeathed to the nation. At the time Charles Mills started collecting and for the twenty years before, London – then as now – was the recognized centre of the art world, for Paris, deprived of commercial and manufacturing stability by the Revolution, had ceased to be the international magnet for collectors and patrons which it had been throughout the eighteenth century. Thus French furniture and *objets d'art* made before the Revolution, when the Guilds were still in a position to control the quality of manufacture, began to acquire a rarity and desirability which they had not up till then possessed. Dominic Daguerre, the leading Parisian *marchand-mercier*, astutely anticipated this trend by moving his stock to London in 1791 – in the middle of the Revolution – and in March of that year Christie's held a two-day sale of porcelain-mounted and lacquer furniture on his behalf. An early link with the Hillingdon collection may be traced to this sale: a Wedgwood and porcelain-mounted secretaire attributed to Weisweiler, formerly in the collection and now in the Metropolitan

Important early Louis XV kingwood and lacquer bureau, by J. F. Dubut. 65¼ in. (166 cm.) wide, 20¼ in. (151 cm.) high. Stamped Dubut JME twice Sold 29.6.72 for 18,000 gns ($46,870) on behalf of the Trustees of Lord Hillingdon

12

Museum, New York, is probably to be identified with Lot 70 on the second day, 26th March 1791. Daguerre eventually set up business in Sloane Street with his partner Martin-Eloy Lignereux and continued to sell furniture of a French type, probably using English cabinet-makers and imported French materials. A porcelain-mounted bonheur-du-jour, also formerly in the collection and now in New York, may have come originally from this source.

English collectors of the generation before Charles Mills – the Prince Regent, William Beckford and George Watson-Taylor chief among them – were extremely well placed to purchase important pieces of French furniture which, partly as a result of dispersals initiated by the revolutionaries and partly from the need of penniless *emigrés* to raise funds, continued to flood the London market. To men like Beckford, there was the additional romantic appeal, appreciated by many late collectors

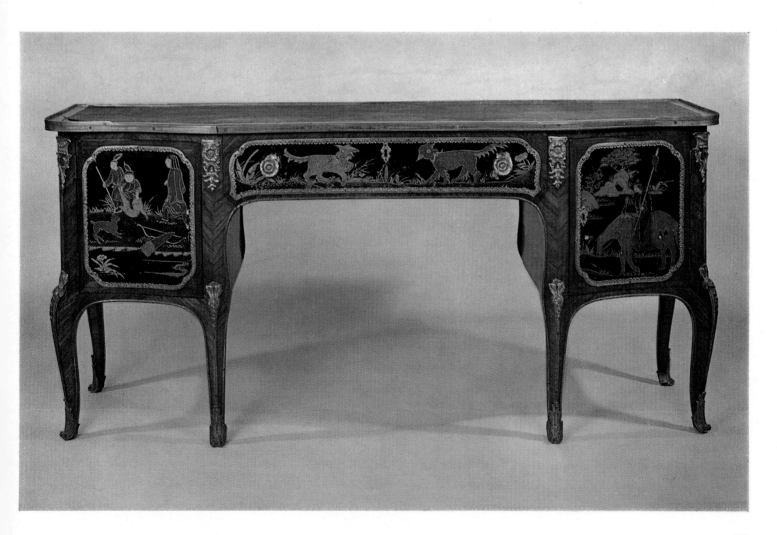

including Charles Mills, of furniture with Royal associations, and cataloguers of the time did not scruple to make much of any supposed (and quite often entirely spurious) Royal provenance. Though the Hillingdon collection contained a very large number of extremely important pieces, only four items of furniture and two or three pieces of porcelain are given Royal provenances in the 1891 catalogue, and in his purchase of these pieces – all impeccably authentic – as with most of his other purchases, Mills was both fortunate and judicious.

With one or two exceptions, collectors at this period and until quite late in the century, did not – for various reasons – keep very full or accurate records of their purchases: Baron Ferdinand de Rothschild for instance, founder of the Waddesdon Collection, actually destroyed all his receipts and bills. And in the case of Charles Mills, too, very little has come to light either about the extent of his expenditure on works of art or where the majority of his purchases were made.

Mills became a partner in the family bank in 1821 and married Emily Cox, daughter of another banker, in 1825. Within these four years two much talked-of sales had taken place: those of the Watson-Taylor and Beckford collections, both extremely rich in French furniture, porcelain and works of art, and it is tempting to hazard that the young Charles Mills should have been awakened by the dispersal of two such famous collections to the desirability of starting his own collection. It has not been possible to trace any purchases in these sales to him, but it does seem fairly certain that he acquired from the collection of Lord Gwydir of Grimsthorpe Castle, sold at Christie's in May 1829, four important pieces (Lots 104–7) of Sèvres-mounted furniture at a cost of £476. 14s. od. Three of the pieces, a secretaire, a meuble d'entre deux and a bonheur-du-jour were made by Martin Carlin, and were among the large group of superb porcelain-mounted furniture – the finest part of the Hillingdon collection – sold by private treaty for £87,000 through Christie's to Lord Duveen in 1936. It is interesting to note that thirty-six years later, on June 29th 1972, one piece from the collection, the black lacquer secretaire by M. Carlin (see *frontispiece*) fetched £126,000 ($302,400) only the fourth piece of furniture to realize over £100,000 ($240,000) at auction.

The purchase of these four pieces suggests that Charles Mills had a formidable eye for quality from the start, and in succeeding years while furnishing Camelford House and his newly built country house, Hillingdon Court, Uxbridge, he made a long series of important purchases, regrettably for the most part unrecorded, of porcelain mounted and marquetry furniture.

Unlike most of his contemporary collectors, Mills seems to have had only a limited interest in furniture of the Louis XV or earlier periods. An exception was the purchase in 1848 of a pair of magnificent Boulle cabinets from Princess Sophia's collection;

Important pair of transitional ormolu and Meissen porcelain candelabra 23¾ in.(59 cm.) high. Sold 29.6.72 for 3200 gns. ($8320) on behalf of the Trustees of Lord Hillingdon

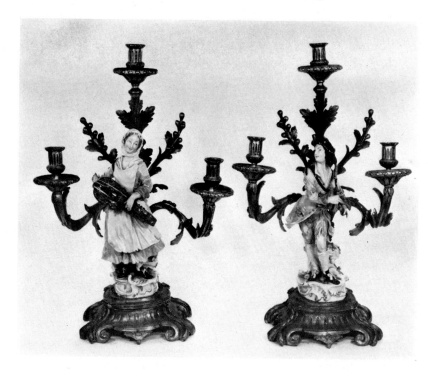

Important Louis XVI Sèvres-mounted guéridon, 30¾ in. (78 cm.) high, 14½ in. (36 cm.) wide, the Sèvres top with date letter E for 1757. Sold 29.6.72 for 11,000 gns. ($28,640). Sold on behalf of the Trustees of Lord Hillingdon

Far right: Louis XVI Sèvres-mounted marquetry guéridon, 30¾ in. (78 cm.) high, 15 in. (38 cm.) wide, the Sèvres top with date letter EE for 1782, probably painted by Pierre Jeune and gilded by Boulanger père. Sold 29.6.72 for 9000 gns. ($23,436). Sold on behalf of the Trustees of Lord Hillingdon

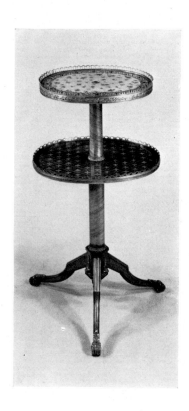

otherwise, as the sale from the collection on June 29th this year indicated, his taste was almost exclusively for furniture from the Louis XVI period, with an emphasis on porcelain-mounted and, unusually for the period, Roentgen marquetry furniture. Other auctions at which he is known to have made purchases include the Stowe sale in 1848 and the Bernal sale in 1855 where he purchased thirteen items including some fine pieces of Sèvres, some small pieces of French furniture and a few French portraits. Sèvres porcelain, whether mounted on furniture or by itself, was one of Charles Mills's keenest passions – the 1891 catalogue lists nearly a thousand pieces, including the fifty or sixty pieces now in the Metropolitan – and it was from this porcelain collection especially that he made generous loans both to the Manchester Museum Loan Exhibition in 1857 and to the Special Loan Collection at the South Kensington Museum in 1862.

In 1868 Charles Mills was given a baronetcy for his services to the Council of India, and he died at the age of eighty in 1872. His son Charles Henry Mills was created Baron Hillingdon in 1886, and while he probably added little to the collection of furniture (though it seems he made a few purchases of furniture at the Hamilton Palace sale in 1882), he contributed magnificently to the collection in the form of a group of exceptional English portraits, some of which were sold by Christie's on June 23rd (see page 57). The first Lord Hillingdon died in 1898 and his son and the Dowager Lady Hillingdon perpetuated the family tradition of generous loans, particularly to the Three French Reigns Exhibition held in Sir Philip Sassoon's house in 1933, three years before the first dispersal from the collection took place.

OLD MASTER
PAINTINGS

A fourteenth-century altarpiece

BY WILLIAM MOSTYN-OWEN

No-one would deny that fourteenth-century painting in Italy was dominated by the figure of Giotto, whose revolutionary influence spread throughout the peninsula. And perhaps nowhere outside Florence was his influence more strongly felt than in Padua, which was one of the most culturally important centres of northern Italy at the time, and where he was summoned personally to paint the Capella degli Scrovegni between the years 1304 and 1310.

The University of Padua was then the most important centre for the study of astrology, mathematics and of perspective; Giotto's revolutionary spacial concepts found an immediate response.

The leading local painter was Guariento di Arpo, the date of whose birth is not known, but who is already described as 'maestro' in 1338. His activities are recorded at various periods, culminating in his departure for Venice in 1365 where he painted his enormous fresco of *The Coronation of the Virgin* in the Doge's Palace, a work which was to take him three years and which was to be destroyed by fire in 1577, subsequently being replaced by Tintoretto's *Paradise*.

In 1344 he produced, possibly on the orders of a certain Archdeacon Alberto, a large altarpiece consisting of twenty-four panels representing the Coronation of the Virgin, surrounded by scenes from the life of Christ and topped by a group of smaller panels containing further scenes and figures of Saints. The fact that two of these, Saint Prosdochimus and Saint Justina, are patrons of the city of Padua would seem to indicate that it must have been painted for a local church or religious institution. In fact there are indications that it passed from a suppressed convent into the Tuscan Grand Ducal collections at some period and was subsequently sold in the first half of the nineteenth century. Unfortunately, the original gothic framing has disappeared and the panels were somewhat arbitrarily placed in a new frame in 1847. The more suitable original gothic framing can be deduced from marks on the gold background of some of the panels, and originally the altarpiece must have looked like other Venetian and Paduan altarpieces of the period, some of which can still be seen in the Venice Museums to-day.

GUARIENTO DI ARPO: *Polyptych, in the centre the Coronation of the Virgin*, on panel, inscribed and dated 1344 85 × 105 in. (216 × 266.5 cm.) overall. Sold 7.7.72 for 245,000 gns. ($617,400). From the collection of Rudolf, Graf Czernin

18

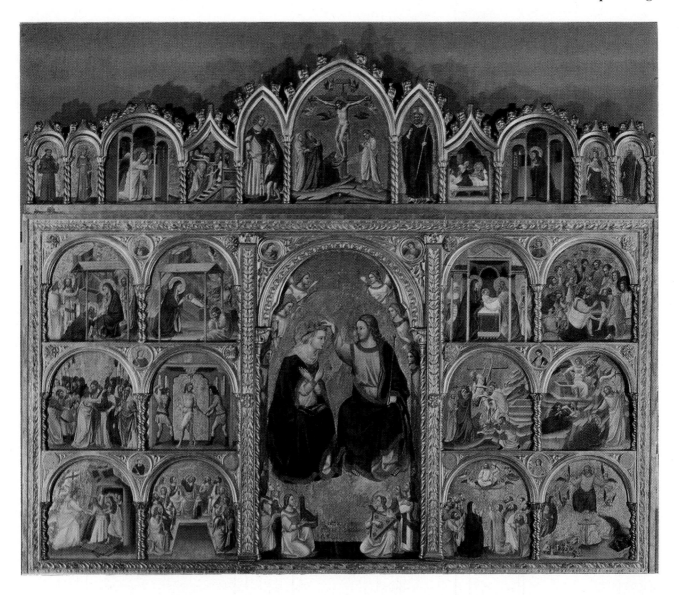

At the time of its re-framing, the altarpiece had been acquired by the Czernin family of Vienna, and it was a direct descendant who sent it for sale on July 7th when it was acquired by Messrs Speelman on behalf of the Norton Simon Foundation for 245,000 guineas ($617,400).

As in so many cases, particularly as applied to early paintings, the origins of this altarpiece remain a matter of hypothesis and conjecture. What is certain, however, is that it is an item of the highest artistic quality and it is most unlikely that anything of its kind will appear on the market again.

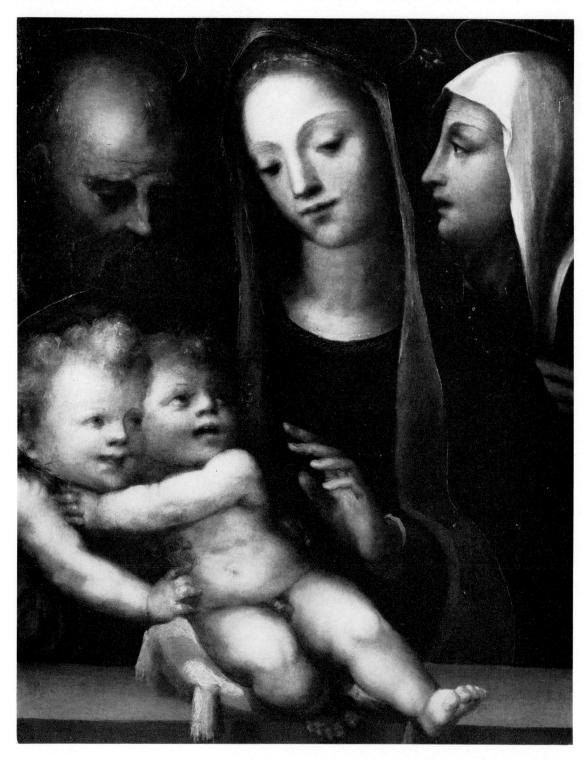

DOMENICO
BECCAFUMI:
*The Holy Family with
the Infant Saint John
the Baptist and Saint
Catherine*, on panel
24 × 20 in.
(60.9 × 50.8 cm.)
Sold 7.7.72 for
13,000 gns. ($32,760)
From the collection
of the Hon Lady
Salmond

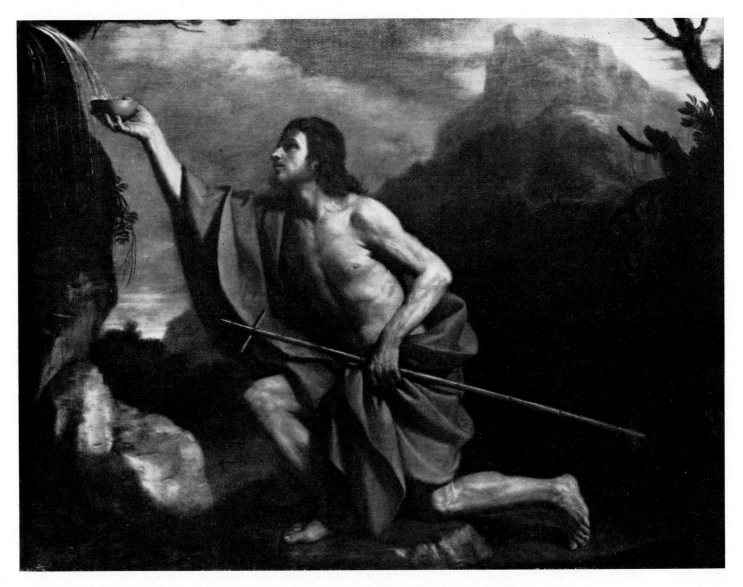

GIOVANNI FRANCESCO BARBIERI, IL GUERCINO: *Saint John the Baptist in the wilderness*
69 × 91½ in. (175 × 232.3 cm.). Sold 26.11.71 for 19,000 gns. ($48,830)
From the collection of The Lord Farnham

Venetian view painters

BY WILLIAM MOSTYN-OWEN

English collectors have always shown a predilection for views of Venice and its surrounding cities painted by a handful of gifted artists whose activity coincided conveniently with the high period of the English nobleman's Grand Tour.

The last season has produced a number of notable examples in the saleroom. Unquestionably the most outstanding item, and arguably one of the most desirable of all views of this kind, was Bellotto's view of the Ponte delle Navi, Verona, which paid its third visit to the saleroom on 26th November, 1971. Exactly two hundred

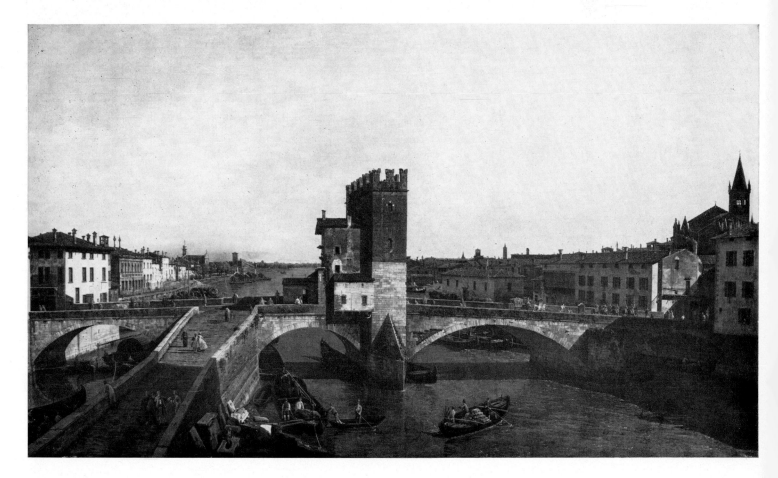

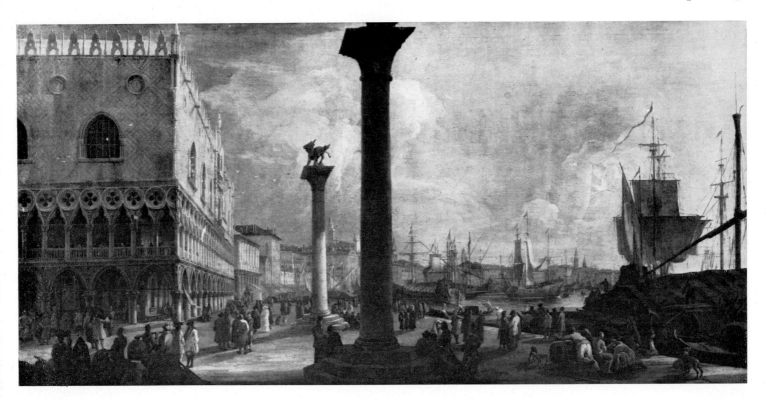

LUCA CARLEVARIJS:
An extensive view of the Molo, Venice
Signed with initials
$34\frac{3}{4} \times 64\frac{1}{2}$ in.
(85.7 × 163.8 cm.)
Sold 26.11.71 for
21,000 gns. ($54,000)
A record auction price
for a work by this artist

years before, and precisely on 29th March, 1771, Mr Christie offered a collection of pictures 'lately consigned from abroad'. Lot 54 was described as follows: 'Canaletti – A large and most capital picture being a remarkable fine view of the city of Verona, on the banks of the Adige: this picture is finely coloured, the perspective, its light and shadow, fine, and uncommonly high finish'd'. It was sold for £260 10s. od. and subsequently found its way into the collection of the Hon George James Welbore Agar-Ellis, later created Lord Dover. It was sold by his grandson on 25th May, 1895 for 2000 guineas being acquired by Agnews on behalf of the grandfather of Major-General Sir George Burns.

Perhaps in no other work did Bellotto come so close to, or even surpass, his uncle Canaletto. The sharp definition of light and shadow on an autumn afternoon, the perfect control of perspective, the busy life on the river, the way the eye is led gently from the bottom left corner up the sloping ramp, across the bridge with all its bustle and activity, and then to the church of San Fermo Maggiore, where it is left to the imagination to sort out the maze of tantalising and narrow streets, combine to form a unique masterpiece.

In his early years, Canaletto had been most strongly influenced by the work of Luca Carlevarijs, who was perhaps the first painter in Venice to devote himself mainly to

23

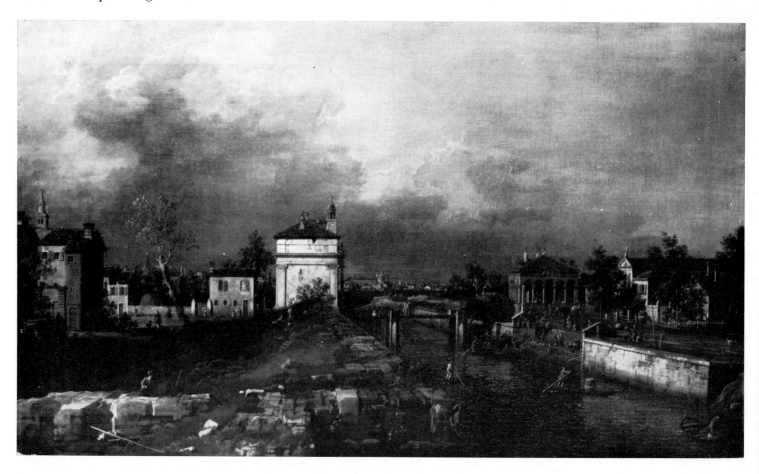

GIOVANNI ANTONIO
CANAL
IL CANALETTO:
*A view of the Brenta
Canal in Padua, with the
Porta Portello*
$24\frac{1}{4} \times 42$ in.
(61.5 × 106.5 cm.)
Sold 7.7.72 for
36,000 gns. ($90,720)
From the collection of
Mr and Mrs Eugene
Ferkauf of New York

topographical views. His work always found a market abroad, especially among the English. One such collector was Christopher Crowe who was British Consul at Genoa from 1720 to 1730. According to family tradition he acquired the Venetian view reproduced on page 23 directly from the artist in Leghorn. He brought the picture back to his Yorkshire home, Kiplin Hall, where it was to remain until sold by his descendant, the late Miss Bridget Talbot, on 26th November, 1971, together with a companion view which had been acquired in the same circumstances.

A view of the Brenta Canal in Padua against a stormy sky (see illustration above) aroused great interest on July 7th and was eventually sold for 36,000 guineas ($90,720). Generally regarded as by Canaletto, it has been considered by some people to be the work of Bellotto, although there are two related drawings by Canaletto in Vienna and at Windsor.

A view of the Piazzetta and the Library in Venice by Canaletto with beautifully grouped figures in the foreground (see illustration page 26) was sold for 38,000 guineas ($95,760), while a view of the Rialto bridge by Michele Marieschi (see

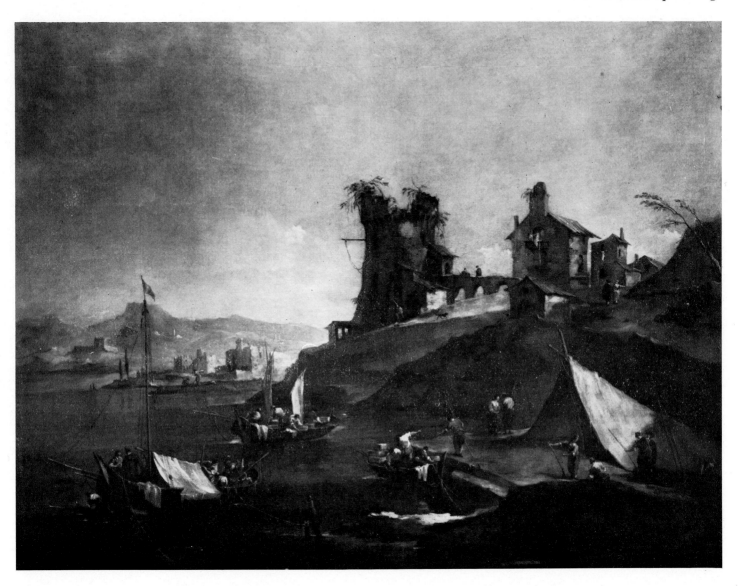

illustration page 27), one of Canaletto's most attractive followers, was sold for 17,000 guineas ($42,840). Even a tiny fragment by Canaletto, measuring 13 in. by 9 in. and cut out of a larger picture, showing a corner of a Venetian Campo, found plenty of interest and was sold on July 7th for 11,000 guineas ($27,720).

The works of Guardi proved as popular as ever. A large *capriccio* landscape (see illustration above) made 42,000 guineas ($103,320) on July 7th, and two post-card-size pictures, one a view on the Grand Canal and the other the courtyard of the Doge's Palace, were sold for 9000 guineas ($22,680) and 6500 guineas ($16,380) respectively.

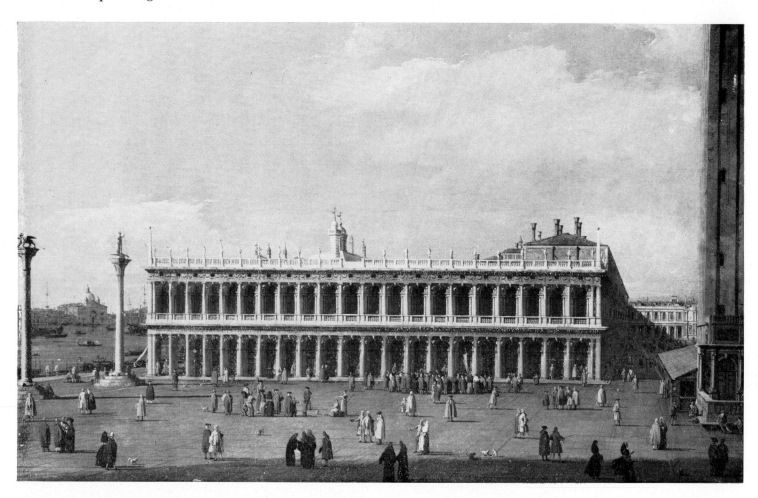

GIOVANNI ANTONIO CANAL, IL CANALETTO: *The Piazzetta, Venice, looking west*
23 × 36½ in. (58.4 × 92.7 cm.)
Sold 7.7.72 for 38,000 gns. ($95,760)

MICHELE
MARIESCHI:
*A view of the Rialto
Bridge, Venice*
$20\frac{1}{2} \times 32$ in.
(52.1 × 81.3 cm.)
Sold 7.7.72 for
17,000 gns.
($42,840)

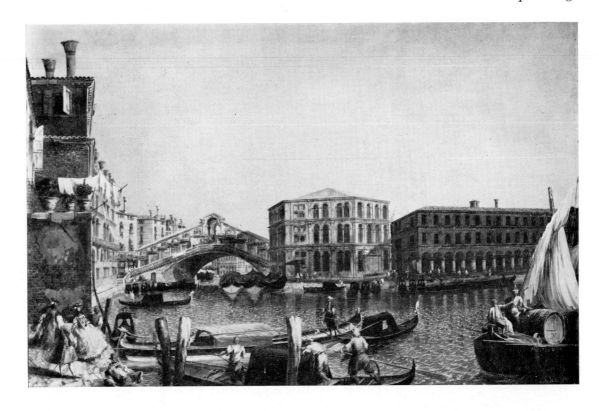

GIOVANNI ANTONIO
CANAL
IL CANALETTO:
*A view of the Doge's
Palace, Venice, from
the Bacino di San
Marco.* $26 \times 44\frac{1}{2}$ in.
(66 × 113 cm.)
Sold 7.7.72 for
24,000 gns. ($60,480)
From the collection
of the late
R. C. Pratt, Esq

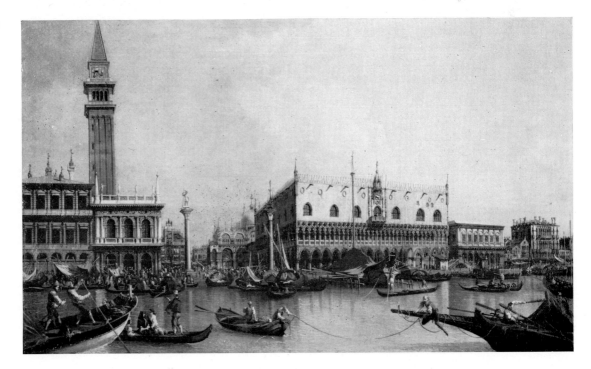

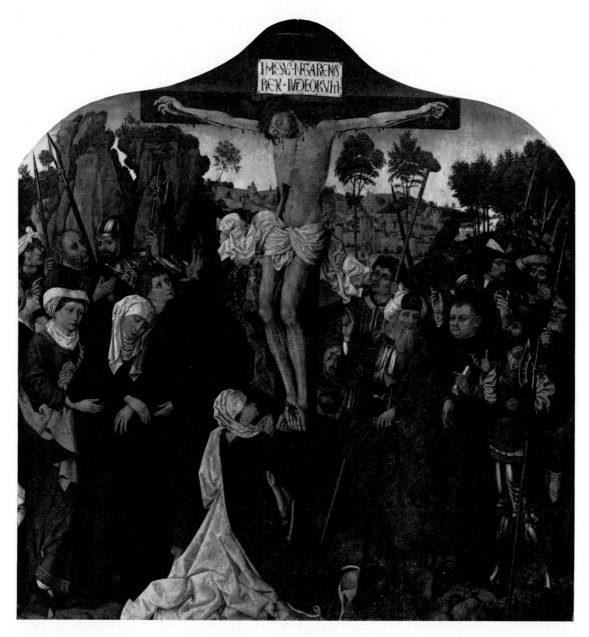

FRANCONIAN SCHOOL, *circa* 1475: *The Crucifixion*, bears Dürer monogram, on panel, shaped top
58 × 56 in. (147.3 × 142.2 cm.). Sold 7.7.72 for 25,000 gns ($63,000)
From the collection of Mrs Hugo Meynell

PIETER
CLAYSSENS II:
*Saint Mary
Magdalen*, signed and
dated 1602, on panel
16 × 12½ in.
(40.6 × 31.7 cm.)
Sold 7.7.72 for
12,000 gns. ($30,240).
From the collection
of the Hon
Lady Salmond

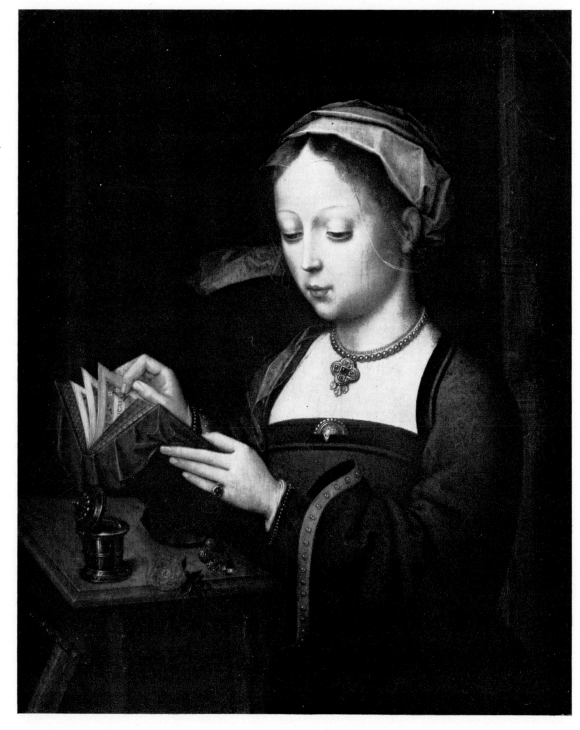

A card party by Lucas van Leyden

BY GREGORY MARTIN

Lucas van Leyden, the friend of Jan Mabuse and the acquaintance of Dürer, was the leading north Netherlandish artist of the High Renaissance. Like Dürer, his fame chiefly rested in his lifetime on his graphic work. His paintings are rare and treasured: about thirty are known, one of which – *The card players* – was sold at Christie's on November 26th.

The card players only came to full prominence some twenty years ago. It was shown to the public for the first time in the great exhibition of Dutch painting at the Royal Academy in 1952–3, and it was subsequently discussed in Friedlaender's monograph on the artist, edited by Winkler and published in 1963.

It is a small and – at first glance – perhaps an almost unobtrusive work. But all Lucas's genius is present in this wistful masterpiece: the treatment of the figures – the acute delineation of the features of the faces and the marvellous rendering of the hands – speak of a man who had mastered the discipline of describing actual appearances.

Not very much is known about this little man who was active in Leyden. His first dated work is of 1508 – how old he was then is not known – but the date marks the beginning of a career that spanned a quarter of a century.

The dating of *The card players* is uncertain. It has been suggested that it is an early work, executed before 1511, but a case can also be made for dating it round 1520. The head-dress and face of the woman is similar to that in a drawing at Weimar of 1521; the head of the young man recalls that of the Emperor Maximilian in Lucas's print of the previous year, while the treatment of the foliage is comparable to that in the diptych at Munich of 1522.

Lucas concentrated on religious themes, but on at least two other occasions he depicted game players: in *The chess players* at Berlin and in *The card players* owned by the Earl of Pembroke. Both these scenes are set in interiors, and in the Wilton *card players*, for example, Lucas's interest centred on describing the tension of gambling. This important, brilliantly colourful and elaborate work lies at the root of the development of Dutch genre painting.

The card players we sold is set out of doors and the mood is more mysterious. The

LUCAS VAN LEYDEN: *The card players* inscribed FM on the lady's bodice, on panel, $11\frac{3}{4} \times 15\frac{1}{2}$ in. (29.8 × 39.4 cm.) Sold 26.11.71 for 100,000 gns. ($257,000). From the collection of The Lady Dunsany

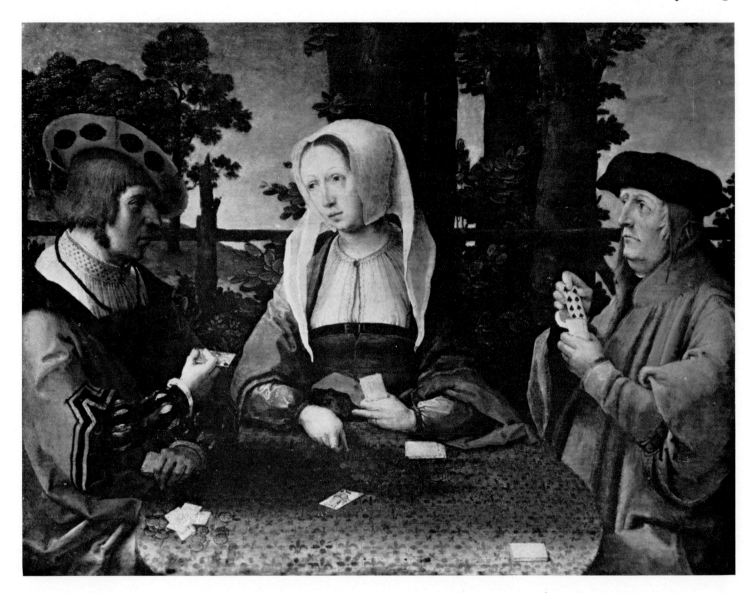

old man is a strange type to find at the gambling table. The woman turns with what seems to be a look of longing at the fashionably dressed young man whose determined look reflects a confidence that he has the winning card.

The trio are playing for money; but more seems to be at stake. Is it a choice between the active and the contemplative life that faces the woman who holds the centre of the stage? Lucas, indeed, concentrates on her and tells us that the initials of her name are F.M.

There is, in fact, a secret in this work that has yet to be unravelled; but while its precise meaning remains obscure, it holds our attention as a work of art by the genius chiefly responsible for taking Dutch painting into the mainstream of European art in the sixteenth century.

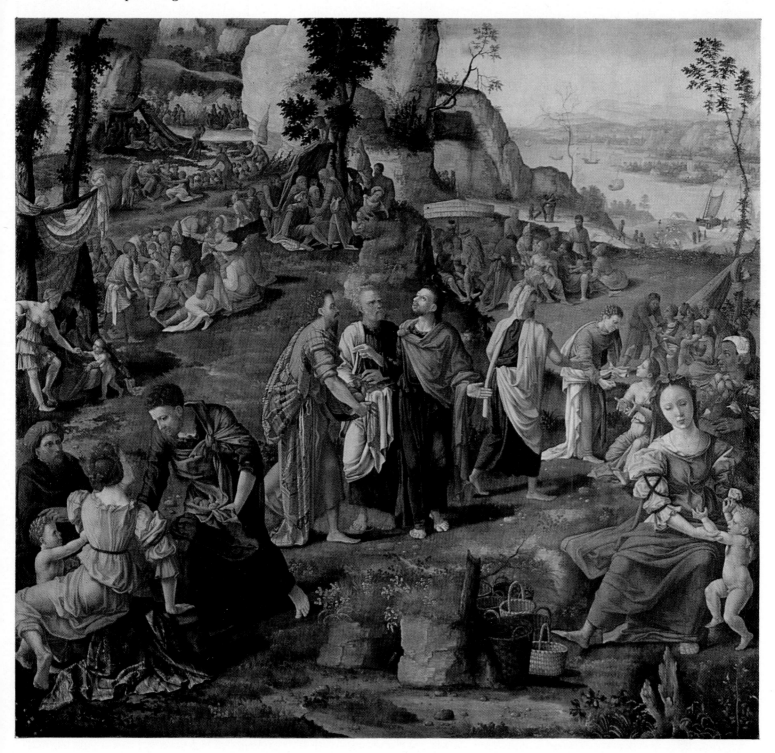

JAN VAN DER HEYDEN: *A view of the church of Saint Pantaleon, Cologne,* signed, on panel
15½ × 23 in. (39.4 × 58.4 cm.). Sold 7.7.72 for 29,000 gns. ($73,080)
From the collection of Mr and Mrs Eugene Ferkauf of New York

Opposite
LAMBERT LOMBARD: *The miracle of the loaves and fishes,* on panel
40¾ × 43¾ in. (103.5 × 111.1 cm.). Sold 7.7.72 for 34,000 gns. ($85,680)
From the collection of Somerset de Chair, Esq, removed from St Osyth's Priory

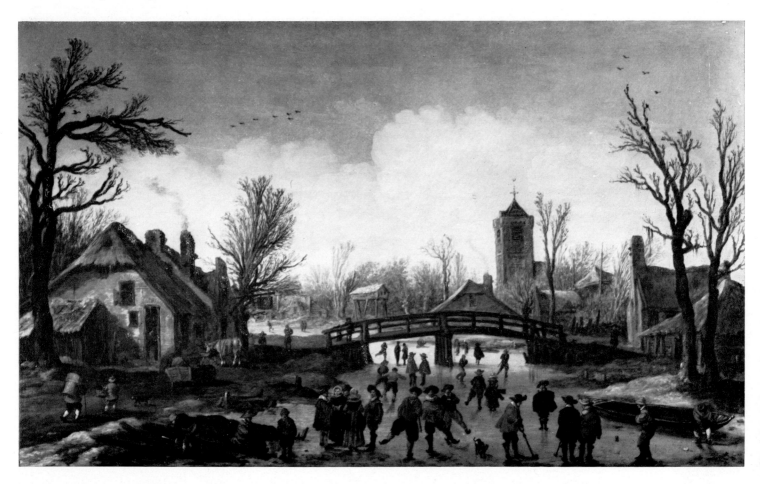

Opposite: JAN VAN GOYEN: *A frozen river landscape,* signed and dated 1625, on panel
$14\frac{3}{4} \times 25\frac{1}{2}$ in. (37.5×64.8 cm.)
Sold 7.7.72 for 45,000 gns. ($113,400)
From the collection of Mr and Mrs Eugene Ferkauf of New York

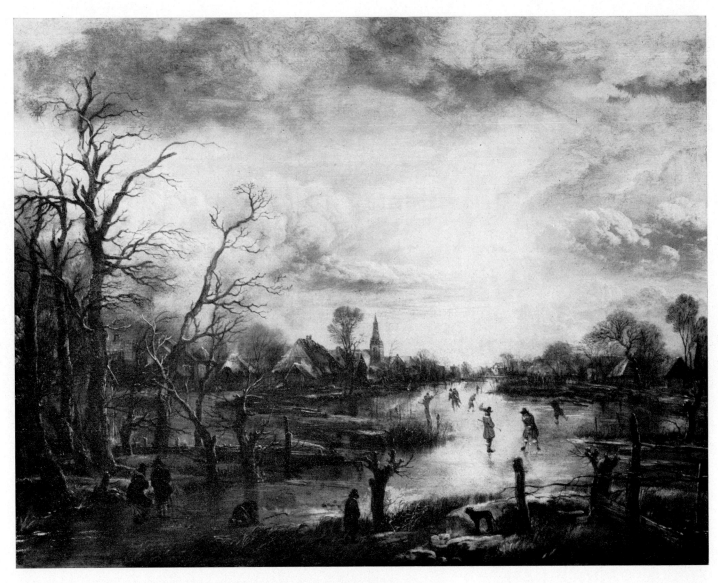

AERT VAN DER NEER: *A winter village landscape*, signed with two monograms
22¼ × 30 in. (56.6 × 71.2 cm.). Sold 7.7.72 for 80,000 gns. ($201,600)
Sold by the Trustees of Lord Hillingdon

JAN STEEN:
An extensive landscape
Signed, on panel
$18\frac{1}{2} \times 25\frac{3}{4}$ in. (47×65.5 cm.)
Sold 7.7.72 for 30,000 gns.
($75,600)
From the collection of the late
Miss A. C. Innes

JAN WIJNANTS:
An extensive wooded landscape, signed
$31\frac{1}{2} \times 40$ in. (80×101.6 cm.)
Sold 7.7.72 for 14,500 gns. ($36,540)
From the collection of the late
Mrs J. S. Alston

BARTOLOMÉ
ESTÉBAN MURILLO:
The adoration of the Magi
$73\frac{1}{2} \times 56\frac{3}{4}$ in.
(187 × 144 cm.)
Sold 7.7.72 for
30,000 gns. ($75,600)

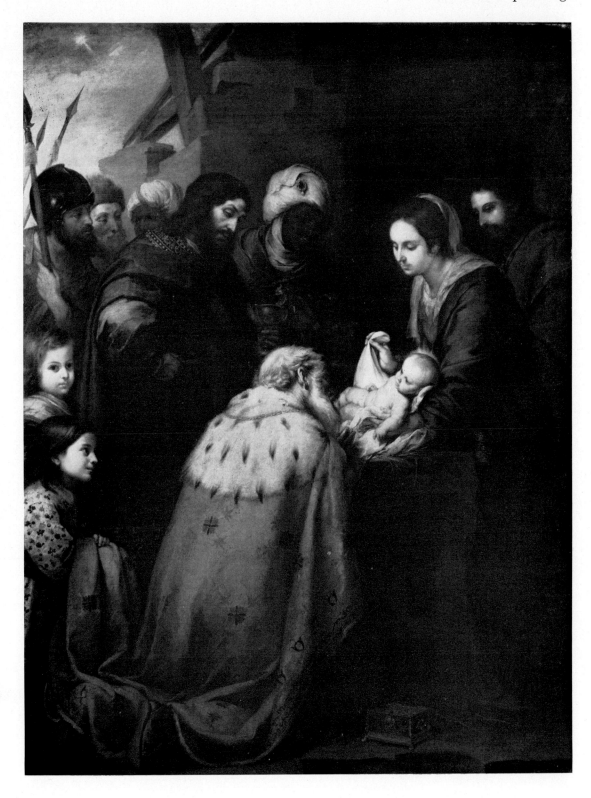

JEAN-HONORÉ FRAGONARD: *Le pont de bois*
$23\frac{1}{2} \times 32\frac{1}{2}$ in. (58.7 × 82.6 cm)
Sold 7.7.72 for 65,000 gns. ($163,800)
From the collection of Mr and Mrs Eugene Ferkauf of New York

FRANÇOIS BOUCHER: *'L'après-midi d'une Faune'*
Signed and dated 1760, oval.
$30\frac{1}{2} \times 25$ in. (77.5 × 63.5 cm.)
Sold 7.7.72 for 35,000 gns. ($88,200)

FRANÇOIS BOUCHER: *A shepherd and a shepherdess in a landscape*, signed and dated 1761, oval.
$30 \times 23\frac{1}{2}$ in. (76.2 × 59.7 cm.)
Sold 7.7.72 for 40,000 gns. ($100,800)
From the collection of Mrs Gaby Salomon

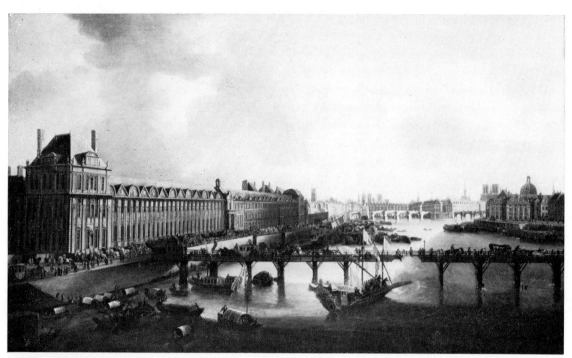

FRENCH SCHOOL
circa 1675:
*A view on the Seine,
Paris, looking east*
(one of a pair)
34½ × 59½ in.
(87.6 × 151.1 cm.)
Sold 7.7.72 for
32,000 gns. ($80,640)
Sold by the Trustees
of Lord Hillingdon

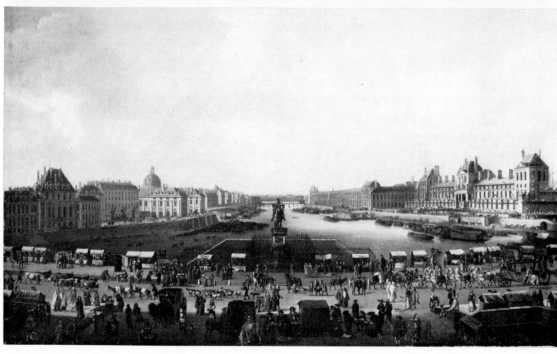

FRENCH SCHOOL
circa 1675:
*A view on the Seine,
Paris, looking west*
(one of a pair, with
above)

Paris in the seventeenth century

Topographical views of cities have a particular fascination for both historians and collectors. Two views on the Seine in Paris, sent in by the Trustees of Lord Hillingdon for sale on July 7th, are a case in point.

One view, looking East, shows the Pont Rouge in the foreground, the Palais du Louvre on the left, the Collège des Nations (now the Institut de France) on the right, the Pont Neuf, and Notre Dame and other churches in the distance; the other view, looking West, with the Pont Neuf in the foreground, shows the Palais du Louvre on the right, and the Collège des Nations on the left. These views can be fairly precisely dated. La Vau's Collège des Nations was built between 1663–72. Perrault's alterations to Le Vau's south-east wing of the Louvre (built by 1664) were begun in 1668 and were abandoned by *circa* 1678. The Pont Rouge, originally called the Pont Barbier, was built in 1632 and was destroyed in 1684.

The authorship of these two paintings is uncertain. A number of views from the Pont Neuf of about this time are known; comparable views of the Seine looking East and West were earlier etched by Callot. It is possible that two hands were responsible for these two pictures; that responsible for the staffage shows connections with the style of Pieter van Bredael. The procession of carriages along the Quai des Tuileries may be headed by Louis XIV; a royal barge is firing a salute. The Pont Rouge was replaced by the Pont Royal designed by Mansart. Gianbologna and Pierre de Francheville's statue of Henri IV on the Pont Neuf was destroyed in 1792, and was later replaced by that by Lemot. The façade of the Louvre was not completed until the nineteenth century.

A still life by de Heem

BY GREGORY MARTIN

Like the Dutch nation itself, still-life painting – the genre most intimately associated with it – achieved its full independence in the seventeenth century. But because its roots lay so firmly in the tradition of Netherlandish painting as a whole, it was appropriate that one of the greatest practitioners of the genre – Jan Davidsz. de Heem – should have been a Dutchman who spent much of his career in Antwerp, one of the major cities in the southern Netherlands that was to retain its traditional allegiance to Spain.

De Heem added a Flemish flamboyance and sense of luxury (he is recorded in Antwerp for the first time in 1636, four years before the death of Rubens) to the colder more analytic styles of the first generation of Dutch seventeenth century still-life painters, from whom initially he learnt much. In other genres such a mixture tended to blur the impact of the resulting work: not so with de Heem. His art grew in vigour and dimension to set the seal on the development of still-life painting that was to run through Chardin, Delacroix and the Impressionists to Braque.

He is best known, perhaps, for large 'banquet' still lifes; equally important in his oeuvre are his still lifes of flowers – one of the largest and most notable examples of which was sold for a record price at Christie's on March 24th. This signed masterpiece depicts over thirty blooms in a glass jar set on a stone ledge before a niche.

De Heem carefully selected and then rigorously examined each flower before placing it in the jar. His sense of flower arrangement was such that he was able to construct a rich and swirling image of contrasting shapes and different colours. The arrangement has a studied, random air; no artist before had dared to tempt the laws of gravity so far with such an attentive reverence for detailed observation. He creates a horticulturalist's dream that describes the wonderful beauty of nature when coaxed by man's ingenuity.

The sense of reverence was heightened by the symbolic meaning attaching to some of the flowers selected. As with Ophelia drifting into madness, so with de Heem pushing his art to higher peaks: a flower was beautiful in itself and conjured up spiritual associations. Thus purity, immortality and love are here alluded to by the presence of the lily, sunflower and carnation.

The ears of corn – otherwise seemingly out of place – underscore a new level of meaning: they symbolize the bread of the Sacrament and Christ's body. Thus too the goldfinch is present – the bird which symbolizes Christ's passion – and the butterfly that alludes to His Resurrection. In this way, de Heem celebrates the here and touches on the hereafter.

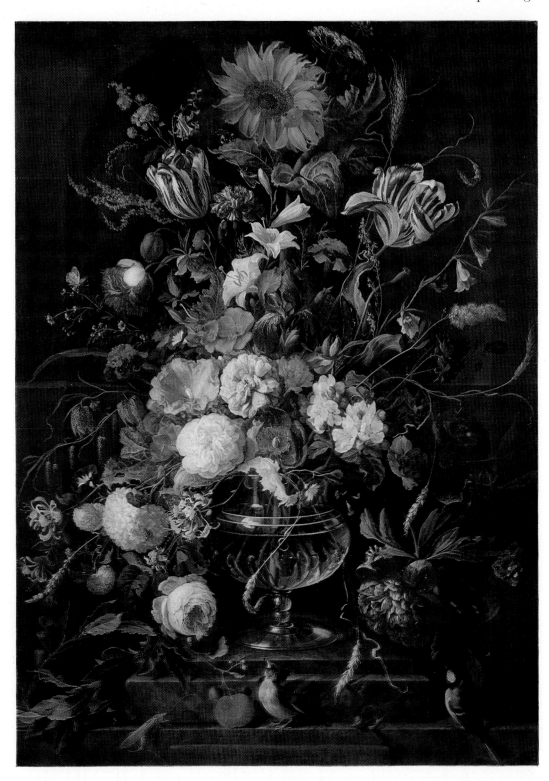

JAN DAVIDSZ. DE HEEM:
A still life of numerous flowers in a glass bowl, with insects and birds on a stone ledge in a niche. Signed
$39\frac{1}{2} \times$ 30 in.
(100.3×76.2 cm.)
Sold 24.3.72 for 40,000 gns.
($109,200)

Old Master paintings

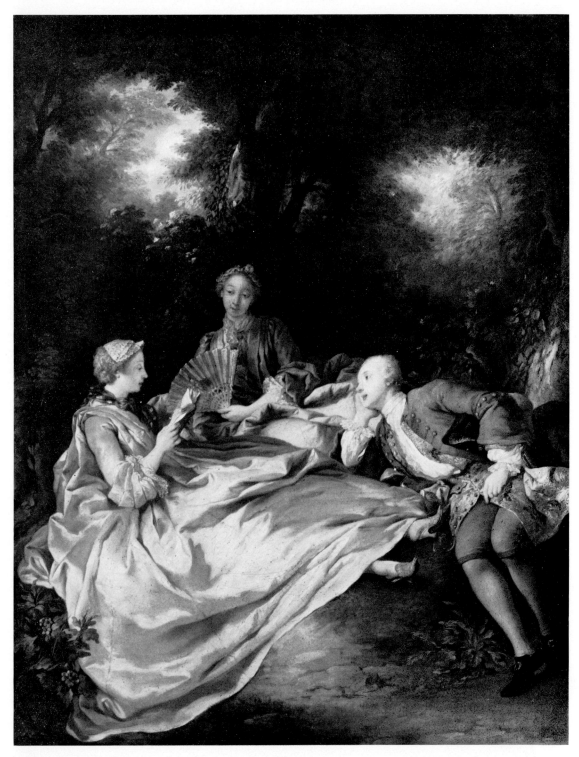

JEAN FRANCOIS
DE TROY:
The reading party
Signed and dated
1735
31 × 25 in.
(78.7 × 63.5 cm.)
Sold 7.7.72 for
48,000 gns. ($120,960)
From the collection
of the late Mrs
Derek Fitzgerald

Buried treasure

BY LADY DOROTHY LYGON

It is over three years since Christie's decided to make a systematic record of the catalogues of their early picture sales. Summaries of these and other sales, already recorded by Redford who was really the pioneer in this line, in Roberts' Memorials of Christie's, and more recently, research by Gerald Reitlinger, made it clear that there was an enormous amount of information in them which, with the increasing importance attached to the provenance of pictures, would be of great value if it were more readily available.

Accordingly, a card index has been devised which is cross-referenced in various ways. Its basis is a file of painters, with particulars of their works as they occur in the sales; this is cross-referenced to the buyers and sellers, and separate lists are kept of references to provenances, named portraits, engraved or inscribed pictures and sales from painters' studios. Although there is a long way to go, a great deal of information is coming to light, not only about the movement of pictures, but also about the buyers and sellers. 1810–33 is the period so far covered and it is interesting to note how many pictures were sent from abroad. There were consignments from Russia in 1813 and 1817 (the latter sale included a picture sold here in 1810), from Leipzig and Munich, as well as frequent consignments from France, Italy and the Low Countries. There were of course pictures from Spain as well; these were not sold by Spanish families but came principally from Englishmen who had worked in Spain (either at Seville or Cadiz) for many years, or were brought back by Army officers from the Peninsular Wars. Italian families and firms, however, sent pictures for sale, notably from Sicily and Bologna, as well as the large number exported by the English living and touring in Italy.

It has not been possible to discover the identity of all the sellers; their names were not always written into the catalogue, but the day-books, which begin in 1811, have sometimes filled the gaps. The day-books are also very useful in that they often give addresses which, with the help of Boyle's *Court Guide*, early *Debretts*, or the *Royal Kelendar* for the appropriate year, has made it possible to identify what first appeared as a surname with no other clues. The entries in the day-book seem to have been made by porters, clerks or James Christie, the younger, himself; the spelling is sometimes in-

Two typical entries from day-books of the 1820's

spired – 'historackle nacked figgers' appear far more startling than the conventional form. If there was a large collection of pictures Mr Christie would often catalogue them straight into the day-book, though it is not clear if this was done from an accompanying list or if it was his own work. When the sellers composed their own descriptions they were apt to be grandiloquently phrased, and it is possible to read through two inches of glowing prose and still be none the wiser about what the picture looked like. A Van Dyck of Charles I was described as: Charles I in armour, exhibiting rather more than his bust; but the frequent 'landscape and figures' leaves even more to the imagination.

Measurements were given in some of the more important sales from 1818 onwards, generally with height preceding breadth, but the finer points of cataloguing were a long way from being hammered out; more often than not the fact that a picture was signed and dated was omitted; inscriptions are mentioned without being quoted; the spelling of proper names was inconsistent, varying even in the same sale; many painters are referred to by their nicknames, such as Honthorst, who appears both under his own name and as Gherardo della Notte. It seems as if a picture listed as Ruysdael would be assumed to be by Jacob rather than Salomon; two of the many pictures ascribed to A. Carracci have proved to be by Annibale, and one has been linked with Agostino. 'Poussin' is even more ambiguous, though in the eighteenth century it is thought to have implied Dughet (who frequently appears as 'Gasper') rather than Nicholas.

Although the big collectors employed dealers or agents to bid for them they often went to sales and bid for themselves and Lord Yarmouth bought pictures for George IV. Lord Mulgrave and his brother General Phipps, Lord Northwick, Samuel Rogers, Lord Lansdowne, Lord (Charles) Townshend, Lord Egremont, Allen Gilmore, Baring and Lord Normanton all appear as buyers; of the pictures bought by Lord Egremont, all except one were still at Petworth in 1919.

When a collection was sold following the owner's death, it was a frequent arrangement for a relation, a friend, or an agent to 'buy back' those pictures the family wanted to keep; thus, pictures belonging to Sir Harry Englefield, dec'd., came up for sale in 1823, a number of which he had bought at various sales here; five of them reappeared in the sale of Sir H. C. Englefield, dec'd., sixty years later.

'Messman' was first recorded as a buyer in 1812; he bought steadily from 1818 onwards, generally paying under £10 for his pictures. His correct name was Daniel Mesman, of 7 Trevor Terrace, Knightsbridge; on his death in 1834 he left between seventy and eighty pictures to the Fitzwilliam Museum, a number of which, including the Elsheimers, can be traced to these sales.

A sale of Alexander Day's in 1833 has provided a reference to the National Gallery's

No. 809, ascribed to Michelangelo, the *Manchester Madonna;* and a sale in 1829 records (Wynn) Ellis's purchase of P. Veronese's *The Magdalen laying aside her Jewels* (NG 931) from W. Smith, MP, with an eighteenth-century provenance from Sir Gregory Page Turner of Blackheath. The Antoine Caron now in the Louvre was sold here in 1823.

The Abbegg Foundation in Switzerland have a Botticelli of St Thomas Aquinas which was in the Holford Collection; it has been possible to follow it back from Samuel Rogers' sale in 1856, when it was *Lot 611, Cimabue: St. Thomas Aquinas holding an inkstand, from the collections of W. Young Ottley and the Hon. C. Greville.* Rogers had bought it at the sale of pictures following Ottley's death in 1837, when it was *Lot 60, Cimabue: Head of an Evangelist – a curious specimen.* It had been unsold at Ottley's earlier sale in 1811, when it appeared as *Lot 30, Masaccio: St. Dominic, head and hands, distemper, from the late Hon. C. Greville's collection.* In the latter's sale in 1810 it was *Lot 77, Masaccio: Head of an Evangelist, painted on a gold ground, a singular and fine specimen, Bt. by Pinney.* Rogers was present at this sale (where he bought another picture, also attributed to Masaccio, now NG 276, ascribed to Aretino Spinello), so presumably he remembered the picture and was able to restore its Greville provenance. A note in the catalogue referring to Greville's Italian pictures said '. . . they were selected by the late intelligent proprietor from authentic situations and they may therefore be deemed invaluable'.

The Velazquez picture of the *Old woman cooking eggs* now in the National Gallery of Scotland was first recorded in England in a sale here in 1813. The pair of G. B. Castigliones sold here in 1970 by Sir Ian MacDonald of Sleat were among pictures bought by his ancestor Colonel Bosville at the sale of the Marquis of Bute's pictures from Luton Hoo in 1822. These are only a few of previously unknown provenances which have come to light and many more must remain to be found.

It is difficult to assess the comparative value of prices between this period and the present day; the highest price recorded so far is the £5250 which Lord Yarmouth paid on behalf of George IV for Rembrandt's *The Master Shipbuilder,* but four-figure prices were rare. Perhaps one factor in keeping prices down was the much smaller range of knowledge about the provenance and authenticity of pictures – people had to rely heavily on their own judgment and the sort of expertise, information and research readily available today did not exist. A work like Pilkington's *Dictionary of Painters* shows how many painters known today were not recognized then, and works were freely ascribed to known painters whose style approximated to the picture in question. But acknowledged copies of works by painters such as Raphael and Correggio were acceptable currency when there was no other way of knowing what a particular work looked like; 'a fine copy of the Madonna della Sedia' was

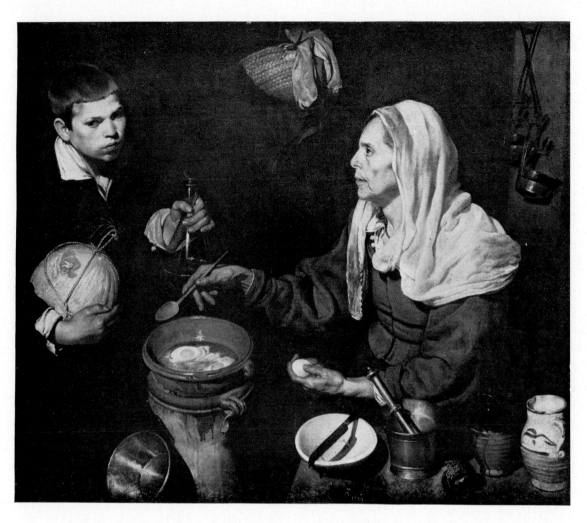

DIEGO RODRIGUEZ
DE SILVA
VELAZQUEZ:
Old woman cooking eggs
By courtesy of the National
Gallery of Scotland

unsold at 40 guineas, with a reserve of £100 in 1814, and other copies made £20–£25; a copy of the Correggio in the National Gallery (No. 23) made £131 5s. 0d. in Sir Thomas Lawrence's Sale in 1830, yet the Cornbury Park Giovanni Bellini sold for only £43 1s. 0d. in 1812.

Contemporary letters, diaries and memoirs are an invaluable source of information about the collectors and dealers of the day; there is hardly one which does not add something new – it is like dropping another piece into an immense jig-saw puzzle.

Christie's principal rival as an auctioneer was Phillips of Bond Street; the big dealers seem to have used both firms impartially. Stanley, Squibb, Coxe and Foster were other firms whose catalogues survive who had regular picture sales. William Buchanan, Thomas Emmerson, the three Woodburn brothers, Pinney, Norton, J. Smith and Peacock were among the leading dealers; judging by the quantity of

pictures they bought, they must have had a considerable turnover, though no doubt they were sometimes buying for private clients. For example, Henry Walton bought for Lord Fitzwilliam; Bone bought pictures for Neeld of Grittleton; Rodd and Dunford bought for Lord Northwick.

It is a fascinating task pursuing so many and such varied clues in such a wealthy archive – nearly every sale turns up some item of interest – and it is hoped that the card-index will become increasingly useful to picture galleries and students alike.

DUTCH AND ENGLISH
18th- AND 19th-CENTURY
PAINTINGS

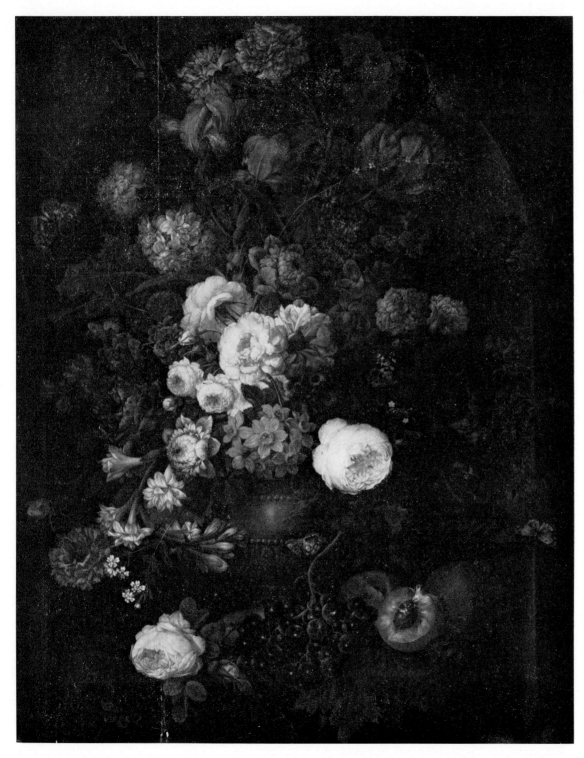

JOHANN BAPTISTE
DRECHSLER:
*Roses, tulips, carnations,
irises, marigolds,
jonquils, etc.*
Signed and dated
1811, on panel
30 × 24 in.
(76.2 × 60.9 cm.)
Sold 4.2.72 for
7500 gns. ($20,410)
World auction
record price for
this artist

ANDREAS
SCHELFHOUT and
JOSEPHUS JODOCUS
MOERENHOUT:
A hawking party
Signed by both
artists and dated 1841
40 × 55 in.
(101.5 × 140 cm.)
Sold 12.5.72 for
20,000 gns. ($54,600)
From the collection
of Mrs W. D.
Dereham
World auction record
price for any
nineteenth-century
Dutch artist

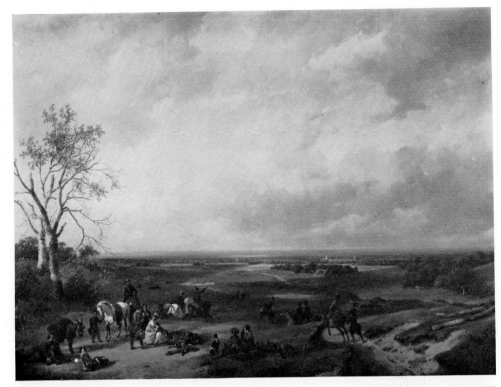

JACQUES
CARABAIN:
*A view of the Hotel de
Ville de Goslar, Harz*
Signed, and with an
old label on the
reverse signed by the
artist
31½ × 43 in.
(80 × 109.2 cm.)
Sold 12.5.72 for
9000 gns. ($24,570)
From the collection of
Michael Mason, Esq
World auction record
price for this artist

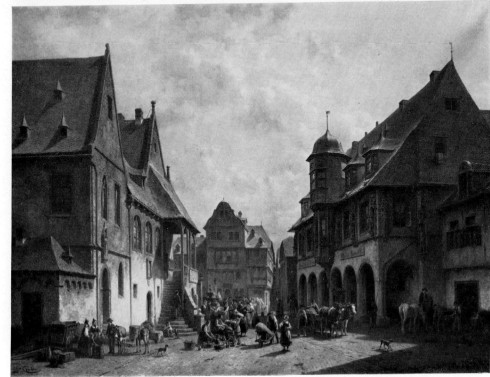

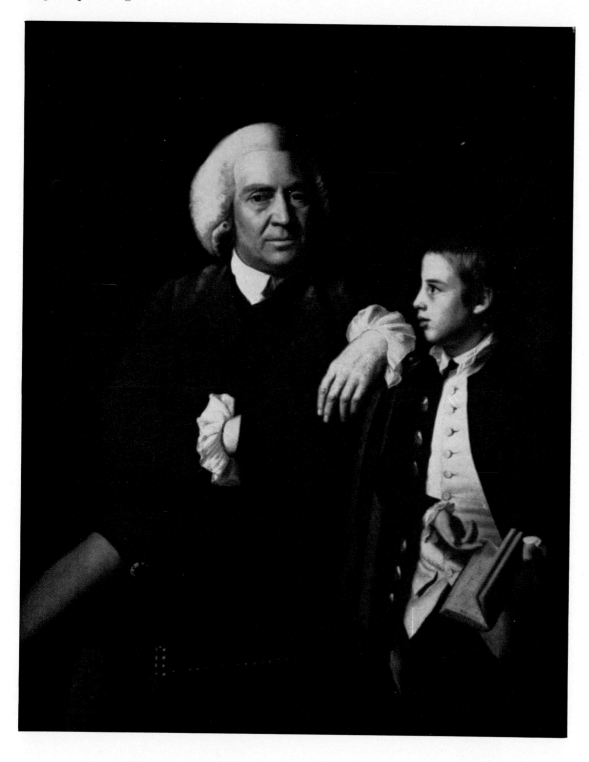

JOHN SINGLETON
COPLEY:
*Portrait of William
Vassall and his son
Leonard* (b. 1764)
49½ × 40 in.
(125.7 × 101.6 cm.)
Sold 23.6.72 for
70,000 gns. ($191,100)
From the collection
of Leonard Vassall,
Esq

JAMES SEYMOUR:
An equestrian portrait
of Sir Roger
Burgoyne, on his
favourite horse
'Badger' with his
bitch 'Juno'
Signed, inscribed and
dated 1740
48 × 68 in.
(121.8 × 172.6 cm.)
Sold 17.3.72 for
26,000 gns. ($70,980)
From the collection
of the Hon David
Astor

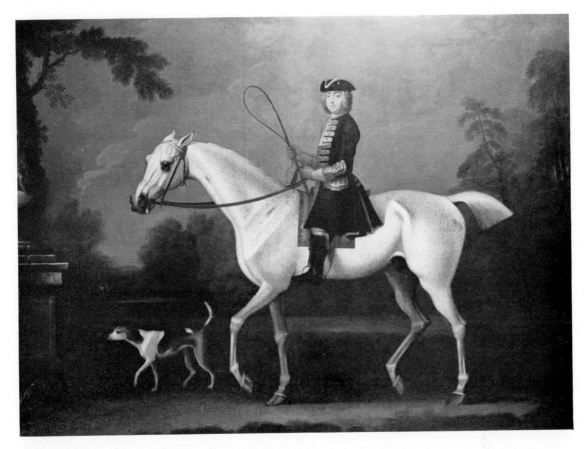

PETER MONAMY:
A man-o'-war
becalmed offshore
27 × 50½ in.
(68.6 × 128.3 cm.)
Sold 17.3.72 for
14,000 gns. ($38,222)
From the collection
of the late Ernest
Thornton Smith

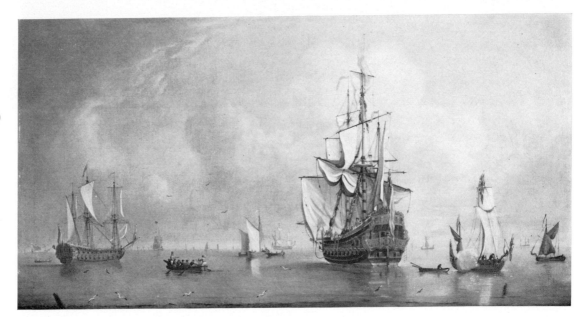

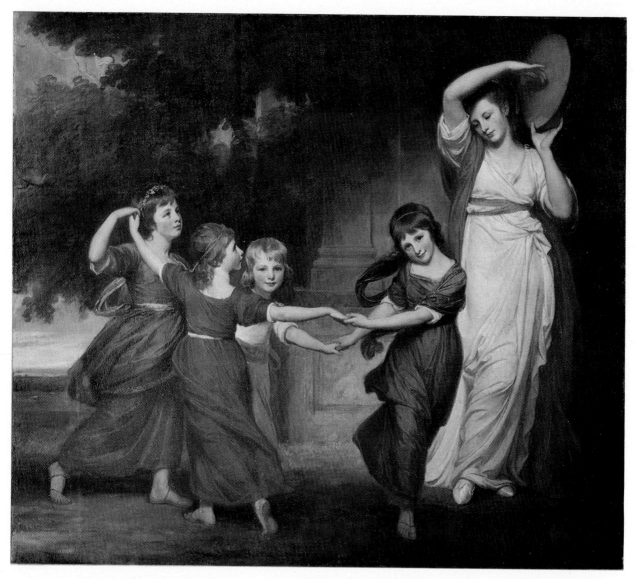

GEORGE ROMNEY: *The Gower Family.* 70 × 90 in. (178 × 228.5 cm.) Sold 23.6.72 fo 140,000 gns. ($482,200) From the collection of The Countess of Sutherland. World record auction price for a work by this artist

A memorable season for English pictures

BY CHRISTOPHER WOOD

For once, sales of English pictures this season have been more remarkable in their way than the Old Master sales. In particular, the great sale of June 23rd, which made a record total of £972,000 ($2,527,159), may well prove to be a historic turning-point in the revaluation of English painting.

The outstanding feature of the sale was a magnificent group of eighteenth-century portraits, including the *Gower Family* by Romney, and three superb Reynolds. The prices even outstripped those paid by Lord Duveen in his heyday before the last war. The Romney made £147,000 ($382,200), a new record for the artist. For the previous Romney record one has to go back as far as 1926 when Duveen paid £60,900 at Christie's for a portrait of Mrs Bromley Davenport. (This price remained the record auction figure for any picture until the Westminster altarpiece by Rubens was sold in 1959 for £275,000 [$775,550]). After the Romney came the delightful Reynolds of Mrs Abington, the actress, which made a staggering £105,000 ($273,000). Although Duveen is said to have sold a Reynolds of *Mrs Siddons as the Tragic Muse* to Huntington for about £70,000, the previous highest auction price was only £25,000 ($70,000), paid for the *Portrait of James Boswell* in 1965. Two other pictures by Reynolds also topped this record, the *Portrait of Sir Richard Peers Symons,* a superb full length, at £39,900 ($103,740), and *Mrs Sarah Wodehouse,* at £57,750 ($150,150).

Three other portraits made records – a Boston-period Copley of *William Vassall and his son Leonard,* £73,500 ($191,100); a Benjamin Wilson of *A lady and gentleman in the park at Rievaulx Abbey,* £18,900 ($49,140); and *A man* by George Richmond at £3675 ($9555). The sale reflects a dramatic swing back to favour for the English eighteenth-century portrait which has been out of fashion since the war. Present-day buyers, however, are much more selective than those of the Duveen era when very high prices were sometimes paid for indifferent and second-rate works.

Landscapes of the eighteenth and nineteenth centuries also achieved significant new records. A calm and reflective *View of Hampstead Heath* by Constable made £94,500 ($245,700). This more than doubled the 1951 record of £44,100 ($132,300) paid at the Hutchinson sale for *The Young Waltonians.* Frederick William Watts,

friend and imitator of Constable, has also had a memorable season. His record has been broken no less than three times. Firstly, in December, a very Constable-like example made £13,650 ($33,410); secondly, a signed and dated one made £16,800 ($42,260) in January; and finally, on June 23rd, a large and sweeping *View of Hampstead Heath* went to £17,850 ($46,410). This picture made only 15 guineas when it was offered by Christie's in 1887.

Two very different artists, Richard Wilson and Samuel Palmer, made new records of almost the same amount. The Wilson, a large and impressive composition, entitled *Solitude* made £47,250 ($122,850). The Palmer, by contrast, a tiny jewel-like oil of the Shoreham period, was entitled *The Harvest Moon*. This picture was perhaps the most exciting discovery of the sale as its owners had no idea of its value when they brought it to Christie's. They did know that their family had bought it at Christie's at about the turn of the century for a small sum. A rapid check in our archives revealed that it was sold by A. H. Palmer, the artist's son, in 1909; the price 5 guineas. The price in 1972 was £46,200 ($120,120). John Linnell, Palmer's father-in-law, has always been underrated, and I was glad to see a landscape by him also went to a record £7875 ($20,475). Two other notable records were £13,650 ($35,490) for a splendid panorama of *London from Greenwich Hill* by George Arnald, and £8,400 ($21,840) for an *Indian view* by Thomas Daniell.

Sporting and marine pictures have also done well this season. A James Seymour of *Sir Roger Burgoyne on his favourite Horse* made £27,300 ($70,980), and works by Ferneley, Herring, Towne, Marshall and others continue to sell for very high prices. Among the marine painters, Peter Monamy and Thomas Whitcombe both went to new records of £14,700 ($38,222). Robert Salmon, a Liverpool painter who emigrated to Boston, has always been popular with American buyers, and two works by him made £7350 ($18,007) and £9975 ($24,420).

SIR JOSHUA
REYNOLDS, PRA:
Portrait of Mrs
Abington as Miss
Prue, in Congreve's
'Love for Love'
Inscribed
30 × 27 in.
(76.2 × 61.6 cm.)
Sold 23.6.72 for
100,000 gns.
($273,000)
Sold by the Trustees
of Lord Hillingdon
A world record price
for this artist

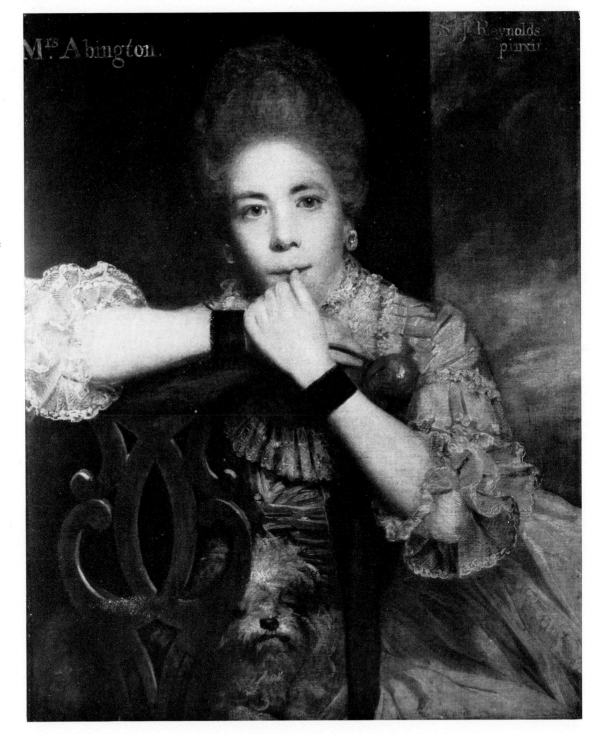

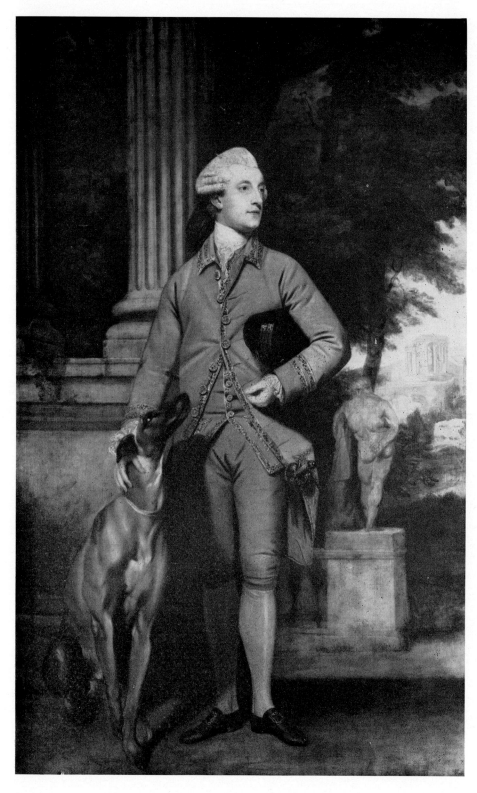

SIR JOSHUA REYNOLDS, PRA:
Portrait of Sir Richard (Peers)
Symons, Bt.
$93\frac{1}{2} \times 57\frac{1}{2}$ in. (273.3×146 cm.)
Sold 23.6.72 for 38,000 gns. ($103,740)
From the collection of
Sir Richard Blunt, BT.

SIR JOSHUA
REYNOLDS, PRA:
*Portrait of Mrs
Sarah Wodehouse*
49 × 39 in.
(124.3 × 99 cm.)
Sold 23.6.72 for
55,000 gns. ($150,150)
Sold by the Trustees
of Lord Hillingdon

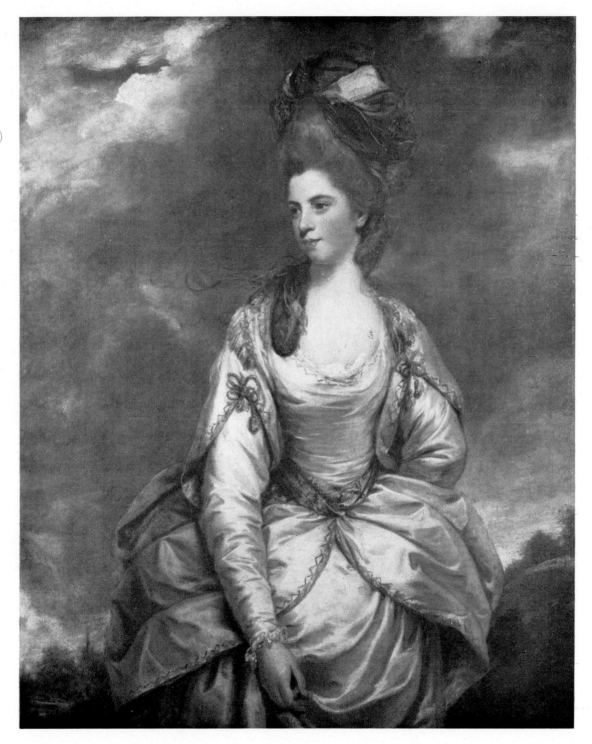

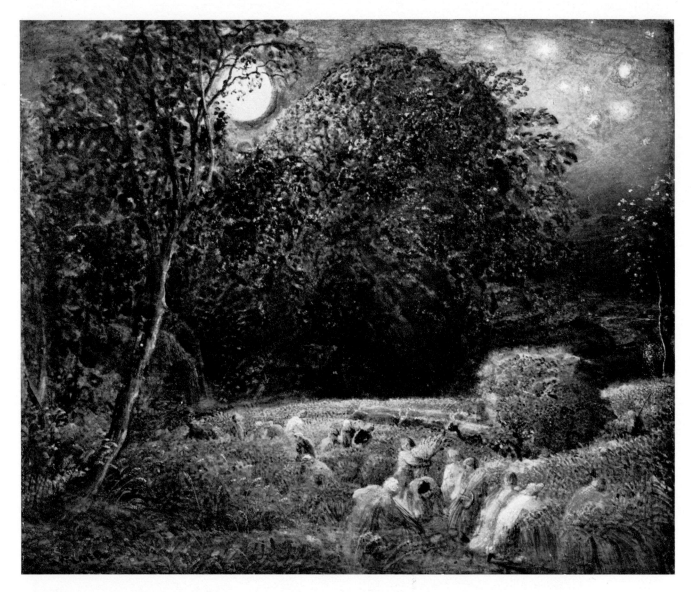

SAMUEL PALMER: *The harvest moon*
Signed, oil on paper laid on panel
$8\frac{3}{4} \times 10\frac{5}{8}$ in. $(22.2 \times 27$ cm.$)$
Sold 23.6.72 for 44,000 gns. ($120,120)
A world record price for this artist

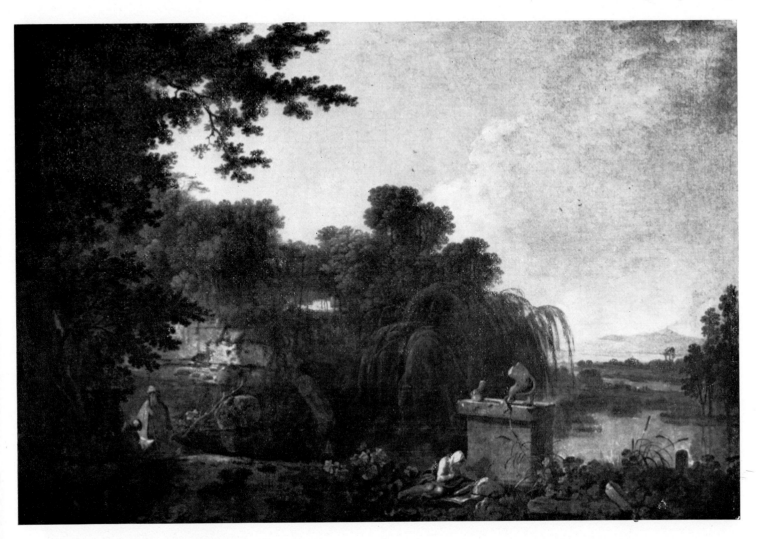

RICHARD WILSON, RA: *Solitude*
$54\frac{1}{2} \times 81\frac{3}{4}$ in. (138.5 × 207.7 cm.)
Sold 23.6.72 for 45,000 gns. ($122,850)
From the collection of the Fountaine family

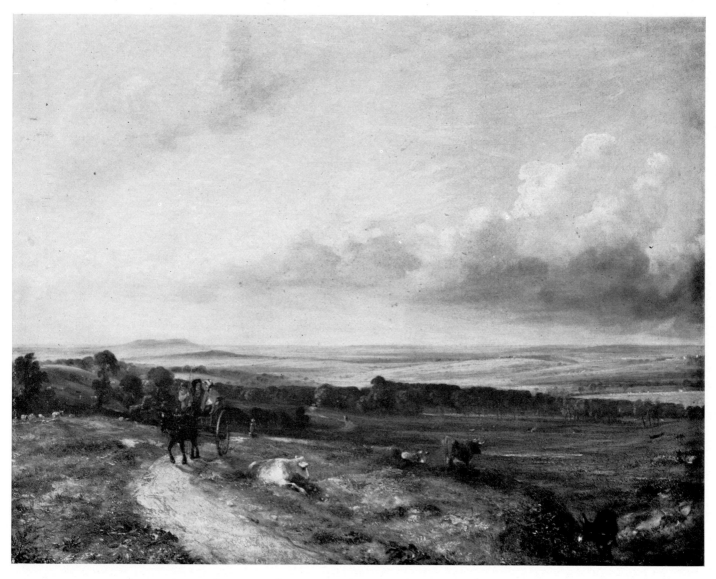

JOHN CONSTABLE, RA: *A view on Hampstead Heath*
Signed and dated 1824
$23\frac{1}{2} \times 30\frac{1}{2}$ in. (59.6 × 77.4 cm.)
Sold 23.6.72 for 90,000 gns. ($245,700)
Sold by the Trustees of Lord Hillingdon
A world record price for this artist

FREDERICK
WILLIAM WATTS:
*A view on Hampstead
Heath*
$46 \times 71\frac{1}{2}$ in.
(116.7×181.5 cm.)
Sold 23.6.72 for
17,000 gns. ($46,410)
From the collection
of Lady Summers
World auction record
price for this artist

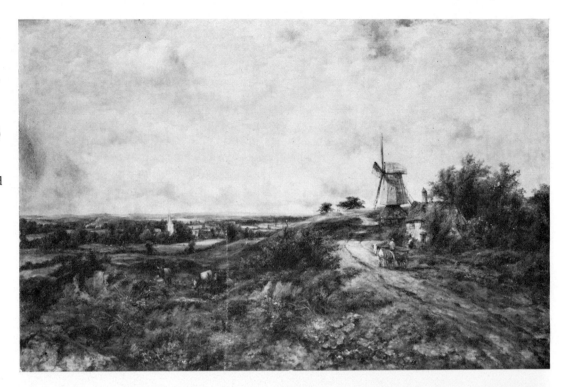

BENJAMIN
WILLIAMS
LEADER, RA:
*A Welsh stream in
summer time*
Signed and dated
1881
$47 \times 71\frac{1}{2}$ in.
(119.2×181.5 cm.)
Sold 28.1.72 for
4800 gns. ($12,850)
World auction record
price for this artist

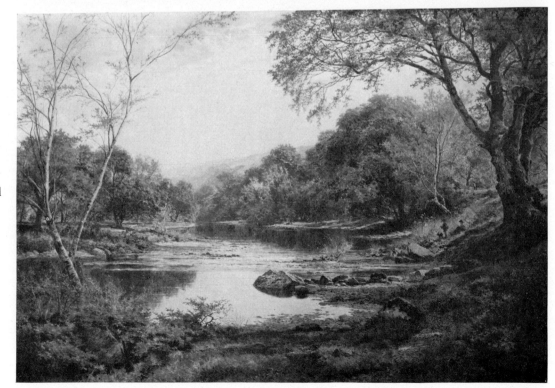

SIR JOHN EVERETT
MILLAIS, BT, PRA:
The proscribed Royalist
(a reduced replica)
Signed with
monogram, on panel
10 × 7½ in.
(25.4 × 19 cm.)
Sold 28.1.72 for
12,000 gns. ($32,100)
From the collection
of the late Captain
H. E. Rimington-
Wilson

SIR JOHN EVERETT
MILLAIS, BT, PRA:
*A Huguenot on Saint Bartholomew's
day refusing to shield himself from
danger by wearing the Roman Catholic
badge*
Signed and dated 1852, arched top
$36\frac{1}{2} \times 24\frac{1}{2}$ in. (92.7 × 61.6 cm.)
Sold 14.7.72 for
30,000 gns. ($75,600)
From the collection of
Mr Huntington Hartford

SIR WILLIAM
QUILLER
ORCHARDSON, RA:
Trouble
Signed with initials
and dated '96
45 × 36 in.
(114.3 × 91.4 cm.)
Sold 14.7.72 for
3200 gns. ($8150)

OLD MASTER AND ENGLISH DRAWINGS AND WATERCOLOURS

REMBRANDT HARMENSZ VAN RIJN: *A man with a moustache*
Pen and brown ink, brown wash, the sheet made up at the bottom
$4\frac{5}{8} \times 2\frac{5}{8}$ in. (11.6 × 6.5 cm.)
Sold 4.7.72 for 15,000 gns. ($37,800)
From the collection of the late Mrs F. L. Evans

ADRIAEN VAN OSTADE:
Peasants drinking and making music in a tavern
Signed, pen and brown ink and
watercolour heightened with white
$5\frac{1}{4} \times 4\frac{1}{2}$ in. (13.3 × 11.2 cm.)
Sold 4.7.72 for 6800 gns. ($17,136)
From the collection of
the late Mrs F. L. Evans

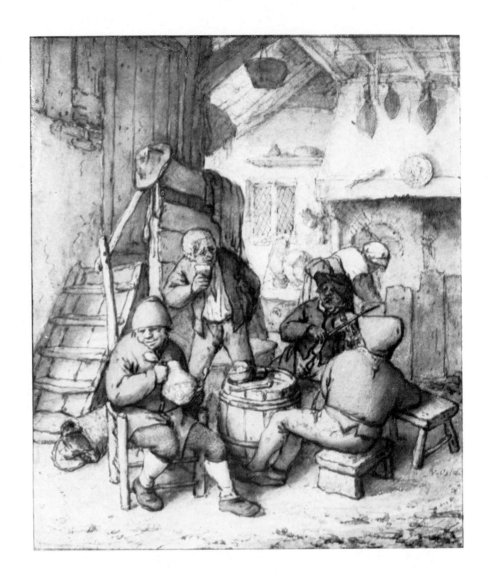

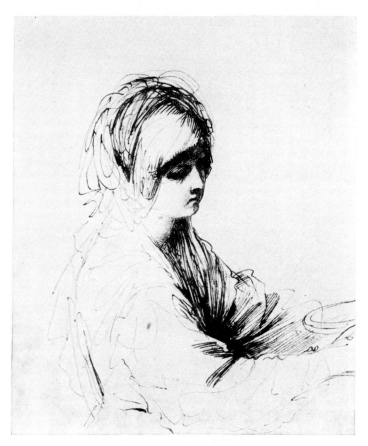

GIOVANNI FRANCESCO BARBIERI, IL GUERCINO:
Study of a girl, turned to the right, holding a dish
Pen and brown ink. $7\frac{5}{8} \times 6\frac{1}{8}$ in. (19.5×15.5 cm.)
Sold 23.11.71 for 1000 gns. ($2570)
From the collection of the Earl of Gainsborough

Guercino drawings from the Gainsborough Collection

BY FRANCIS RUSSELL

Of the Italian painters of the seicento it was surely Guercino who took most naturally to the role of draughtsman. Fluent with pen and wash and beautifully composed in chalk, his assurance in either medium is only matched by his large output in both. Although it is unusual to hold a good Old Master drawings sale in which he is not represented, it is even more exceptional to find so distinguished a group of Guercino drawings as that sold by Lord Gainsborough in November. For of the thirteen sheets drawn by the painter or in his workshop, nine were of outstanding quality, and the whole group shares a remarkable provenance.

Though Guercino's drawings were already prized in his lifetime, the majority remained in his studio, passing to his nephews, the Gennari, and then to their descendants. Despite occasional sales, the collection remained largely intact at Casa Gennari until 1762, when the extensive series of drawings now at Windsor was secured for King George III. About the same time a further series was acquired *en bloc*, through the Bolognese dealer Formi, by Edward Bouverie, whose collection was in

GIOVANNI
FRANCESCO
BARBIERI
IL GUERCINO:
Ahasuerus
Pen and brown ink
$8\frac{7}{8} \times 7\frac{1}{4}$ in.
(22.6 × 18.4 cm.)
Sold 23.11.71 for
1350 gns. ($3470)
From the collection
of the Earl of
Gainsborough

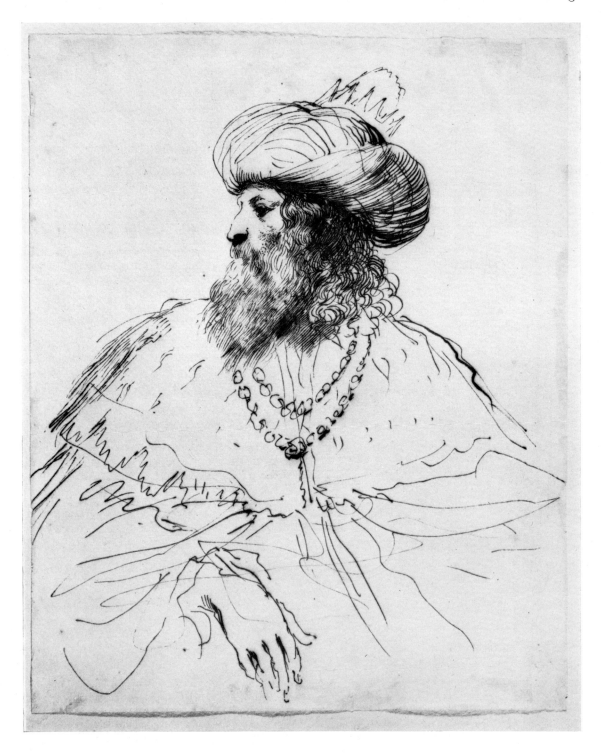

turn inherited by his nephew, Mr Hervey. While 116 drawings by the artist were sold with the rest of the Bouverie collection at Christie's in 1859, the greater portion of the Guercino series seems to have been purchased privately by the 1st Earl of Gainsborough. Most of the drawings thus acquired were sold, again at Christie's, by the 3rd Earl in 1922, and the recent sale was thus the third in which Guercino drawings from the Bouverie collection have been dispersed at King Street.

The Guercino collection at Windsor includes a high proportion of workshop material, but most of the drawings traceable to Bouverie's are both of remarkable quality and in fresh condition – a factor of some importance as the brilliance of Guercino's draughtsmanship is impaired in faded sheets. Those in the recent sale proved no exception.

Three of the drawings, two studies of St Jerome and one of Paul the Hermit, belong to the long sequence in which Guercino projects a single saint against a landscape setting – a sequence which reached a restrained and definitive conclusion in the large picture of *St John in the Wilderness*, sold by Lord Farnham in the same month. In these drawings the penwork is infected with something of the fervour of Guercino's subject. Equally brilliant, but of more obvious beauty, were two half-length studies of girls, also in ink. That of the girl holding a vessel (see illustration, p. 72) was among the drawings at Casa Gennari copied by Bartolozzi who played an important part in the 1762 sale, and it is not difficult to understand why such a drawing appealed to eighteenth-century taste. Bartolozzi also copied the masterly sheet (see opposite) with three studies of a child's head in chalk, drawn in preparation for a putto in the altarpiece of *St Margaret of Corona* of 1646–8, now in the Vatican. A drawing at once of immediate and subtle beauty, handled with extraordinary delicacy, it is scarcely surprising that this fetched 2600 guineas ($6688).

In complete contrast is the powerful pen sketch of Ahasuerus (see illustration, p. 73), probably a study for the celebrated picture of Esther before the King in the Michigan Museum, for which Guercino was paid in 1639. This splendidly definitive profile of the King with his broad turban and regal chain is curiously reminiscent of the early Rembrandt, and the very fact that the drawing does sustain such a comparison is in itself an illustration both of Guercino's versatility and of the high standard of the collection from which it comes.

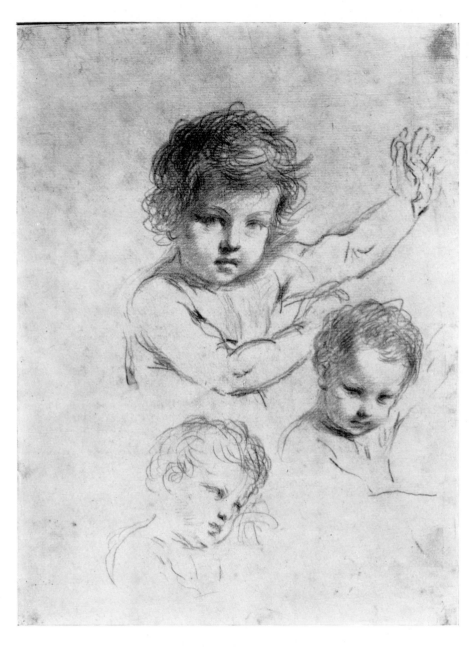

GIOVANNI FRANCESCO BARBIERI, IL GUERCINO:
Three studies of a putto
Red chalk, 10¾ × 7⅞ in. (27.3 × 19.9 cm.)
Sold 23.11.71 for 2600 gns. ($6688)
From the collection of The Earl of Gainsborough

LUCA SIGNORELLI:
Study of a male nude
Black chalk
9⅝ × 3⅝ in. (24.3 × 9.2 cm.)
Sold 23.11.71 for
4800 gns. ($12,348)

JUSEPE DE RIBERA:
Studies of a bat and two ears
Inscribed 'Fulget semper
virtus', red chalk and wash
$6\frac{1}{8} \times 10\frac{5}{8}$ in. (15.5 × 27 cm.)
Sold 28.3.72 for 600 gns.
($1638)

FRANCESCO PRIMATICCIO:
*Jupiter sending the three
Goddesses for the Judgement
of Paris*
Pen and brown ink, brown
wash heightened with white
on blue paper, on seven
attached pieces of paper
with three additions
Squared in black chalk
Oval, $7\frac{1}{2} \times 11$ in.
(19.1 × 28 cm.)
Sold 28.3.72 for 1600 gns.
($4368)
Engraved by Antonio Fantuzzi
in 1543

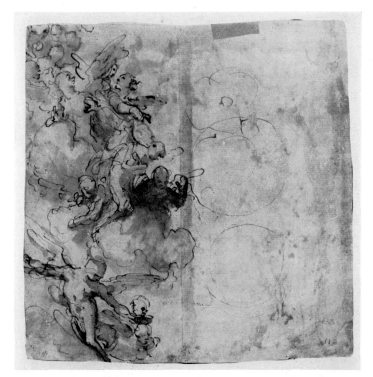

GUIDO RENI: *Head of St Francis, looking up to the right*
Black, red and white chalks on blue paper
$9\frac{1}{2} \times 8\frac{1}{2}$ in. (24.1×21.4 cm.)
Sold 23.11.71 for 1700 gns. ($4369)
From the collection of the Earl of Gainsborough

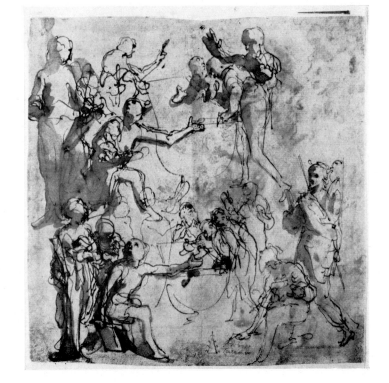

FEDERICO ZUCCARO: *A sheet of studies for an
Assumption of the Virgin, with Apostles looking into a
sarcophagus* (recto); and *studies of angels on clouds* (verso)
Inscribed 'Federigo Zuccaro' with Federico's device
of a sugar-loaf
Pen and brown ink, brown wash on
pink washed paper, $7\frac{1}{8} \times 7$ in. (18×17.7 cm.)
Sold 28.3.72 for 1300 gns. ($3549)

THOMAS WYCK:
View of the Waterhouse and old
St Paul's, London
Black lead and grey wash on two
attached sheets of paper with a
Strasburg lily watermark
$9 \times 13\frac{1}{2}$ in. (22.7×34.2 cm.)
Sold 23.11.71 for
1700 gns. ($4369)
From the collection of
The Lady Celia Milnes Coates

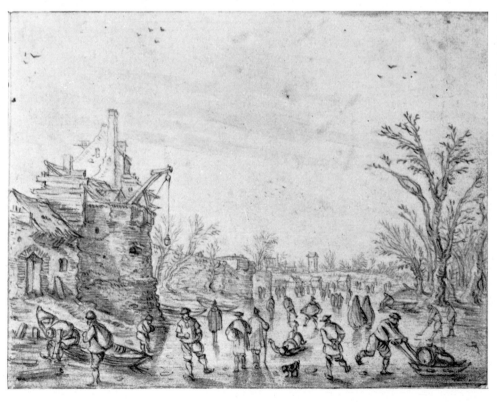

ESAIAS VAN DE VELDE:
Figures skating outside a town
Black chalk and purplish-grey wash
$5\frac{1}{8} \times 6\frac{3}{4}$ in. (12.6×17.1 cm.)
Sold 23.11.71 for
700 gns. ($1799)

BACCIO DEL BIANCO:
A Parade of animals and birds
in human dress
Inscribed 'Baccio del Bianco'
on the reverse
Pen and brown ink
brown wash
$9\frac{1}{2} \times 15\frac{5}{8}$ in. (24×39.7 cm.)
Sold 23.11.71 for
1600 gns. ($4112)
From the collection of
The Earl of Gainsborough

SIMONE CANTARINI:
Bathers in a rocky wooded
landscape
Inscribed 'Cantar 10'
on the reverse
Pen and brown ink
$7\frac{1}{2} \times 10\frac{1}{2}$ in. (19.1×26.5 cm.)
Sold 23.11.71 for
350 gns. ($899)
From the collection of
Mr and Mrs Winslow Ames

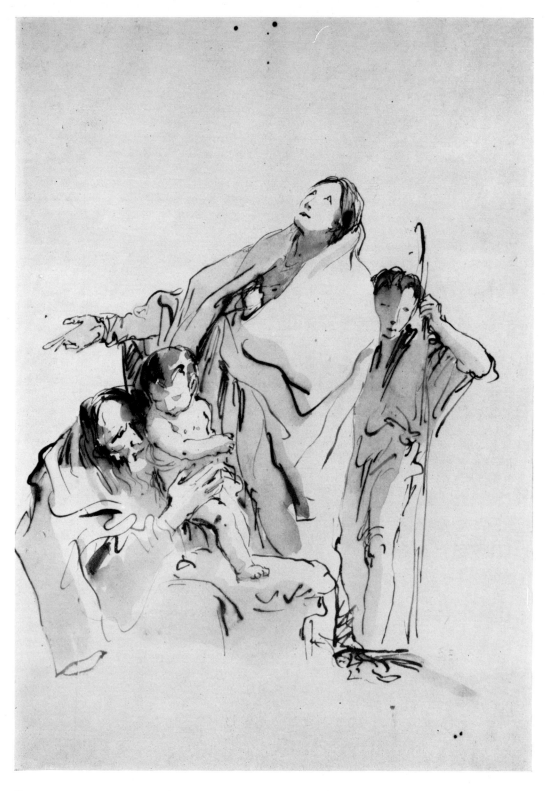

GIOVANNI BATTISTA
TIEPOLO:
The Holy Family with a
shepherd boy
Pen and brown ink
brown wash
11⅜ × 8⅛ in. (29 × 20.5 cm.)
Sold 23.11.71 for
6500 gns. ($16,721)

Top left:

ABRAHAM BLOEMAERT:
*A monk kneeling at prayer,
in profile to the right; with
a separate study of a
drooping hand*
Red chalk heightened
with white on buff paper
$8\frac{1}{2} \times 5\frac{1}{4}$ in. (13.3×21.6
cm) Sold 28.3.72 for
450 gns. ($1228)

Top right:

ANDREA BOSCOLI:
Esther before Ahasuerus
Pen and brown ink
brown wash
$9\frac{5}{8} \times 6\frac{1}{2}$ in. (24.6×16.5
cm.) Sold 28.3.72 for
480 gns. ($1310)

Bottom right:

LUCA CAMBIASO:
Study of a seated figure
Inscribed, red chalk,
pen and brown ink,
brown and grey washes
$7\frac{1}{8} \times 5\frac{1}{8}$ in.
(18.1×13 cm.)
Sold 28.3.72 for
750 gns. ($2041)

Bottom left:

OTTAVIO MARIA
LEONI:
*Portrait of Signora
Felice Cochini*
Half-length, dated
'Aprile 1615'
Numbered 13 and
inscribed on the
reverse, black chalk
heightened with
white on blue paper
$9 \times 6\frac{5}{8}$ in.
(22.9×16.9 cm)
Sold 28.3.72 for
800 gns. ($2184)

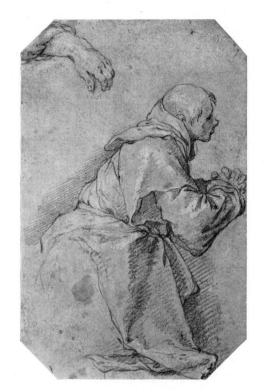

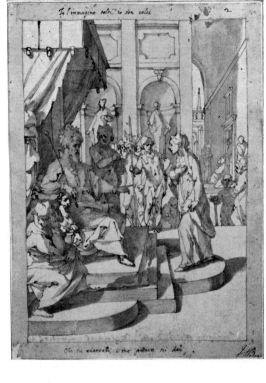

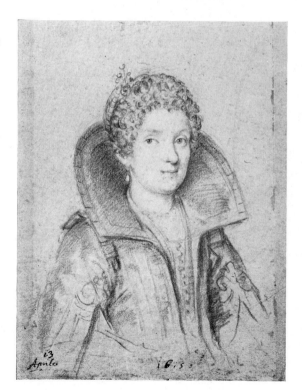

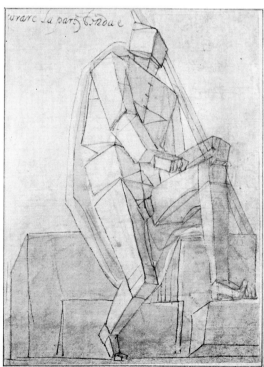

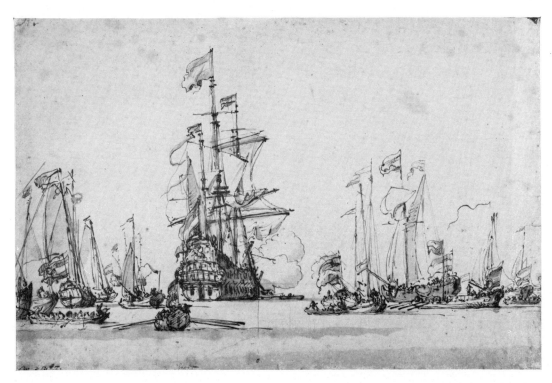

WILLEM VAN DE
VELDE II:
*Shipping on the Υ
before Amsterdam*
Signed with initials and
inscribed Lager
Pen and brown ink
grey wash
$11\frac{1}{8} \times 17\frac{3}{8}$ in.
(28.1 × 44.2 cm.)
Sold 28.3.72 for
4000 gns. ($10,920)
A study for the painting
of 1686 in the
Rijkmuseum

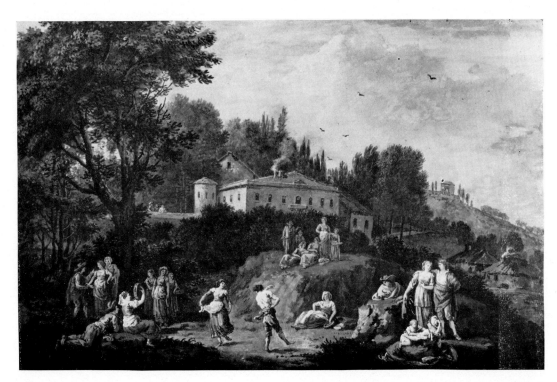

FRANCESCO
ZUCCARELLI, RA:
*Italian peasants
merrymaking near a
village*
Signed with monogram
Bodycolour
$13\frac{5}{8} \times 21\frac{1}{2}$ in.
(34.6 × 54.7 cm.)
Sold 4.7.72 for
2800 gns. ($7056)
From the collection of
Lt-Col
A. E. Jelf-Reveley, DL, JP

DOMINIC SERRES, RA:
English and Dutch shipping off the Cape of Good Hope
Signed with initials and dated 1776 on the mount, pen and black ink and watercolour
12 × 18 in. (30.4 × 45.8 cm.)
Sold 9.11.71 for
1000 gns. ($2570)
From the collection of Mrs James de Rothschild

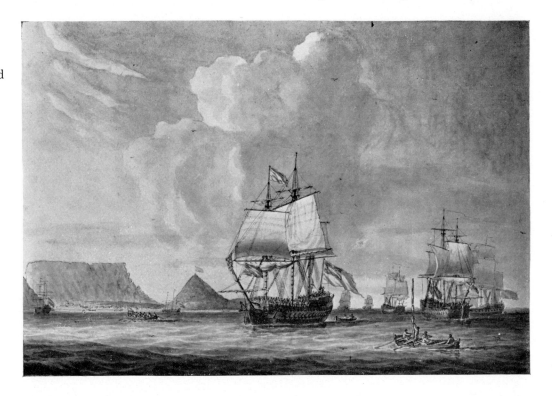

JOHN WHITE ABBOTT:
Torquay, Devon
Signed with initials on the back of the old mount
Inscribed and dated Augt.27.1800
Pen and grey ink and watercolour
5¾ × 8⅝ in. (14.7 × 21.9 cm.)
Sold 9.11.71 for
850 gns. ($2185)

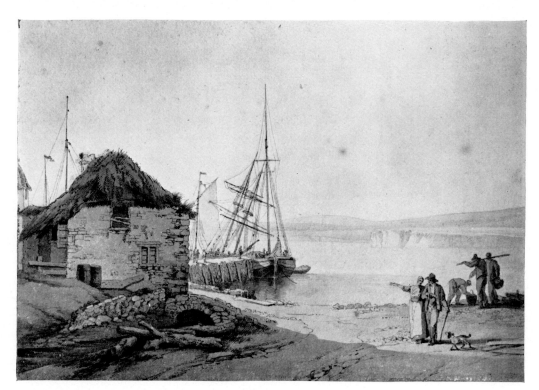

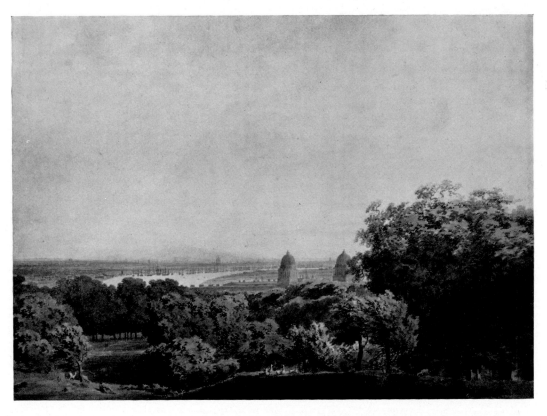

JOHN ROBERT COZENS:
A view of London from Greenwich Park, with St Paul's and Westminster Abbey in the distance
Pencil and watercolour
$14\frac{3}{4} \times 21\frac{1}{8}$ in.
(37.6 × 53.6 cm.)
Sold 6.6.72 for 13,000 gns.
($35,490)
From the collection of Lt-Col
A. E. Jelf-Reveley, DL, JP

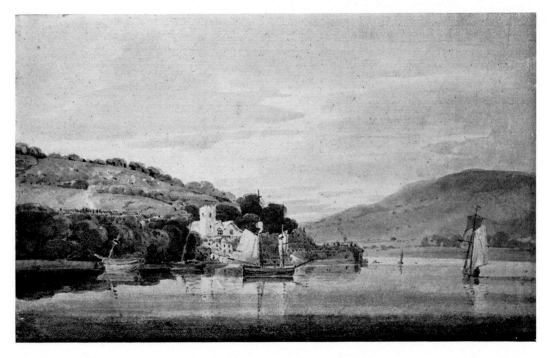

THOMAS GIRTIN:
Kingsweare, near Dartmouth
Watercolour
$7\frac{1}{2} \times 12\frac{1}{2}$ in. (19 × 31.8 cm.)
Sold 6.6.72 for 8000 gns.
($21,840)

FRANÇOIS LOUIS
THOMAS FRANCIA:
The harbour at Calais, low tide
Signed, watercolour
$8\frac{1}{4} \times 11\frac{3}{4}$ in. $(21 \times 29.8$ cm.$)$
Sold 6.6.72 for 1600 gns.
($4368)
From the collection of Prince
Henry de Faucigny-Lucinge

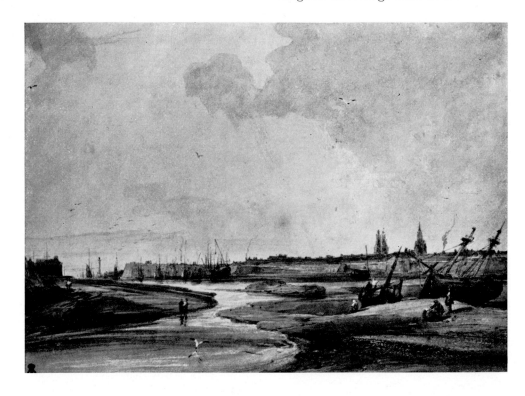

WILLIAM PARS, ARA:
*The Castle of Lismore on the
Blackwater*
Signed and inscribed on the
original mount, pen and grey
ink and watercolour heightened
with white
$10\frac{1}{2} \times 14\frac{3}{4}$ in. $(26.6 \times 37.5$ cm.$)$
Sold 6.6.72 for 1600 gns.
($4368)
From the collection of
S. G. Kerridge, Esq

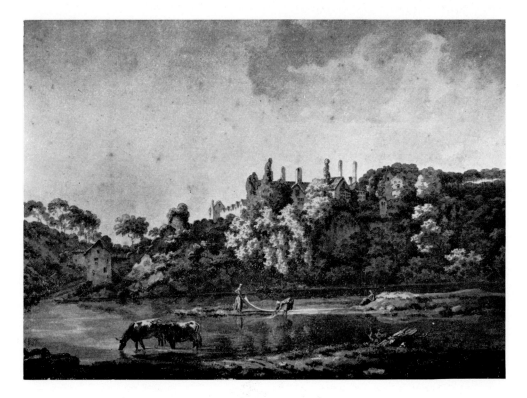

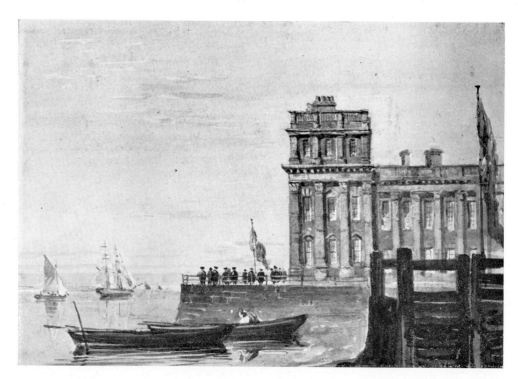

DAVID COX:
The old Customs House, Greenwich
Watercolour
$5\frac{3}{4} \times 8\frac{1}{2}$ in. (14.7 × 21.5 cm.)
Sold 6.6.72 for 1100 gns.
($3003)

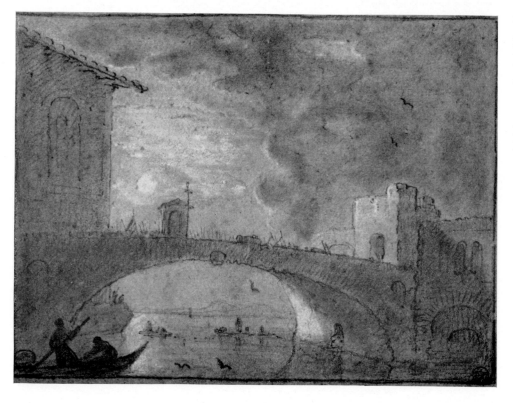

RICHARD WILSON, RA:
A bridge in an Italian town
Black chalk heightened with
white on grey paper
$6 \times 8\frac{1}{8}$ in. (15.3 × 20.6 cm.)
Sold 6.6.72 for 750 gns.
($2041)
From the collection of the late
Mrs F. L. Evans

RICHARD PARKES
BONINGTON:
Figures on a track near Burnham
Signed with initials, watercolour
$5\frac{1}{2} \times 7$ in. (14×17.8 cm.)
Sold 7.3.72 for 7000 gns.
($19,110)

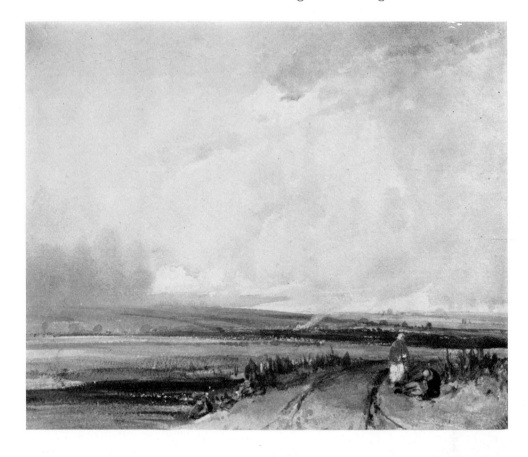

THOMAS SHOTTER BOYS:
*A view of the dome of the
Pantheon from the Seine at Bercy
in the evening*
Pencil and watercolour
$7\frac{1}{8} \times 11\frac{7}{8}$ in. (18.1×30.2 cm.)
Sold 9.11.71 for 2000 gns.
($5140)
From the collection of
P. T. Meal, Esq

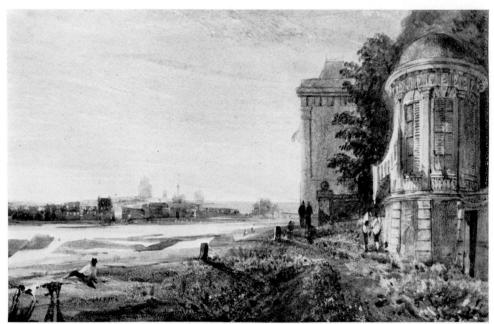

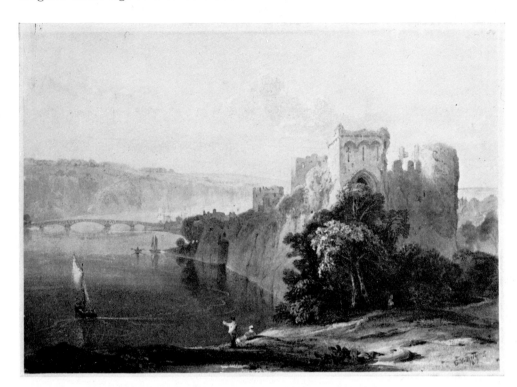

ANTHONY VANDYKE
COPLEY FIELDING:
Chepstow Castle
Signed and dated 1817
Watercolour
6 × 8⅜ in. (15.2 × 21.3 cm.)
Sold 9.11.71 for 580 gns.
($1491)
From the collection of
The Lord Wraxhall

THOMAS HEARNE:
The ruins of Leiston Abbey
Signed and dated 1781
Pencil and watercolour
7 × 9¾ in. (17.8 × 24.8 cm.)
Sold 7.3.72 for 750 gns.
($2041)
From the collection of the
late J. E. Mills, Esq

WILLIAM HOLMAN HUNT, OM: *The wilderness of Gizeh*
Signed with monogram and dated 1854.66
Watercolour heightened with white, in contemporary gilt frame, $9\frac{3}{4} \times 27\frac{3}{4}$ in. (24.8 × 70.5 cm.)
Sold 9.11.71 for 3200 gns. ($5654)
From the collection of Robert Clive, Esq

JOSEPH MALLORD
WILLIAM TURNER,
RA: *On the Washburn*
Pencil and watercolour
$11 \times 17\frac{1}{2}$ in.
(27.9 × 44.4 cm.)
Sold 9.11.71 for
7000 gns. ($18,007)
From the collection of
Miss Dorothea Short
Acquired by Mr and
Mrs Paul Mellon, this
is a study for the
finished watercolour
also in the Mellon
collection
Both watercolours
were formerly known
as 'On the Wharfe',
but the correct
identification has
recently been made

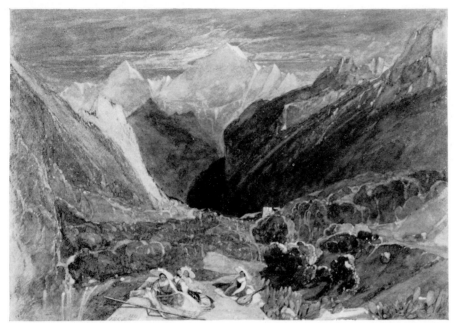

JOHN SELL COTMAN:
The entrance of the Valley of Lauterbrunnen from Interlaken
Signed and dated 1831 and inscribed on a label attached to the backing, pencil and watercolour
$12\frac{3}{4} \times 18\frac{5}{8}$ in (32.3×47.3 cm.)
Sold 14.12.71 for 7500 gns. ($19,280)
From the collection of Dr Theodore Besterman

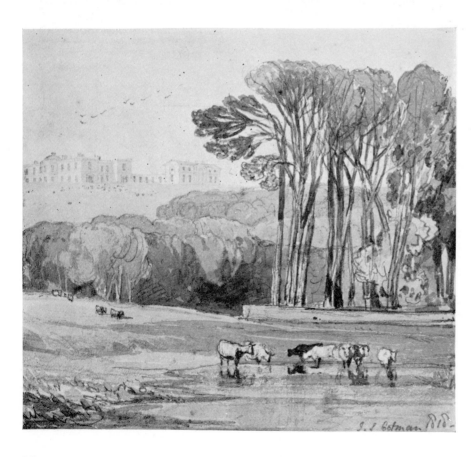

JOHN SELL COTMAN:
In the park of Sir Robert Reade, Barsham, Suffolk
Signed and dated 1818, with an inscription on the reverse, pencil and brown wash
$6\frac{1}{2} \times 7\frac{1}{4}$ in. (16.5×18.3 cm.)
Sold 6.6.72 for 2000 gns. ($5460)

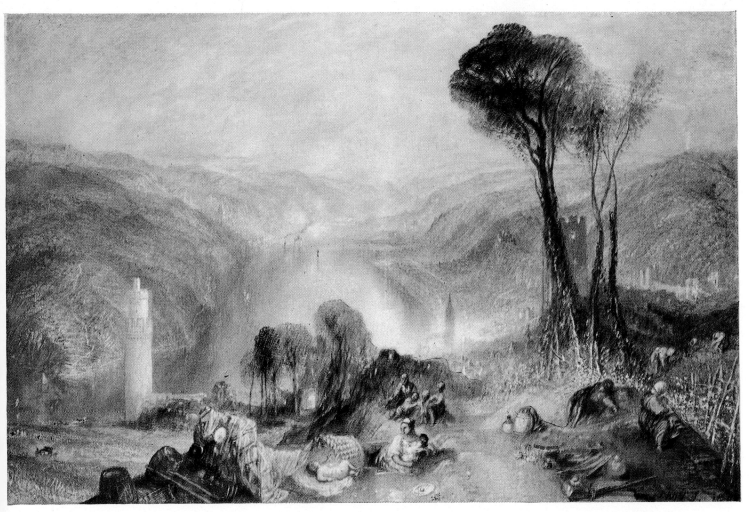

JOSEPH MALLORD WILLIAM TURNER, RA: *Oberwesel: Harvesters resting on the slope above the town, with distant steamers on the Rhine*
Signed and dated 1840, watercolour, $13\frac{3}{8} \times 20\frac{3}{4}$ in. (34×52.7 cm.)
Sold 6.6.72 for 16,000 gns. ($43,680)

ANGELICA KAUFFMAN, RA:
A design for a fan
c. 1780
Water and bodycolour and
gilding
$6\frac{1}{2} \times 24\frac{1}{4}$ in. (16.5 × 51.5 cm.)
Sold 9.11.71 for 1050 gns.
($2699)

JULIUS CAESAR IBBETSON:
The sailor's farewell
Signed and dated 1801, pen
and grey ink and watercolour
$11\frac{5}{8} \times 15\frac{5}{8}$ in. (29.6 × 39.7 cm.)
Sold 9.11.71 for 2800 gns.
($7196)
From the collection of
P. Dangar, Esq, of
Armidale, New South Wales

FRANCIS COTES, RA:
Portrait of Elizabeth Gunning
Signed and dated 1751, pastel
29½ × 23 in. (74.9 × 58.4 cm.)
Sold 6.6.72 for 1300 gns.
($3549)
Now in the National Portrait
Gallery

The Beauties

Maria and Elizabeth Gunning, known as 'The Beauties' were the daughters of John Gunning of Castlecoote, County Roscommon, and despite their notable lack of intelligence, they made a great impression upon their contemporaries. Maria (1733–60) held by Horace Walpole to be the more beautiful, married the Earl of Coventry. Elizabeth (1734–90) married the 6th Duke of Hamilton at midnight on 14th February, 1752 'with a ring of a bed curtain', and in 1759 the Marquess of Lorne, later Duke of Argyll. She was a favourite of the King and Queen and was made Baroness Hamilton of Hambleton in her own right. Their brother John (1732–97) was notorious primarily for the complex scandals of his private life. He became a Lieutenant-General and Colonel of the 65th Regiment of Foot, distinguishing himself at Bunker Hill. He was married to Susannah Minifie, a novelist whose works were said to be 'exceedingly harmless; an absence of plot forming their chief characteristic'. Kitty Gunning, a third sister, married Robert Traver.

THOMAS DANIELL, RA:
The Armenian bridge, near
St. Thomas's Mount, Madras
Inscribed on the reverse
Pencil, pen and brown
ink, grey and brown washes
$13\frac{3}{4} \times 21$ in. (34.9×53.3 cm.)
Sold 6.6.72 for 350 gns.
($955)

SAMUEL DANIELL:
Pallah deer in an African
landscape
Pencil and watercolour
13×18 in. (33×45.7 cm.)
Sold 6.6.72 for 1900 gns.
($5187)

The Daniells in India and Africa

BY HUON MALLALIEU

When Thomas Daniell and his nephew William landed at Spithead in November, 1793, they had been out of England for eight and a half years. They had twice visited China, had travelled extensively in both north and south India painting innumerable views of the places and buildings which they saw, some of them previously unseen by any European. They had also made a brief excursion by way of Bombay to Muscat,

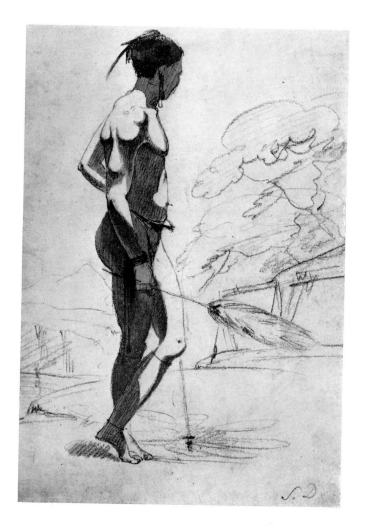

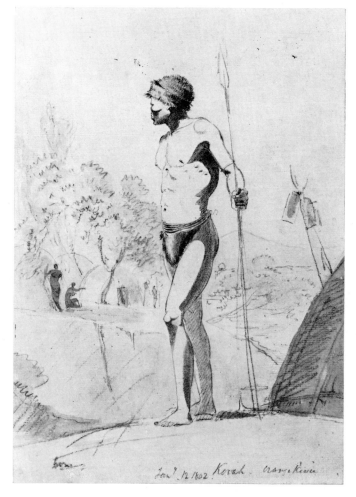

and the whole tour had provided the two artists with a fund of material and inspiration upon which they were to draw for the rest of their lives.

Their phenomenal industry is shown clearly in the journals kept by William during their Indian tours and which were bought for 2200 gns. ($4824) in our sale of June 6. The sale also included a number of Thomas's drawings and watercolours actually taken in India. He was not an adventurous user of watercolour, and the majority of his working drawings are in fact monochrome views with an occasional touch of coloured tinting. However, these drawings, as well as his full watercolours, show that Thomas Daniell could convey a marvellous sense of atmosphere and above all of spaciousness.

On their return to England the Daniells at once began work on their *magnum opus*, the six volumes of *The Oriental Scenery*, which contained in all 150 aquatint engravings. The majority of the plates – one of which is illustrated on page 247 – were engraved by William and fully endorse the opinions of the many judges who regard him as the greatest artist to work in aquatint. His other major undertaking was the engraving of the 309 plates for *A Voyage Round Great Britain* which appeared between 1814 and 1825.

William's younger brother Samuel Daniell had also inherited the family love of travel. At the age of twenty-four he sailed for the Cape of Good Hope where he quickly became attached to the Governor's staff. The chief event of his three-year stay in South Africa was the expedition to Bechuanaland or Botswana which he accompanied as draughtsman between October 1801 and the following April. This resulted in many fascinating sketches of tribesmen which, despite their apparent simplicity, show a complete mastery of line and wash drawing, and in a number of

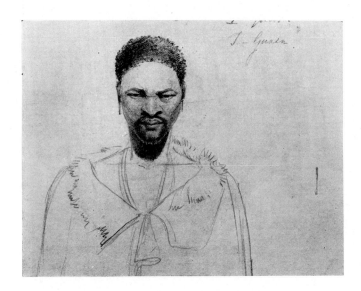

SAMUEL DANIELL: *An album containing fifty studies of South African tribesmen*
Five signed with initials, many inscribed, some with working notes, variously dated between January 12 and March 9, 1802, pencil or pencil and brown or grey washes, some with touches of watercolour, three squared in pencil
$10\frac{3}{8} \times 7\frac{1}{4}$ in. (26.2 × 18.3 cm.) and smaller
Sold 6.6.72 for 8000 gns. ($21,840)

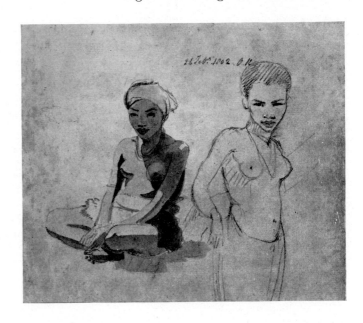

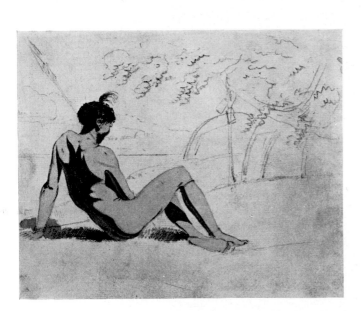

highly finished watercolours of animals and landscapes, many of which were later engraved by William.

After a brief return to England, Samuel departed for Ceylon not later than the end of 1805. From there he sent home many drawings to be engraved by his brother, and he led a pleasant and eccentric life ranging the jungle in search of animals to sketch. There, too, he died in 1811 at the early age of thirty-five.

Samuel was probably the greatest artist of the three, but both Thomas and William were careful, competent and at times inspired painters who well deserved election to the Royal Academy, despite the carping with which their elevation was greeted by a number of their contemporaries. As Colonel M. H. Grant put it in his *Old English Landscape Painters*: 'A good "Thomas Daniell", is, in short, a very fine thing.'

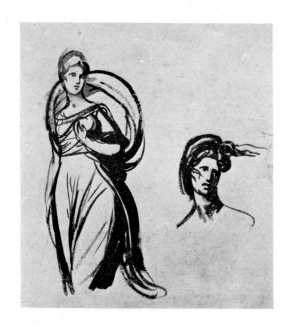

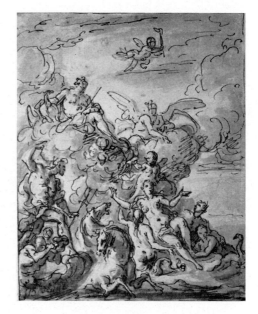

GEORGE ROMNEY:
Sketches for
Viscountess Bulkeley as Hebe
Pencil and brown wash
$12\frac{1}{4} \times 11$ in.
(31.2 × 27.9 cm.)
Sold 6.6.72
for 700 gns. ($1911)
From the collection of
R. C. Harford, Esq

SIR JAMES THORNHILL:
The birth of Venus
Inscribed J. Bassani
Black lead, pen and
brown ink, grey wash
$7\frac{1}{4} \times 5\frac{7}{8}$ in. (18.4 × 15 cm.)
Sold 7.3.72 for
700 gns. ($1911)

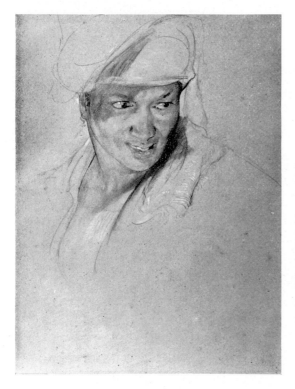

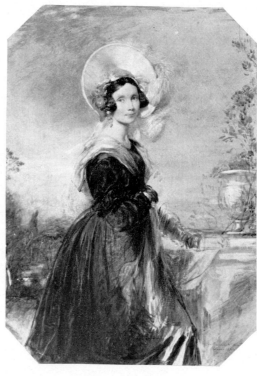

SIR DAVID WILKIE, RA:
The fortune-teller
Black and red chalk, pen
and brown ink heightened
with white on stone-
coloured paper
$11\frac{1}{2} \times 8\frac{3}{4}$ in.
(29.2 × 22.2 cm.)
Sold 9.11.71 for
1050 gns. ($2699)
Now in the National
Gallery of Scotland
A study for the painting
there, of 1837
*The Empress Josephine and
the Fortune-Teller*

GEORGE
RICHMOND, RA:
Portrait of a young lady
Signed and dated
Rome 1838, watercolour
heightened with white
Octagonal, 18 × 13 in.
(45.7 × 33 cm.)
Sold 6.6.72 for
900 gns. ($2457)

SIR EDWARD COLEY
BURNE-JONES, BT, ARA:
The Star of Bethlehem
Mixed media with gilt
$24\frac{5}{8} \times 38\frac{1}{4}$ in. (62.5 × 97 cm.)
Sold 7.3.72 for 4000 gns.
($10,920)
From the collection of
Mrs Mary Ryde and
Mrs David Yorke
A larger version is in the
Birmingham City Art Gallery

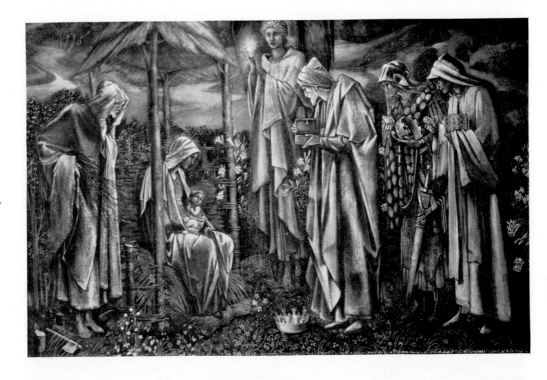

SIR EDWARD JOHN
POYNTER, BT, PRA:
*A view at Wilden
Worcestershire*
Watercolour heightened
with white
$9\frac{3}{4} \times 13\frac{3}{4}$ in. (24.8 × 35 cm.)
Sold 9.11.72 for 750 gns.
($1928)

DANTE GABRIEL ROSSETTI:
The Annunciation
Watercolour
14 × 9½ in. (35.5 × 24 cm.)
Sold 11.7.72 for 5000 gns.
($12,600)
From the collection of
Dr R. J. B. Marsden and
E. C. Marsden, Esq
Bought from the artist by
George P. Boyce in 1855

WILLIAM BLAKE: '*Prone on the lowly grave –she drops – clings yet more closely to the senseless turf nor heeds the passenger who looks that way*'
Inscribed on the original mount
Pen and grey ink and watercolour
$6\frac{1}{8} \times 8\frac{1}{4}$ in. (15.5 × 21 cm.)
Sold 9.11.71 for 2000 gns. ($5140)
From the collection of Gwen, Lady Melchett

WILLIAM BLAKE: *Tiriel supporting the swooning Myratana and addressing his son*
Pen and grey ink, grey wash
$7\frac{1}{2} \times 10\frac{3}{4}$ in. (19 × 27.3 cm.)
Sold 9.11.71 for 6000 gns. ($15,420)
From the collection of Gwen, Lady Melchett

ALBERT GOODWIN: *Wells*
Signed with monogram, dated '91 and inscribed on the original mount, watercolour with touches of pen and brown ink
$9\frac{3}{4} \times 13\frac{3}{8}$ in. (24.8 × 34 cm.)
Sold 11.7.72 for 950 gns. ($2394)

OLD MASTER
AND MODERN
PRINTS

4

GIOVANNI BATTISTA TIEPOLO, GIOVANNI
DOMENICO TIEPOLO and
LORENZO TIEPOLO: *Varie Opere*
Three from a collection of 194 etchings by
the Tiepolo family published by Giovanni
Domenico Tiepolo in Venice about 1775
Sold 1.12.71 for 19,000 gns. ($48,877)
Plate no. 16 from *Idee pittoresche sopra la
fugga in egitto* (De V. 1–27), by G. D.
Tiepolo
Saint Thecla interceding for the town of Este
(De V. 3), by Lorenzo Tiepolo
Plate no. 16 from *Scherzi di Fantasia*
(De V. 13–35), by G. B. Tiepolo

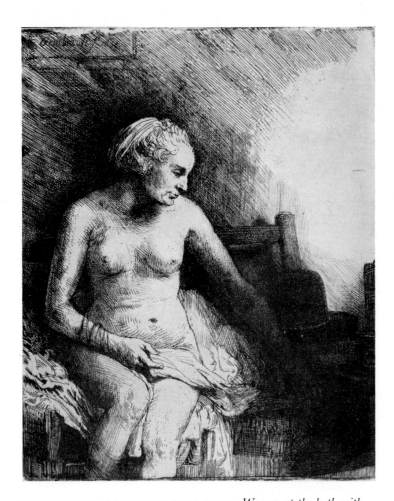

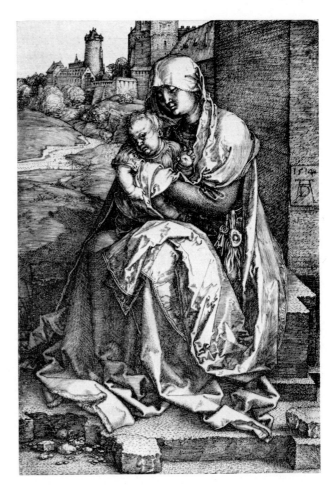

REMBRANDT HARMENSZ VAN RIJN: *Woman at the bath with a hat beside her* (B., Holl. 199; H. 297) Etching, second state, on Japan paper
Sold 1.12.71 for 4800 gns. ($12,348)
From the collection of Norton Simon, Esq

ALBRECHT DÜRER: *The Virgin and Child seated by the wall* (B. 40; M., Holl. 36) Engraving
Sold 1.12.71 for 1600 gns. ($4112)
From the collection of Norton Simon, Esq

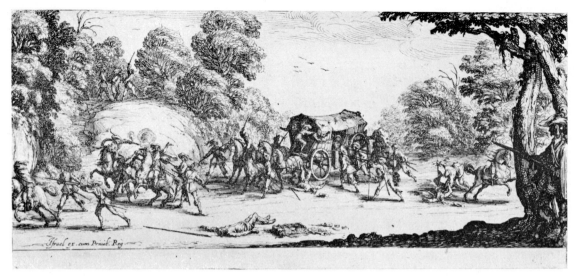

JACQUES CALLOT:
Plate from *Les
Grandes Miseres de la
guerre* (L. 1339–1356)
Etchings, frontispiece
and seventeen plates
Sold 27.6.72 for
1400 gns. ($3822)
From the collection
of Mrs John
Sheffield

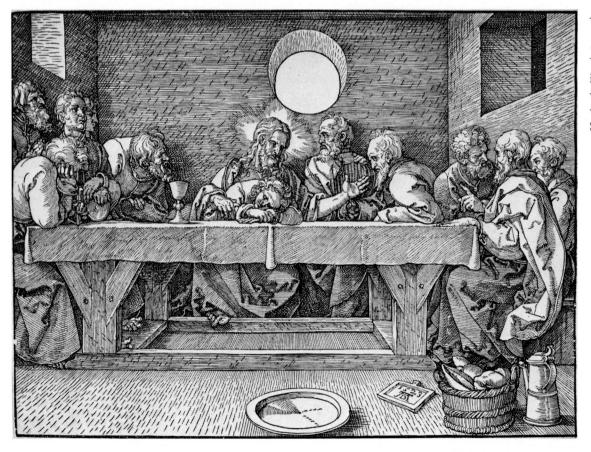

ALBRECHT DÜRER:
The last supper
(B. 53; M., Holl. 184)
Woodcut, a Meder B
impression on paper
with a High Crown
watermark (M. 20)
Sold 27.6.72 for
1300 gns. ($3549)

SCHOOL OF MANTEGNA: *The entombment with the three birds* (B. 2; Borenius 8)
Engraving
Sold 27.6.72 for 700 gns. ($1911)

LA VOLTIGEUSE.

After JEAN-ANTOINE
WATTEAU:
Plate from *L'Oeuvre
d'Antoine Watteau peintre du
roy en son academie roiale de
peinture et sculpture grave
d'après ses tableaux et
desseins originaux tirez du
Cabinet du Roy et des plus
curieux de l'Europe Par les
soins de M. de Jullienne
A Paris fixe a cent
exemplaires des premières
épreuves Imprimés sur grand
papier*
Engravings, the complete
set of 279 plates, in two
large folio volumes
Sold 27.6.72 for 5500 gns.
($15,015)

GEORGE STUBBS, ARA:
A foxhound on the scent
Mixed method engraving
Published 1 May 1778.
A preparatory drawing in
reverse for this print was sold
in these rooms on 19 Nov., 1968
and is now in the Mellon
Collection
Sold 27.6.72 for 1100 gns.
($3003)

Right: JAMES ENSOR:
L'entrée du Christ a Bruxelles
(C.114)
Etching and drypoint, third
state, printed on Japan
paper, signed and dated
1888
Sold 1.12.71 for 600 gns.
($1542)
From the collection of
A. Eftichiou, Esq

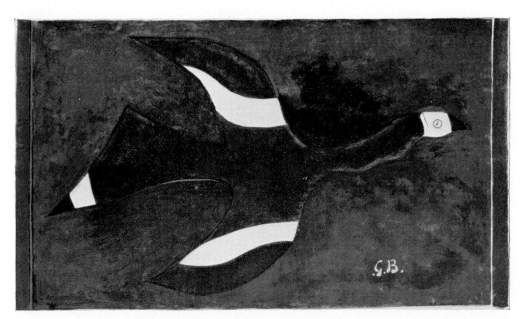

GEORGES BRAQUE:
Vol de Nuit (M. 49)
Lithograph, printed in
colours on Arches, signed in
pencil and numbered
31/75,
Sold 27.6.72 for 1000 gns.
($2730)
From the collection of
Alan Best, Esq

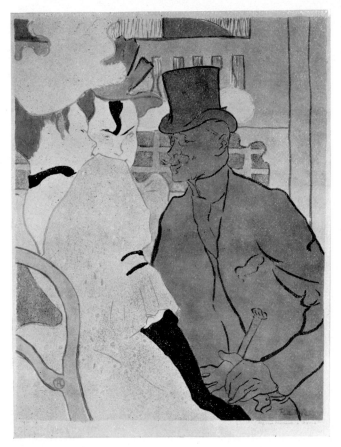

HENRI DE TOULOUSE-LAUTREC:
L'Anglais au Moulin Rouge (L.D. 12; A. 3) 1892
Lithograph printed in colours, signed in pencil
and numbered 43
Sold 1.12.71 for 3100 gns. ($7974)
From the collection of Mrs H. Oswell

PIERRE-AUGUSTE
RENOIR:
Le chapeau épinglé
1897 (L.D. 29)
Lithograph, printed in
greenish-black, signed in
chalk
Sold 27.6.72 for 1500 gns.
($3937)
From the collection of
Mrs John Dugdale

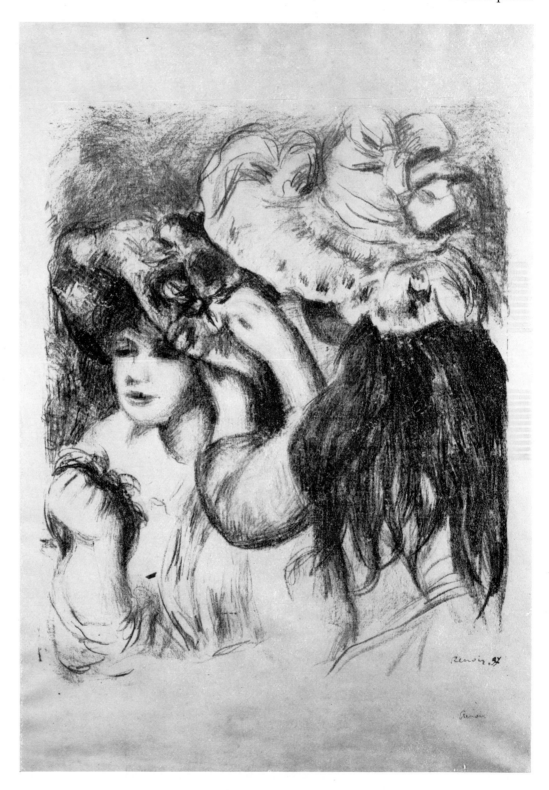

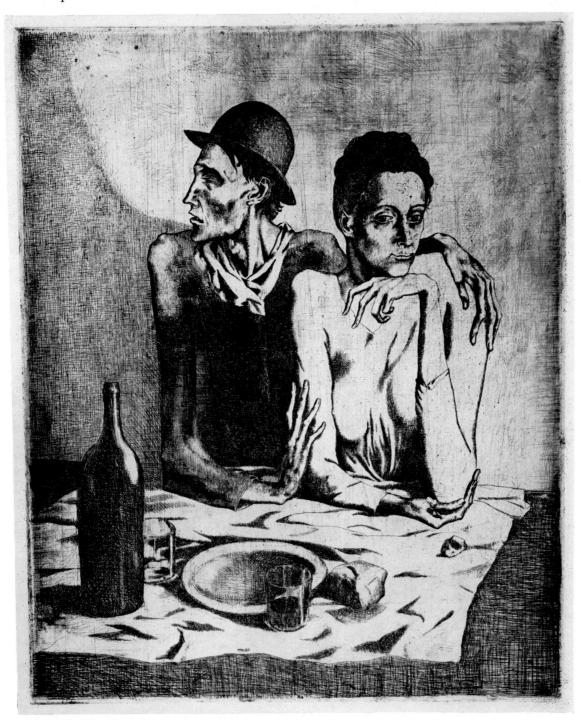

PABLO PICASSO: *Le repas frugal* (Bl. 1; G. 2)
Etching, one of the edition of 250 printed on Van Gelder
Sold 27.6.72 for 4500 gns. ($11,812)
From the collection of the late Dr Erich Alport

IMPRESSIONIST AND TWENTIETH-CENTURY PAINTINGS AND SCULPTURE

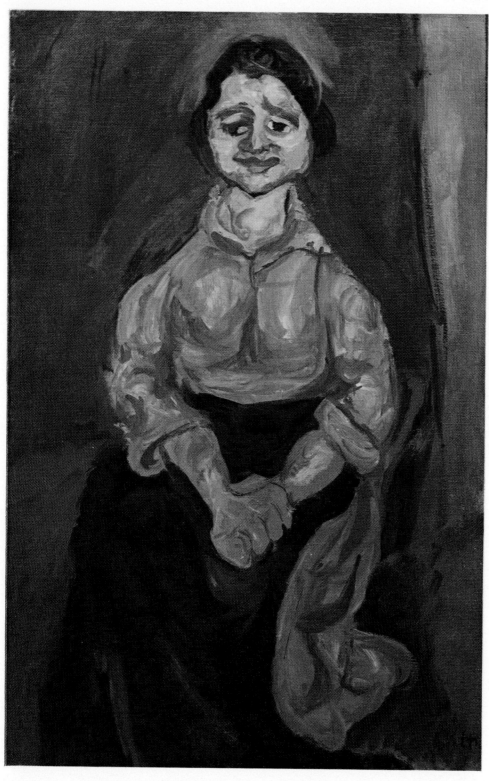

CHAIM SOUTINE: *La Folle*
Signed
$36\frac{1}{4} \times 24$ in. $(92 \times 61$ cm.)
Sold 27.6.72 for 40,000 gns.
($109,200)
From the collection of
Leo M. Rogers

PIERRE AUGUSTE
RENOIR:
Portrait de Jean Renoir
Stamped (L. 2137b)
$15\frac{3}{4} \times 12\frac{1}{2}$ in.
$(40 \times 32$ cm.)
Sold 27.6.72 for
70,000 gns. ($191,100)

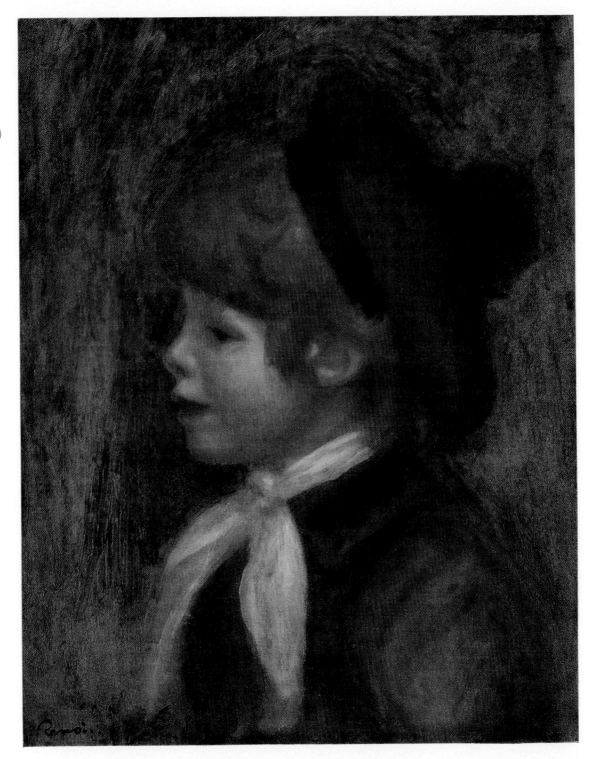

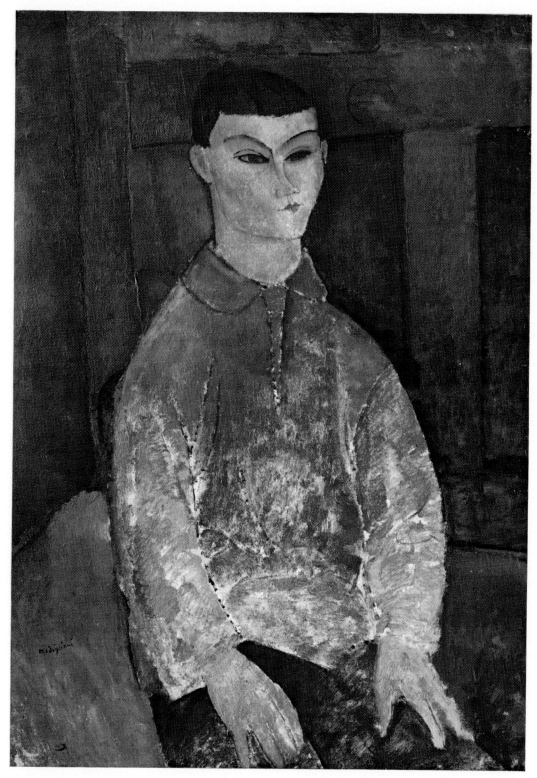

AMEDEO MODIGLIANI:
Portrait du peintre
Moise Kisling
Signed
41 × 29½ in. (104 × 75 cm.)
Sold 27.6.72 for
100,000 gns. ($273,000)
From the collection of
Leo M. Rogers

Portrait of a friend

BY CHRISTOPHER BURGE

In 1906, Modigliani arrived in Paris from his native Italy and for the next fourteen years of his short life it was to be his home.

At first it was to be a time of struggle and experiment, and one can clearly see the influence of the 'nineties (Beardsley, Lautrec, Steinlein and others) in his early portraits. Later, however, despite the influence of the Fauves and the emergence of the Cubists he remained curiously detached from what was happening amongst his contemporaries – indeed of all his meetings and friendships with other artists, only his meeting with Brancusi in 1909 seems to have had a lasting and profound influence on his work. So much so that he turned to sculpture and for several years it was to be of paramount importance to him. Even when he could no longer sculpt – he had contracted tuberculosis in 1901 and the stone dust finally endangered his lungs – many of his sculptural intentions were transfered to canvas.

In 1910, a year after Modigliani's meeting with Brancusi, Moise Kisling came to Paris from Cracow in Poland. It was inevitable that the young Polish artist should meet Modigliani at some stage, and it has in fact been suggested that it was their mutual love of poetry which brought them together. In any event, Kisling offered Modigliani the use of his studio, when the latter had none, and it was there in 1915, in the Rue Joseph-Bara, that a preliminary pencil study for this magnificent portrait of Kisling was made. Indeed it is quite probable that the portrait itself was also painted there. Certainly it was at about this time that Modigliani finally abandoned any thoughts of continuing his sculpture and again turned all his efforts to painting.

He executed many portraits of artist friends (including Picasso, Bakst, Laurens, Lipchitz and Soutine) and there are three known oils and five known drawings of Kisling, all in the period of 1915–16, as well as two portraits of Renée Kisling, his wife. The first portrait of Kisling, dated 1915, is a head, whereas the other two show him seated, his hands resting on his thighs (a pose also employed in Modigliani's first portrait of Soutine). This, the largest of the three, was painted when Modigliani was finding his mature style for the first time, a style which was to flower over the next four years, culminating in the simplification of the last great portraits.

Modigliani was not a healthy man when he first came to Paris, and the drugs and

drink in which he so liberally indulged only served to hasten the inevitable. He was also an immensely prolific artist – it is amazing that so much of his work survives even though he twice destroyed the entire contents of his studio – and his tremendous creative energy and constant work must have adversely affected his health. Despite a trip to the South of France in 1918–19, nothing could save him and on 24th January, 1920, at the age of thirty-five, he died in the Hôpital de la Charité, in Paris.

Without Kisling's friendship and generosity he might never have painted this and many other great portraits, and, at the last, it was Kisling who saved him from a pauper's grave by arranging a magnificent funeral and burial in the Père-Lachaise cemetery. It was also Kisling who, with the help of Conrad Moricand and Jacques Lipchitz, was responsible for a plaster death mask of Modigliani, which was subsequently cast in bronze.

EUGENE BOUDIN: *Casino de Trouville*
Signed, on panel, $9\frac{1}{4} \times 17$ in. (23.5 × 43 cm.)
Sold 11.4.72 for 34,000 gns. ($92,820)

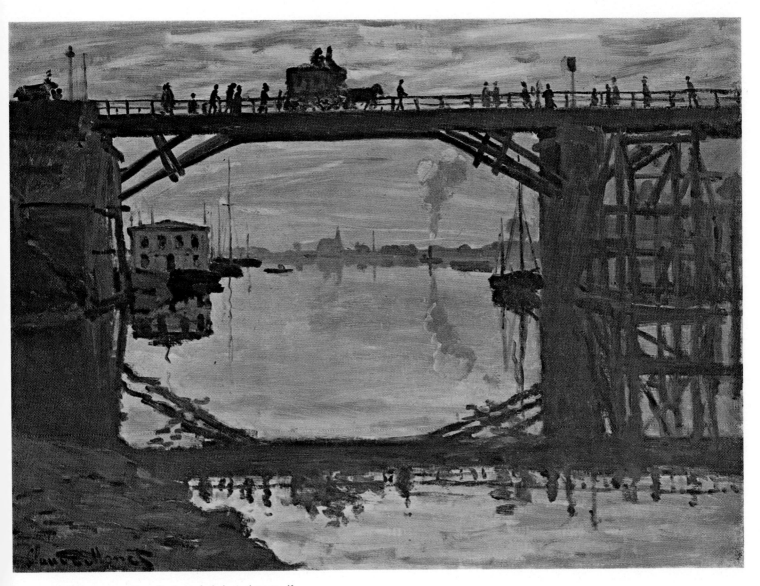

CLAUDE MONET: *Le pont de bois à Argenteuil*
Signed, 21 × 28¾ in. (54 × 73 cm.)
Sold 30.11.71 for 160,000 gns. ($411,000)
From the collection of Norton Simon, Esq

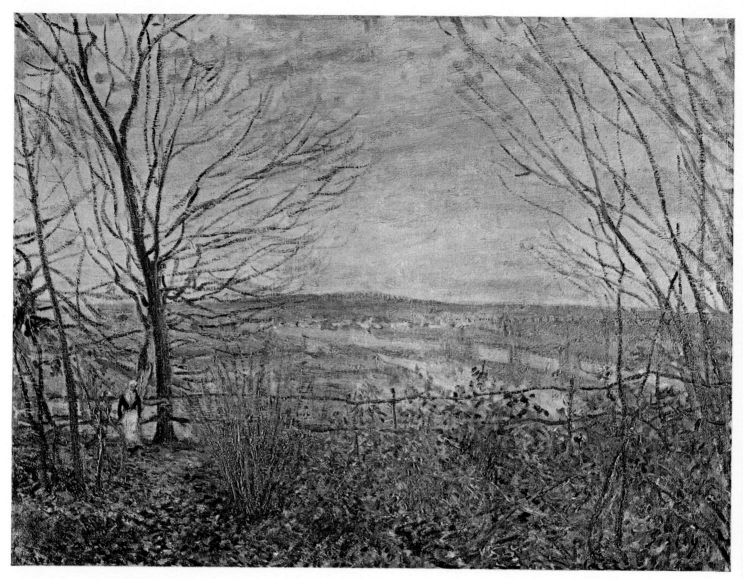

ALFRED SISLEY: *La plaine de Saint-Mammès, vue du bois des roches*
Signed, $21\frac{1}{4} \times 28\frac{3}{4}$ in. (54×73 cm.)
Sold 11.4.72 for 52,000 gns. ($141,960)
From the collection of The Torcuato di Tella Foundation and The Torcuato di Tella Institute, Buenos Aires

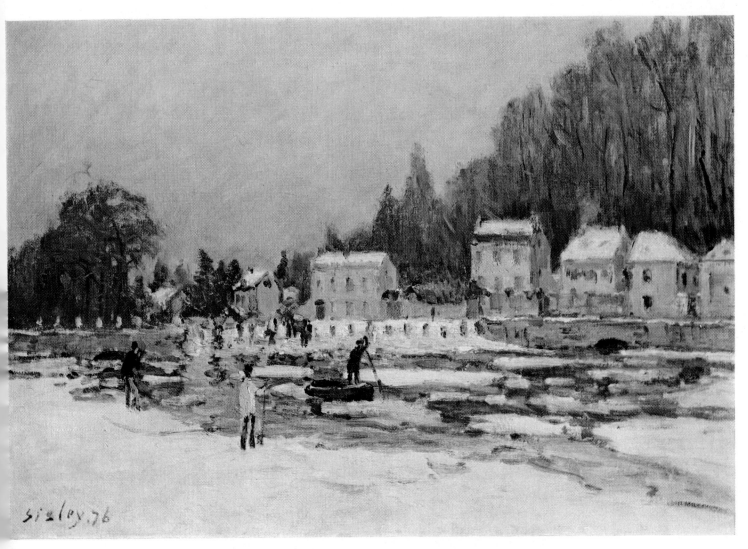

ALFRED SISLEY: *La débâcle de la Seine à Port-Marly*
Signed and dated '76. 15 × 21½ in. (38 × 55 cm.)
Sold 27.6.72 for 48,000 gns. ($131,040)
From the collection of Leo M. Rogers

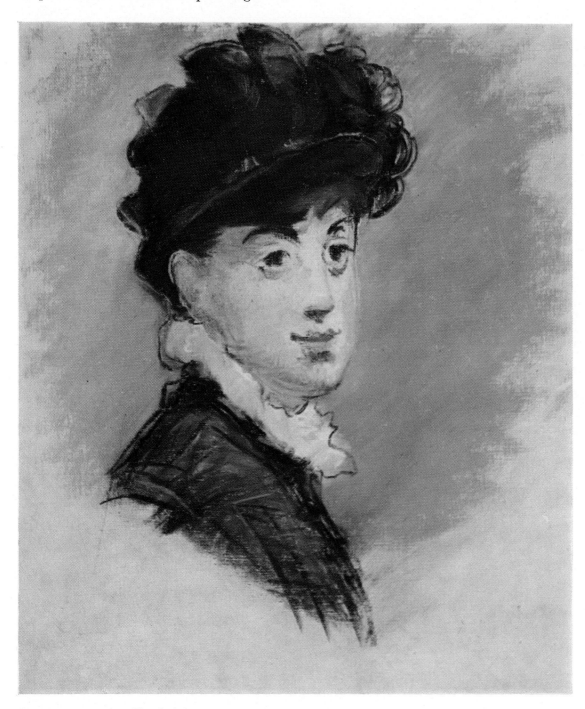

EDOUARD MANET: *Tete de femme au chapeau noir*
Pastel, $21\frac{1}{4} \times 17\frac{3}{4}$ in. (54×45 cm.)
Sold 27.6.72 for 45,000 gns. ($122,850)
From the collection of Leo M. Rogers

JEAN BAPTISTE
CAMILLE COROT:
*Coin de village, Ecouen
(Seine et Oise)*
Stamped (L. 461)
Painted *c.* 1870
$11\frac{1}{2} \times 9\frac{1}{4}$ in.
(29 × 23.5 cm.)
Sold 27.6.72 for
26,000 gns. ($70,980)
From the collection
of the late
Mrs F. L. Evans

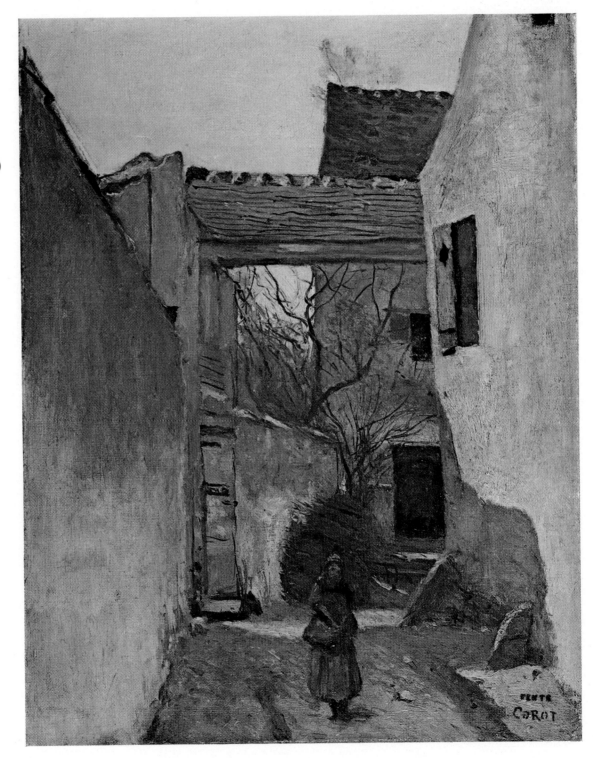

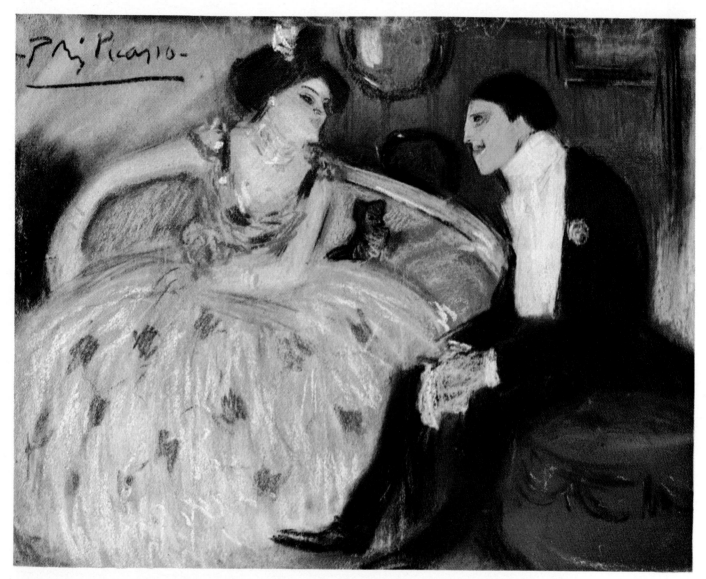

PABLO PICASSO: *Le boudoir*
Pastel, signed P. Ruiz Picasso
13 × 16½ in. (33 × 42 cm.)
Painted in Madrid in 1901
Sold 27.6.72 for 44,000 gns. ($120,120)
From the collection of Leo M. Rogers

PABLO PICASSO:
Buste d'homme
Signed, gouache
$24\frac{3}{4} \times 19\frac{1}{2}$ in.
(63×49.5 cm.)
Sold 27.6.72 for
44,000 gns.
($120,120)
From the collection
of Leo M. Rogers

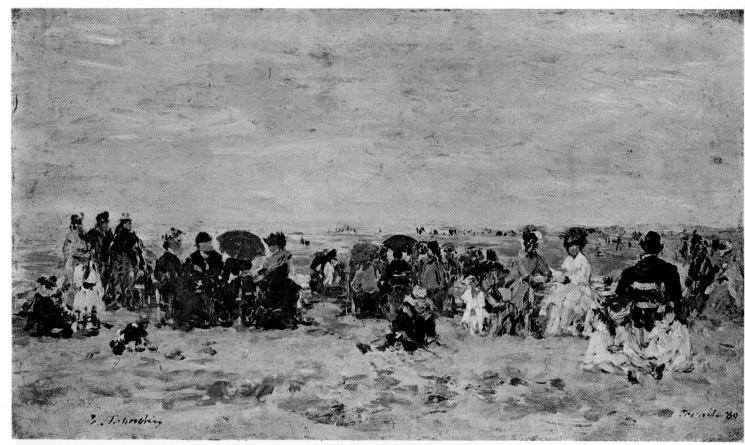

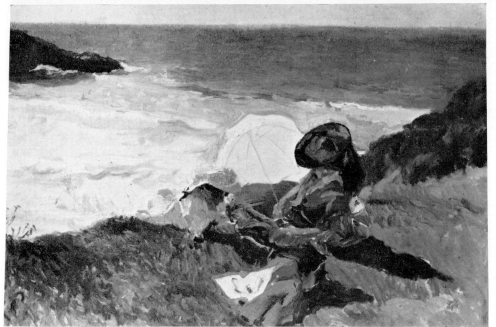

EUGENE BOUDIN:
La plage à Trouville
Signed, inscribed and dated '80
On panel, 8 × 14 in.
(20.5 × 35.5 cm)
Sold 30.11.71 for 27,000 gns.
($69,400)

JOAQUIN SOROLLA
Y BASTIDA:
Sol poniente, Biarritz
Signed and dated 1906
$23\frac{1}{2} \times 26\frac{1}{2}$ in (60 × 67.5 cm.)
Sold 30.11.71 for 24,000 gns.
($61,700)

HENRI EDMOND
CROSS:
Antibes, matin
Signed and dated '08
$32 \times 25\frac{1}{2}$ in.
(81×65 cm.)
Sold 27.6.72 for
41,000 gns.
($111,930)

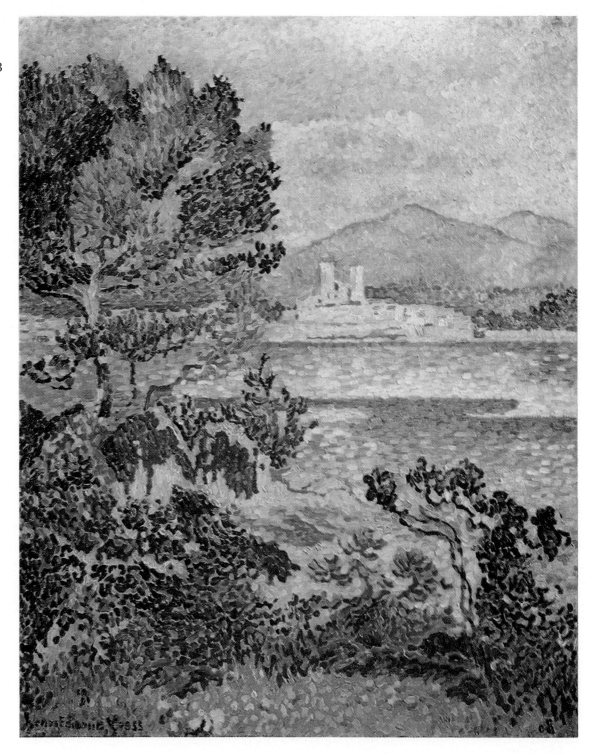

'La muse endormie'

BY SIDNEY GEIST

La muse endormie, the most recent example of this theme to come to light, brings to five the number of bronzes now recorded. Two examples are at the Musée National d'Art Moderne, Paris, and the others may be found at the Art Institute of Chicago, and the Metropolitan Museum of Art, New York. It is not likely that any others exist.

The work is dated by the inscription '1910' on one of the Paris bronzes. All are signed by the sculptor and bear the cachet of the founder, C. Valsuani, with the words *'cire perdue.'* Because the work was transferred to wax it was easy to make small changes in each copy even before casting in metal. The length of the bronzes varies slightly around an average of $10\frac{3}{4}$ inches, while treatment of the bottom of the neck, the chignon, and indeed the side of the head also varies from piece to piece. The casts were surely made at different times and were finished by the artist, the face and neck being brought to a clear metallic – but not reflective – surface, and the hair left dull or allowed to darken. Areas of gilding are apparent on our version, showing the piece to have been a *bronze doré;* in its present state it resembles other *bronzes dorés* which Brancusi made at an early date and which have lost some of their gold in similar fashion, unless, as is possible, it was removed by the sculptor,

The bronzes of *La muse endormie* are all casts, slightly modified, from the original marble in the Joseph H. Hirshhorn Collection. Oddly enough, it is clear on the marble that the head was carved with the eyes open, and so was probably conceived initially to be upright. In order to accommodate the eyes to the 'sleeping' position, Brancusi merely subdued the eyelids without altogether eradicating them. In the bronze, however, the eyes appear closed. The head tapers from the fullness of the face to almost a ridge at the back, so that the ears are much closer together than on a more naturalistic head, a feature which is not apparent when the work is in its horizontal position. The sculptor has adjusted the head to the fact that it is a recumbent object whose back is of minor importance, and on which only one ear, in any case, is visible at any moment.

The marble itself derives from a more naturalistic upright head in limestone, entitled *Baroness R. F.,* whose facial features it rationalizes into a few simple and marvellously unified forms. The inspiration for these works was a young woman of

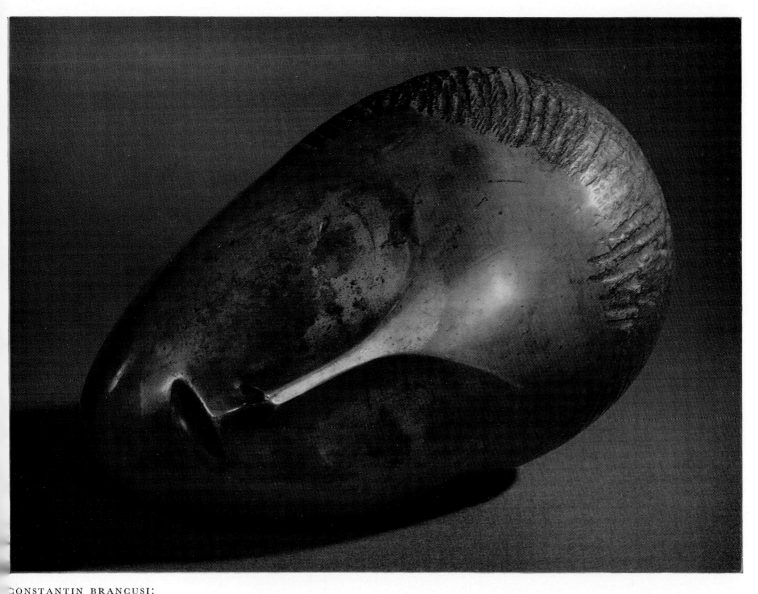

CONSTANTIN BRANCUSI:
La Muse endormie
Signed and stamped
'C. Valsuani, cire perdue'
Bronze with dull gold
patina, length 10½ in.
(27 cm.)
Sold 27.6.72 for 68,000 gns.
($185,640)
A world record auction
price for a work by this
artist

Basque origin, Baroness Renée Frachon, née Toussaint, whose father was a novelist and playwright under the pseudonym René Maizeroy. She remained a lifelong friend of Brancusi, and some years ago made a gift to the Musée National d'Art Moderne of a *Muse endormie* which he had given her.

The five bronzes discussed above are to be distinguished from four bronzes cast from a second version carved later in alabaster. These show formal variations from the first version, are about a half inch longer, and are polished to a reflective surface.

With *La muse endormie* Brancusi leaves behind a period of somewhat primitive

limestone carvings, and begins to design in marble with a classic elegance and firmness. It was probably *La muse endormie* which caused the Douanier Rousseau to remark to Brancusi: 'You have transformed the antique into the modern.' The head is a work of serene poetry that draws us into a revery of sleep and dream. As he does with a number of other themes, Brancusi carries *La muse endormie* through several transformations. He maintains the general design in two variants, *La muse, 1912,* and *La muse endormie II, 1917–18,* but, in a different direction, he pursues the poetry of sleep by going below the image, as it were, to make a head-like form, *Sculpture for the blind, circa 1916,* and then descends further to a more simple, buoyant ovoid, *Beginning of the World, circa 1920,* which is the shape of universal sleep before Creation. Brancusi's themes are themselves sculptural reveries.

TSUGHOUHARA FOUJITA: *Nu allongé*
Signed and dated 1927, 32 × 39½ in. (81 × 100 cm.)
Sold 30.11.71 for 11,000 gns. ($28,300)

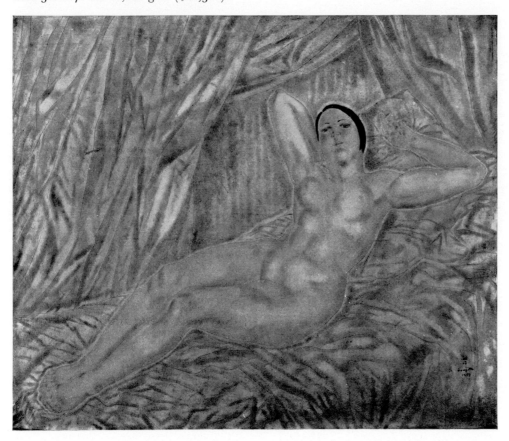

JULES PASCIN:
Jeune fille assise
Signed
36 × 30 in.
(91 × 76 cm.)
Sold 27.6.72 for
22,000 gns. ($60,060)
From the collection
of Leo M. Rogers

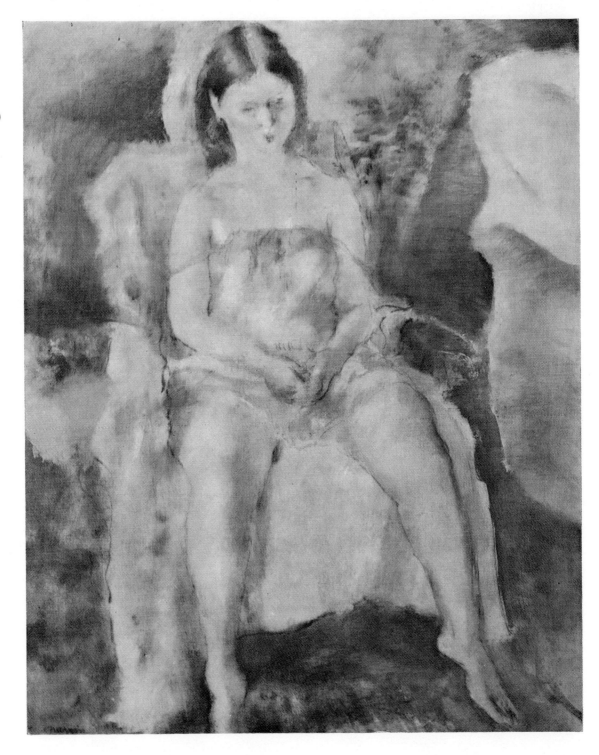

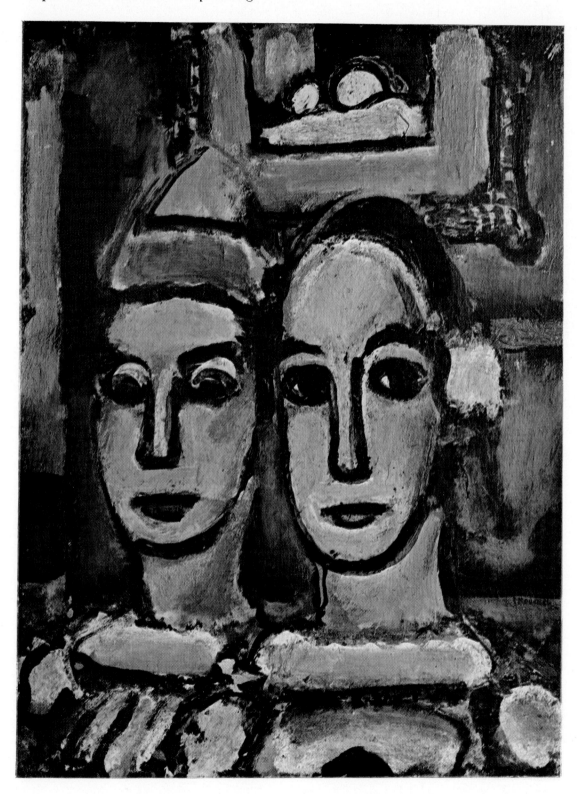

GEORGES ROUAULT:
Duo
Signed
26 × 20 in.
(66 × 51 cm.)
Sold 27.6.72 for
42,000 gns.
($114,660)
From the collection
of Leo M. Rogers

MAX BECKMANN:
Bildnis Quappi mit weissem pelz
Inscribed and dated 10.12.1937
Amsterdam
43 × 25¼ in. (109 × 64 cm.)
Sold 27.6.72 for 24,000 gns. ($65,520)
A world record auction price for a work
by this artist
From the collection of the late
Mrs Ala Story

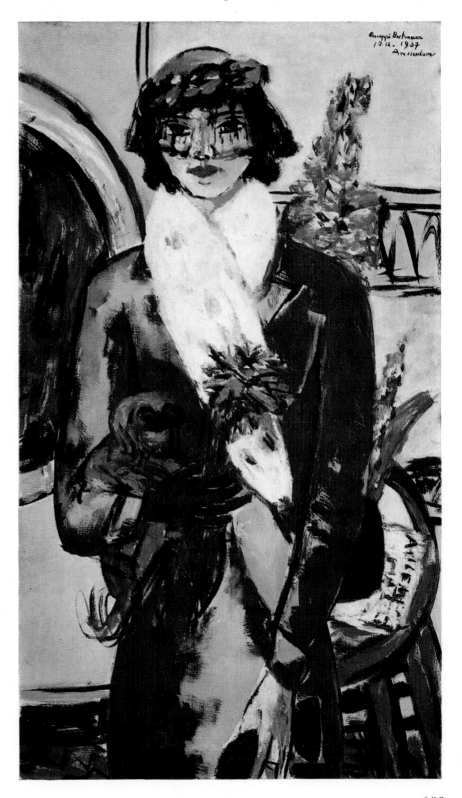

'Feriengäste II, 1915'

BY MARTIN URBAN

Feriengäste II has its origins on the island of Alsen in the Baltic where, in 1903, Nolde was living in a small fisherman's house. Near the house on the shore stood his modest studio, a wooden hut. Here Nolde painted his first flower and garden pictures, which were so important for the development of his work, especially in relation to his use of colours. These garden pictures of 1906–1908 brought him his first successes. However, this shy painter, alarmed by his successes, felt that he might have been misunderstood, and from then until 1915 he tended to avoid these themes. During the intervening years he painted large pictures of great importance, in the manner and colours after which he was striving; also religious pictures, a series of Berlin nightlife, and many pictures featuring figures, masks, still lifes with exotic figures, wintry seas, landscapes, and finally pictures of his trip to the South Seas. During this prolific period, the *Feriengäste* took shape.

It was during the summer of 1911, a period of intensive work for Nolde, that he wrote in *Jahre der Kämpfe*: '. . . then guests arrived, wicked people for whom I had no time, a singer, tired of city life, with a dark skin, mauve stockings and a white jacket. I made two group sketches of him and some young women, my dear Ada amongst them; I drew them on canvas and painted them in later, after the guests had gone, when I was alone with the colours.'

Feriengäste I was painted in 1911 and *Feriengäste II* in 1915. There also exists a portrait of the man with the white jacket also painted in 1911. These dates are known to us from a list, written by Nolde himself, of his paintings. Although the two versions are almost identical in their subject, their chief difference is in their artistic style.

Emil Nolde's friend and biographer, Max Sauerlandt, when writing about the first version of *Feriengäste*, which he once owned and is now in the Brucke Museum in Berlin, says: '. . . . it has the great charm of a primitive creation'. The composition depends mainly on the independent grouping of the three women on the left seated around a blue jar, the seated man on the right with the white jacket and mauve stockings and above them, across the canvas, the green lawn and geometrical blue fence. The compositional order is solid, immovable, the people remain very much on their own and isolated.

EMILE NOLDE:
Feriengäste II
Signed
$33\frac{1}{2} \times 39\frac{1}{2}$ in.
(85 × 100 cm.)
Sold 27.6.72 for
58,000 gns.
($158,340)
A world record
auction price for a
work by this artist
From the collection
of Leo M. Rogers

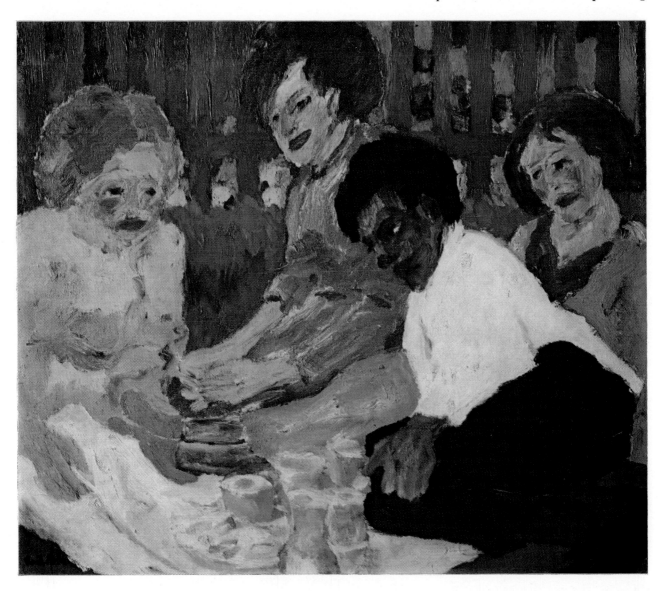

Feriengäste II is exactly the same size as the first version, yet it seems larger. Everything appears closer together and more compact, almost as if bursting out of the frame. However, the ensemble of the figures is hardly different, but the composition is dynamic and entirely based on the colours. The painting has its three focal points, with the man on the one side moving towards the middle, the white of his jacket, between black and dark brown, together with the blue of the dress of the seated woman forming the main theme; then the lime-green and the red of the dresses on the left, with the white of the napkin, the red-orange hands, stockings, shoes and

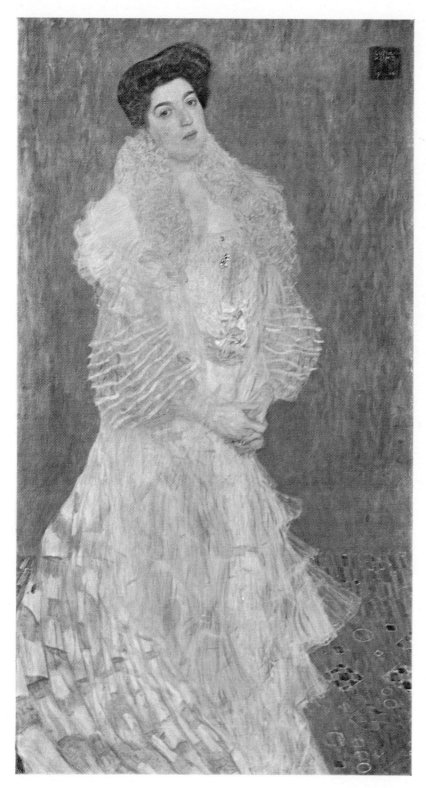

GUSTAV KLIMT: *Bildnis Hermine Gallia*
Signed and dated 1904
67 × 38 in. (170.5 × 96.5 cm.)
Sold 30.11.71 for 20,000 gns. ($51,400)
From the collection of Dr K. Gallia and
Mrs M. H. Gallia

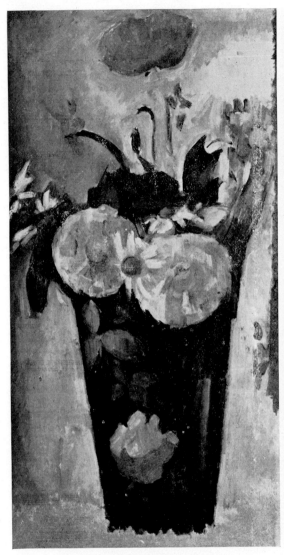

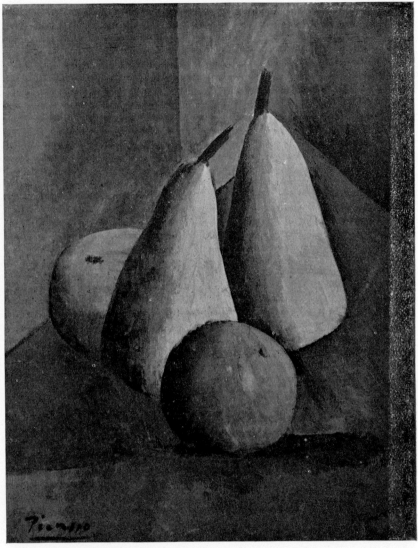

PAUL CEZANNE: *Le vase bleu*
15¾ × 17¾ in. (40 × 20 cm.)
Sold 11.4.72 for 45,000 gns. ($122,850)
From the collection of The Torcuato di
Tella Foundation and The Torcuato di
Tella Institute, Buenos Aires

PABLO PICASSO: *Poires et pommes*
Signed, on panel, 10½ × 8¼ in. (26.5 × 21 cm.)
Sold 11.4.72 for 24,000 gns. ($65,520)
From the collection of George Morton, Esq

the blue-white of the glasses in front, and finally, behind, the rhythmic pattern of the dark-blue fence.

Four years lie between the first sketch and the completion of the picture. Nolde did not like writing about his work, but admitted in a letter to the sculptor Mhe (dated 15.3.1918) '. . . my best pictures are often not finished for many years, and only after I have resumed work on them many times.'

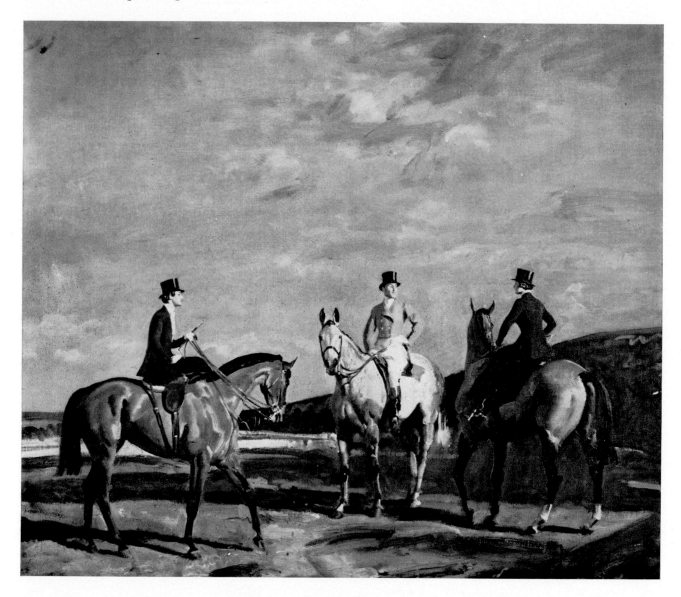

SIR ALFRED MUNNINGS, PRA: *Two busvines and a cutaway*
Signed, 25 × 30 in. (63.5 × 76.2 cm.)
Busvines was a ladies' tailor in Brook Street, W.1., specialising in hunting clothes. The shop closed in 1951
Sold 29.10.71 for 12,000 gns. ($30,840)
From the collection of the late Sir Henry P. Maybury, GBE, GCMG, CB

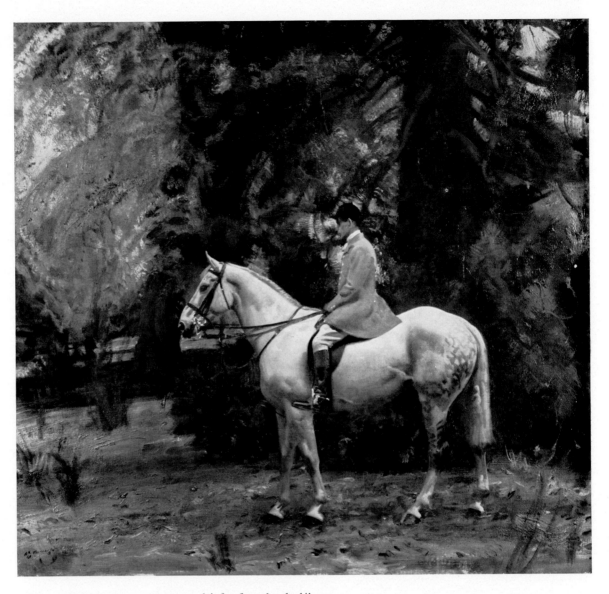

SIR ALFRED MUNNINGS, PRA: '*A fox for a hundred!*'
Signed, 36 × 40 in. (91.4 × 101.5 cm.)
Painted at Dedham
Sold 29.10.71 for 18,000 gns. ($46,260)
From the collection of the late Sir Henry P. Maybury, GBE, GCMG, CB

JAMES ABBOTT
MCNEILL WHISTLER:
Beach scene
Signed with the butterfly
mark, watercolour
5 × 8¼ in. (12.7 × 21 cm.)
Sold 19.5.72 for 3400 gns.
($9103)
From the collection of the
late Mrs F. L. Evans

CHARLES CONDER:
The beach at Brighton
Signed
18 × 24 in. (45.7 × 60.9 cm.)
Sold 19.5.72 for 4200 gns.
($11,245)
From the collection of the
late Mrs F. L. Evans

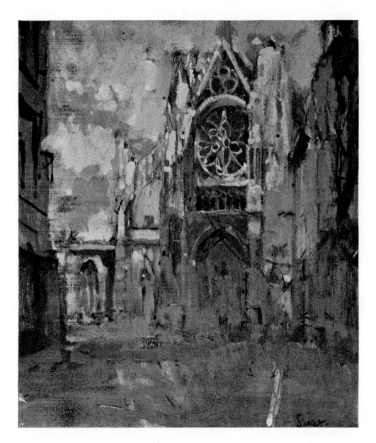

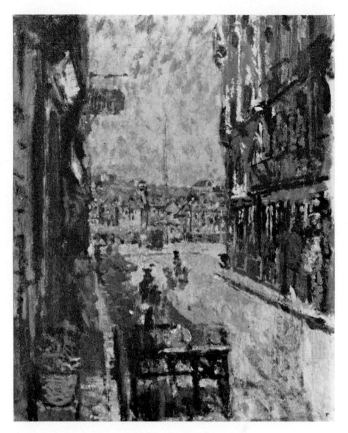

WALTER RICHARD SICKERT, ARA:
The façade of St Jacques, Dieppe
Signed, 18 × 15 in. (45.7 × 38.1 cm.)
Sold 21.1.72 for 1800 gns. ($4819)
From the collection of Ian Farquar, Esq

WALTER RICHARD SICKERT, ARA:
Street scene, Dieppe
On board, 9¼ × 7 in. (23.5 × 17.7 cm.)
Sold 19.5.72 for 2400 gns. ($6426)
From the collection of the late Mrs F. L. Evans

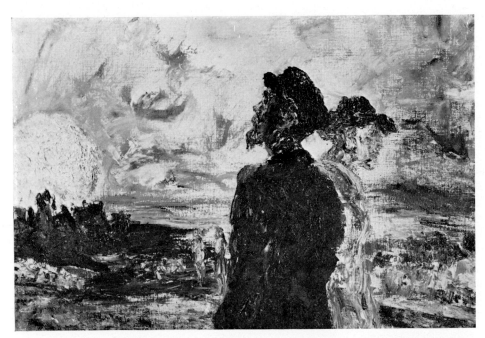

JACK BUTLER YEATS:
Harvest moon
Signed, 24 × 36 in. (60.9 × 91.4 cm.)
Sold 19.5.72 for 5000 gns. ($13,650)
A world record auction price for a
work by this artist

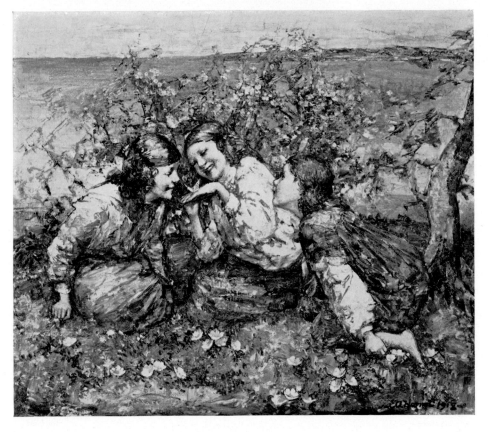

EDWARD ATKINSON HORNEL:
Butterflies
Signed and dated 1918
20 × 24 in (50.8 × 60.9 cm)
Sold 19.5.72 for 1200 gns. ($3213)
From the collection of the late
Sir Thomas Jaffrey

LESLIE HUNTER:
*Still life with chrysanthemums
in a vase*
Signed, on board
$25\frac{1}{4} \times 20\frac{3}{4}$ in. $(64 \times 52.7$ cm.)
Sold 19.5.72 for 2000 gns. ($5355)
A world record auction price for a
work by this artist
From the collection of the late
Sir Thomas Jaffrey

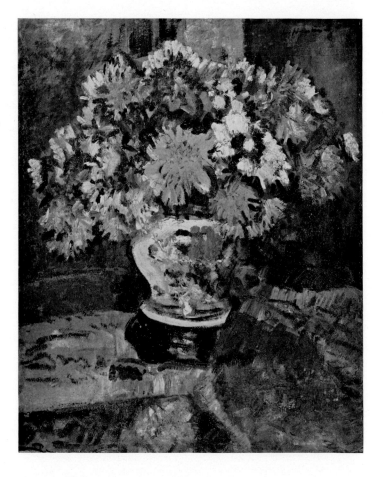

Scottish painting

It is particularly gratifying to find pictures by Scottish artists as wide apart technically as Sir D. Y. Cameron, Robin Philipson, Anne Redpath and E. A. Hornel all fetching high prices when offered for sale in London. Five or six years ago this was not the case. The appeal of Peploe, Cadell and Hunter has been fostered by the comprehensive exhibition of these three colourists organised by the Scottish Arts Council and shown at The Fine Art Society, two years ago.

Amongst such works last season was a group from the collection of the late Sir Thomas Jaffrey of Aberdeen, which were of a particularly high standard. The still life *Chrysanthemums* by Leslie Hunter fetched 2000 guineas ($5355), almost double the previous record for a similar work which was sold in March 1971. Another work of outstanding quality was a large painting of *The small holding* by Henry Herbert la Thangue, RA, which sold for 3200 guineas ($8568). This was a very pleasing study and made effective use of filtered sunlight on the white backs of the ducks, and produced splashes of surprising whiteness.

Despite a certain similarity of subject manner and treatment, the busily painted

pictures of Edwin Atkinson Hornel continue to be very popular. Hornel made some journeys to Japan and many of his later pictures are of Japanese girls in elaborately flowered kimonos. A painting of 1919 entitled *Apple Blossom* sold in the summer for the high price of 1900 guineas ($5087). In 1969, when we sold a number of works by Scottish painters at Hopetoun, this picture would probably have fetched only about 1000 guineas ($3024).

JOHN NASH, RA: *Threshing*
Signed and dated 1915, 30 × 25 in. (76.2 × 63.5 cm.)
Sold 29.10.71 for 1200 gns. ($3080)
From the collection of Lancelot de G. Sieveking, Esq, DSC

HENRY HERBERT LA THANGUE, RA:
The small holding
Signed, 42 × 34 in. (106.6 × 86.3 cm.)
Sold 19.5.72 for 3200 gns. ($8568)
A world record auction price for a work by this artist
From the collection of the late Sir Thomas Jaffrey

MARK GERTLER: *Coster woman*
Signed and dated '23, 24½ × 16 in. (62.2 × 40.6 cm.)
Sold 29.10.71 for 2200 gns. ($5650)
A world record auction price for a work by this artist
Presented by Peter Pears, Esq, and sold on behalf of The Aldeburgh Festival

SIR WILLIAM RUSSELL FLINT, RA: *Reclining nude*
Signed, watercolour, 13 × 24 in. (33 × 60.9 cm.)
Sold 19.5.72 for 6000 gns. ($16,065)
A world record auction price for a work by this artist

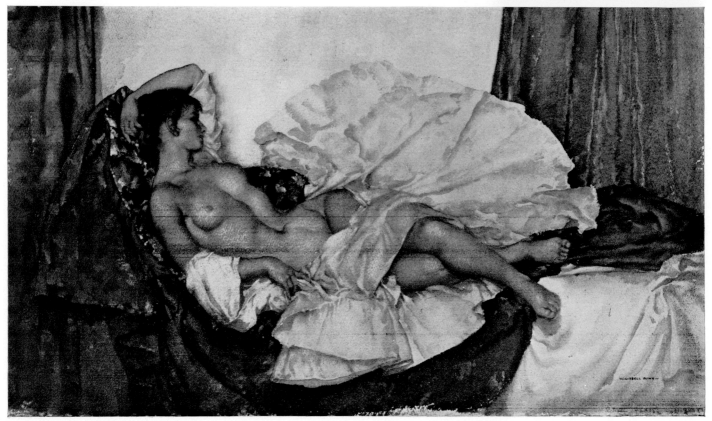

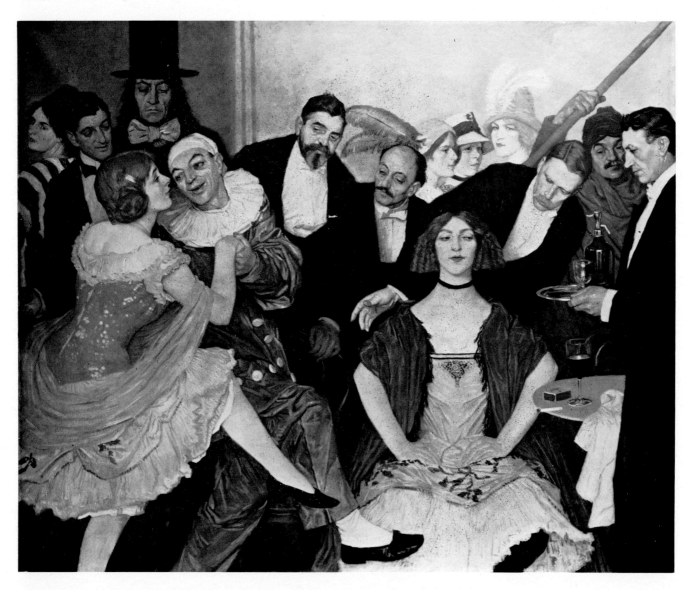

WILLIAM STRANG, ARA: *Group of actors, actresses, dancers and others at the Café Royal*
Signed and dated 1913, 47½ × 59 in. (119.3 × 149.8 cm.)
Sold 16.5.72 for 2400 gns. ($6550)
From the collection of Colonel Sir John Crompton-Inglefield, TD

AUGUSTUS JOHN,
OM, RA:
Portrait of
Vivien Leigh
Signed
36 × 28 in.
(91.44 × 71.1 cm.)
Sold 21.1.72 for
3000 gns. ($8030)

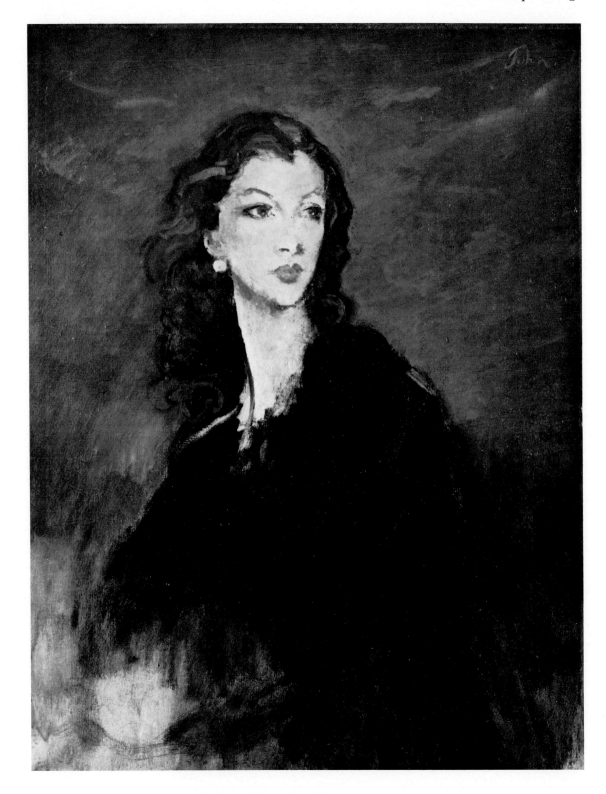

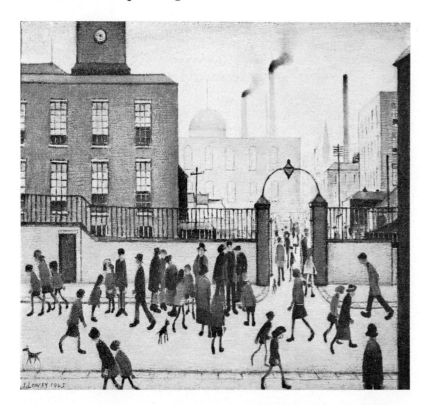

LAURENCE STEPHEN LOWRY, RA:
Mill gates
Signed and dated 1945, 16 × 18 in. (40.6 × 45.7 cm.)
Sold 19.5.72 for 9600 gns. ($25,436)
From the collection of the late Mrs Doris Perry

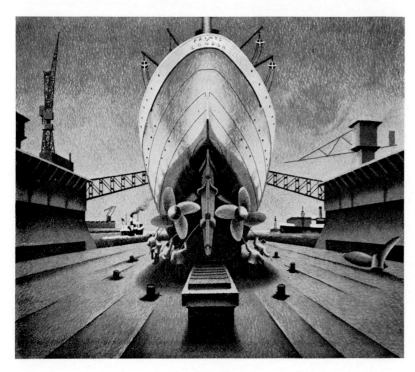

EDWARD WADSWORTH: *Ship in dry dock*
Signed and dated 1941, tempera
19¾ × 23½ in. (50 × 59.6 cm.)
Sold 10.3.72 for 950 gns. ($2593)
From the collection of Mrs Sidney Rogerson

DAVID HOCKNEY: *Man with wings and rocks*
Painted in 1963. 24½ × 24½ in. (62.2 × 62.2 cm.)
Sold 10.3.72 for 1500 gns. ($4095)

PETER BLAKE: *Boy with badges*
Signed, inscribed and dated 1961–1966 on the reverse
Acrylic on board, 7½ × 6¼ in. (19 × 16 cm.)
Sold 10.3.72 for 900 gns. ($2457)

Sculpture

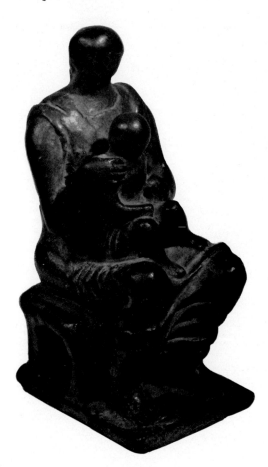

HENRY MOORE, OM, CH: *Madonna and Child*
Signed, bronze with green patina, height 6¼ in. (15.8 cm.)
Sold 18.7.72 for 7000 gns. ($16,940)
This is a maquette for the Madonna and Child executed
in stone for the Church of St Matthew, Northampton
The bronze was cast in an edition of seven in 1943
From the collection of the late Dr Erich Alport

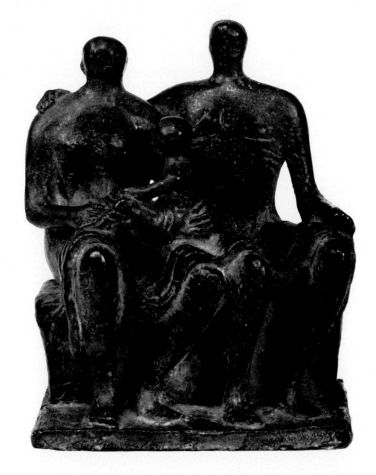

HENRY MOORE, OM, CH: *Project for family group*
Signed, bronze with green patina, height 5¼ in. (13.3 cm.)
Sold 29.10.71 for 7000 gns. ($17,990)
Executed in 1944, this is one of an edition of seven
From the collection of John Lewis, Esq

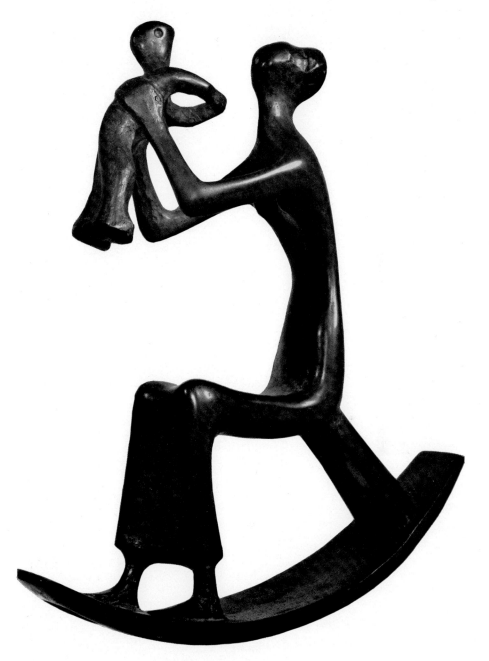

HENRY MOORE, OM, CH: *Rocking Chair No. 1*
Bronze, height 13 in. (33 cm.)
Sold 18.7.72 for 23,000 gns. ($57,960)
One of an edition of six executed in 1950
From the collection of the late Dr Erich Alport

Australian sales

BY JOHN HENSHAW

Our picture sale held early in the season in Sydney made a record total of £235,924 (A.$504,880). It included an important group of paintings, gouaches and drawings by the late Sir William Dobell. Amongst these was a painting of the controversial Sydney Opera House seen as an oriental mirage floating above wispy sails in Sydney harbour; this attracted considerable overseas interest and fetched £7475 (A.$16,000). *The Night of the Pigs* by the same artist went to the Art Gallery of New South Wales for £4672 (A.$10,000), having been sent for sale by the newly formed Sir William Dobell Art Foundation, a charitable trust for the assistance of art in New South Wales. Dobell's lively realism, tempered with a love of traditional values, possessed enough expressionist force to command an important place in the modern scene. His portraiture at its best stood beside the finest of this genre in twentieth-century art. The highest price in the sale was £10,279 (A.$22,000) which was paid for Sir Russell Drysdale's *Happy Jack*, 1961, which is a record for a work by this artist and indicated the competition which exists for works by this relatively unprolific artist.

Three outstanding landscapes – *Burning Off* by Arthur Boyd, 1958, with its ingenuous naivety of vision, *Williamstown Jetty* by John Perceval and *Yellow Landscape* by Frederick Williams – at £5139 (A.$11,000), £5139 ($11,000) and £5372 ($11,500) respectively, indicated the arrival of these artists at Old Master status within the Australian contemporary art scene.

Another rare artist whose reputation has increased dramatically over the past few years is John Passmore who was represented by a Cezannish bather composition titled *Four Girls* for which a well-known Melbourne collector paid £3971 (A.$8500). A *Nude and Moon* by Godfrey Miller at £3738 (A.$8000) went to the National Gallery of Victoria, indicating a comparable extension of interest. Among a group of European works introduced for the first time in our Australian auctions, a small but unique bronze hand by Auguste Rodin fetched an exceptional £3971 (A.$8500).

Of the two book sales held during the season the most important was that of the Australian Art Reference Library of Mr and Mrs Douglas Carnegie, the well-known patrons of Australian contemporary painting. The library was offered on Thursday,

Left:
SIR ARTHUR
ERNEST STREETON:
*McMahon's
Point, 1890*
Signed and dated
35⅞ × 27¾ in.
(91 × 70.5 cm.)
Sold 14.3.72 for
£10,280 (A$22,000)
at The Age Gallery,
Melbourne
From the collection
of Lady McCaughey

Right:
ARTHUR BOYD:
Burning off, 1958
Signed and dated
36 × 48 in.
(91.5 × 121.8 cm.)
Sold 5.11.71 for
£7470 (A$16,000)
at the Wentworth
Hotel, Sydney

October 14th and comprised many small and scarce items relating to early exhibitions of painters now well known, early catalogues of Australian collections, and many inscribed copies of Australian Art monographs.

Individual plates from Gould's *Birds of Australia* were offered in the Melbourne sale in March and the prices for these separate lithographs explain why so many bound copies of this book are broken up for framing. Where individual plates can realize £46 (A.$100) or more the potential value of the complete work of 681 plates is, for a print dealer or decorator, a temptation too difficult to resist. During the season two copies of Gould's *Mammals of Australia* were offered, one in original boards which realized £1401 (A.$3000) and another bound copy which realized £1074 (A.$2300)

Expansion into sales of Oriental porcelain and English silver highlighted the March auctions at the Age Gallery in Melbourne. A superb George III epergne by William Cripps, London, 1761, was sold to an American buyer for £3036 (A.$6500); and a fine Charles II beaker of 1680 fetched £467 (A.$1000).

The Symons Collection of Chinese Porcelain which was auctioned next, included good quality sang-de-boeuf pieces. A pair of rare white honeycomb vases realized the highest price of £242 (A.$520) and a tiny Yuan Dynasty brown jade feline reached £195 (A.$420).

Sir William Dobell's paintings were also strongly in evidence in the March 14th and 15th auctions. A fine New Guinea landscape went for £4205 (A.$9000) and *A Portrait on a Terrace, Wangi* for £3504 (A.$7500). *Afternoon Tea, Wangi* fetched £3036 (A.$6500) and a miniature sized study of *A Girl with A Rose* went for £2102 (A.$4500). However, the most important event of the sale occurred with the purchase by the National Collections, Canberra, of an almost unknown painting by Sir Arthur Streeton, of *McMahon's Point,* for £10,279 (A.$22,000). This view towards Sydney Heads, looking over a paddle-steamer ferry pulling into a wharf, retained all the nostalgia of a leisurely period when the young artist, along with Roberts, Conder and McCubbin, was discovering with a fresh eye the brilliant light of a new continent. Prominent in a total of £122,165 (A.$454,046) were unusual prices for Clifton Pugh's *A Feral Cat* at £2803 (A.$6000), Constance Stokes's *Lady with a Basket* at £2102 (A.$4500) and John Brack's *The Bathroom* at £2569 (A.$5500).

LAWREN HARRIS: *Sun, fog and ice—Smith Sound*
Signed on verso, 40 × 50 in. (101.7 × 127 cm.)
Sold 14.10.71 for £10,800 ($27,000) at the Ritz Carlton Hotel, Montreal

M. EMILY CARR: *Trees, Vancouver Island*
Signed, oil on paper laid down on board
23 × 34 in. (58.4 × 86.3 cm.)
Sold 27.4.72 for £6154 ($16,000) at the Ritz Carlton Hotel, Montreal

CORNELIUS KRIEGHOFF:
The settler's homestead
Signed, 12¾ × 17½ in. (32 × 45 cm.)
Sold 14.10.71 for £11,200 ($28,000) at the
Ritz Carlton Hotel, Montreal

EASTMAN JOHNSON: *The card sharp*
Signed and dated 1851
18½ × 22½ in. (47 × 57.1 cm.)
Sold 25.2.72 for 5800 gns. ($15,830)

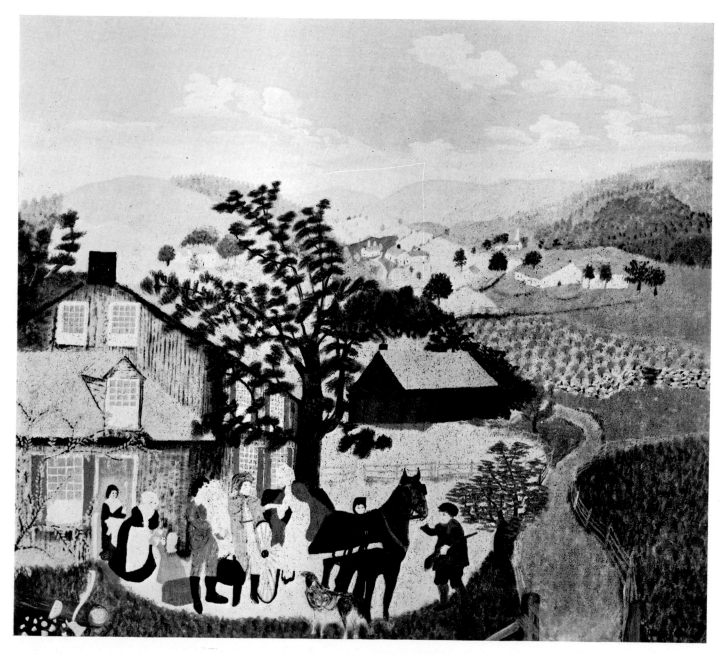

ANNA MARY ROBERTSON ('GRANDMA') MOSES: *The Daughter's homecoming*
Signed, on board, $19\frac{1}{4} \times 22\frac{3}{4}$ in. $(49 \times 58$ cm.)
Sold 25.2.72 for 2800 gns. ($7640)

REMBRANDT
PEALE, NA:
*Portrait of George
Washington (The
Porthole Portrait)*
Signed, in a painted
oval, $35\frac{1}{2} \times 28\frac{1}{2}$ in.
(90.1 × 72.3 cm.)
Sold 25.2.72 for
11,000 gns.
($30,030)
From the collection
of Duncan Rogers
Esq

ANTON VAN
WOUW:
Bad news
Signed, inscribed
'S.A. Joh-burg' and
'G. Nisini fuse
Roma' and dated
1907, bronze, height
13 in. (33 cm.)
Sold 25.2.72 for
2800 gns. ($7640)
From the collection
of J. H. D.
Wickham, Esq

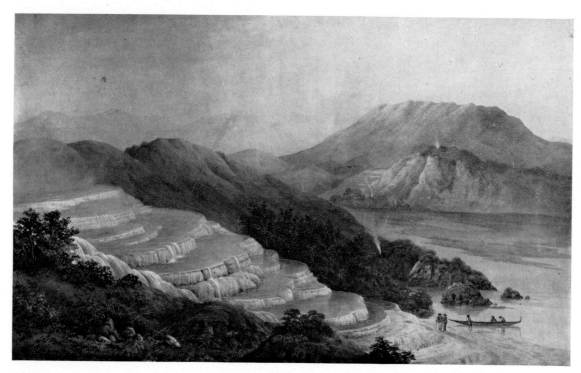

JOHN CLARKE
HOYTE:
*Terraces at Rotorua,
North Island*
Signed and dated
1873
Watercolour
$18\frac{3}{4} \times 30\frac{1}{2}$ in.
(47.5 × 77.5 cm.)
Sold 25.2.72 for
340 gns. ($928)

JEWELLERY

Important ruby and
diamond bracelet
Sold 19.4.72 for
£8000 ($20,800)

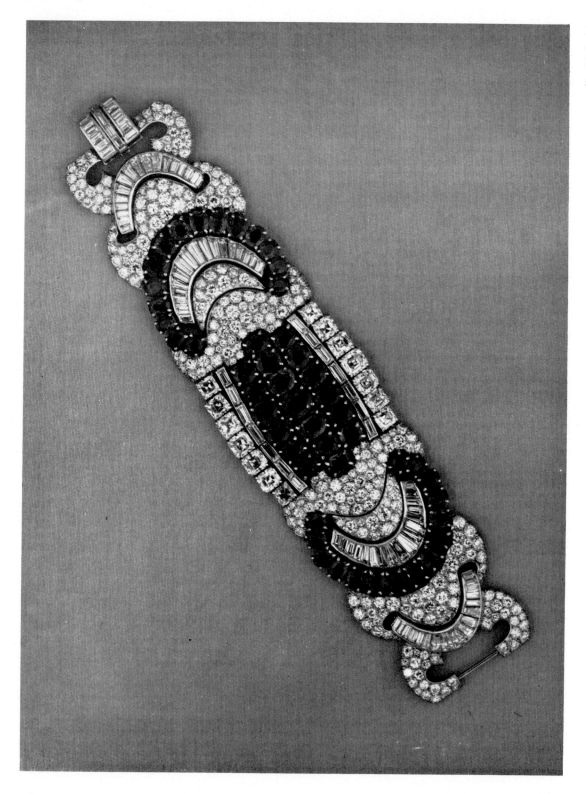

Important floral brooch, mounted with calibre
rubies and diamonds
Sold 18.11.71 at the Hotel Richemond, Geneva
for £7000 (Sw fr 70,000)

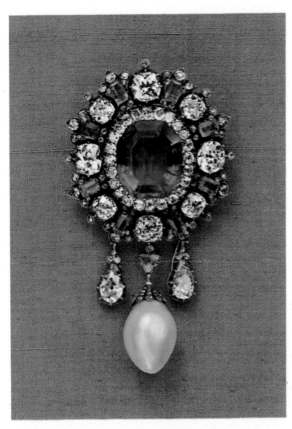

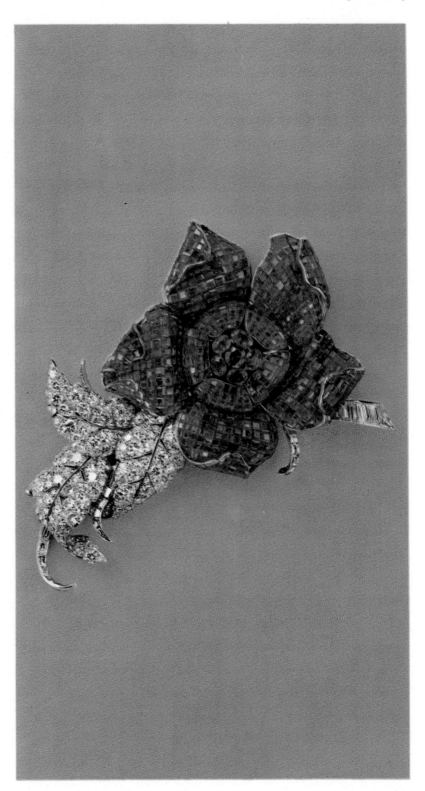

Highly important emerald, diamond and pearl
pendant-brooch, known as the 'Stuart
Emerald', English, early 19th century
Sold 18.11.71 at the Hotel Richemond, Geneva
for £52,000 (Sw fr 520,000)

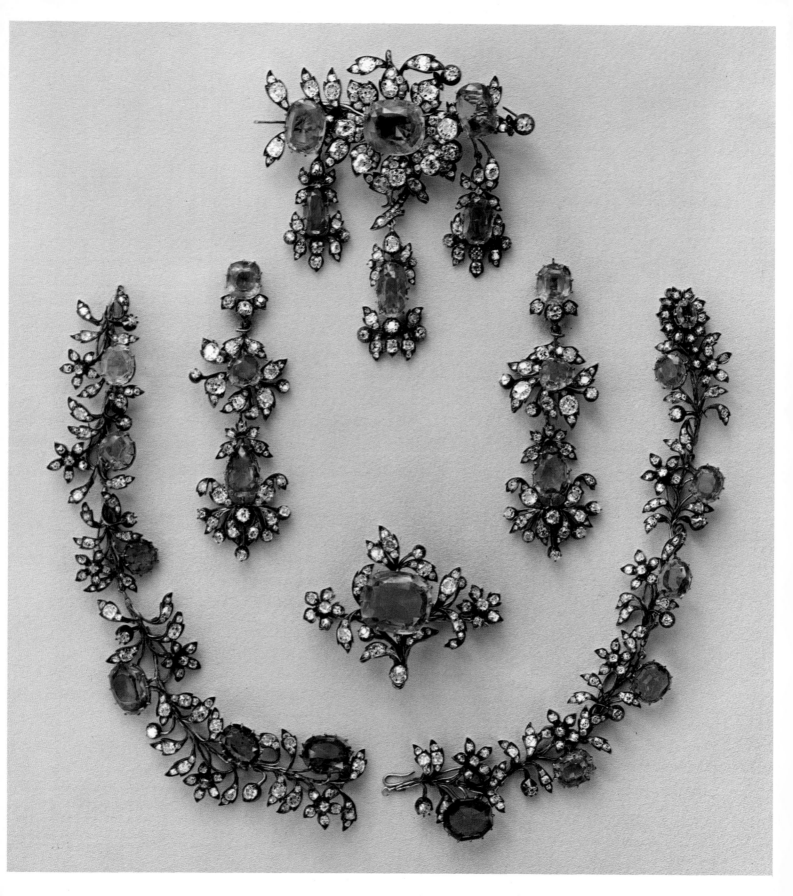

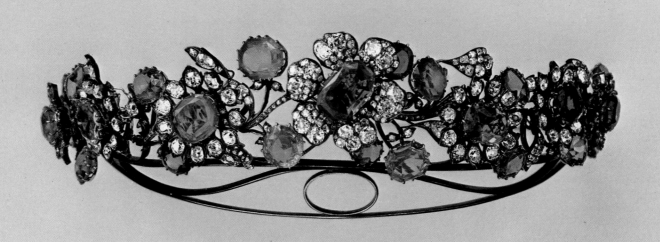

Left and above: Important and rare antique sapphire and diamond parure, *circa* 1800
Sold 18.11.71 at the Hotel Richemond
Geneva for £8000 (Sw fr 80,000)
The Barberini Jewels

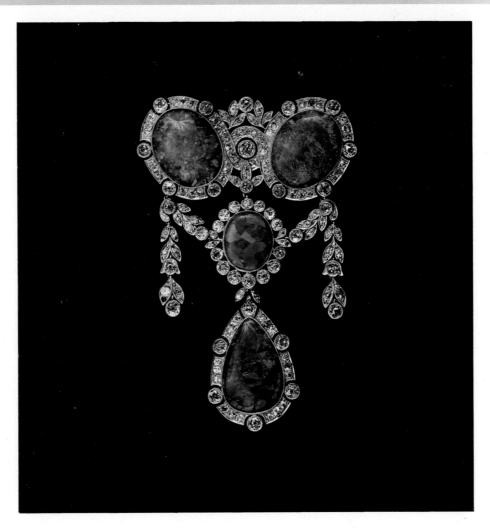

Right: Magnificent black opal and
diamond pendant-brooch
Sold 18.11.71 at the Hotel Richemond
Geneva for £11,000 (Sw fr 110,000)

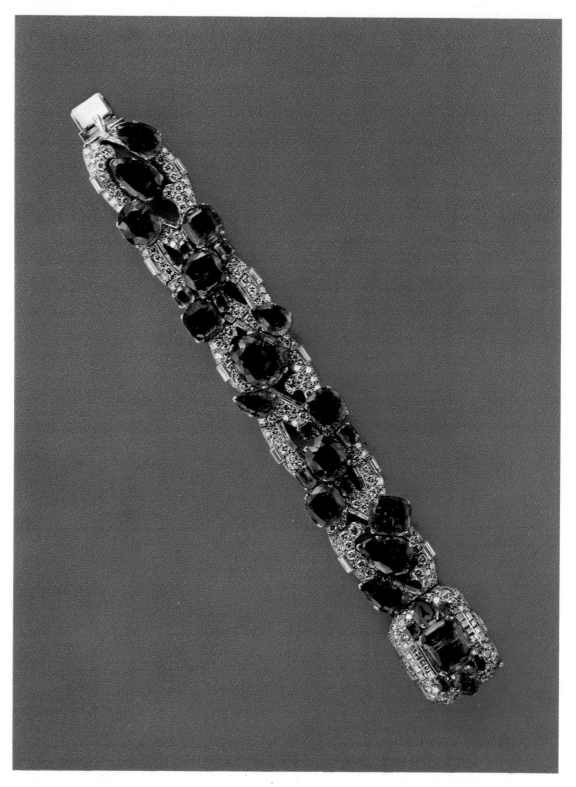

Important emerald
and diamond
bracelet, by Cartier
Sold 18.11.71 at the
Hotel Richemond
Geneva for
£27,500
(Sw fr 275,000)

Important diamond
bracelet
By Cartier
Sold 19.4.72 for
£6500 ($16,900)

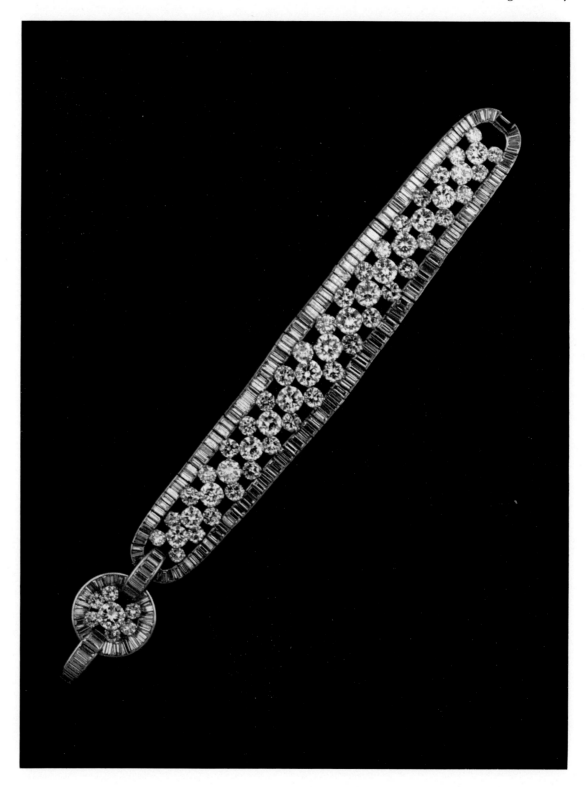

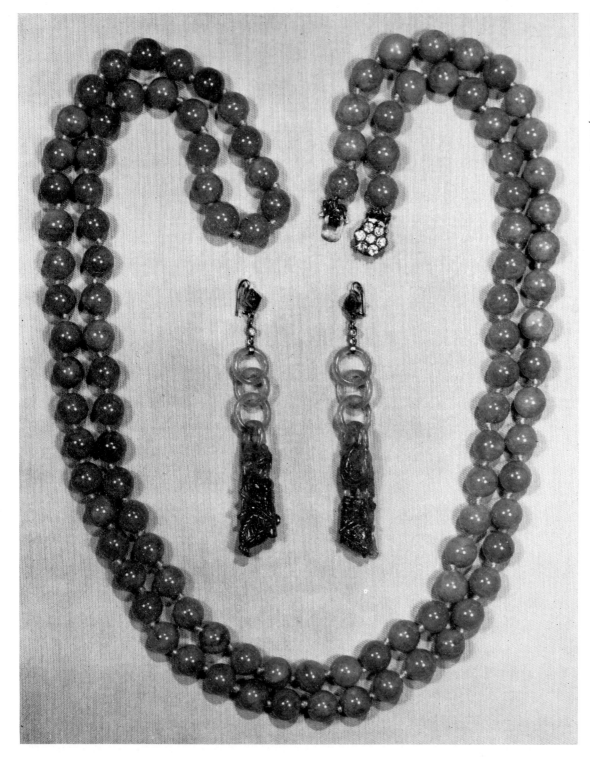

Pair of unusual jade
ear-pendants
Sold 19.4.72 for
£340 ($884)

Important single row
jade bead rope
necklace
Sold 19.4.72 for
£1200 ($3120)

Rectangular emerald mounted
as a single stone ring
Sold 6.10.71 for £3000
($7350)

Attractive Victorian emerald
and diamond brooch
Sold 6.10.71 for £6400
($15,680)

Victorian diamond and
turquoise necklace
Sold 6.10.71 for £1000
($2450)

From the collection of the late
Capt H. E. Rimington-Wilson

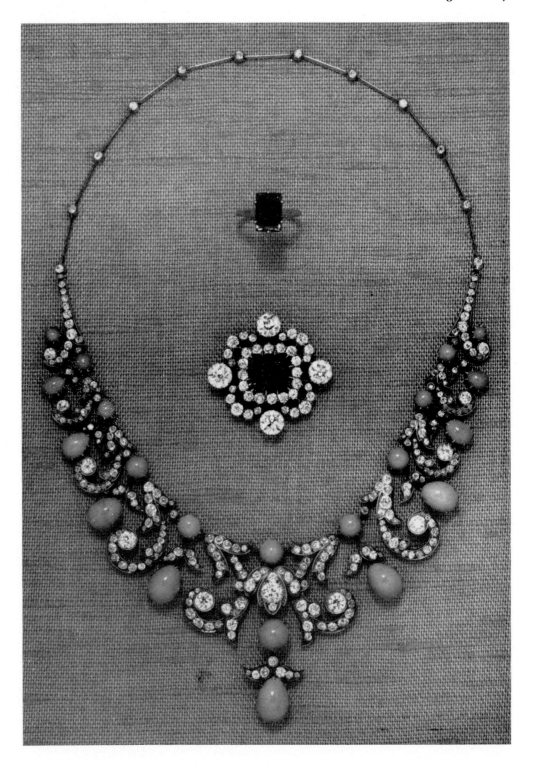

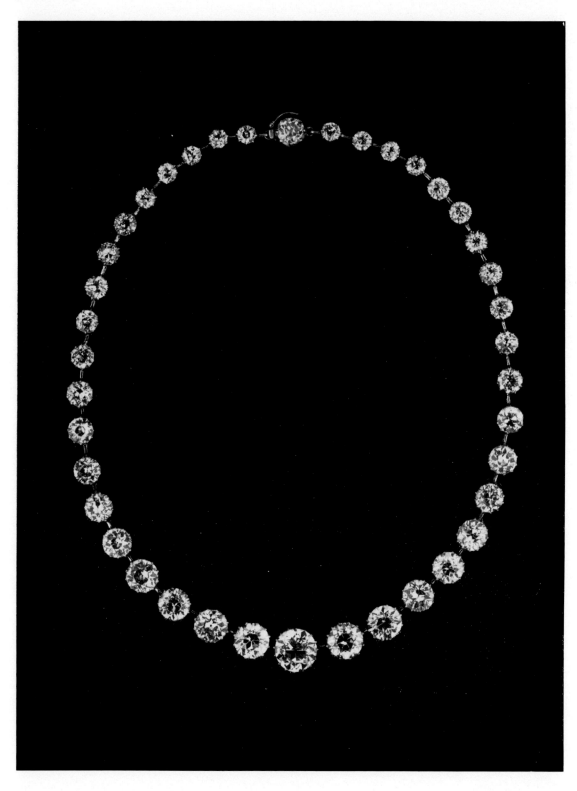

Important diamond
necklace
Sold 29.3.72 for
£8200 ($21,320)
From the collection
of Commander
Charles G. Powney,
DSC

Important diamond brooch
pendant designed as a
Maltese cross
Sold 1.12.71 for £2500 ($6130)

Antique diamond necklace
Sold 1.12.71 for £2300 ($5640)

From the collection of the late
E. A. Webster, Esq

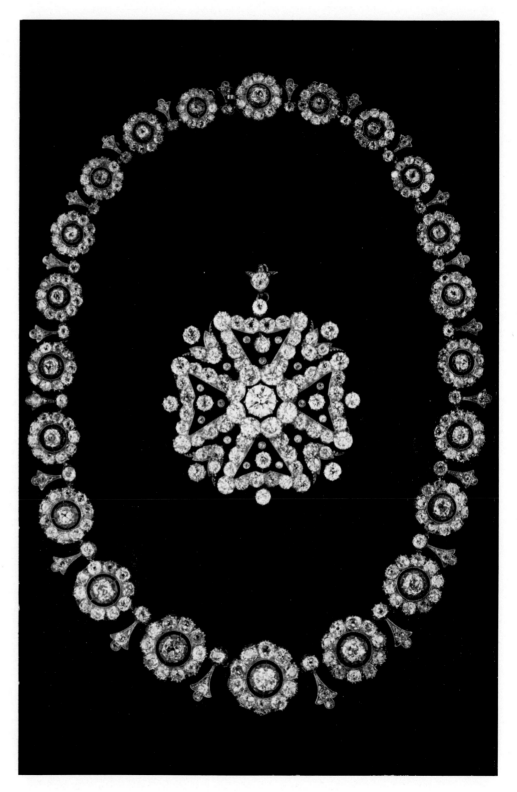

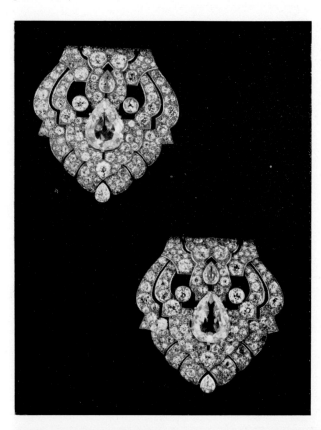

Pair of important diamond clip-brooches
Sold 29.3.72 for £5800 ($15,100)
From the collection of Mrs D. Coventry

Important pearl and diamond tiara
Sold 27.4.72 at the Hotel Richemond, Geneva, for £6800
(Sw fr 68,000)

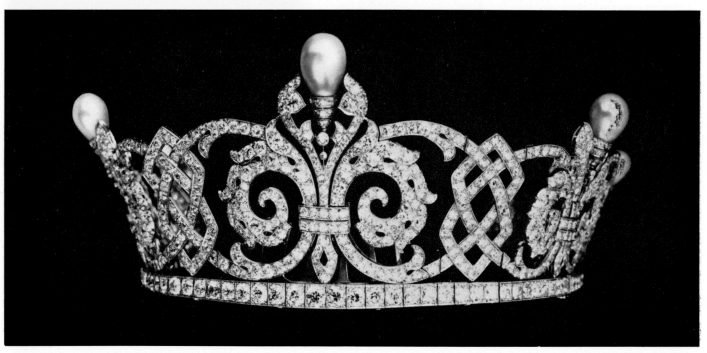

Set of four attractive
Victorian diamond
butterfly brooches
Sold 19.4.72 for
£3900 ($10,140)
From the collection
of Mrs J. Goldsmid

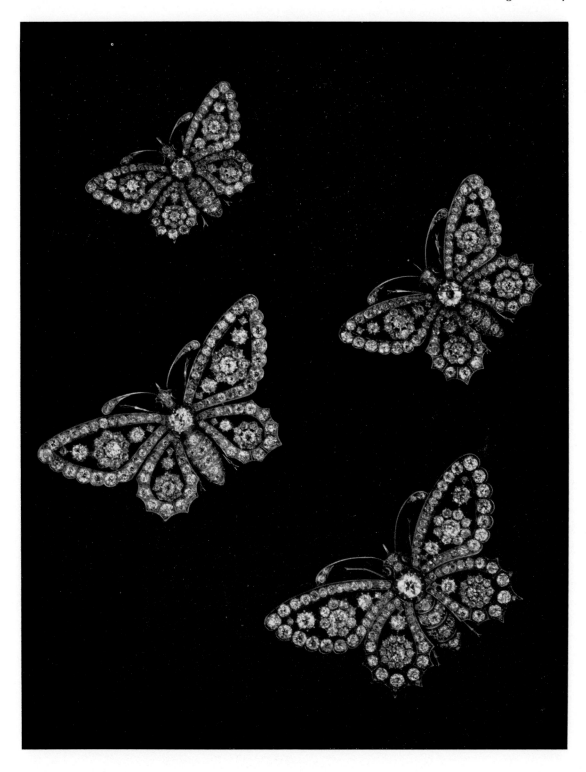

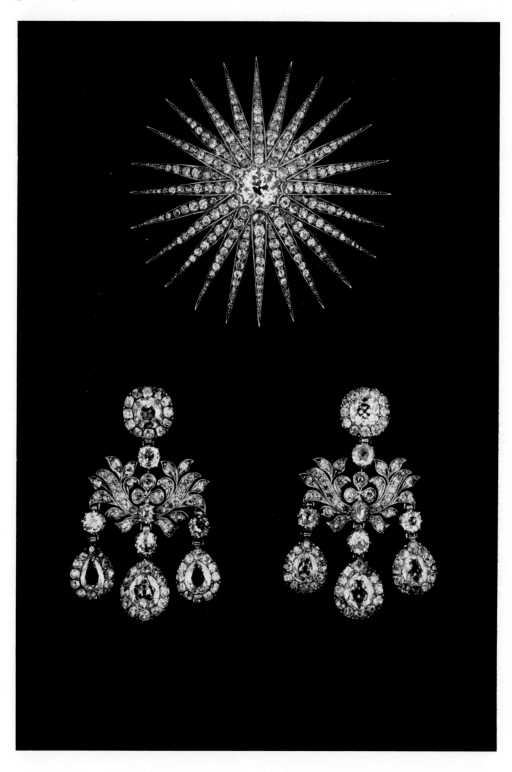

Victorian diamond brooch
Sold 1.12.71 for £1350
($3310)

Pair of important antique
diamond earrings
Sold 1.12.71 for £3400
($8340)

Highly important
ruby and diamond
necklace
By Bulgari, Rome
44 rubies weighing
71.21 ct., 297
brilliants 77.60 ct.
Sold 27.4.72 at the
Hotel Richemond,
Geneva for £26,000
(S.F. 260,000)

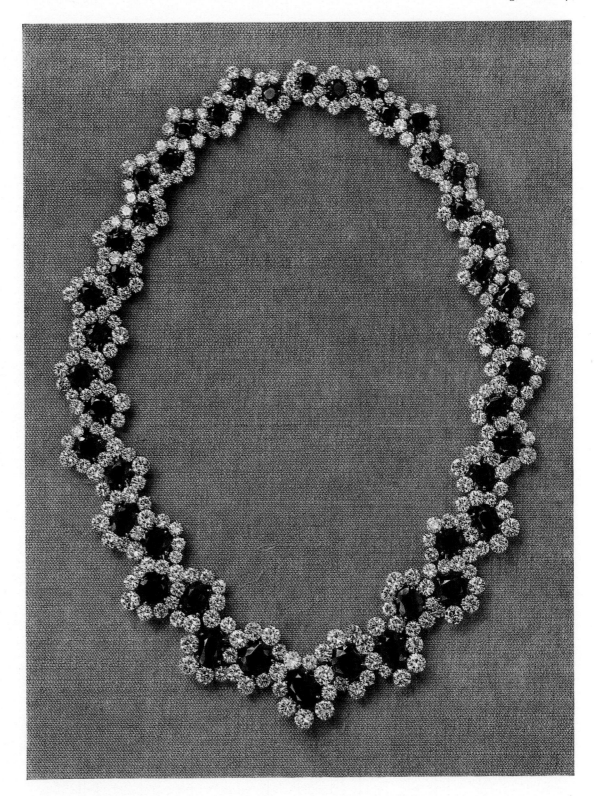

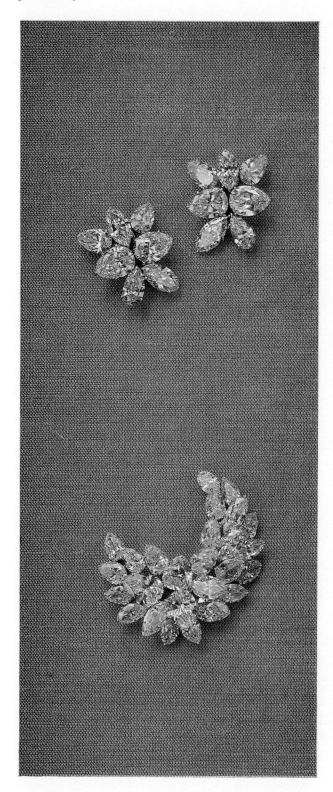

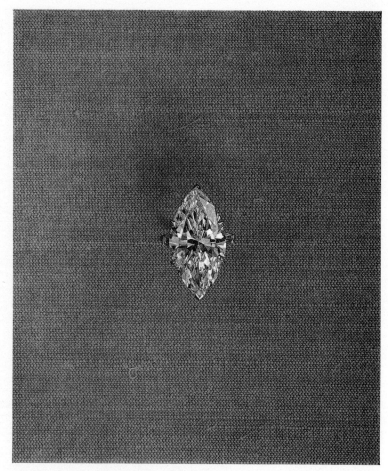

Above: Magnificent diamond ring
By Harry Winston
Weight of diamond 17.39 ct.
Sold 27.4.72 at the Hotel Richemond, Geneva, for £56,000
(S.F. 560,000)

Top left: Pair of highly important diamond ear-clips, set with
navette and drop-shaped diamonds, weighing 31.82 ct.
By Harry Winston
Sold 27.4.72 at the Hotel Richemond, Geneva, for £17,000
(S.F. 170,000).

Bottom left: Magnificent diamond brooch
By Harry Winston
Sold 27.4.72 at the Hotel Richemond, Geneva, for £15,000
(S.F. 150,000)

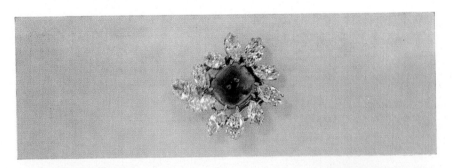

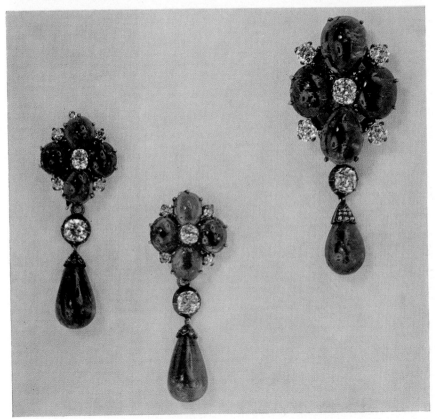

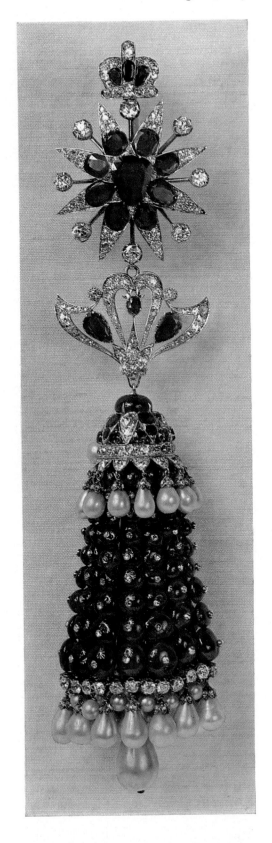

Top: Attractive cabochon emerald and diamond brooch, cabochon emerald of 6.51 ct., diamonds weighing 6.62 ct. By Cartier
Sold 27.4.72 at the Hotel Richemond, Geneva, for £5200 (S.F. 52,000)

Bottom: Important and attractive antique suite of emerald and diamond jewels Russian, nineteenth century
Sold 27.4.72 at the Hotel Richemond, Geneva, for £30,000 (S.F. 300,000)

Right: Magnificent Indian sarpech (turban ornament)
Actual length approx. 8¾ in. (22.5 cm.)
Sold 27.4.72 at the Hotel Richemond, Geneva, for £8000 (S.F. 80,000)

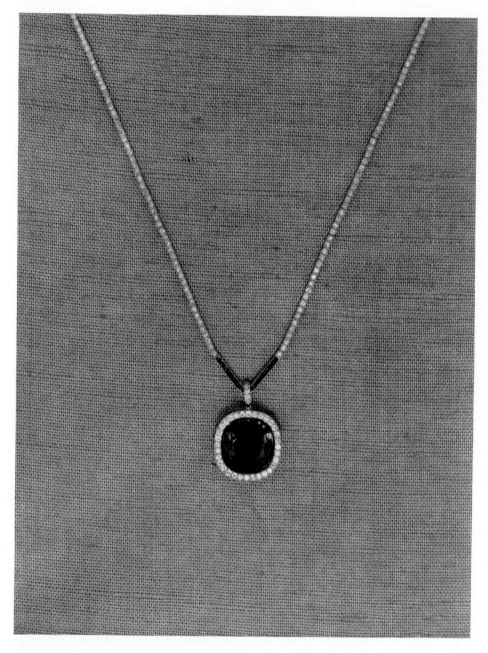

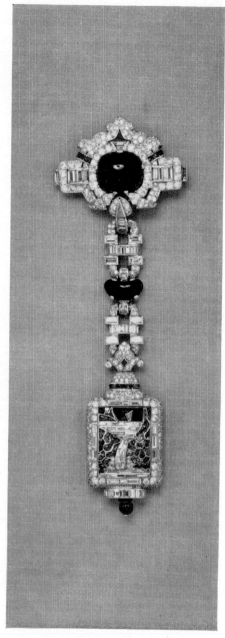

Important sapphire and diamond pendant on diamond and calibre
sapphire necklace
By Cartier
Sold 6.10.71 for £14,000 ($34,300)
From the collection of Mrs Georgiana Oborne

Attractive diamond, emerald and
multi-gem fob watch
Sold 21.6.72 for £5400 ($14,040)
From the collection of Mrs N. B.
Thomson

SILVER

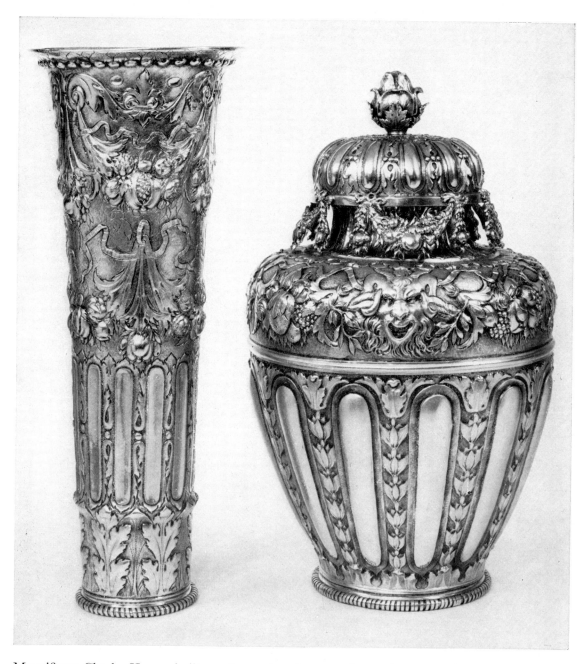

Magnificent Charles II parcel-gilt garniture, comprising two jars and covers and two beakers
Height of jars 17¼ in. (43.8 cm.), height of beakers 18⅛ in. (46.4 cm.)
Circa 1675 (one jar and one beaker showing)
Sold 24.11.71 for £15,400 ($37,730)

A superb garniture

This superb garniture probably came from Belton House, Grantham, through the marriage in 1825 of Sir William Fowle-Middleton, 2nd Baronet, with Anne, daughter of Brownlow Cust, 4th Baronet and 1st Baron Brownlow of Belton. They then passed into the de Saumarez family of Saumarez, Guernsey, and Brook Hall and Shrubland Park, Ipswich on the marriage in 1882 of Jane, eldest daughter of Captain Charles Acton Vere Broke to the 4th Baron de Saumarez.

The design of this garniture would have been taken from a pattern book circulating London and their execution would only have been entrusted to one of the best qualified goldsmiths. It is interesting to note that these smiths did not cling avidly to the printed designs but allowed their imagination and skill to alter certain features if they considered this would result in a more satisfactory aesthetic result. For instance, the covered vase and pair of beakers at Knole, Kent, show a close similarity to the design of this garniture, but the vase is cast and chased with pendant medallions on the shoulder as opposed to bacchanalian masks.

The vases are inspired by Dutch models based upon the shape of ginger jars. It is, however, a misnomer to call these vases by that description; they are too massive in size and were intended solely for display. The diarist, John Evelyn, noticed a similar garniture in the dressing room of Countess Abingdon at Goring House. The shape of the beakers derives from Chinese porcelain examples or later Dutch Delft copies and their decoration from contemporary Dutch engravings; this last may be seen in particular in the work of Barent van Milanen of The Hague.

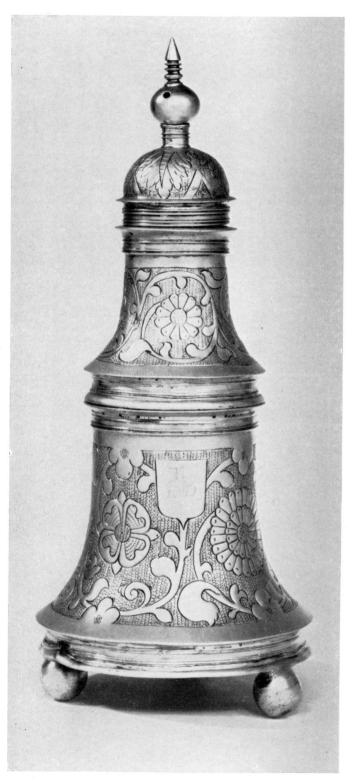

James I silver-gilt bell-salt
9½ in. (24.1 cm.) high
1607, maker's mark TS in monogram
Sold 24.11.71 for £6000 ($14,700)
Sold by the trustees of the 7th Earl of Radnor's
marriage settlement

Pair of Charles II silver-gilt octagonal toilet-bottles
5½ in. (13.9 cm.) high
1683, maker's mark three storks
Sold 24.11.71 for £1900 ($4655)

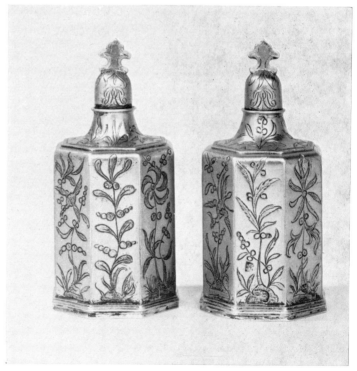

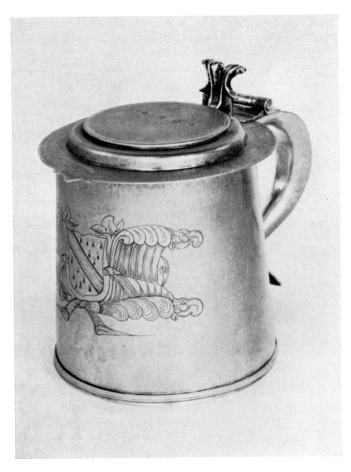

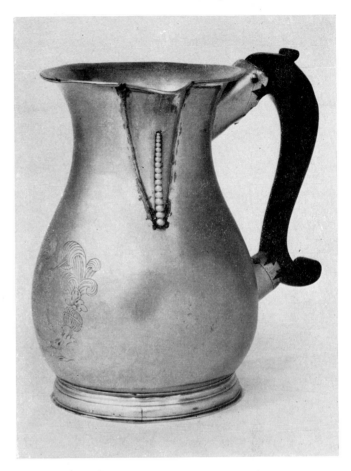

Rare Charles II tankard and cover
5¾ in. (14.6 cm.) high
By Thomas Havers, Norwich, *circa* 1675
Sold 5.7.72 for £4800 ($11,520)
The property of Sir Andrew Noble, BT
From the collection of the late Sir John Noble

Rare William and Mary plain pear-shaped jug
7 in. (17.8 cm.) high
By Ralph Walley, Chester, 1690–92
Sold 15.3.72 for £2900 ($7540)
From the collection of the late A. C. D. Pain, Esq

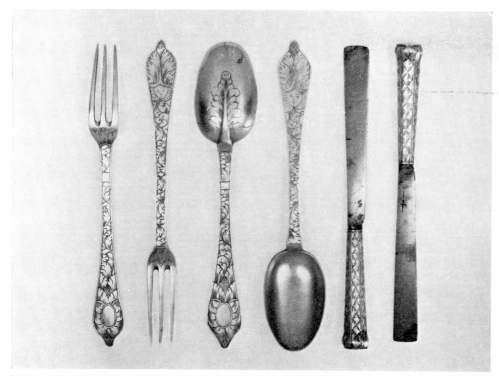

Set of six William and Mary silver-gilt sweetmeat rat-tailed spoons, three-pronged forks and cannon-handled knives
Circa 1690, maker's mark only PR coronet above
Sold 15.3.72 for £1500 ($3900) from the collection of the late A. C. D. Pain, Esq

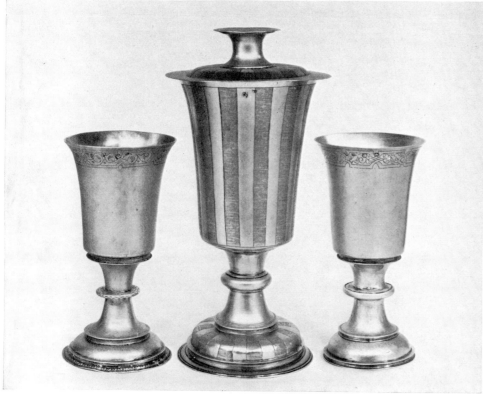

Left: Elizabeth I communion cup and paten
$7\frac{7}{8}$ in. (20.1 cm.) high, $5\frac{1}{4}$ in. (13.4 cm.) diam., 1559, maker's mark IW pellet below in shaped cartouche
Sold 15.3.72 for £1500 ($3900)

Centre: James I silver-gilt communion cup and paten
$10\frac{1}{8}$ in. (25.6 cm.) high, $6\frac{1}{4}$ in. (15.7 cm.) diam., *circa* 1620
Maker's mark only VS
Fleur de lys below
Sold 15.3.72 for £3700 ($9620)

Right: Charles I communion cup
$7\frac{7}{8}$ in. (19.9 cm.) high, 1628
Maker's mark SW
Sold 15.3.72 for £460 ($1196)

From St. Mary's Church, Rickmansworth

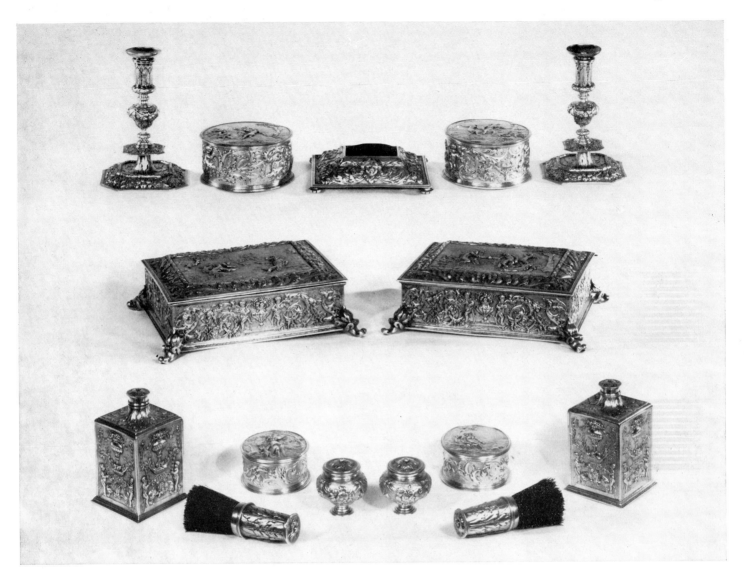

Charles II silver-gilt toilet-service, 1683, one box marked
Sold 26.4.72 for £5500 ($14,300)
From the collection of The Earl of Lichfield

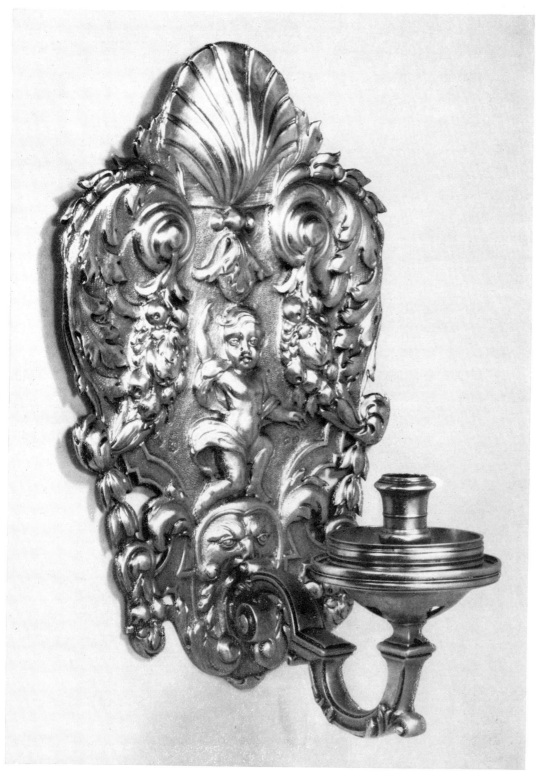

One of an important set of
four Queen Anne sconces
13½ in. (33.7 cm.) high
By John Jackson, 1707
Sold 24.11.71 for £15,500
($37,975)
Sold by the Trustees of the
7th Earl of Radnor's
marriage settlement

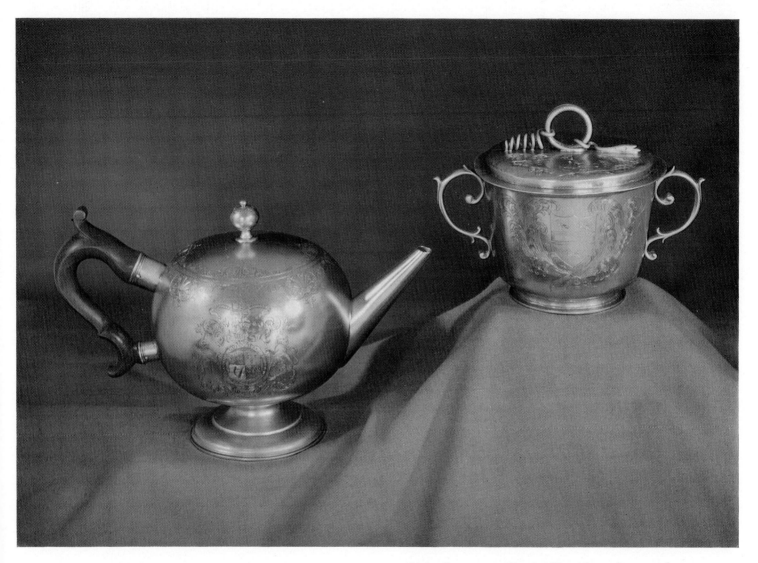

Left: George II Royal Race prize gold teapot
By James Ker, Edinburgh, 1736, maker's mark only
Sold 5.7.72 for £38,000 ($91,200)
From the collection of the late Mr Charles Engelhard

Right: Important Charles II gold porringer and cover
4¾ in. (12.1 cm.) high, 1671, maker's mark IN
Sold 5.7.72 for £25,000 ($60,000)
From the collection of the late Mr Charles Engelhard

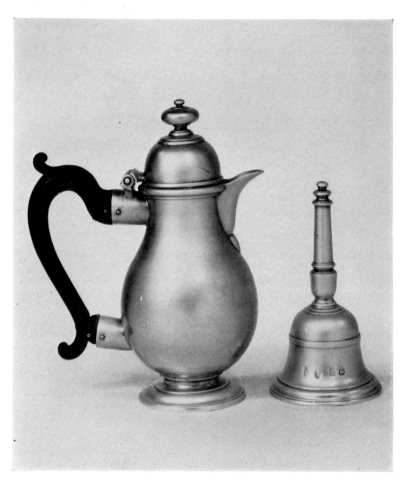

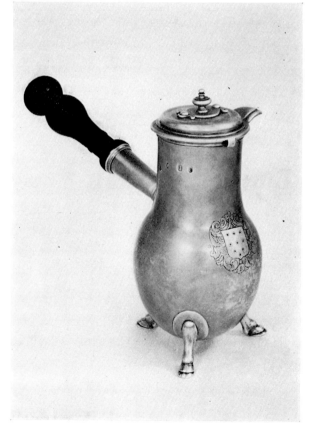

Left: George I plain pear-shaped hot-milk jug
6¼ in. (15.9 cm.) high
By Simon Pantin, 1721
Sold 5.7.72 for £4600 ($11,040)

Right: George I plain table-bell
4½ in. (11.4 cm.) high
By Paul De Lamerie, 1723
Sold 5.7.72 for £1300 ($3120)
From the collection of the late Helena, Dowager
Countess of Kintore

Fine Queen Anne pear-shaped chocolate-pot
7⅝ in. (19.3 cm.) high
By Pierre Harache, 1703
Sold 5.7.72 for £6800 ($16,320)
From the collection of the late Mr Charles Engelhard

One of a pair of George III
fine small two-handled soup-
tureens, covers and stands
Overall length of tureens 13 in.
(33 cm.)
By William Cripps, 1763
Overall length of stand
$21\frac{7}{8}$ in. (55.2 cm.)
1818, maker's mark IH
Sold 26.4.72 for £4000
($10,400)
Sold by order of the Executors
of the late Richard James
Meade-Fetherstonhaugh, Esq

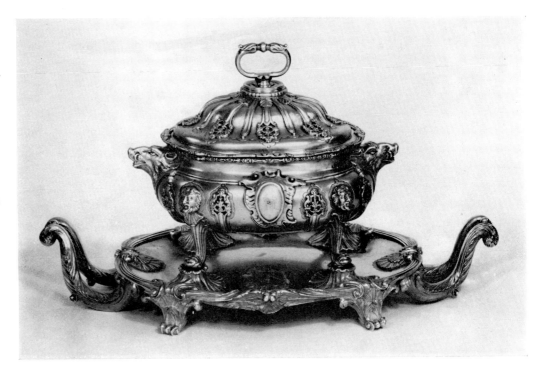

George II fine silver-gilt
oblong inkstand
$14\frac{1}{4}$ in. (36.2 cm.) long
By Phillips Garden, 1753
Sold 26.4.72 for £2400
($6240)
Sold by order of the Executors
of the late Richard James
Meade-Fetherstonhaugh, Esq

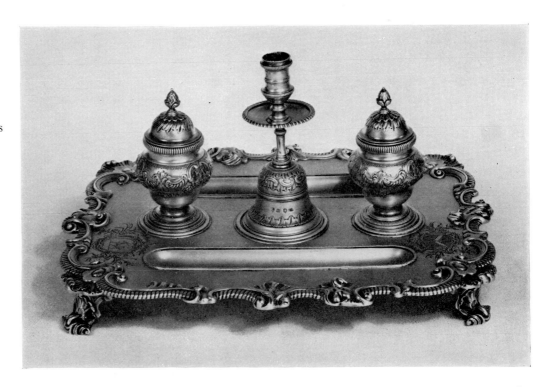

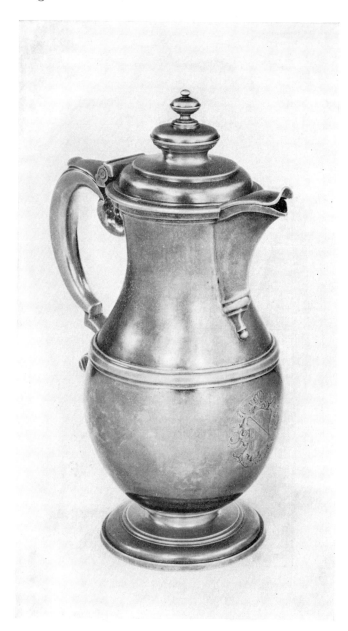

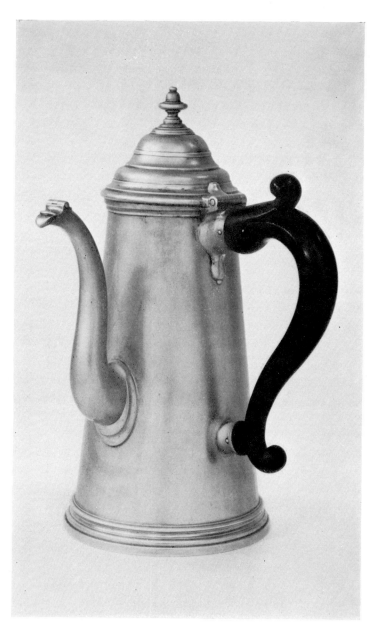

George I plain pear-shaped covered jug
10⅜ in. (26.4 cm.) high
By John White, 1720
Sold 5.7.72 for £8500 ($20,400)
From the collection of the late Mr Charles Engelhard

Queen Anne plain cylindrical coffee-pot
10 in. (25.3 cm.) high
By Jacob Margas, 1710
Sold 15.3.72 for £3400 ($8840)
From the collection of the late A. C. D. Pain, Esq

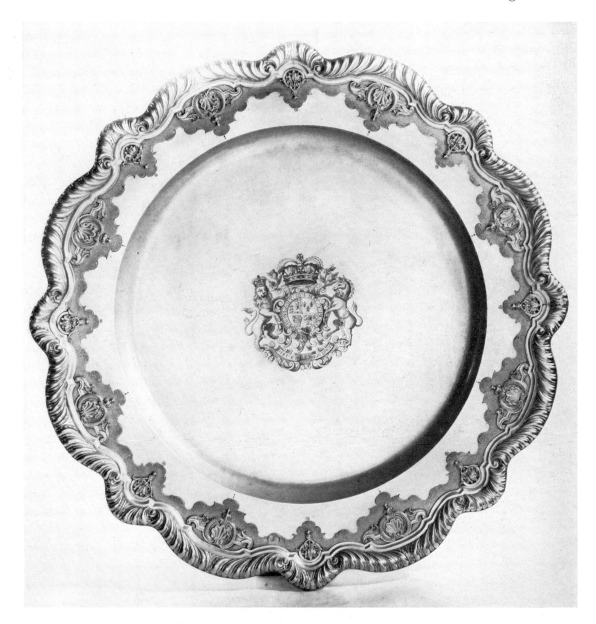

Important George I silver-gilt charger
27 in. (68.5 cm.) diam., by Louis Mettayer, 1717
Sold 24.11.71 for £13,000 ($31,850)
Sold by the Trustees of the 7th Earl of Radnor's marriage settlement

English silver

George II circular salver
8½ in. (22.6 cm.) diam.
By Paul De Lamerie, 1728
Sold 5.7.72 for £3200 ($7680)
From the collection of the late
Mr Charles Engelhard

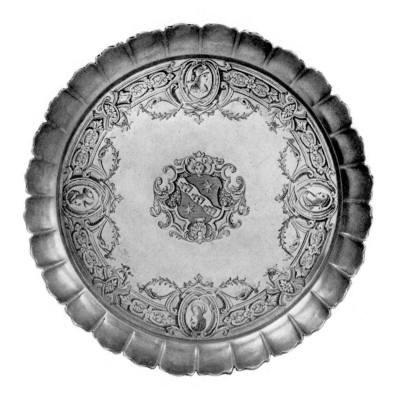

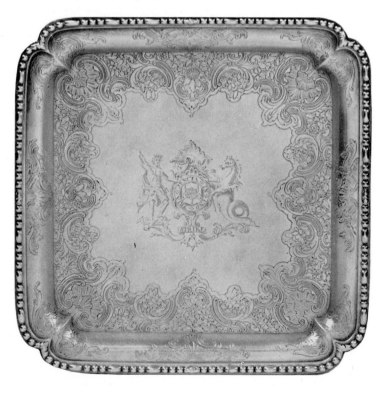

One of a highly important pair of George II salvers
8⅞ in. (22.5 cm.) square
By Paul De Lamerie, 1749
Sold 5.7.72 for £16,000 ($38,400)
From the collection of the late Mr Charles Engelhard

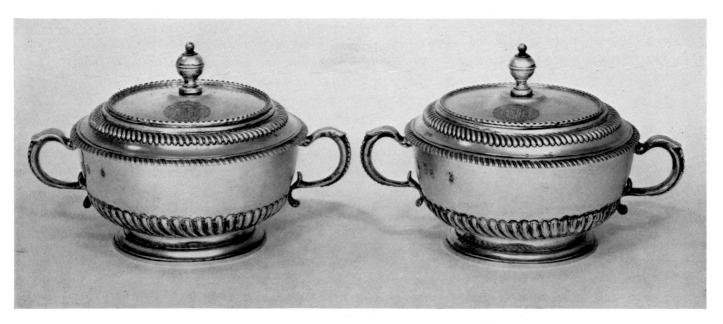

Top: Pair of William III silver-gilt two-handled circular bowls and covers, 5 in. (12.7 cm.) diam., by John Bodington
Sold 24.11.71 for £1800 ($4410)

Bottom: George I plain circular bowl, 7⅝ in. (19.3 cm.) diam., by John Hamilton, Dublin, 1725
Sold 5.7.72 for £2200 ($5280). From the collection of the late Helena, Dowager Countess of Kintore

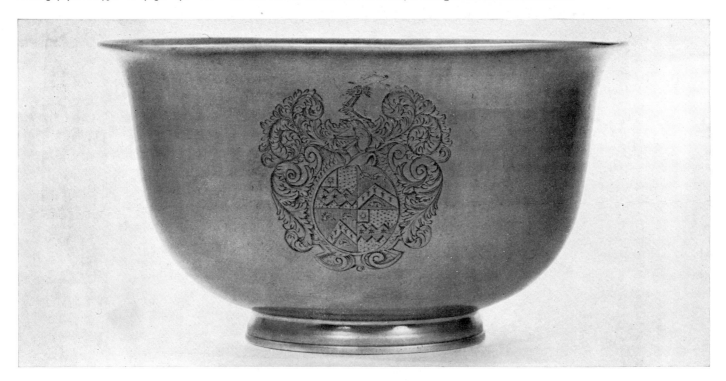

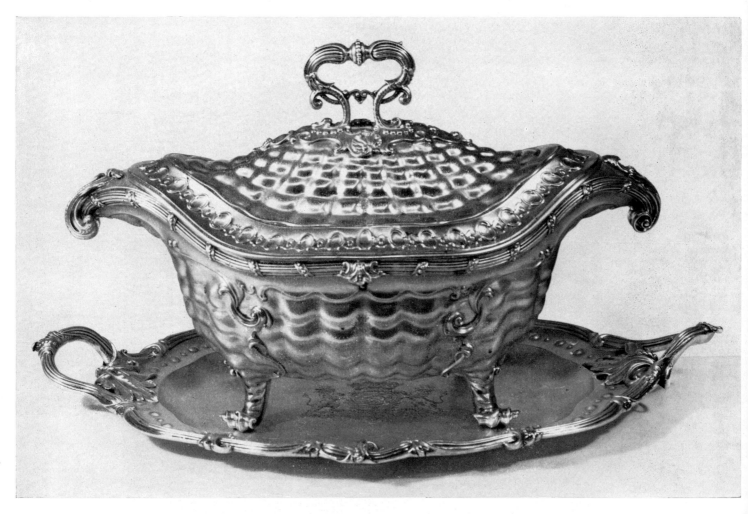

One of a pair of important George II soup-tureens, covers and stands
Overall length of tureens 18¾in. (47.6 cm.), length of stands 22⅝ in. (57.5 cm.), by Edward Wakelin, 1755
Sold 5.7.72 for £8200 ($19,680)
From the collection of the late Mr Charles Engelhard

Fine George II two-handled vase-shaped cup and cover
15½ in. (39.4 cm.) high
By Paul De Lamerie
1739
Sold 24.11.71 for
£7000 ($17,150)
From the collection of the late the Rt Hon The Viscountess Gage

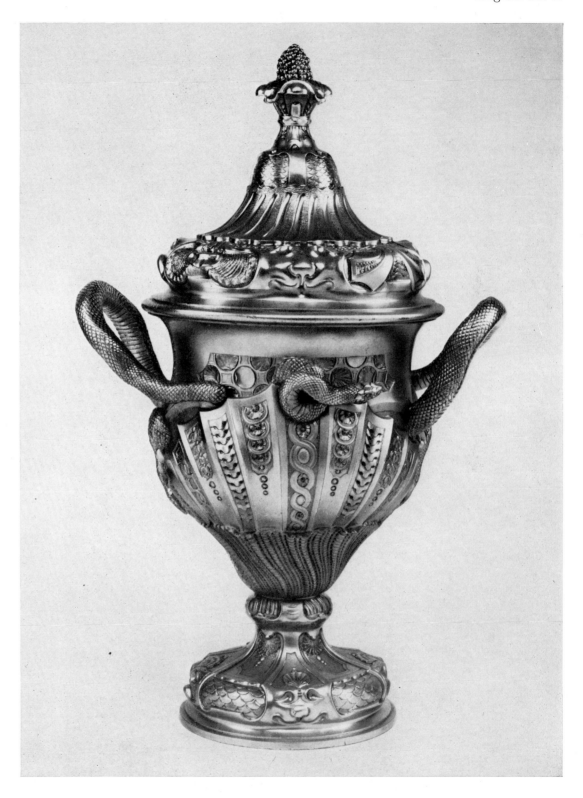

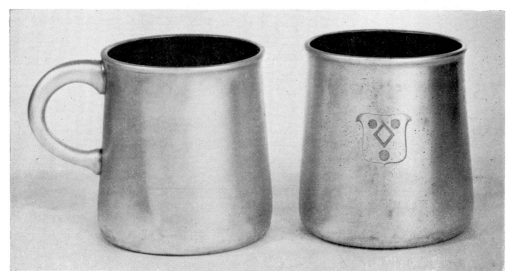

Two of a set of four George II
plain cylindrical mugs
Two 3⅜ in. (86 cm.), two 3⅞ in.
(99 cm.) high
By Paul De Lamerie, 1746
Sold 5.7.72 for £6800
($16,320)
From the collection of the late
Mr Charles Engelhard

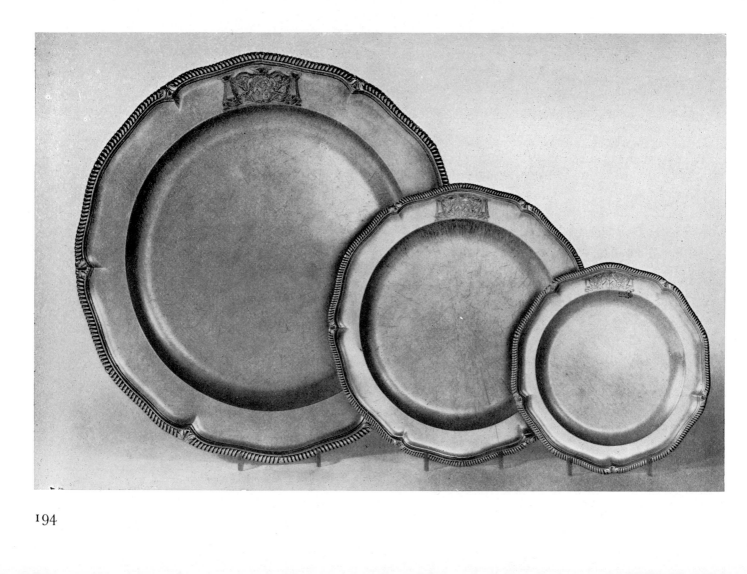

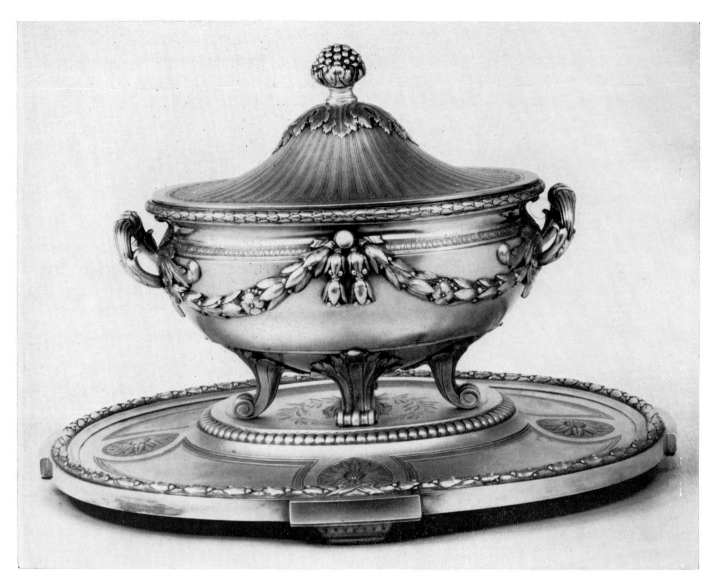

Important Louis XVI soup-tureen, cover and stand
Length of tureen 12⅝ in. (32.1 cm.), length of stand 20⅞ in. (53 cm.)
By Robert-Joseph Auguste, Paris, 1779, with the mark of Jean-Baptiste Fouache and Dominique Compant as Fermiers
Sold 5.7.72 for £13,000 ($31,200)

Opposite:
Left: George III shaped circular sideboard-dish, 18⅞ in. (48 cm.) diam., by Louis Herne and Francis Butty, 1763
Sold 26.4.72 for £2800 ($7280)
Centre: One of a pair of George III circular second-course dishes, 13 in. (33 cm.) diam. Sold 26.4.72 for £1000 ($2600)
Right: One of a set of twelve George III plain shaped circular dinner-plates, 9⅝ in. (24.5 cm.) diam., by Louis Herne and Francis Butty, 1762. Sold 26.4.72 for £3100 ($8060)
Sold by order of the Executors of Richard James Meade-Fetherstonhaugh, Esq

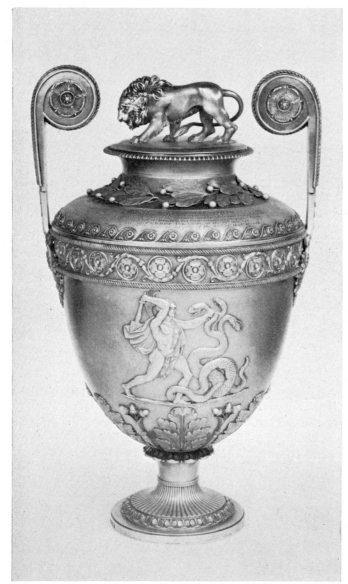

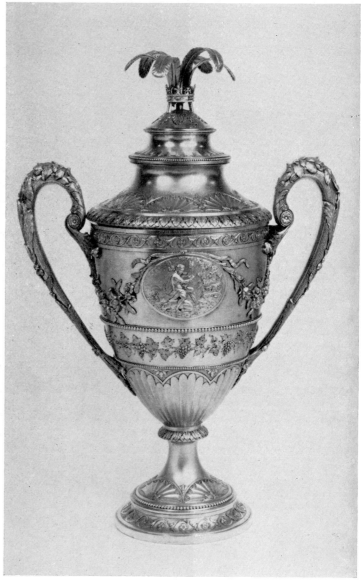

George III Patriotic Fund vase
15¼ in. (38.7 cm.) high
By Digby Scott and Benjamin Smith, 1805
Sold 26.4.72 for £1650 ($4290)
From the collection of D. L. Blackstone, Esq

The Princes Cup
A George III silver-gilt two-handled
vase-shaped cup and cover
20 in. (50.8 cm.) high
By James Young, 1785
Sold 26.4.72 for £1650 ($4290)
Sold by order of the Executors of
Richard James Meade-Fetherstonhaugh, Esq

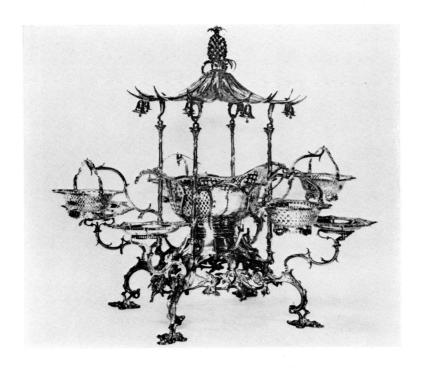

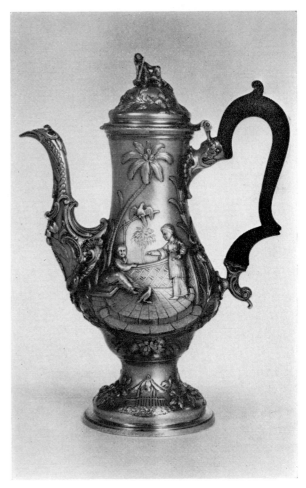

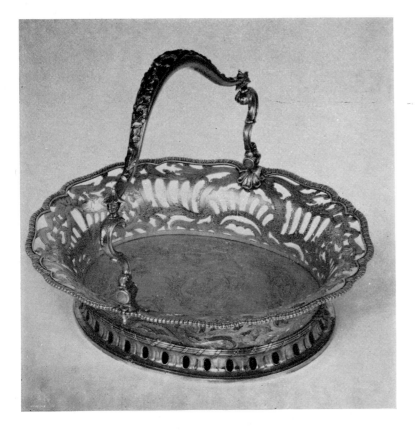

Top left: George III épergne, of Chinese Pagoda form, 22½ in. (57.2 cm.) high,
By William Cripps, 1761
Sold 21.3.72 for £3036 (A.$6500)
At the Age Gallery, Melbourne

Above: George III pear-shaped coffee-pot
12 in. (30.4 cm.) high, by Charles Wright and Thomas Whipham, 1767
Sold 24.5.72 for £820 ($2132)
From the collection of Cyril Connolly, Esq

Left: George II cake-basket, 13½ in. (34.3 cm.) long, by Paul Crespin, 1750
Sold 26.4.72 for £1600 ($4160)
From the collection of Colonel Ireland-Smith

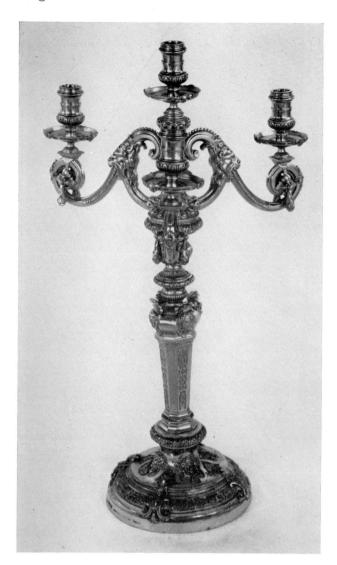

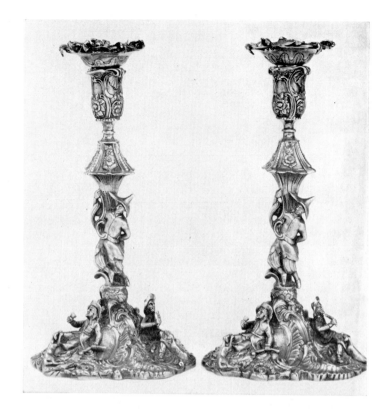

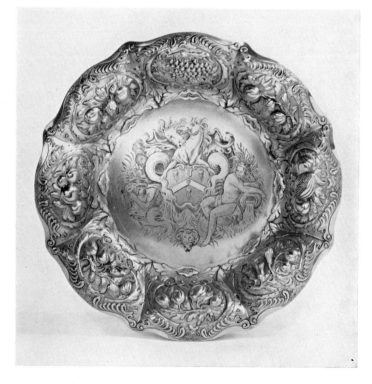

Above: One of a pair of Victorian silver-gilt four-light candelabra, 28⅜ in. (72.1 cm.) high, by Robert Garrard, 1858. Sold 12.7.72 for £2800 ($5620) From the collection of Mrs N. Locan

Top right: Two of a set of four George IV table candlesticks, 13⅜ in. (33.6 cm.) high, by Edward Farrell, 1821. Sold 24.11.71 for 3000 gns. ($7850)

Right: One of a pair of George IV silver-gilt shaped circular sideboard-dishes, 15 in. (38 cm.) diam., by Edward Farrell, 1824. Sold 26.4.72 for £1000 ($2600) Sold by order of the Executors of Richard James Meade-Fetherstonhaugh, Esq

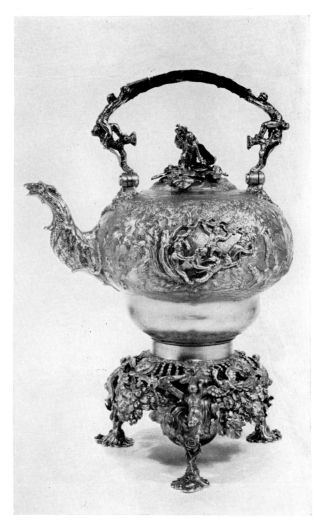

Pair of unusual Regency silver-gilt two-light candelabra
15⅛ in. (38.3 cm.) high
By Benjamin Smith, 1814
Sold 26.4.72 for £3600 ($9360)
Sold by order of the Executors of
Richard James Meade-Fetherstonhaugh, Esq

George IV tea-kettle, stand and lamp
14 in. (36 cm.) high
By Edward Farrell, 1822
Sold 26.4.72 for £600 ($1560)
Sold by order of the Executors of
Richard James Meade-Fetherstonhaugh, Esq

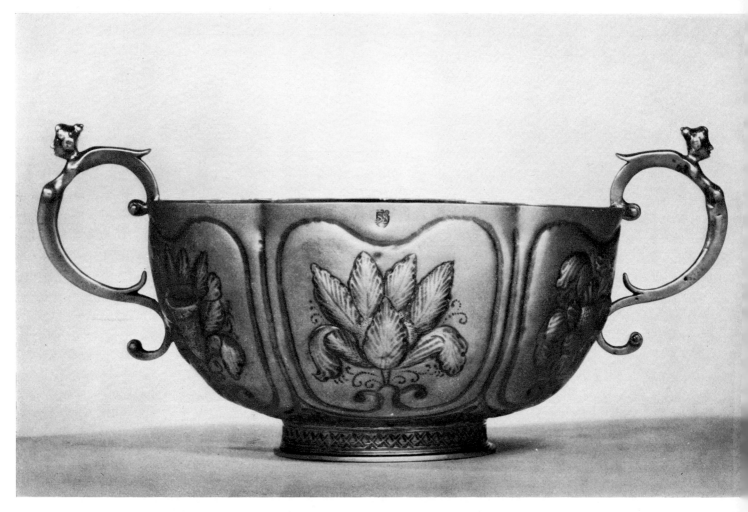

Important American punch bowl
7¾ in. (19.8 cm.) diam.
By Jacob Boelen I, New York, *circa* 1700
Sold 5.7.72 for £6200 ($14,880)
From the collection of the late Helena, Dowager Countess of Kintore

American silver

The position held by the early American silversmith reflected considerable confidence in their integrity. We know that in Boston there are records 'that care be taken all ware made of pewter or silver whether brought to the countrie or made here and exported to sale be of ye just alloy' but this was not the case in New York. Since America had no hallmarking system as practised in England and some Continental countries, the maker's mark struck on a piece of silver was important as a means of identification in case of loss or theft and was no guarantee of the standard of metal. The smith was in the position of banker and upholder of the local community. Jacob Boelen I is no exception. He was appointed brantmaster by the New York Council in 1689, a special assessor in 1693 required to 'assess and rate the inhabitants Resistance and Freeholders', and elected Alderman of the North ward in 1695 and 1697.

This punch bowl is an interesting example of the flow of works of art across the Atlantic. Consigned to Christie's for sale by the Trustees of the late Helena, Dowager Countess of Kintore, we can assume that this bowl originally left America when the 10th Earl of Kintore married Helena Zimmerman of Cincinatti in 1937. From that time its origin was forgotten and its importance unrealized.

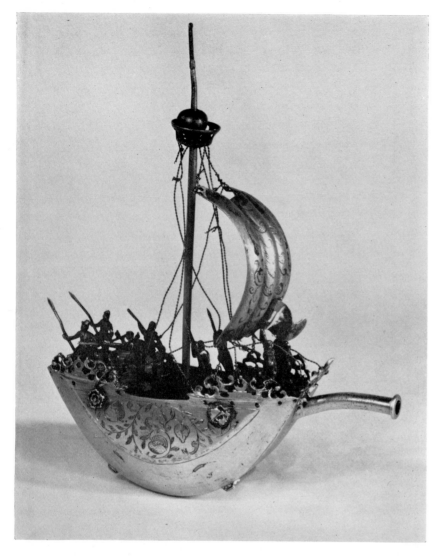

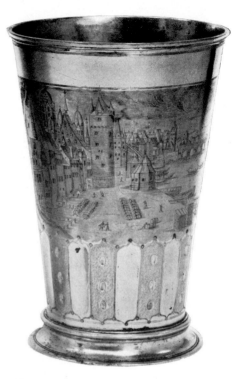

German parcel-gilt beaker
6 in. (15.2 cm.) high
Augsburg, *circa* 1680
Maker's mark II in oval
The view on this beaker is taken
from an engraving by M. Merian of
Frankfurt, *circa* 1646
Sold 24.5.72 for £5200 ($13,520)
From the collection of
Mrs James de Rothschild

German silver-gilt small single-masted nef
7 in. (17.8 cm.) high
By Caspar Beutmüller the Younger, Nuremberg, *circa* 1625
Sold 24.5.72 for £540 ($1404)
From the collection of Mrs James de Rothschild

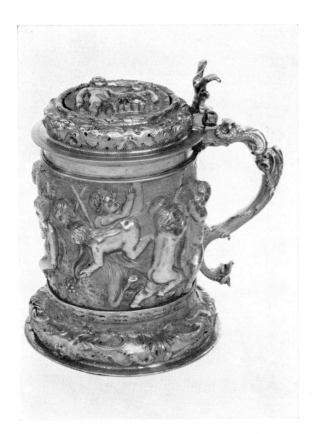

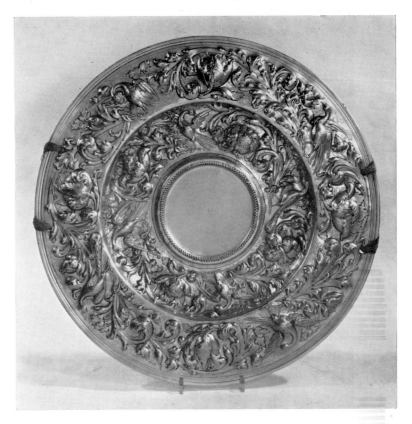

German parcel-gilt cylindrical tankard and cover
8⅝ in. (21.7 cm.) high
Hamburg, *circa* 1660
Maker's mark HG in monogram
Sold 5.7.72 for £800 ($1920)

One of a pair of Portuguese silver-gilt circular sideboard-dishes
18⅛ in. (46 cm.) diam.
Lisbon, late 17th century
Maker's mark BD conjoined crown above
Sold 5.7.72 for £1350 ($3240)

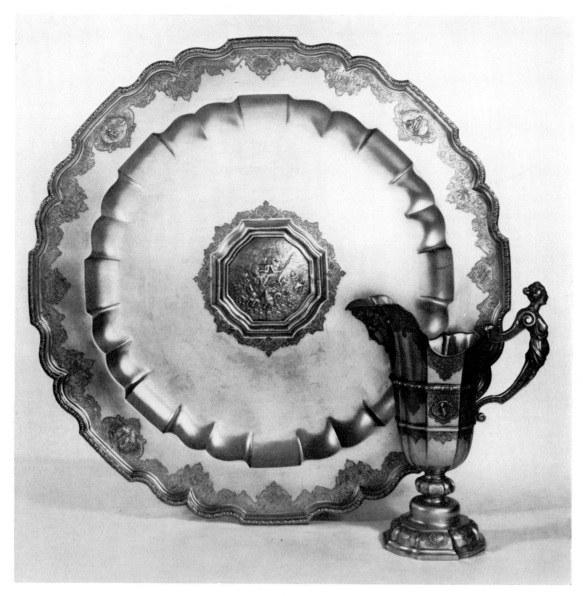

Fine German silver-gilt ewer and dish
Diam. of dish 20½ in. (51.1 cm.), height of ewer 10 in. (25.2 cm.)
By Joh. Erhard Heuglin II, Augsburg, *circa* 1720
Sold 24.11.71 for £8000 ($19,600)
From the collection of the late the Rt Hon The Viscountess Gage

OBJECTS OF ART
AND VERTU,
COINS,
ICONS,
AND ANTIQUITIES

JOHN HOSKINS:
A lady of the North family
Signed with monogram
2¼ in. (56 mm.) high
Sold 2.11.71 for 1700 gns.
($4369)
From the collection of a
descendant of William
6th Lord North and Grey

JOHN HOSKINS:
A lady of the North family
Signed with monogram
2⅛ in. (53 mm.) high
Sold 2.11.71 for 2200 gns.
($5654)
From the collection of a
descendant of William
6th Lord North and Grey

ISAAC OLIVER:
Dudley, 3rd Lord North
2⅛ in. (53 mm.) high
Sold 2.11.71 for 10,000 gns.
($25,725)
From the collection of a
descendant of William
6th Lord North and Grey

BENJAMIN ARLAUD:
William, 2nd Lord Grey of
Rolleston and 6th Baron North
2½ in. (64 mm.) high
Sold 2.11.71 for 950 gns. ($2442)
From the collection of a
descendant of William
6th Lord North and Grey

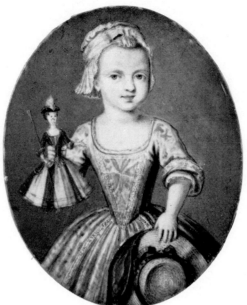

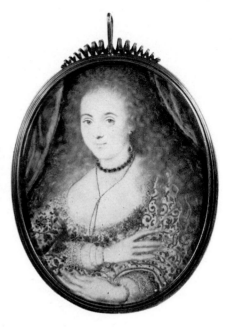

SAMUEL COOPER:
James, 3rd Earl of Northampton
(1622–81)
Signed with monogram
2¾ in. (73 mm.) high
Sold 29.2.72 for 1800 gns.
($4914)

BERNARD LENS:
Katherine Whitmore
Signed with monogram
3 in. (76 mm.) high
Sold 2.11.71 for 500 gns. ($1,285)
From the collection of
Lady Whitmore

ISAAC OLIVER:
Lady Dorothy Percy
Countess of Leicester
Signed with monogram
2¾ in. (71 mm.) high
Sold 14.12.71 for 2400 gns.
($6168)

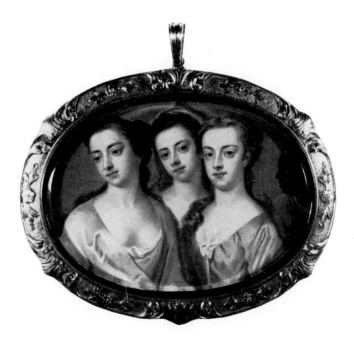

CHRISTIAN RICHTER:
Three ladies called Isabella,
Elizabeth and Anna Lawson
Signed on the reverse and
dated 1715
3¼ in. (82 mm.) wide
Sold 29.2.72 for 900 gns.
($2457)

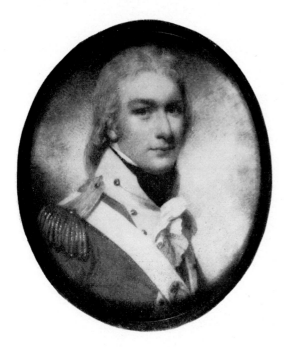

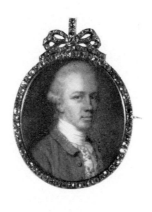

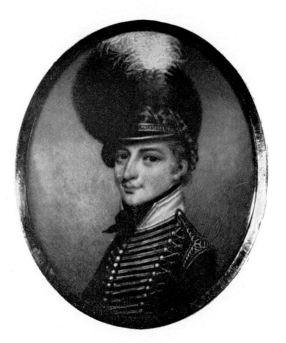

WILLIAM WOOD:
An officer
$2\frac{7}{8}$ in. (73 mm.) high
Sold 18.4.72 for 580 gns.
($1583)

JOHN SMART:
A gentleman
Signed with initials and
dated 1772
$1\frac{1}{4}$ in. (33 mm.) high
Diamond-set gold frame
Sold 23.5.72 for
2000 gns. ($5460)

N. FREEZE:
A young officer in the Light Dragoons
3 in. (77 mm.) high
the reverse with the initials JGD
within a lock of hair on glass
Sold 2.11.71 for 500 gns. ($1285)

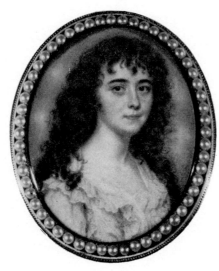

JOHN SMART:
A lady
Signed with initials and dated 1788,
with I for India
$2\frac{1}{4}$ in. (56 mm.) high
Sold 10.7.72 for 2600 gns. ($6552)
From the collection of Mrs. C. H. Aall

Top left: RICHARD CROSSE:
The Marchioness of Salisbury
3¾ in. (9.8 cm.) high
Sold 2.11.71 for 950 gns.
($2442)

Top right: ANDREW PLIMER:
Mrs George Elliot 3 in. (7.5 cm.)
high, diamond-set frame.
Sold 29.2.72 for 520 gns.
($1420)

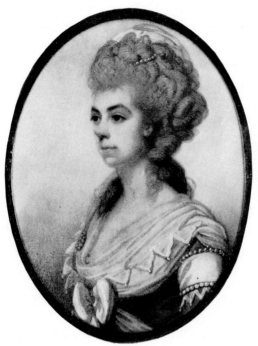
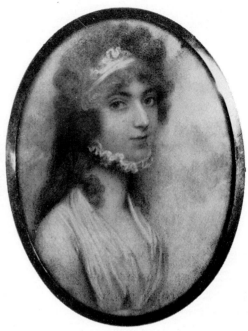

Bottom left: ANDREW PLIMER:
A lady, probably Elizabeth
Cruger, wife of John Tower.
3 in. (7.7 cm.) high.
Sold 10.7.72 for 550 gns. ($1386)
From the collection of Miss
Kathleen de Courcy
Montgomery

Bottom right: JAMES PEALE:
John Tower
Signed with initials and dated
1796. 3¾ in. (6.9 cm.) high. John
Tower married Elizabeth Cruger
of Rosehill Great-granddaughter
of John Cruger, Mayor of New
York 1739–44. Sold 10.7.72 for
1000 gns. ($2520)
From the collection of Miss
Kathleen de Courcy
Montgomery

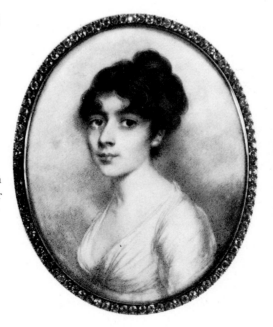
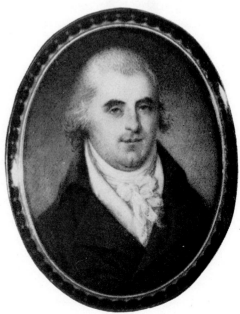

Gold snuff-boxes

BY HERMIONE WATERFIELD

The group of gold snuff-boxes sold by us last June for £328,703 ($854,625) on behalf of the late Charles Engelhard was one of the high points of the season. Fine gold boxes, however, are no newcomers to 8 King Street, although there can be few alive today who saw the dazzling riches of the Hawkins Collection, sold after their owner's death in 1904. This was the biggest single dispersal of such treasures that can ever have taken place anywhere in the world. Their owner, C. H. T. Hawkins, of an old Devon family, lived in Portland Place surrounded by a veritable museum of small and intimate works of art – porcelain, ivories, miniatures, watches, jewels, varied objects of vertu and above all nearly one thousand snuff-boxes many of which, the story has it, were found after his death in cardboard boxes under the beds!

The main sale of the collection was arranged in three portions – four days in March 1904, six days in May and eight days in June—and numbered 2430 lots of which 794 were snuff-boxes (about as many as James Boswell recorded at Count Bruhl's sale at Leipzig in 1794), totalling £102,553 out of a gross total of £173,496. But this was not the end of the Hawkins saga. Further subsidiary sales took place in 1906 and 1907 followed by a further section sold in 1927 and 1928 as the property of the widow Mrs Jane Ellen Hawkins, which included four days of jewels totalling £85,000. When she at last died in 1936 the dispersal was finally completed with a further four days sale of objects of vertu, Japanese art, ivories and hardstones, as well as more jewellery, silver and pictures.

Unfortunately, the catalogue of the major sale of 1904 is entirely unillustrated and since little was then known of the mystery of French *poinçons* the catalogue descriptions are indefinite and the tracing today of snuff-boxes which came from the Hawkins Collection is almost impossible. They must, however, by now be spread in collections world wide. For instance, the 'Louis XV oblong gold box with *en plein* enamel panels of bouquets of flowers signed Hainelin (correctly Hamelin) 1758, the sides and covers enriched with diamonds' for which Duveen paid £6400 in 1904, is now in the Taft Museum in Cincinnati and is known both to be by Jean Ducrolley 1757, and to have a secret compartment in the lid. Was this latter feature missed by our cataloguer in 1904 or perchance glossed over to conceal embarrassment? But where is the

Superb Louis XV rectangular enamelled gold
snuff-box, $3\frac{1}{8}$ in. (8.1 cm.) wide
By Jean-Francois Garand, Paris, 1757
The enamels by Charles-Jacques de Mailly
Signed on the cover
Sold 28.6.72 for 46,000 gns. ($125,580)
From the collection of the late Charles
Engelhard, Esq

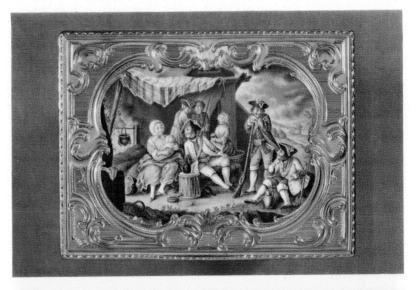

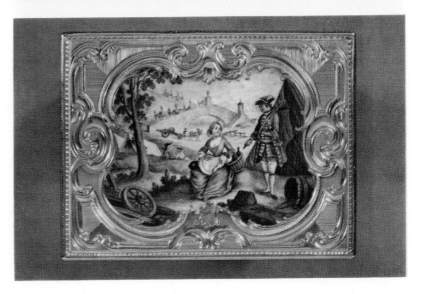

following lot from the Hawkins sale – a Louis XV oval box enamelled *en plein* with scenes after Chardin, which fell that spring morning to Durlacher for £1550?

Such prices, though seemingly modest by today's standards, were of course measured in gold sovereigns rather than the decimalized paper that now serves for money and were, in fact, clear indication of the esteem in which such 'pretty toys' were held in that leisured and seemingly secure society. But whatever the monetary measure of appreciation may be from age to age, there would be few to deny that in the gold boxes of France, England or other European countries of the eighteenth century we have one of the most intimate expressions of delight in the combination of exquisite design, precious and rare materials and meticulous skill that the human eye and hand have ever devised.

The Engelhard Collection could scarcely have been bettered for its range of techniques, forms, quality of craftsmanship and aesthetic appeal. In gold, used alone without other complementary materials in England, were the relatively simple and small boxes of George I and II periods; the extremely rare George III combined snuff-box, watch and étui of about 1770; the dazzling tour-de-force in chasing of the oval box signed by George Michael Moser (see illustration page 215), whom Sir Joshua called 'the first gold chaser in the Kingdom'; the elegantly restrained oval diapered box 1781; and the two imposing 'Freedom' boxes. One of these (see illustration page 217), was given by the Skinners' Company to Admiral Howe in the rejoicing that followed his trouncing of the French fleet on 'The Glorious 1st of June'. For craftsmanship, this would be hard to surpass even though some may think that Admiral Vernon's box, presented by the City of London for his Portobello victory, or the enamel and gold box, also given by the City to Admiral Keppel, may equal it. The former can be seen in the National Maritime Museum, and the latter in the Guildhall Museum.

Gold alone was, of course, frequently employed by the Paris makers, a usage represented in the Engelhard Collection by the two comparatively simple boxes in vari-coloured technique not met with in England. One by Philippe Emmanuel Garbe was chased with hunting putti, and the other with rustic figures, animals and trophies of 1756; these two, incidentally, were the first and last boxes acquired by the late collector. But it is, of course, for their unparalleled skill in the conjunction of different materials to enrich the gold that the French *orfèvriers* excelled, and of this there was full evidence in the collection. Comparisons are, as always, odious and each will have his favourite, but for sophisticated and restrained elegance one would have to go far to excel the box by Jean-François Garard made in 1757 (see illustration page 211), with its *en plein* enamel panels of military camp scenes signed by Charles Jacques de Mailly which include the charming group of the *vivandière* nursing her child. This artist was versatile enough to execute other decorations of flowers and grisaille

Louis XV oval enamelled gold
snuff-box, $3\frac{1}{8}$ in. (8 cm.) wide
By Charles Simon Bocher, Paris, 1753
Bearing the poincons of Julien Berthe
Sold 28.6.72 for 32,000 gns. ($87,360)
From the collection of the late
Charles Engelhard, Esq

Superb Berlin gold-mounted
jewelled agate snuff-box, traditionally
held to have belonged to Frederick II
of Prussia
4 in. (10.1 cm.) wide, *circa* 1750
Sold 28.6.72 for 26,000 gns. ($70,980)
From the collection of the late
Charles Engelhard, Esq

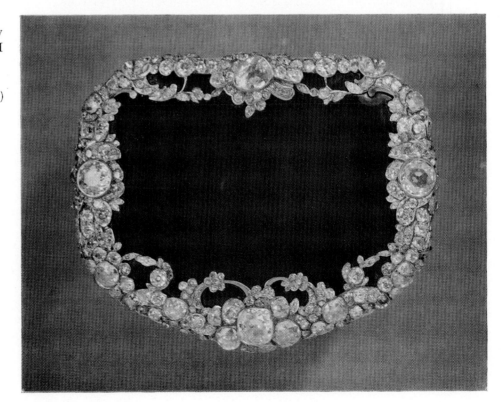

allegorical scenes and worked for more than one box maker, since his signature appears on a box of 1766 in the Louvre bearing the mark of L. P. Demay. Bird lovers might perhaps instead vote for either Pierre-Aymé Joubert's delicious confection of 1744, encrusted with showy birds in tinted mother-of-pearl, or the equally rich box attributable to Jacques Malquis Le Quin, paralleled by another by him in the Louvre Collection, with its exotic fowl and flowers in thick relief enamel in a border of pink, white and blue ribbons.

Another striking box in the Engelhard Collection was the oval example by Charles Simon Bocher of 1753 (see illustration page 213) enamelled with convolvulus, violets and a butterfly in deep blues and green *en basse taille,* that is with the gold ground cut away to allow the enamel to lie flush with the surface as in the medieval technique of *champlevé* enamel on copper used chiefly at Limoges. Queen Charlotte, George III's wife, owned a rectangular box with very similar decoration, now in the British Museum, which is apparently unmarked and somewhat strangely attributed to Berlin, perhaps on the grounds that the Queen herself was of German birth; this is not to say that German goldsmiths were not as accomplished as their French rivals, but aesthetically there was a tendency in the designs used in Germany to an overloading of detail and some relative lack of control in the mixing of techniques. A case in point was the Dresden gold and mother-of-pearl box in the Engelhard sale which shows affinities to one in the same materials in the Metropolitan Museum, New York. Rich too, almost to the point of embarrassment, are the massive Potsdam boxes of which Frederick the Great was so fond, the bodies of agate or chrysoprase overlaid with gold *capriccii* of rustic scenes and ruins or with thickly encrusted

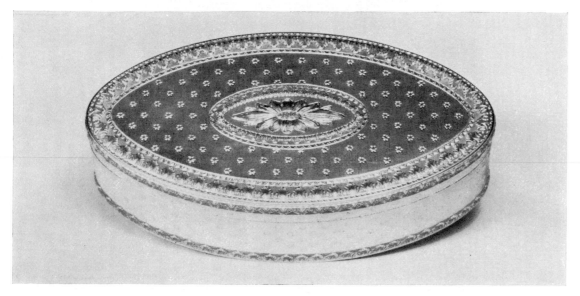

George III shuttle-shaped gold snuff-box
4⅜ in. (11 cm.) wide
London, 1781
Maker's mark CB
Sold 28.6.72 for
3500 gns. ($9555)
From the collection
of the late Charles
Engelhard, Esq

Important English chased gold
snuff-box, 3½ in. (8.9 cm.) wide
Unmarked, *circa* 1760, by George
Michael Moser, signed on the
cover, G. M. Moser fecit, the
base, Moser F.
Sold 28.6.72 for 23,000 gns. ($62,790)
From the collection of the late
Charles Engelhard, Esq

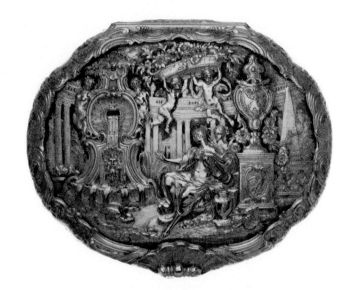

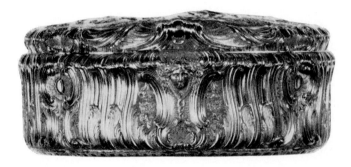

diamond borders as in the Engelhard example, certainly the most extravagant, if not the most refined manifestation of the snuff-box maker's craft.

Diamond enrichment however was not confined to Germany and an interesting problem is posed by the pouch-shaped gold box, chased with Venus and Cupid at Vulcan's forge and outlined in small diamonds which, being quite unmarked, remains potentially attributable to a number of places of origin. Although decorated in a formal manner with chased shells and fluting, there is in the Metropolitan Museum, New York, a French box by Daniel Govaers (or Gouers) Paris 1733, which shows very similar technique and inspiration, while others by the same maker in the Louvre and at Dresden display the same liking for diamond enrichment. On the other hand English and German examples not far removed from the Engelhard box are also known, and since Govaers himself fled to the Low Countries after bankruptcy in Paris, unmarked examples could well be from his hand in exile – a possibility which demonstrates the rashness of too dogmatic an attribution in such cases.

Finally we may consider what on any count must be considered the rarest of all the Engelhard boxes – the fascinating nielloed gold box known as the Stroganoff Box

from the tradition that it was given to the millionaire Count by Catherine the Great (see illustration below). Nielloed silver boxes from Russia are of course well known but the Stroganoff Box would appear to be the only example of this form of decoration on gold. This alone would make it remarkable, but far beyond this technical consideration is the delightful gay-hearted treatment of the scenes epitomizing the whole spirit of the rococo style with the lightest possible touch, somewhat surprising to find in a Russian piece, although at the same time so characteristically treated. There is perhaps here an instance of the use of French engravings as the source material, for the figure subjects blended with the more native rendering of the rococo borders to produce what, albeit with some trepidation, we may dare to pronounce a unique piece of remarkable beauty.

The Stroganoff box. An extremely rare Russian rectangular gold snuff-box, *c.* 1760
$3\frac{5}{8}$ in. (9.2 cm.) wide
Sold 28.6.72 for
28,000 gns. ($70,560)

Superb George III rectangular gold Freedom
Box presented to The Rt Hon Richard, Earl
Howe, for his defeat of the French on the
1st June, 1794, by the Worshipful Company of
Skinners, London
4¼ in. (10.7 cm.) wide
By Sebastian Guerint, London 1794
Sold 28.6.72 for 9000 gns. ($24,570)
From the collection of the late
Charles Engelhard, Esq

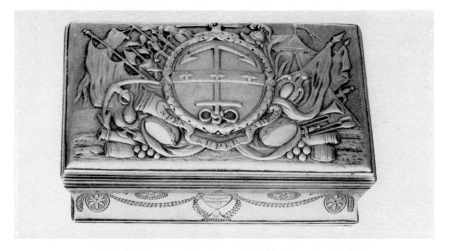

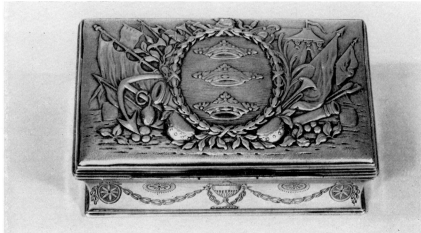

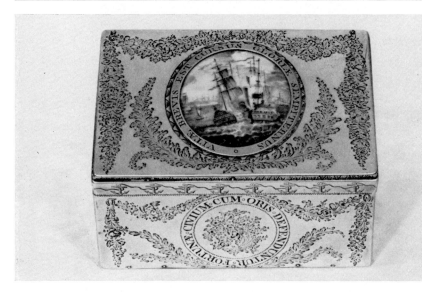

Above: George III octagonal gold Freedom Box, 3½ in. (8.8 cm.) wide, Dublin, 1793 Maker's mark AT, 22 ct. gold, presented to The Rt Hon John Foster, Speaker of the House of Commons. Sold 28.6.72 for 3200 gns. ($8736). The property of Sir Andrew Noble, BT. From the collection of the late Sir John Noble, BT

Top left: The Trinity House of Hull guild box: presented to Sir Richard Pearson 4½ in. (11.5 cm.) wide, by T. Phipps & E. Robinson, London, 1783 Sold 30.11.71 for 3000 gns. ($7710) From the collection of Miss L. C. Pearson

Centre left: The Corporation of Kingston-upon-Hull box, presented to Richard Pearson, Esq, 4½ in. (11.5 cm.) wide By James Phipps, *circa* 1779 Maker's mark and lion passant only Sold 30.11.71 for 2600 gns. ($6680) From the collection of Miss L. C. Pearson

Bottom left: The Scarborough Freedom box, presented to Richard Pearson, Esq 4⅛ in. (10.5 cm.) wide, unmarked, *circa* 1780 Sold 30.11.71 for 3600 gns. ($9260) From the collection of Miss L. C. Pearson

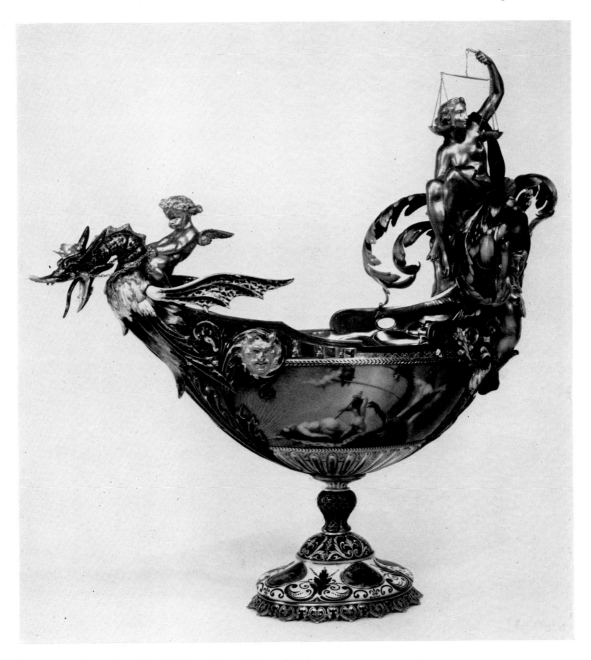

Important French gold and enamel boat-shaped tazza
13¾ in. (35 cm.) wide, by Charles Lepec, mid-19th century
Sold 30.11.71 for 3800 gns. ($9700)
From the collection of The Rt Hon Lord Margadale of Islay, TD

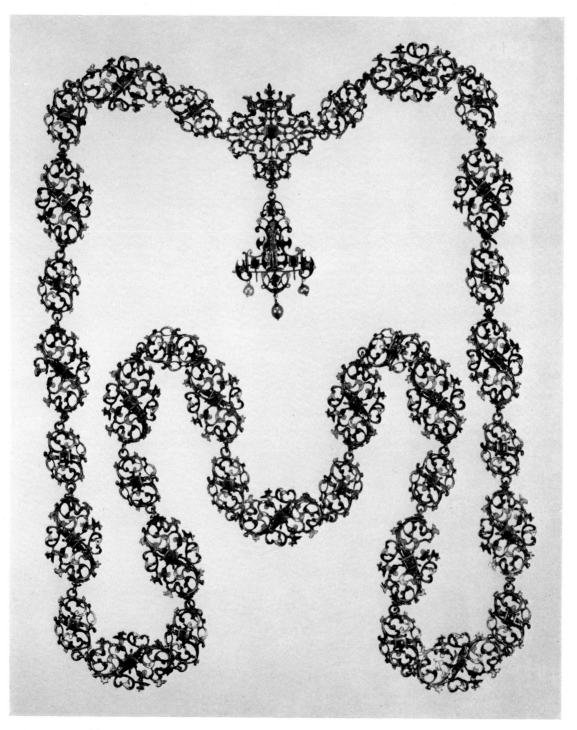

Fine and elaborate
South German gold
and enamelled
jewelled necklace
and pendant
Late 16th century
Sold 28.6.72 for
6500 gns. ($17,745)
From the collection
of The Dowager
Marchioness of
Cholmondeley

Top: Important gold and enamel combined badge of the Order of the Golden Fleece and the Annunciation 4½ in. (11.4 cm.) high Late sixteenth century, the enamel quatrefoils later. Sold 28.6.72 for 2600 gns. ($7098)

Left: Rare pendant jewel, in the form of a stallion prancing to the right, 3 in. (7.8 cm.) high, South German or Italian, late sixteenth century. Sold 28.6.72 for 5200 gns. ($14,196)

Right: Spanish gold and enamel pendant jewel Formed as a horse 2¾ in. (7 cm.) high, late sixteenth century. Sold 28.6.72 for 1600 gns. ($4368)

Bottom: Magnificent French jewelled and enamelled Badge of the Order of St. Michael 2¾ in. (7 cm.) high Henri II Court style Mid-sixteenth century Sold 28.6.72 for 9000 gns. ($24,570)

All from the collection of The Dowager Marchioness of Cholmondeley

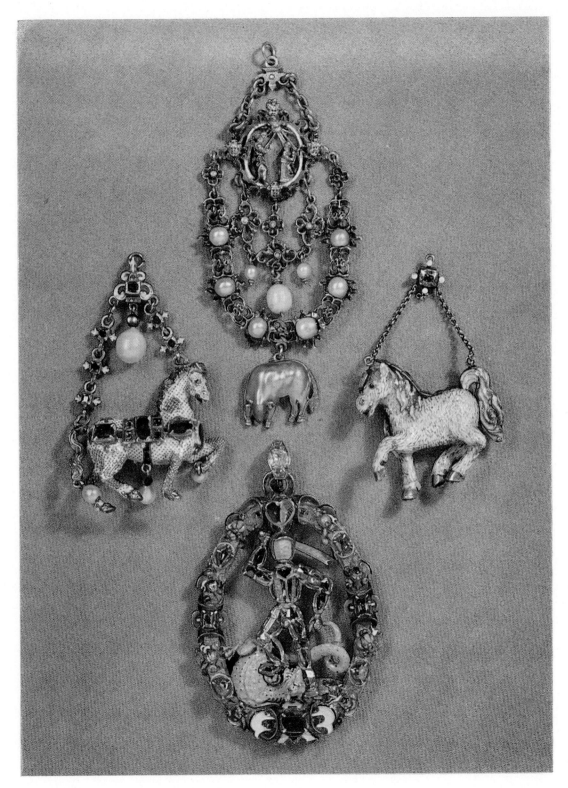

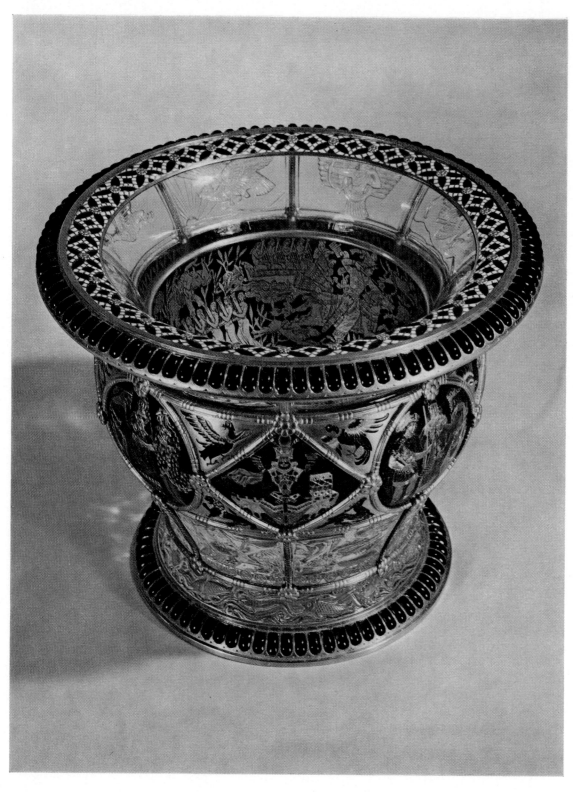

Important French rock-crystal and enamel vase, in the Iranian style, by A. Falize
8½ in. (21.5 cm.) diam. Third quarter of the nineteenth century, in fitted wood case stamped: Bapst & Falize, 6 Rue d'Antin, Paris
Sold 30.11.71 for 7800 gns. ($20,000) From the collection of The Rt. Hon. Lord Margadale of Islay, TD

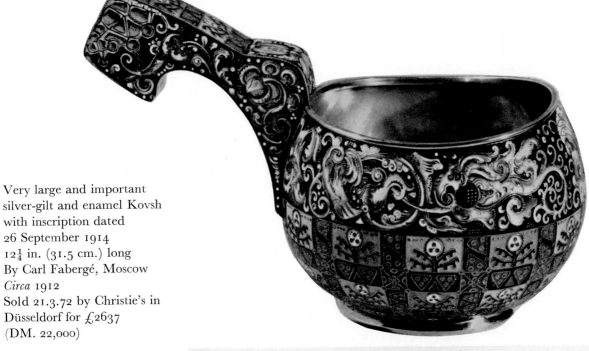

Very large and important
silver-gilt and enamel Kovsh
with inscription dated
26 September 1914
12¼ in. (31.5 cm.) long
By Carl Fabergé, Moscow
Circa 1912
Sold 21.3.72 by Christie's in
Düsseldorf for £2637
(DM. 22,000)

Fine Venetian rock-crystal
and gilt-wood casket
15½ in. (39.4 cm.) wide
17th century
Sold 20.10.71 for 1000 gns.
($2570)
From the collection of
Peter Harris, Esq

Russian jasper carp
2⅜ in. (6.1 cm.) wide
By Carl Fabergé
Sold 23.5.72 for 1550 gns.
($4232)

Russian agate owl
2¼ in. (5.6 cm.) high
By Carl Fabergé
The perch of 72 zolotniks
Sold 23.5.72 for 1400 gns.
($3822)

Russian lapis-lazuli rabbit
1¾ in. (4.5 cm.) wide
By Carl Fabergé
Sold 23.5.72 for 1050 gns.
($2867)
From the collection of a member
of a former European Royal
House

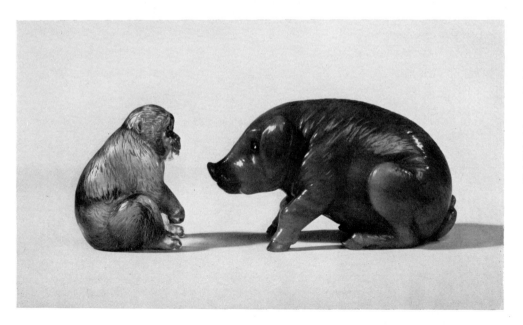

Russian smoky quartz
chimpanzee
1¾ in (4.4 cm.) high,
By Carl Fabergé
Sold 23.5.72 for 3200 gns.
($8736)

Russian adventurine-quartz pig
3½ in. (8.9 cm.) wide
By Carl Fabergé
Sold 23.5.72 for 4200 gns.
($11,486)

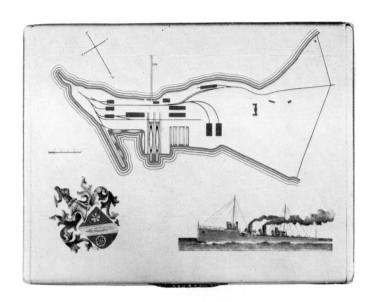

Left: Fine Russian rectangular gold and enamel cigarette-case 3 in. (7.6 cm.) high By Carl Fabergé Sold 23.5.72 for 3400 gns. ($9282) From the collection of a member of a former European Royal House

Right: Russian rectangular gold cigarette-case 3⅝ in. (9.3 cm.) wide By Carl Fabergé Workmaster Henrik Wigstrom, 72 zolotniks Sold 23.5.72 for 1450 gns. ($3959)

Centre right: Fine English rectangular blue glass snuff-box 2⅜ in. (6 cm.) wide Birmingham or South Staffordshire, *circa* 1760 Sold 30.11.71 for 620 gns. ($1593)

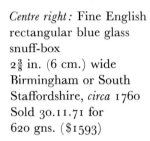

Bottom left: Fine George II enamel scent-flask with watch The movement signed Hughes, London No. 2341 4⅛ in. (10.5 cm) high Sold 23.5.72 for 1550 gns. ($4232)

Bottom right: Silver replica of George Washington's marble sarcophagus By Robinson, Edkins & Aston, Birmingham, 1846 7½ in. (19 cm.) wide Sold 23.5.72 for 480 gns. ($1310)

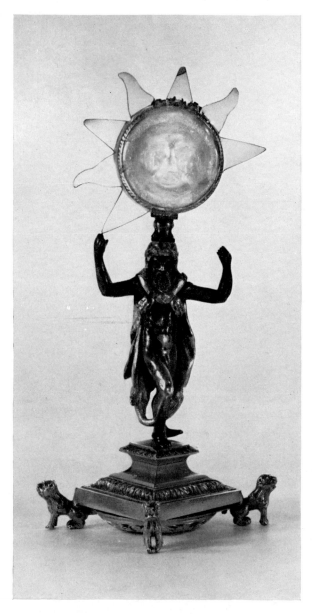

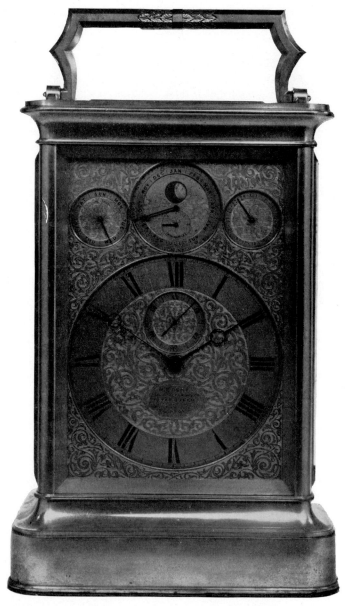

Very rare miniature rock-crystal and silver
striking monstrance clock, by Jaques Sermand
5¾ in. (14 cm.) high, *circa* 1640
Sold 21.3.72 for 5200 gns. ($14,196)

Fine and large English striking perpetual calendar
carriage clock, signed on the dial M. F. Dent
Chronometer maker to the Queen, with chronometer
escapement and indicating the bissextile calendar and
the equation of time. 15½ in. (39.5 cm.) high
Sold 26.10.71 for 13,000 gns. ($33,410)

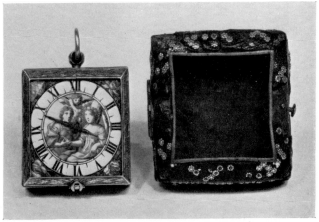

Above: Fine and rare French gilt-metal and enamel hour-striking 'oignon' clock-watch By Baltazar Martinot à Paris 2¼ in. (6 cm.) diam., *circa* 1690 Sold 21.3.72 for 3800 gns. ($10,374)

Very rare French square gold and enamel Verge watch, the square movement signed Louis Barouneau à Paris, 1¼ in. (3 cm.) square, *circa* 1650 Sold 26.10.71 for 6500 gns. ($16,710)

Left: Fine English pair-cased gilt-metal calendar watch By Jeremie Gregory, 2 in. (5 cm.) diam., *circa* 1655 Sold 21.3.72 for 2100 gns. ($5733) From the collection of Mrs D. Sealy-Vidal

Near right: Fine ivory tablet dial Signed Leonhart Miller Dated 1636. 4 in. (10.1 cm.) long Sold 7.6.72 for 500 gns. ($1365)

Centre right: Ivory magnetic analemmatic dial Signed C Bloud à Dieppe 3⅝ in. (9.3 cm.) wide, *circa* 1670 Sold 7.6.72 for 500 gns. ($1,365)

Far right: Rare tortoiseshell and silver tablet dial Signed Charles Bloud à Dieppe 2½ in. (6.4 cm.) wide, inscribed twice with the initials L.D.S. *Circa* 1670 Sold 7.6.72 for 1600 gns. ($4368) From the collection of Mrs James de Rothschild

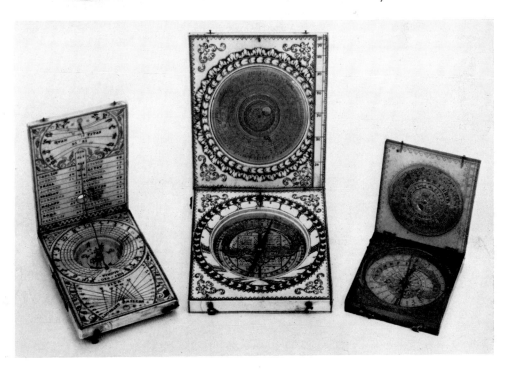

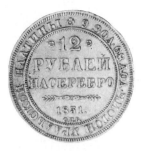

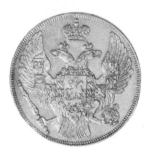

Russia, Platinum
12 Roubles, 1831, £650

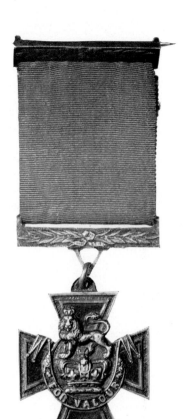

Victoria Cross, awarded to Brevet-Major James Leith, named to
the 6th Dragoons but won while serving with the 14th Light
Dragoons, April 1st, 1858, £1600

United Nations, suggested
coinage in Platinum, 1946
£350

Judea, 1st Revolt (AD 66–70) Shekel of
Year 3, £250

Judea, 2nd Revolt (AD 132–5)
Denarius, £75

Judea, 1st Revolt, Half-shekel of
Year 1, £180

Charles V (1500–58) and Ferdinand (1503–46)
Gold medal, £380

Ferdinand I and Maximillian II Gold medal
1548, £450

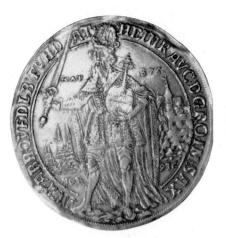

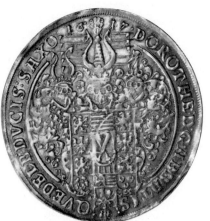

Whaddon
Chase Gold
stater (*circa*
40–20 BC)
£150

Germany, Quedlinburg (Abbey) Dorothea of Saxony (1610–17)
9-ducats (?), £680

Sicily, Akragas
(550–472 BC)
Didrachm
£130

U.S.A. Quarter-dollar, 1796, £840

Russia, Gold medal commemorating the death of Alexander III, 1894
(Half-size), £550

James I, Angel, m. m. trefoil, 1624, pierced for
use as a touch-piece, £130

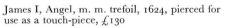

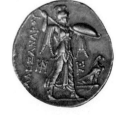

Egypt, Ptolomy I (323–284 BC), Tetradrachm, £85

Russia, Gold medal commemorating the death of Alexander II
1881 (Half-size), £600

229

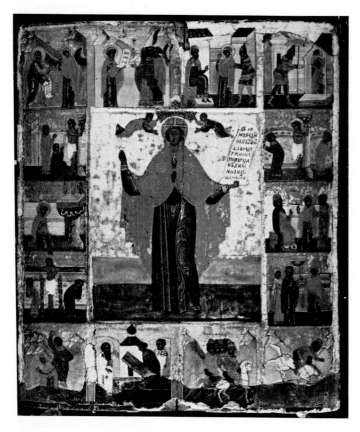

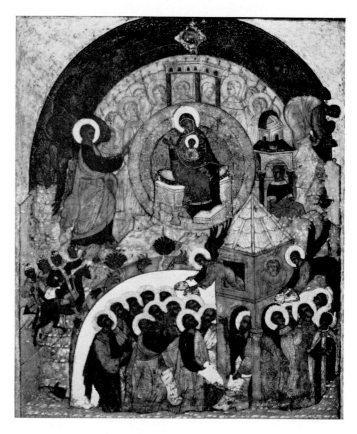

Rare biographical icon of St. Parasceva
19½ in. (55 cm.) high
Novgorod School, early 16th century
Sold 16.11.71 for 3200 gns. ($8220)

Rare double-sided tabletka, the obverse (shown here)
depicting the Synaxis of the Virgin, the reverse
portraying the Forty Martyrs of Sebaste
9 in. (22.8 cm.) high
Novgorod School, early 16th century
Sold 11.7.72 for 3500 gns. ($9072)

The Hodegitria Virgin
39¼ in. (99.6 cm.) high
Cretan School, seventeenth
century
Sold 11.11.71 for 1600 gns.
($4112)

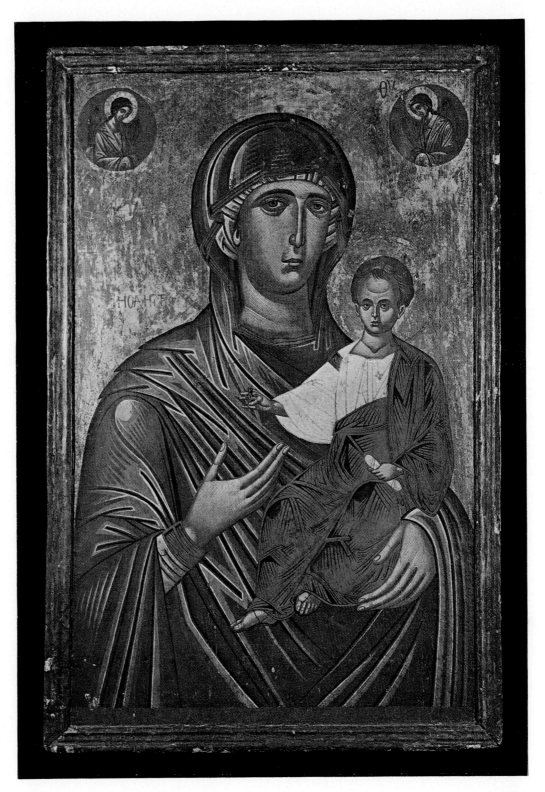

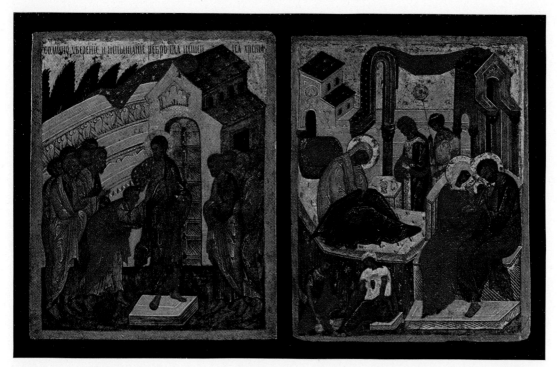

Top and bottom far left:
Double-sided tabletka
depicting on one side the
Doubting of Thomas
(shown here), on the
reverse the three miracle-
working bishops of
Rostov, Ss. Ignatius,
Leontius, and Isaiah
9¼ in. (22.5 cm.) high
Moscow School, early
sixteenth century
Sold 16.11.71 for
2900 gns. ($7450)

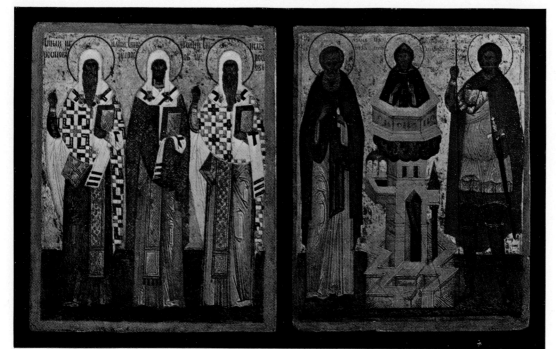

Top and bottom near left:
Double-sided tabletka
depicting the Birth of the
Virgin, the obverse side
(shown here) shows
St. John of Novgorod
and the martyr Nikita
standing between
St. Symeon Stylites
positioned on his column
9¼ in. (22.5 cm.) high
Moscow School, early
sixteenth century
Sold 16.11.71 for
2900 gns. ($7450)

French champlevé enamel pax
of shaped quatrefoil form
5 in. (12.8 cm.) diam.
Limoges, early 14th century
Converted from a Morse at an early date
Sold 20.6.72 for 3400 gns. ($9282)
From the collection of the late
Sir Nicholas Throckmorton, BT
And removed from Coughton Court, Warwickshire

Superb French ivory triptych, of the
Death, Assumption, and Coronation of the
Virgin Mary
10⅜ in. (26.5 cm.) high
Sold 20.10.71 for 6000 gns. ($15,420)

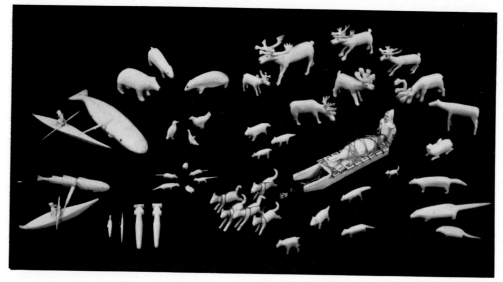

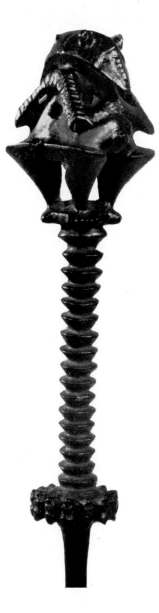

Top: Collection of Eskimo walrus ivory carvings of Labrador
Sold 27.3.72 for 950 gns. ($2593)
Collected prior to 1865 by Robert Henry Ramsden or his father
Right: Fine Tahitian wood fly-whisk handle
10¾ in. (27.5 cm.) long
Sold 27.3.72 for 5000 gns. ($13,650)
Bottom: Early northwest coast oval wood oil dish
10½ in. (26.5 cm.) long
Haida, Queen Charlotte Islands, collected prior to 1860
Sold 27.3.72 for 1200 gns. ($3276)
From the collection formed by the late Robert Henry Ramsden
of Carlton Hall, Worksop

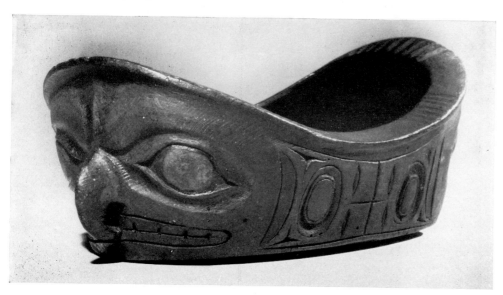

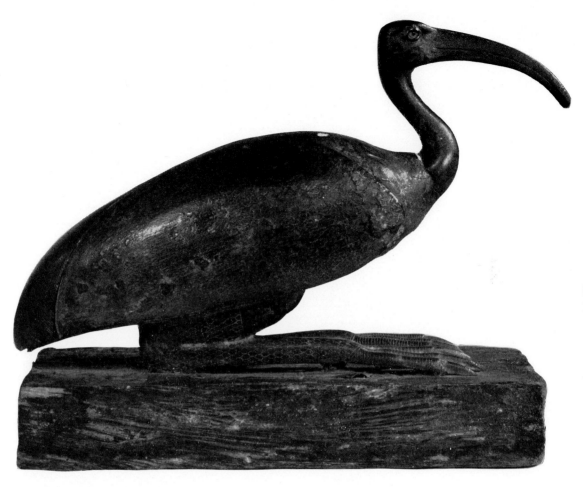

Fine wood and bronze figure of a squatting ibis
$10\frac{5}{8}$ in. (27 cm.) long, $6\frac{1}{2}$ in. (16.5 cm.) high
26th Dynasty
Sold 11.4.72 for 1300 gns. ($3549)

Greek bronze votive figure of a bull
Inscribed Kabiro Hiaro
$3\frac{1}{2}$ in. (8.9 cm.) long, Thebes, *circa* 500 BC
Sold 12.7.72 for 1300 gns. ($3276)
From the collection of
Mrs James de Rothschild

Rare early dynastic black-and-white
speckled diorite spouted bowl
$4\frac{1}{4}$ in. (10.7 cm.) diam.
Saqqara, late 1st Dynasty
Sold 11.4.72 for 1000 gns. ($2730)

Hellenistic millefiori glass bowl
$5\frac{3}{8}$ in. (13.7 cm.) diam.
Circa 1st century AD
Sold 7.12.71 for 1500 gns. ($3860)

Right: Syrian bronze figure of a man
9¼ in. (23.5 cm.) high
18th–16th century BC
Sold 11.4.72 for 420 gns. ($1147)

Hittite basalt relief head of the storm god Teshub
11⅝ in. (29.5 cm.) high
14th–12th century BC
Sold 12.7.72 for 1250 gns. ($3150)

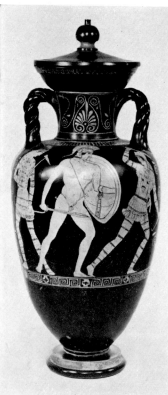

Left: Attic red-figure amphora and cover
19⅞ in. (50.5 cm.) high, *circa* 440 BC
Sold 12.7.72 for 2200 gns. ($5544)

Fragment of a fine Roman mosaic pavement showing Neptune driving his sea chariot
62 × 41 in. (157.5 × 104.2 cm.), *circa* AD 300
Sold 12.7.72 for 2100 gns. ($5292)

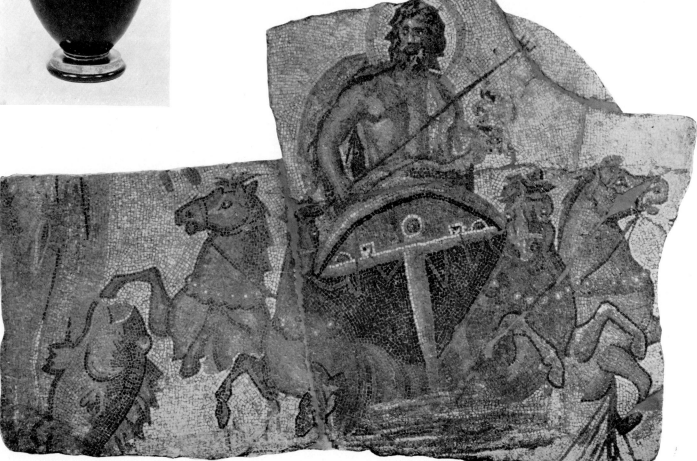

BOOKS AND
MANUSCRIPTS

John Gould and Samuel Curtis

BY STEPHEN MASSEY

Since December 1966, Christie's have been holding regular sales of Natural History and Travel books. The spectacular rise in prices realised for the colour-plate books of birds and flowers was clearly to be seen at our sale on April 12th.

The highlight was a fine collection of works by the dedicated English ornithologist John Gould (1804–81). The founder of the Pharmaceutical Society, Jacob Bell, made a timely bequest of them to the Royal Institution ten days before his death on 2nd June, 1859. The Royal Institution continued the subscription with the result that, apart from three of the minor works, the collection was complete, even to the point of having both first and second editions of the monographs on Toucans and Trogons.

Gould was the son of the foreman gardener at Windsor. While he was still a boy he developed a keen interest in taxidermy which, in 1827, brought him to the attention of the naturalist N. A. Vigors who immediately employed him as taxidermist to the newly formed Zoological Society of London. Together they collaborated on *Century of Birds from the Himalaya Mountains* in 1831. This was hailed by the Royal Society as the most accurate illustrated work on foreign ornithology published up to that time, and it marked the beginning of a series of forty-five folio volumes with over 3000 superb plates. It is interesting to note that the format always remained the same through fifty-seven years, even after his death when the work was completed by Richard Bowdler Sharpe. With the assistance of his wife Elizabeth and an able team of naturalists, Gould travelled to Australia and New Guinea in search of species then unknown. Of the many illustrators who worked for him, Edward Lear became the most famous, and his amusing illustrations of parrots with their wicked expressions are reminiscent of his later *Nonsense* books. The Royal Institution's Collection realized £55,370 ($132,890) for seventeen Lots, fifteen of which were sold for world record auction prices.

Although our sale from Knowsley Hall in June last year contained thirty-seven great botanical books, this class was well represented in the sale by three outstanding examples. A complete set of the *Flora Danica* realized £5000 ($12,000) (see illustration page 242), a world record. The publication of this comprehensive work on Scandinavian flowers spanned 122 years from 1761–1883, and as a result, complete sets are very scarce. In addition, this set was exceptional because all its 3241 plates were

JOHN GOULD:
The Birds of Great Britain
367 coloured plates, 5 vols.
1862–73. One of a fine
collection of works by this
author which sold 12.4.72 for
£55,370 ($143,950)
From the collection of the Royal
Institution of Great Britain

JOHN JAMES AUDUBON: *The Birds of America*
Second Folio Edition, 150 coloured illustrations, New York, 1858–60
Sold 12.4.72 for £6000 ($15,600)
From the collection of James Balfour, Esq, MC

Flora Danica a complete coloured copy
3,241 plates, 19 vols., Copenhagen
1761–1883
Sold 12.4.72 for £5000 ($13,000)

coloured. It inspired Theodor Holmskjold of the Copenhagen Porcelain Factory to persuade the Crown Prince of Denmark to commission a table service in 1790, but after 2000 pieces were produced it was discontinued in 1802.

Throughout English botanical history, the name Curtis has long been associated with *The Botanical Magazine*, an illustrated periodical founded by William Curtis in 1787, which has continued an almost unbroken run since that date until the present day. After William's death in 1799, his only daughter married his first cousin, Samuel Curtis (1779–1860), an important nursery gardener from Walworth in Surrey. Although not so widely known as his father-in-law, Samuel must be remembered as the author of two of the finest English flower books: *Monograph on the Genus Camellia*, 1819, and *Beauties of Flora*, 1820 (see illustrations on pages 243 to 245). Copies of both were sold on behalf of direct descendants of the author for £2600 ($6240) and £5400 ($12,960) respectively, world record prices.

In order to assess the merits of these two works it is necessary to provide some kind of background to botanical illustration at that time. In France, Redouté was approach-

SAMUEL CURTIS:
The Beauties of Flora
10 coloured plates by Clara
Maria Pope, 1820
Sold 12.4.72 for £5400 ($14,040)
From the collection of the direct
descendants of Samuel and
William Curtis

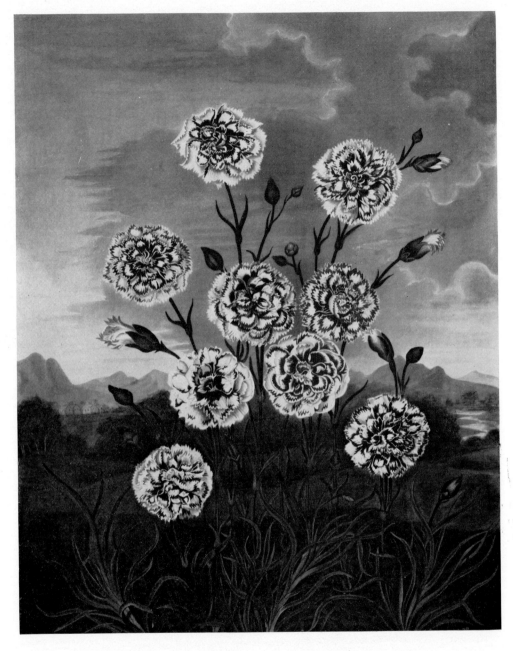

ing the height of his powers as a flower painter by the publication of his most cele-
brated monograph *Les Roses* in 1817, with its delicate coloured stipple-engravings, one
specimen per page standing vividly against a plain white background. Possibly through
the lack of the magnificent patronage which Redouté had enjoyed earlier from the
Empress Josephine, English botanical illustrators could not match the scope of
his publications. They had to finance themselves.

Far left:
SAMUEL CURTIS:
Monograph on the Genus Camellia
1819
Sold 12.4.72 for
£2600 ($6760)

Left:
SAMUEL CURTIS:
The Beauties of Flora
1820
Sold 12.4.72 for
£5400 ($14,040)

However, between 1799 and 1807 an eccentric educationalist, painter and botanist, Robert John Thornton, squandered a fortune on the publication of one book in commemoration of the work of Carolus Linnaeus. This work, *Temple of Flora*, owed much to English romanticism. It was the first in which flowers were set dramatically against gothic landscape backgrounds. Curtis obviously intended to rival Thornton's work when he prepared the first illustration of Tulips for *Beauties of Flora* on an even larger plate than its predecessor. His artist was Clara Maria Pope, who had great merit, and, like Audubon (see illustration on page 242), a strong sense of the dramatic. She always painted flowers life-size. To achieve the natural effects in the plates, mezzotint and aquatint engraving processes were combined and watercolour added. Publishing of this kind proved so expensive that it brought about Thornton's financial collapse.

Curtis, however, seems to have been a better businessman. He shelved the publication for fourteen years, and it was not until 1820 that the completed *Beauties of Flora*, with only ten plates, appeared. The work is so scarce that one suspects that very few copies were made. During the whole of this century only five odd plates have been sold at auction in London in 1946.

The *Monograph on the Genus Camellia*, appeared in 1819. Its five coloured aquatint plates are the same size as *Beauties of Flora*, and even though only five species were illustrated, it is recognized as the finest monograph in existence on that flower. Together the two works must be the rarest English flower books.

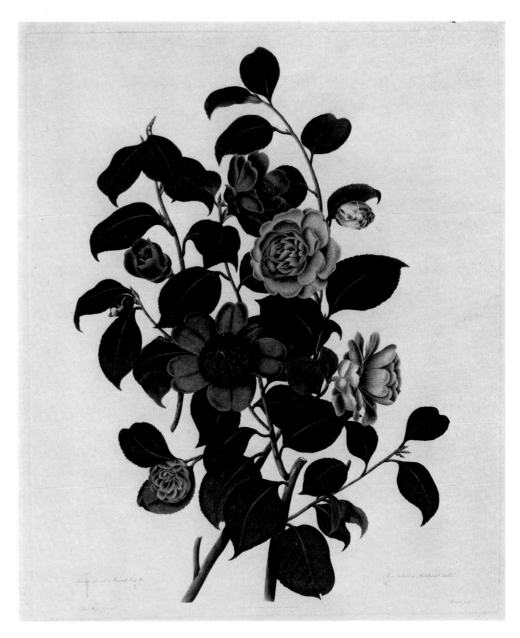

SAMUEL CURTIS: *A Monograph on the Genus Camellia*
5 coloured plates by Clara Maria Pope, 1819
Sold 12.4.72 for £2600 ($6760)
From the collection of direct descendants of Samuel and William Curtis

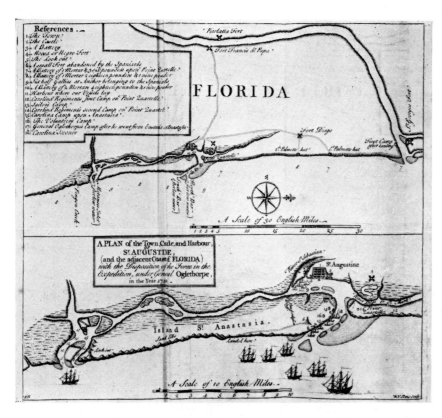

South Carolina and Florida, the Oglethorpe Expeditions
4 works, bound together, 1742–44
Sold 8.12.71 for £1600 ($4160)
From the collection of Clare, Duchess of Sutherland

IZAAK WALTON: *The Compleat Angler*, 1653
First edition
Sold 24.11.71 for £1900 ($4940)
From the collection of the late
Capt H. E. Rimington Wilson

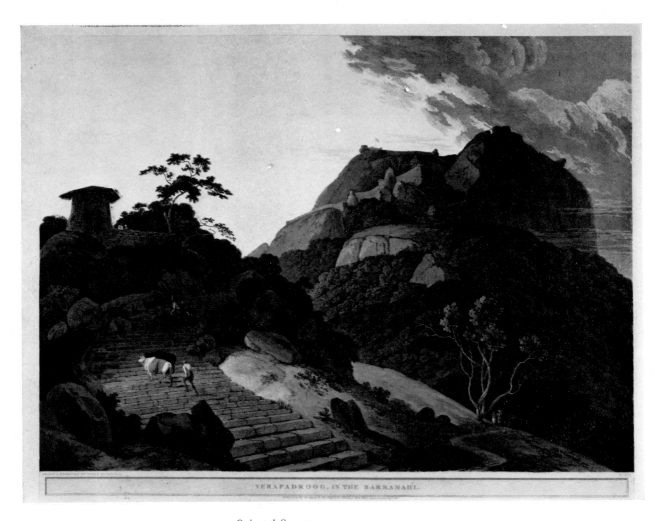

VERAPADROOG, IN THE BARRANAHL.

THOMAS AND WILLIAM DANIELL: *Oriental Scenery*
144 coloured aquatint plates, 6 portfolios, 1795–1807–1808
Sold 28.6.72 for £3400 ($8840)
From the collection of Dr Maurice Shellim
(See article on the Daniells, page 95)

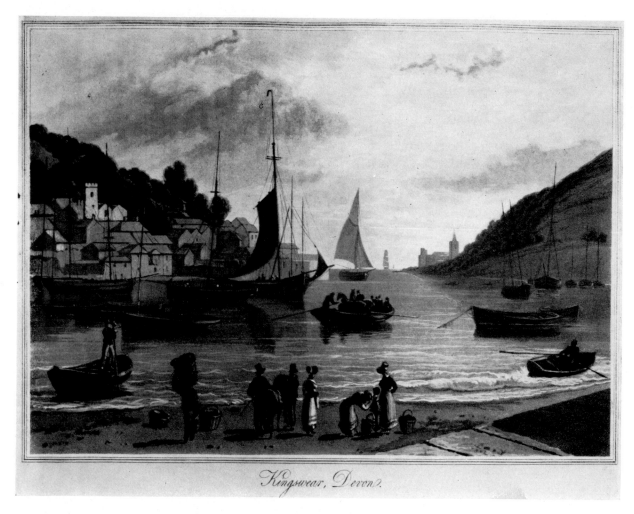

Kingswear, Devon.

WILLIAM DANIELL AND RICHARD AYRTON: *A Voyage Round Great Britain*
308 coloured aquatint plates, 8 vols., 1814–25
Sold 28.6.72 for £1900 ($4940)
From the collection of Dr Maurice Shellim
(See article on the Daniells, page 95)

Books of Hours

BY FRANK LISSAUER

Books of Hours, more conveniently and accurately called *Horae* (most are in Latin) are the most variously and lavishly illuminated manuscripts of the later Middle Ages. The very best, a handful of world-famous books, rank with contemporaneous works of art in other media among the supreme masterpieces of the age. Such are the *Très riches Heures* of the Duc de Berry, and the *Hours by the Dresden Master:* household images if not household names, many who are familiar with them from reproductions not realizing that they are books at all. The majority of the masterpieces are now in museums or institutional libraries, and quite a few of them have been traced back to and identified in ancient inventories, but the volume of production in 1470–1520

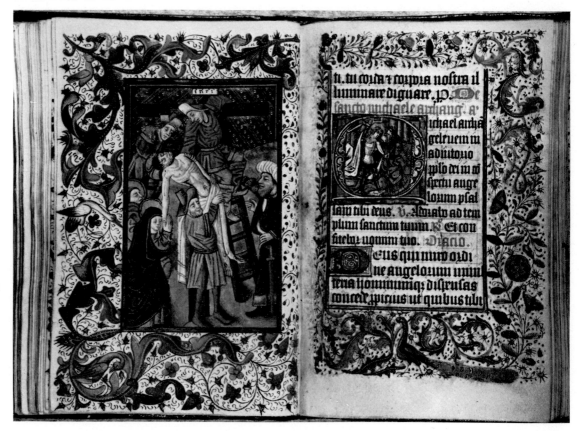

Book of Hours
Illuminated manuscript on vellum with 10 large and 41 small miniatures by two distinct painters, 17th century red morocco gilt in the style of Albert Magnus
Netherlands
Amersfoort
Circa 1460
Sold 28.6.72 for
£5800 ($15,080)

was so great in Northern France and the Netherlands that unknown specimens of fine quality still appear in sale-rooms and catalogues. Moreover the best have nearly always been carefully looked after – one sometimes hears anecdotes of 'precious picture-books which father showed us but wouldn't allow us to handle'. There was also a large production of the same texts in the vernaculars with more or less decoration: collectors of Dutch, English and Flemish *Horae* are insatiable, but these manuscripts fall outside the scope of this essay.

Printers began to compete for this luxury-trade about 1480; they are claimed to have eliminated the purely hand-made book by about 1520, although there cannot have been a very great difference in price in a printed *Horae* and a manuscript one if both were illuminated. In England, for instance, the death of the tradition must have been hastened by *The Common Prayer* (1549); there was no notable revival in Mary's troubled reign. The printers have continued printing *Horae* to the present day, and no doubt they will continue, more or less embellished, with both large and limited editions, in spite of changing liturgical fashions.

It helps to know that the *Horae* grew out of the Psalter, since fine examples of each are to be considered. The Psalter, characteristic private prayerbook of the thirteenth and early fourteenth centuries, at first contained only the Psalms and gradually acquired one or a selection of the following additions: Calendar and Litany, anthems and responsories, the Old and New Testament canticles, a creed, an Office of the Dead, and finally the Hours which in their turn squeezed out the Psalms, although the texts of the Hours consist of selected Psalms.

The Psalter illustrated on this page with arms of the Percy family was unusual in containing only the Psalms without anthems, yet equipped with a splendid York calendar with a heavy Northumbrian emphasis. Its strangest feature was the omission or erasure at a very early date of Psalm 110, which would have needed a full picture initial, the empty pages being filled with a hymn and Franciscan prayers by a near contemporary writer of 'Court hand'. Another peculiarity which, on reflection, seems to have worked against this manuscript was the eccentric pen and ink decorations, mottos, drawings and bits of self-revelation done in the eighteenth century by John Doharty of Worcester, who claimed to have owned shares in the 'Naughty China-Work' and was amongst other things a Freemason. In our opinion his contribution did not spoil but rather enhanced the manuscript; but many margins had been cleaned, and the total effect might well have been more overpowering when the book was still his.

The Dutch *Horae* is important for being probably the earlier of only two known which were decorated in this unusual and experimental style. Large areas of tooled burnished gold were introduced within the miniatures for backgrounds and skies, as if

Psalter in Latin
With arms of the Percys of
Northumberland
Illuminated manuscript on
vellum, 8 pictorial initials
and 24 miniatures in the
Calendar
Eastern England, *circa* 1300
Sold 28.6.72 for £2000
($5200)

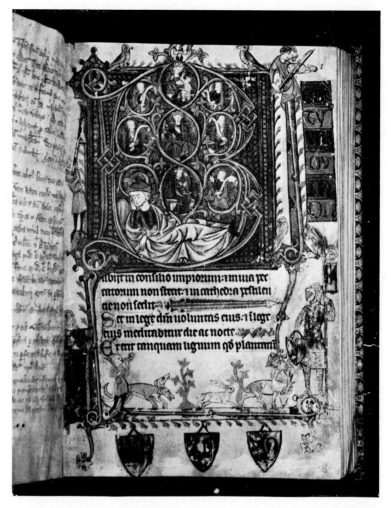

deliberately ignoring the preceding half century of increasing naturalism in this kind of painting (the drawing itself is unremarkable). In one miniature, however, the gold neatly separates the foreground and the background and in the 'twin' manuscript at The Hague, this design is more consistently carried out in more of the miniatures. Broad slabs of gold also appear in the Hague borders, contrasting dramatically with some of the earliest accurate natural history subjects on record such as opened walnuts. Our manuscript with many more miniatures had the added distinction of being made for an English customer, the only clue to his or her identity being a decided association with the Friars Minor, for inscribed in gold in the Calendar was the Feast of the Holy Name, especially allowed to the English Minors in 1457 but to the Church at large only in 1530. Any reader interested in such things will find the history of this Feast rewarding, starting with Rome and continuing in the Anglican books from 1662 down to the most recent American Episcopalian calendar.

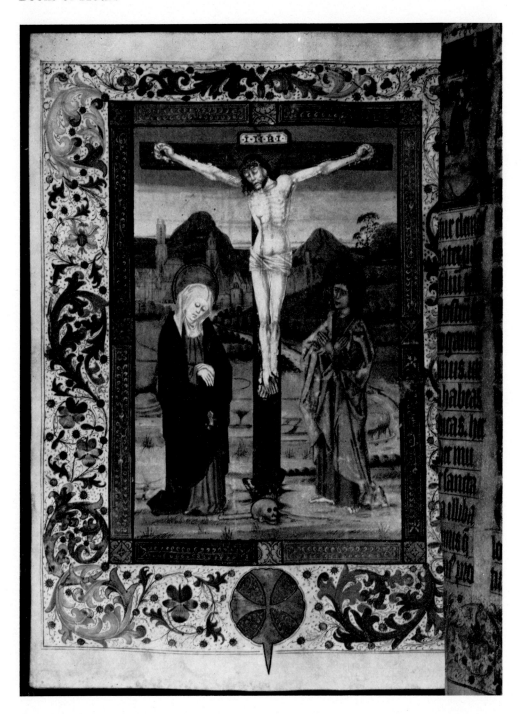

Missal of the Roman Rite
Illuminated manuscript on vellum, Netherlands, Weesp, near Amsterdam, *circa* 1475
Sold 28.6.72 for £1850 ($4810)

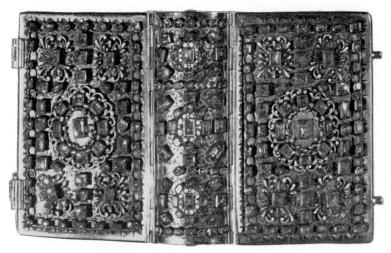

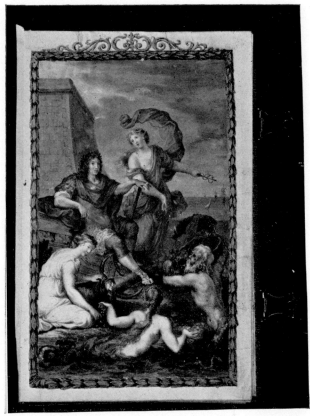

Officium Beatae Mariae Virginis
Manuscript on vellum illuminated probably by Attavante
degli Attavanti of Florence 1510, originally commissioned
by the Albizzi and Pistoi of Tuscany; in a fine jewelled
binding of the early 17th century
Sold 28.6.72 for £6200 ($16,120)

Abregé de la Marine du Roy
1681, manuscript on vellum compiled and illuminated for
Louis XIV, probably at the order of Jean Baptiste
Colbert, architect of the French Navy
Sold 28.6.72 for £1500 ($3900)

Our last illustration is of an unmysterious but competently achieved treasure: a
Florentine *Horae* commissioned by members of the Tuscan Albizzi and Pistoi families
from Attavante degli Attavanti, and probably executed by the Master Attavante
himself. Still treasured a century after its making, it was set in a wonderful topaz-
coloured jewelled binding. An important factor in raising its price now was its being
small enough to attract that highly specialized class of collectors who collect miniature
books. Their books should not be more than two inches high, but they have always
made exceptions for very small *Horae* if sufficiently attractive. In the last seven years it
has been our good fortune to have sold at least three such small *Horae* for exceptional
prices.

To anyone wishing to read further we heartily recommend two old books and one
more recent, none of which have yet been superseded: They are: Herbert (J. A.):
Illuminated Manuscripts (The Connoisseur's Library), 1911; Wordsworth (C.) and
H. Littlehales: *The Old Service-Books of the English Church* (The Antiquary's Books),
1904; Morison (Stanley): *English Prayer Books*, latest edition.

HORACE WALPOLE: *A Catalogue of the Royal and Noble Authors of England*
The second edition, corrected and enlarged, 2 vols., 8vo, 1759
Sold 24.11.71 for £2200 ($5720)
From the collection of the Lord Margadale of Islay, TD
The author's own copy annotated and corrected throughout by him for a new edition
Walpole wrote that 'this copy is corrected and enlarged as I intend it should be printed for the last time'
The copy subsequently belonged to Thomas Kirgate, Walpole's printer, with an inscription by him
'these two volumes were given to me by my Master, Mr. Walpole, July 1785'; it was next owned by
Richard Bull a well-known Walpole collector

Frontispiece H.I.M. SETH of Azania from the painting by a retired artist

EVELYN WAUGH:
Black Mischief, 1937
The Eight Original pen
and ink drawings for
the Large Paper Edition
Sold 16.2.72 for £400
($1040)
From the collection of
Lady Mary Lygon

'Read any good bibliographies lately?'

BY CYRIL CONNOLLY, *Christie's consultant on modern books*

In the days of the First World War one would hear about soldiers whose lives were saved by a Horace, Virgil, or even a Keats in their breast pocket. Then came the time when people always carried a slim volume of modern poetry. In the next war it was Horizon or Penguin New Writing which fitted snugly into battledress. Only Duff Cooper when asked what reading had sustained him through the Blitz replied 'Wine lists', and Somerset Maugham said he never went anywhere without a bookseller's catalogue. That was before the era of the Soho bibliographies, edited by Rupert Hart-Davis from 1951. Since they don't fit into a pocket, we will just have to order bigger suits.

Ordinary readers still fight shy of them from a mistaken fear that bibliography is above their heads. In fact they are labours of love which nobody could undertake without an abiding affection and admiration for an author, for here, summed up by the ominous phrase: 'Contributions to Periodicals', is exposed all his weakness as well as his strength. Such contributions may dig a writer's grave; they inaugurate the 'long littleness of life' for which he is 'magnificently unprepared'. But these 'contributions' are also the index of his vitality, of the force of his impact, the popularity he gains for his ideas; and so they have much to reveal to a patient investigator. Thus Richard Fifoot's bibliography of the three Sitwells, published in the Soho series in 1963, shows Edith with 52 books, 52 contributions to books and 278 contributions to periodicals to her credit, Osbert with 57 books, 54 contributions to books and 474 to periodicals, Sacheverell with 67 books, 58 contributions to books and 208 to periodicals. As one would expect, his lead in the number of books (a lead which he must have greatly increased since he is still writing) was achieved by contributing far fewer articles than his brother or sister. Osbert and Edith produced about the same number of books and contributions to books, yet Osbert published nearly twice as many articles. Was it because he was a man of many interests, including political, or because Dame Edith was apt to be too intransigent to please most editors?

How do these figures compare with their contemporaries like Eliot, Lawrence and Pound who are fortunate in having such prodigious American bibliographers as Professors Donald Gallup and Warren Roberts, or with Joyce – (Slocum and Cahoon)? Joyce made a bare 100 contributions, many of which are serialisations of his novels, Eliot,

568 contributions to periodicals by 1951, Pound, 1890 contributions by 1962. 'Whatever one thinks of Ezra's work', Hart-Davis wrote to me in 1963, 'it is bibliographically fascinating'. Pound began to contribute to magazines in 1905, his record 1890 entries therefore give an average of thirty-four a year or about three a month for fifty-five years. But that is not what really happened since many of his contributions were single poems. In 1911 there were seven contributions, in 1912–36, 1913–52, 1914–46, 1915–45, after which the war slowed him up. The years 1917 and 1918 however showed an increase rising to 116 in 1918, 90 for 1919, 80 for 1920. After that Pound left England for Italy and dropped to 20 for 1921, 15 for 1922 and 6 for 1923. He picks up slowly and by 1936, thanks to the *New English Weekly*, he is up to 105 again. Then a slow decline was followed by his post-war troubles, when in 1948 and 1951 and 1952 he was down to one per annum. The chart reveals not only his creative energy but the limitations enforced on him by his unpopular ideas which led finally to his incarceration. The case of his friend and contemporary Eliot is somewhat different (Gallup-Faber). Here we see the poet getting more and more absorbed in his critical work, so that he begins in 1915 with seven poems published in magazines and no reviews, 1916 four poems and fifteen reviews, rising to 46 articles, but only three poems by 1927. One cannot help noticing that Joyce who contributed so much less to magazines than the others was the only one endowed with a large capital sum. Some writers with private incomes like Firbank (nine contributions to books) were perhaps unemployable.

Professor Warren Roberts makes room to tell us a little of what Lawrence's books were about and to mention the most important reviews they elicited. More vital information is provided by the number of copies printed.

Lawrence's early work was nearly annihilated by the censor. Two thousand five hundred copies of his second novel *The Rainbow* (1916) were ordered to be destroyed, two of the best poems were removed by Chatto from *Look we have come through. The Lost Girl* had to have changes made. After reading *Women in love* Methuen cancelled their contract and Duckworth also refused it. Five years later it was printed semi-privately in New York. Hence *Lady Chatterley* which he published abroad in an edition of a thousand copies at £2 each as a business venture. 'This procedure', wrote Lawrence to Huxley, 'is the solution for us small-selling authors.'

No-one exploited it more successfully than his 'friend' Norman Douglas. Although, compared to these others, Douglas is rather a second-eleven writer, he has been well served by bibliographers. In 1927 Edward Macdonald published a handsome volume at the Centaur Bookshop, Philadelphia, with racy comments on most of his books by Douglas himself, and recently Cecil Woolf has brought him into line with the high Soho standards.

Bibliographies

I have left out the real value of these admirable bibliographies. By identifying every-thing an author has written they help the collector to look for rarities and the critic to enlarge his vision. Knowledge is power. Critical articles are monuments to an author: a bibliography is more like a mummy. Embalmed in the cerements of exact scholarship heaves the living writer, 'when all the breathers of this world are dead'.

PORCELAIN
AND GLASS

Chelsea botanical plate
9½ in. (24 cm.) diam., red anchor mark and no. 34
Sold 17.7.72 for 1900 gns. ($4788)

The design for this plate was copied from the hand-coloured engraving by J. J. and J. E. Haid after the drawings by G. D. Ehret from True (C. J.); *Plantae Selectae*, Nuremberg, 1750–1773, pl. no. VIII Described in full as *Corallodendron Triphyllum Americannum non spinosum foliis magnis acuminatis flore pallide rubente*

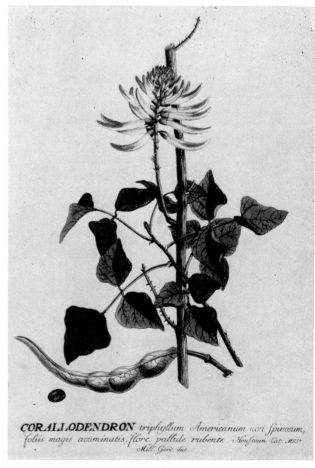

Sources of inspiration for the Chelsea artists

BY CHRISTOPHER ELWES

Some of the most accomplished decoration on English ceramics is found on the famous Chelsea botanical plates, frequently referred to as 'Hans Sloane' plates. This misnomer is due to an advertisement which appears in Faulkner's *Dublin Journal*, 1st–4th July, 1758, offering 'table plates, soup plates and dessert plates enamelled from Sir Hans Sloane's plants'. While there is no evidence to support this assertion we do know that the Chelsea artists copied from the botanical drawings of G. D. Ehret, as the interesting plate opposite proves. It is shown beside the coloured engraving which the decorator copied as exactly as possible, even attempting to match the colours. The engraving is by J. U. and J. E. Haid after the drawings by G. D. Ehret and was published by True (C.J.): *Plantae Selectae*, Nuremburg 1750–73.

Unfortunately it is not possible to link all the Botanical work on Chelsea with engraved originals, but the splendid dish illustrated overleaf is painted in exceptionally rich colours with a tiger-lily that must certainly derive from an engraving. It established a new record price of 2700 guineas ($6480). Not all Botanical plates fetch such high prices, the eleven other fine examples that appeared in our Rooms ranged from 2200 guineas ($6006) to 700 guineas ($1911).

Chelsea 'Fable Type' painting has always rightly held pride of place with collectors and is now very scarce. The teapot, cover and stand illustrated bears all the hallmarks of the famous painter Jefferyes Hamett O'Neale (see p. 263). As with the painters of the Botanical plates, O'Neale also drew upon contemporary publications for his inspiration, and many of his paintings, both on Chelsea and Worcester porcelain, can be linked to engravings illustrating the Fables in Barlow's *Aesop's Fables*, 1687; S. Croxall, *Aesop's Fables*, 1722, and *Fables Choisies par J. de la Fontaine* illustrated by J. B. Oudry. The fable on this teapot of the Mule and the Packhorse cannot be attributed to these sources and so it is probable that O'Neale had other works at his command.

However, this Fable teapot is particularly interesting since it is of Chinese porcelain. It is now considered most unlikely that the Chelsea porcelain factory while trying to establish itself in the face of serious competition from Germany as well as the Orient would have allowed one of their foremost employees to decorate anything but their own products and it can be safely assumed that O'Neale painted this teapot after

leaving Chelsea and before taking up employment at Worcester. Several other 'recognizable' hands are found decorating Chinese porcelain and it is now believed that they were all working for independent enamelling shops, the most famous being that of James Giles in Camden Town. The teapot realized 520 guineas ($1248), a high price since, although interesting, the colours do not blend so attractively into the hard-paste body as they do in the soft-paste Chelsea examples.

The two saucer-dishes illustrated below the teapot are of the raised anchor period dating from about 1752, and are not strictly of Fable type. The painting is radically different from that of O'Neale, who anyway is not thought to have begun at Chelsea until the red anchor period, but is obviously the work of an extremely accomplished hand. These saucers form part of a series painted with either life-like or superbly ferocious imaginary animals. Although in most cases it is unlikely that the animals portray fables or stories of some kind, they are frequently very unusual species painted with great accuracy which does not exclude the possibility that the painter, possibly Fidelle Duvivier, took his animals from a so far unknown publication.

The 1400 guineas ($3360) given for these small saucer-dishes reflects the tremendous demand for early and interesting Chelsea wares.

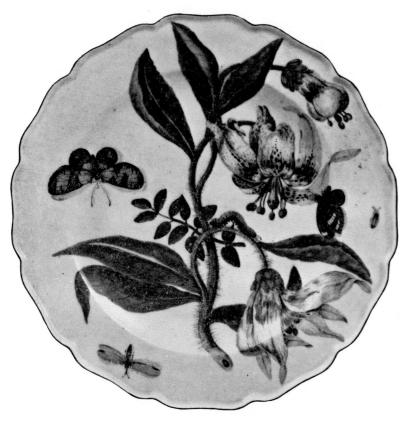

Chelsea botanical plate of 'Hans Sloane' type
11 in. (28 cm.) diam., red anchor mark
Sold 17.1.72 for 2700 gns. ($7229)
World auction record price for a Chelsea botanical plate
Sold by the Trustees of the Rye Art Gallery

O'Neale decorated Chinese porcelain teapot, cover and stand
Painted by Jefferyes Hamett O'Neale
7½ in. (19.5 cm.) high – Ch'ien Lung
Sold 17.1.72 for 520 gns. ($1392)

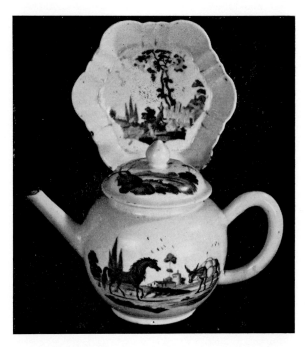

Pair of Chelsea saucer dishes, painted in colours probably by
Fidelle Du Vivier
5¼ in. (13.5 cm.) diam., one with raised anchor mark
Sold 27.3.72 for 1400 gns. ($3822)
Sold by order of the Executors of
Richard James Meade-Fetherstonhaugh, Esq

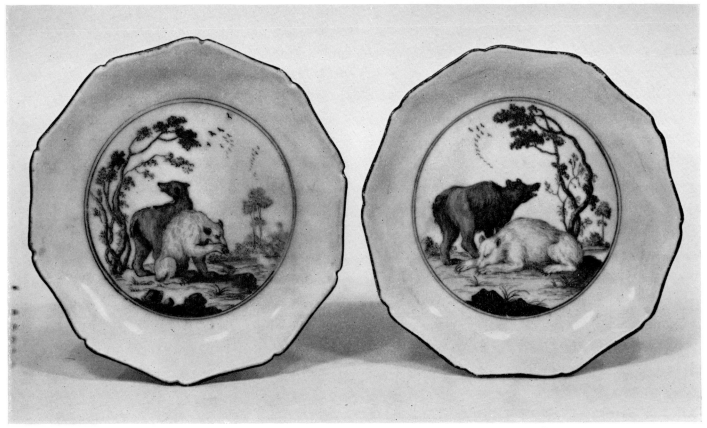

Annigonis of yesteryear

In an age two centuries before the invention of photographic reproduction, the subject who wished to display his loyalty to the Crown frequently turned to the potter. Nowhere is this better shown than on the English Delft portrait charger. From Charles I to George II the sovereign and some other charismatic leaders, such as Marlborough and Prince Eugene, were portrayed in robes of state standing in a pillared interior or schematic landscape or mounted on a prancing horse. The classic example of these dishes intended more for display than use is the dish dated 1753 at Chequers. Isolated examples appear fairly regularly, but a spectrum embracing four reigns is a rare phenomenon. Thus it was with great interest that we offered the group of dishes on July 17 including William III, William and Mary, Prince George of Denmark, George I and two unnamed monarchs, with Prince Eugene and the Duke of Marlborough. In general the prices paid today are in inverse ratio to the popularity of the sitter in his lifetime, since unpopular rulers such a George I are rarely portrayed on Delft and thus fewer chargers are to be found and those that appear are the objects of strong competition.

Important collection
of English royalist
chargers, about
13½ in. (33 cm.)
diam.
Sold 17.7.72 for a
total of £5376
($12,903)

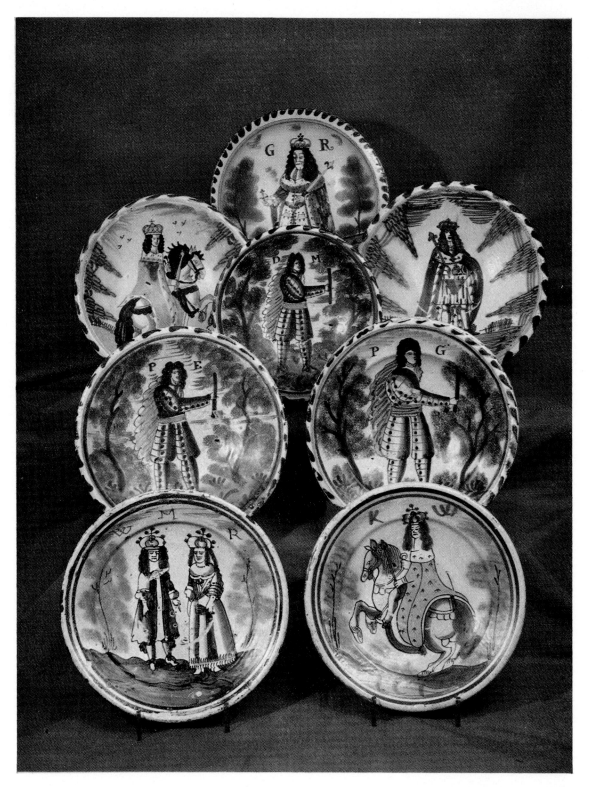

English porcelain

Very rare Wrotham slipware dated jug
By George Richardson, dated 1651
9¾ in. (24.5 cm.) high
Sold 14.2.72 for 1550 gns. ($4141)

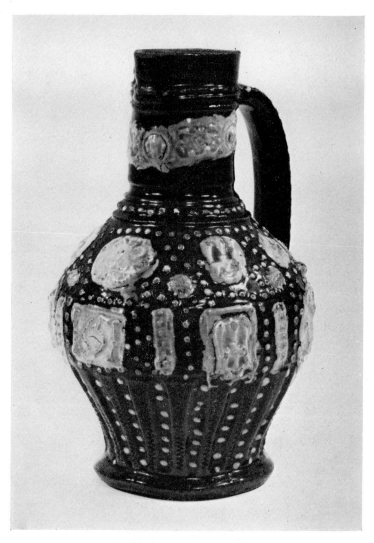

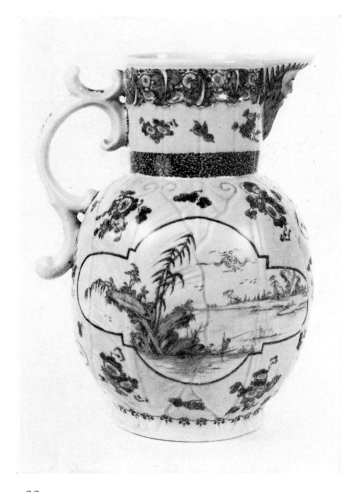

Important Worcester (Dr. Wall) yellow-ground
cabbage-leaf mask jug
10¾ in. (27 cm.) high
Sold 17.7.72 for 1500 gns. ($3780)
Sold on behalf of the Trustees of Lord Hillingdon

Derby two-handled cup
Painted by George Robertson, with shipping scenes, blue mark
Sold 22.5.72 for 520 gns. ($1420)

Very rare Derby yellow ground cabaret
Painted by Jockey Hill, blue and puce marks, gilders nos. 9 for
William Smith
Sold 22.11.71 for 1650 gns. ($4241)

Rare Pinxton tankard, painted by William Billingsley
5 in. (12.5 cm.) high, red P mark and named
Chatsworth Derbyshire
Sold 27.3.72 for 600 gns. ($1638)

Worcester figure of a Turk
5 in. (13 cm.) high
Impressed T.I. mark under the base
Sold 22.11.71 for 2000 gns. ($5140)

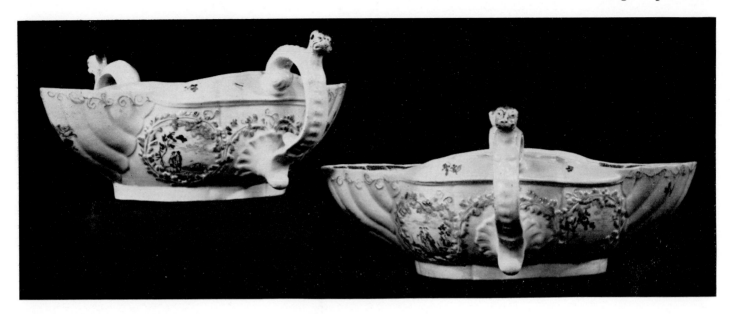

Superb pair of early Worcester two-handled double-lipped sauceboats
8½ in. (21.5 cm.) long
Sold 17.1.72 for 2800 gns. ($7497)

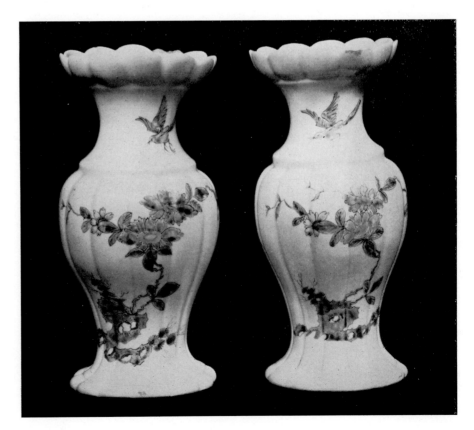

Very rare pair of Lund's Bristol
polychrome vases
7 in. (18 cm.) high
Sold 17.7.72 for 2900 gns. ($7308)
From the collection of
the late L. L. Firth, Esq

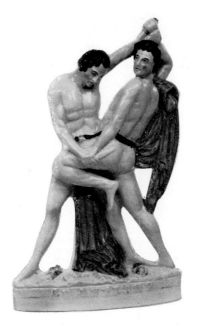

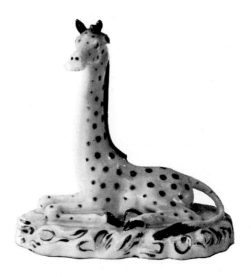

Rare fairing: 'No followers allowed'
Sold 19.6.72 for 300 gns. ($819)

Rare Staffordshire pottery
group of the Grapplers
12 in. (31 cm.) high
Sold 24.7.72 for 480 gns.
($1234)

Worcester (Grainger Lee & Co.)
figure of a recumbent giraffe
4¼ in. (11 cm.) wide, impressed
Grainger Lee & Co., Worcester
Sold 22.5.72 for 110 gns. ($300)

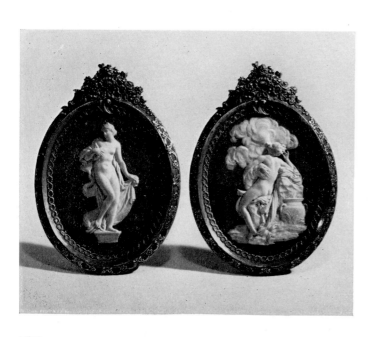

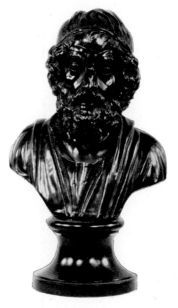

Far left: Pair of Wedgwood
and Bentley oval blue and
white jasper plaques,
3¼ in. (8.5 cm.) wide
Impressed lower case marks
Sold 17.7.72 for 520 gns.
($1310)

Wedgwood and Bentley
black basalt bust of
Homer
13½ in. (34.5 cm.) high
The bust impressed
Homer and Wedgwood &
Bentley lower case mark
Sold 22.5.72 for 620 gns.
($1693)
From the collection of
Mr and Mrs John Balfour
Removed from
Balbirnie, Markinch, Fife

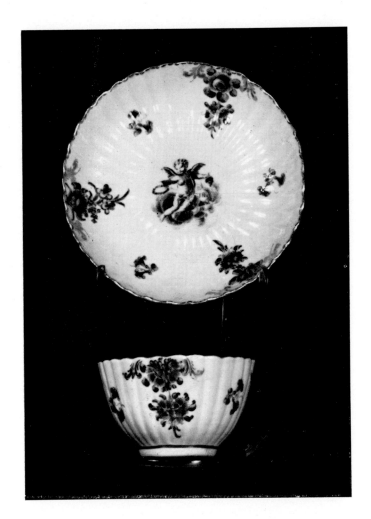

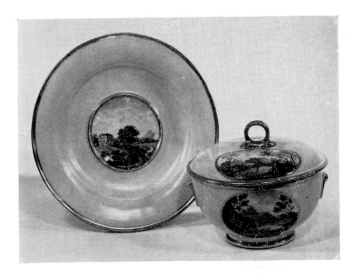

Top left: Bristol fluted teabowl and saucer, from an unrecorded service
Sold 27.3.72 for 1250 gns. ($3412)
Top right: Worcester (Flight & Barr) yellow-ground ecuelle, cover and stand
Sold 17.7.72 for 440 gns. ($1108)
Bottom left: Chamberlain's Worcester oval-shaped dish, painted with 'The New Houses of Parliament'
Sold 22.11.71 for 290 gns. ($735)
Bottom right: Wedgwood creamware part tea-service
Inscribed G.III Anno Regni L, impressed marks
Sold 14.2.72 for 250 gns. ($682)
This rare service was made to celebrate the 1810 Jubilee

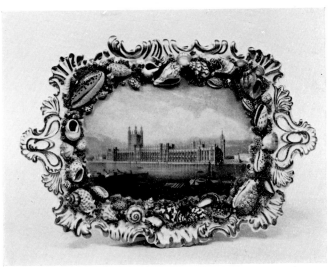

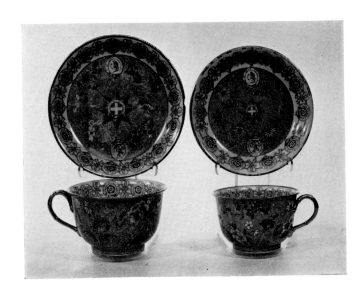

Christie's Italiana

BY HARRY WARD BAILEY

Christie's have now held three sales in Italy. The first took place on 15th October, 1970, in the Villa Miani, high up on the Monte Mario with a view of Rome worthy of Vanvitelli. The large eighteenth-century salon was filled to capacity with photographers and television crews clinging to the walls and spectators sitting in the windows. Patrick Lindsay, 'divo' auctioneer, knocked down 160 Italian Old Masters and nineteenth-century pictures, but only after a series of incredible obstacles.

The size and effectiveness of the opposition was flattering and almost overwhelming. The licence, promised for months, was held up until the very last minute by certain officials who had obviously been approached by the opposition. As the time for the sale drew near, the threats increased, and it was only when a fire started in the grounds of the Villa that the police moved in to protect us and State Security helicopters buzzed overhead. The licence for the sale was only eventually granted through the intervention of the British Ambassador and the Minister of Foreign Commerce.

The sale was a success on several levels. The press coverage was phenomenal, especially once word got out about the Mafia-like ploys of the opposition. Strangely enough, the type of pictures sought by Italian buyers in London, did not seem to hold the same appeal in Rome. The drawings and nineteenth-century pictures did very well. The buyers were for the most part new private collectors who had not bought from any of our auctions previously. The most important purchase of all, however, was made by the Italian Government who purchased a previously unknown work by Guercino for £53,333 (Lire 80 million). It was the first time the Government had bought an important work of art at a public auction and the price paid represented over half their yearly budget for acquisitions. The picture, which represents the nursing of St Sebastian by St Irene, is now in the Museum of Bologna after being exhibited and highly publicized all over Italy.

Christie's second Italian sale was held at the Albergo Villa d'Este on Lake Como on 31st May, 1971. This was the most beautiful location ever for one of our auctions and crowds swarmed in from Switzerland and Germany as well as Milan. The atmosphere was ideal for the collection of Lombard and Venetian pictures, drawings and furniture. The sale made over £333,333 (Lire 500 million) and was even more successful than

the first. Great regional appeal proved to be a highly interesting factor for the still city-state orientated Italian buyers. One of the more ambitious examples of this regional buying is the Cassa di Risparmio di Ferrara, who purchased the large altar panel by Domenico Panetti, the Ferrarese master of the late fifteenth century, for £10,000 (L. 15 million). There is a growing tendency for Italian banks to purchase works of art not only as investment but also for exhibition in the local museums.

Considering the great variety of schools of art in Italy, it would appear that there is a great future for more regional sales. The Italians are more than ever enormously proud and interested in their own artistic heritage and the Government, which previously had been so fearful of its loss to foreign collectors, is now aware that the import of such works is probably greater than the export and have recently eliminated the high export tax on art going to other Common Market countries.

Our most recent sale in Italy was held again in Rome in May in co-operation with SALGA, a small auction house hear the Piazza di Spagna. This joint venture proved most interesting and highly successful and may pave the way for future collaboration. The three-day sale took place in a beautifully preserved *fin de siècle* theatre, Salone Margherita, now a national monument.

The sale was composed of non-Italian works of art belonging to one vast private collection. What one would have thought to be a direct contradiction of what we had done previously, proved to appeal to an entirely new group of buyers both in Italy and abroad. The theatre was filled with buyers from all over Europe and the auctioneer, Hugo Morley-Fletcher, sounded like a United Nations translator as he knocked down £93,890 (L. 140,836,000) for the porcelain alone. The most important piece of porcelain sold was the Royal saucepan made especially for Maria Josepha, daughter of the Emperor Joseph I of Saxony, which made £4333 (L. 6.5 million). An even higher price was paid for the rare group of the Indiscreet Harlequin, which fetched £4606 (L. 7 million), a record price for a piece of porcelain sold in Italy. Thus, with Britain on the threshold of the Common Market, Christie's have already proved the effectiveness and flexibility of an EEC operation.

It seems ironic that after all the opposition when Christie's first came to Italy three years ago, Italian collectors as well as dealers now eagerly await future sales. Italian auction houses even imitate the 'Christie's style' and foreign buyers enjoy returning to this country so rich in art.

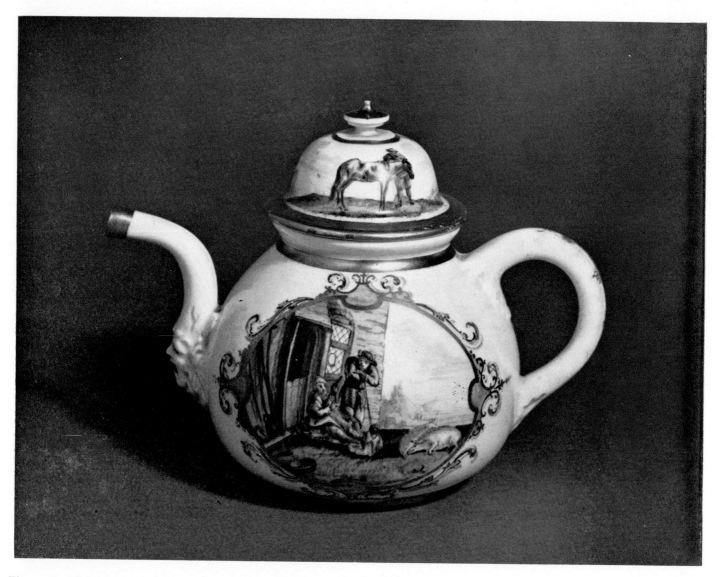

Fine early Meissen teapot and cover, with Dresden Hausmaler decoration
5 in. (13 cm.) high
Sold 26.4.72 at the Hotel Richemond, Geneva, for £1900 (S.F. 19,000)

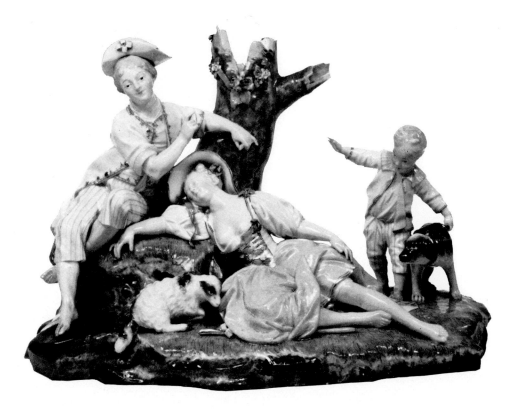

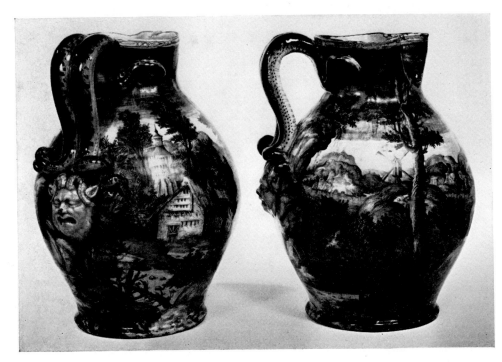

Top left: Höchst group, der Schlummer der Schäferin Modelled by Laurentius Russinger 12 in. (30.5 cm.) wide, incised S mark. Sold 10.4.72 for 1350 gns. ($3685). From the collection of Mrs James de Rothschild

Above: Capodimonte (Carlo III) figure of Pantaloon, modelled by Giuseppe Gricci, 6 in. (15 cm.) high, the base with incised mark of the repairer Aniello. Sold 10.4.72 for 2800 gns. ($7644)

Left: Pair of large Urbino Istoriato armorial jugs, with the arms of Salviati, 15½ in. (39 cm.) high *Circa* 1555. Sold 6.12.71 for 3000 gns. ($7710)

Continental porcelain

Right: Rare Fabeltiere beaker and saucer
Blue crossed swords marks and impressed 24 on saucer
Sold at the Hotel Richemond, Geneva, 26.4.72 for £1600 (S.F. 16,000)

Bottom: Rare early Meissen Hausmaler teapot and cover
11.5 cm (4½ in.) high
Sold 26.4.72 at the Hotel Richemond, Geneva, for £4600 (S.F. 46,000)

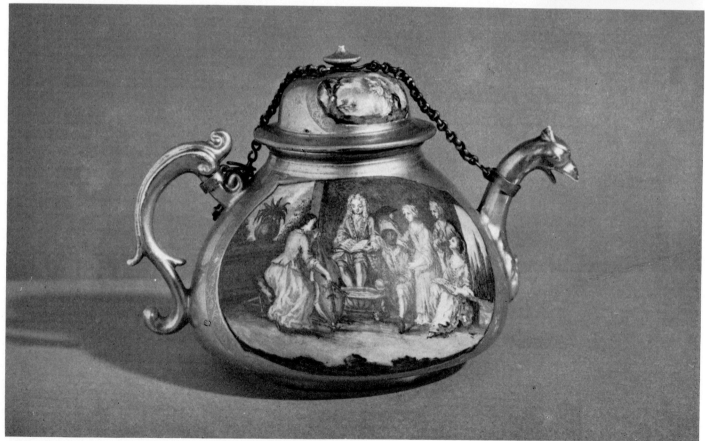

Near right: Rare group of the Indiscreet Harlequin, modelled by J. J. Kändler 7 in. (17.5 cm.) high Sold 24.5.72 in conjunction with Salga, at Salone Margherita, Rome for £4666 (Lire 7,000,000)

Far right: Fine group of Pantaloon and Columbine, modelled by J. J. Kändler 6 in. (15.5 cm.) high Sold 24.5.72 in conjunction with Salga, at Salone Margherita, Rome for £2940 (Lire 4,400,000)

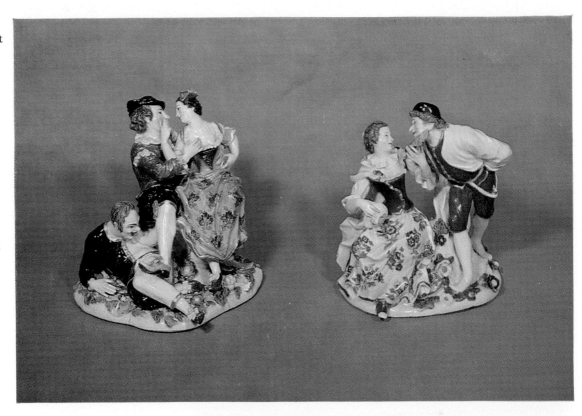

Near right: Very rare figure of a minstrel Modelled by J. J. Kändler, 6½ in. (16.5 cm.) high Sold 24.5.72 in conjunction with Salga, at Salone Margherita, Rome for £2000 (Lire 3,000,000)

Far right: Frankenthal group of a Chinese family Modelled by Konrad Link, 8¼ in. (21 cm.) high Blue crowned CT mark above the date '75 Sold 24.5.72 in conjunction with Salga, at Salone Margherita, Rome, for £1600 (Lire 2,400,000)

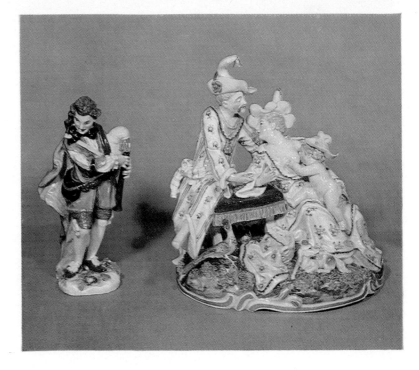

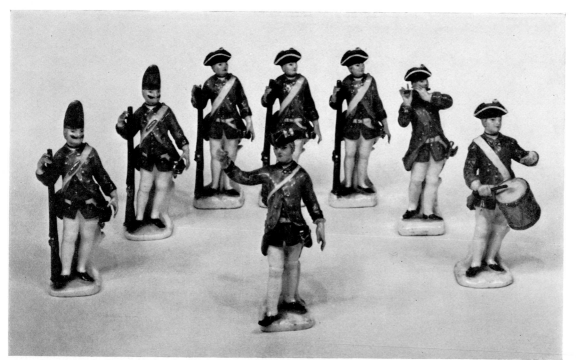

Rare set of Meissen figures of soldiers in the Electoral Saxon uniform
$4\frac{1}{2}$ in. (11 cm.) high
Blue crossed swords marks at back
Sold 4.10.71 for 4800 gns. ($12,340)

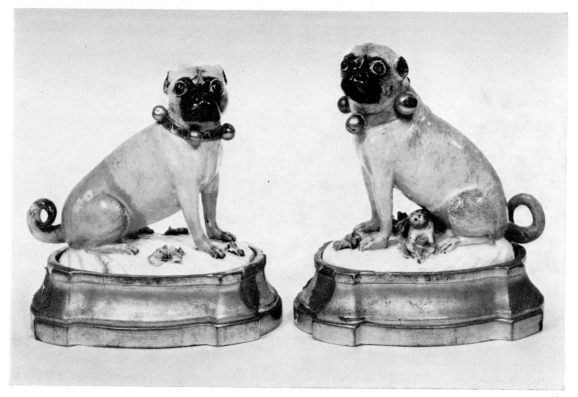

Very rare pair of Tournai figures of pug dogs, after the Meissen originals by J. J. Kändler
$5\frac{1}{4}$ in. (13 cm.) high
Gilt wood stands
Sold 10.4.72 for 1300 gns. ($3549)
From the collection of Mrs James de Rothschild

: (none)

Thirteen Meissen
Cris de Paris figures
Modelled by J. J.
Kändler and
P. Reinicke
Sold 24.5.72 in
conjunction with
Salga, at Salone
Margherita, Rome
for a total of £9103
(Lire 13,660,000)

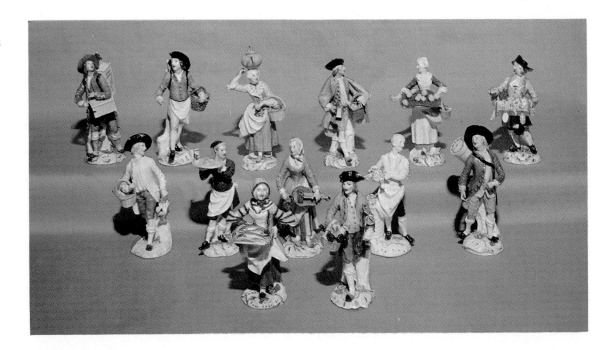

Nine Meissen figures
of craftsmen
Modelled by J. J.
Kändler and
P. Reinicke
Sold 24.5.72 in
conjunction with
Salga, at Salone
Margherita, Rome
for a total of £6411
(Lire 9,620,000)

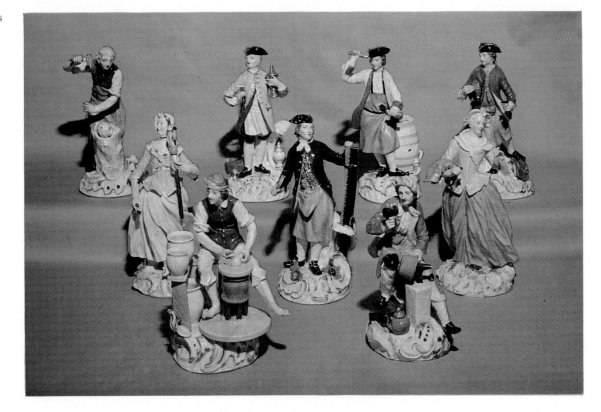

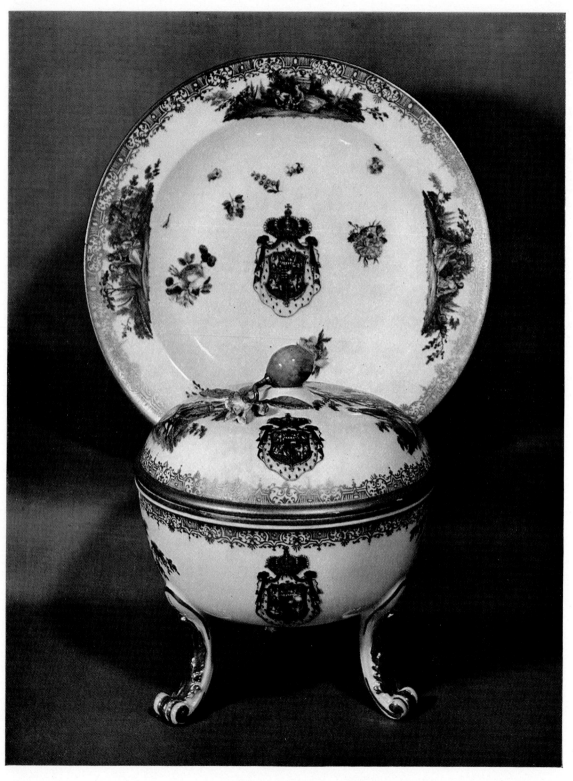

Magnificent Royal saucepan, cover and stand, the stand 10¾ in. (27.5 cm.) diam., the saucepan 7½ in. (19 cm.) high
Both with blue crossed swords marks
Sold 24.5.72 in conjunction with Salga, at Salone Margherita, Rome for £4333
(Lire 6,500,000)
Supplied in 1745 by Meissen to Maria Josepha, Queen of Saxony

A question of fashion

BY HUGO MORLEY-FLETCHER

The interest displayed by collectors in the products of the various porcelain factories is the subject of constant, if subtle, change. Recent years has seen the highest prices given for the early Meissen wares painted with chinoiseries by J. G. Herold and others and increasingly for pieces with outside or *hausmaler* decoration. For the most part figures made after 1745 have suffered a loss of interest though thirty years ago they would have been more sought after than the early wares.

Our two sales on the Continent this year were neatly focussed on these two aspects of Meissen porcelain collecting. In Geneva on April 27 the highest price of the day was the record £4600 (Sw fr 46,000) paid for a gold-ground teapot (see illustration opposite) decorated by the Seuter family at Augsburg. A sugar bowl and cover decorated at Meissen with harbour scenes and bearing, on a milestone, the date 1732 sold for £3200 (Sw fr 32,000), and a tankard with particularly brilliant painting by C. F. Herold fetched £2,800 (Sw fr 28,000). Of particular interest was a teapot painted by Lauche with Teniers subjects, which fetched £1900 (Sw fr 19,000). The decorator was first employed at Meissen and subsequently worked as a *hausmaler* in Dresden. The big question was whether he painted the teapot at the factory or later. The presence of Böttger-lustre, which the *hausmalers* never succeeded in imitating, in the cartouches suggests that the piece was decorated at the factory.

In another vein a remarkable £1600 (Sw fr 16,000) was paid for a *fabeltiere* beaker and saucer, while a lime-green ground octagonal cup and saucer brought £1100 (Sw fr 11,000) reflecting the continuing high demand for fine Meissen ground colours. The prices, though higher than in previous sales, were merely a continuation of a well established trend.

Not so our sale in Rome which included a wide range of figures and wares from the recently unfashionable later period. The most outstanding piece was the armorial saucepan with the Royal Arms of Saxony and Poland with Austria in pretence, which we found in the factory records, was ordered by the Queen of Saxony in 1745. It is a rare event to identify a lost but fully documented piece. The price given £4333 (Lire 6,500,000), reflected the additional value given to fully documented pieces even when outside the strictly fashionable period.

The Emma Budge Collection sold in Berlin in 1939 contained two major series of figures of the early 1750's, the Cris de Paris and the Craftsmen which were then sold in two Lots. These were now split up into individual Lots and were the objects of hot competition. The highest price was £2260 (Lire 3,400,000) for the Potter, while several of the Cris de Paris figures brought sums well in excess of previous auction records for such figures.

Other good prices were: £2266 (Lire 3,400,000) for Count Bruhl's Tailor, more usually found in late versions, £1066 (Lire 1,600,000) for a rare Hunting snuff-box and £613 (Lire 920,000) for a snuff-box with a portrait of Augustus III.

Meissen cylindrical tankard
Painted by C. F. Herold
6 in. (15 cm.) high
Sold 26.4.72 at the Hotel
Richemond, Geneva, for £2800
(Sw fr 28,000)

Important Meissen
Augustus Rex yellow-
ground Chinoiserie
vase and cover
14 in. (36 cm.) high
Blue A.R. monogram
mark
Sold 4.10.71 for
4800 gns. ($12,340)

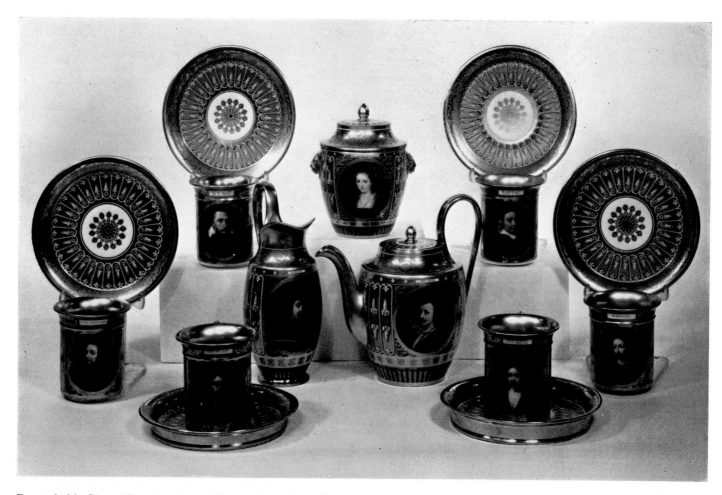

Remarkable Sèvres Restauration coffee-service, with paintings taken from the Old Masters
Each piece signed by the decorator responsible, 1818–22
Sold 10.4.72 for 1300 gns. ($3549)
From the collection of the New York State Historical Association

Very fine Webb cameo double-overlay vase, possibly by Thomas Woodall
8¾ in. (22 cm.) high, with shaped rectangular mark: Thos. Webb & Sons Ltd
Circa 1890 or earlier
Sold 11.7.72 for 2800 gns. ($6720)

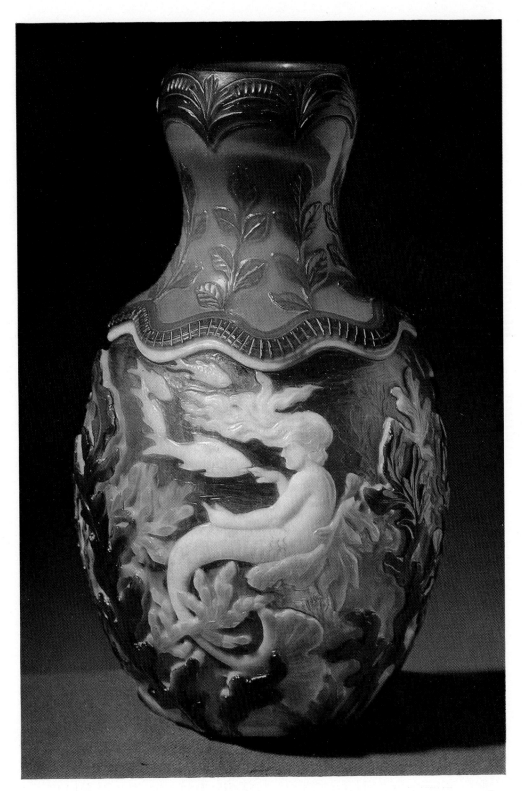

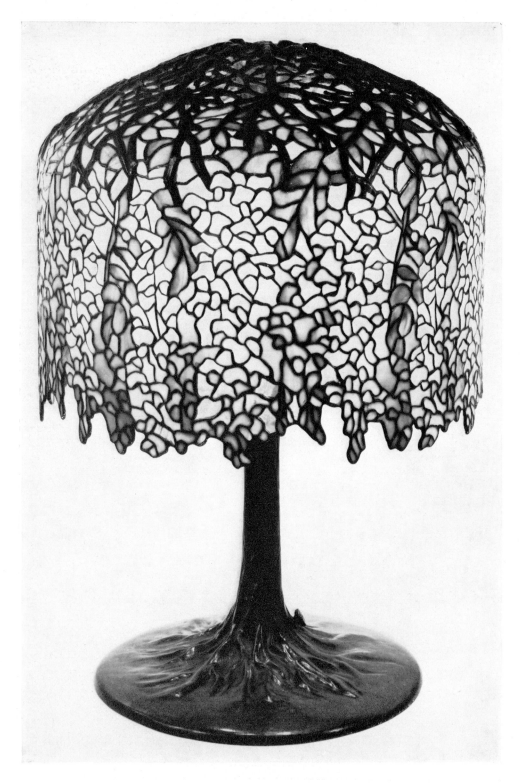

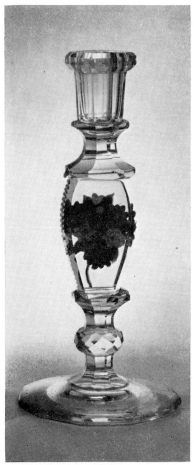

One of a very rare pair of Mount Washington faceted candlesticks. 9 in. (23 cm.) high Sold 9.5.72 for 980 gns. ($2675). From the collection of the late Monsieur and Madame Jean Herbette

Fine Tiffany bronze and stained Wistaria lamp, 28 in. (71 cm.) high, the base marked Tiffany Studios, New York, number 3158 Sold 6.3.72 for 4500 gns. ($12,285)

CHINESE CERAMICS
AND WORKS OF ART

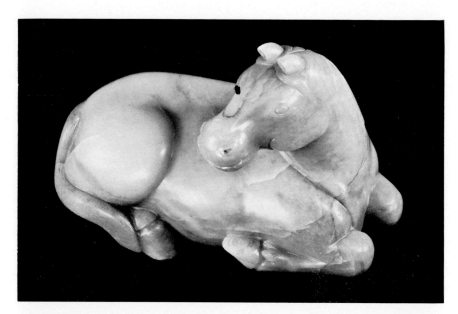

Massive early mottled pale-grey jade
carving of a recumbent Mongolian pony
11½ in. (29.5 cm.) long
Ming dynasty
Sold 5.6.72 for 12,000 gns. ($32,760)

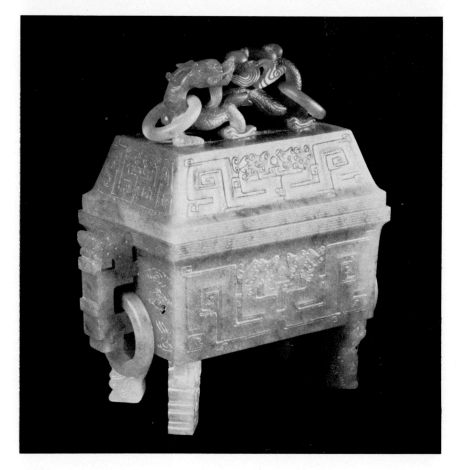

Fine apple-green jade Ting and cover
7¼ in. (18.5 cm.) high
Sold 5.6.72 for 13,000 gns. ($35,490)

Finely carved pale celadon jade water buffalo
6 in. (15 cm.) wide
Ch'ien Lung
Sold 29.11.71 for 1600 gns. ($4112)

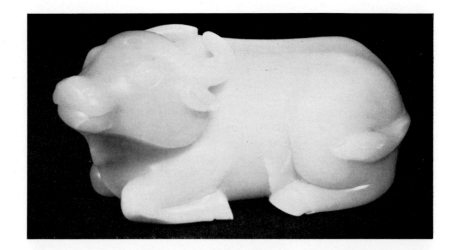

Fine egg-shell jade vase and cover
9½ in. (24 cm.) high
Tao Kuang
Sold 5.6.72 for 5500 gns. ($15,015)

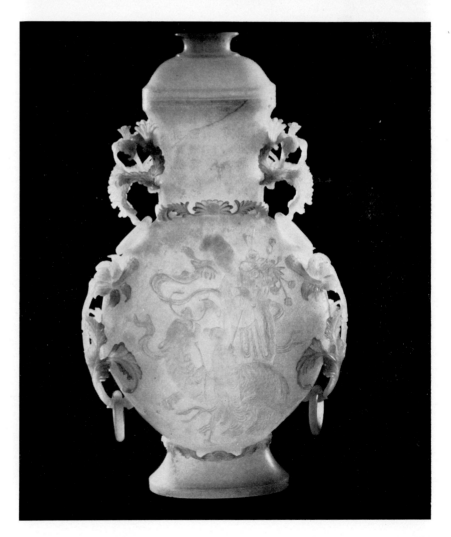

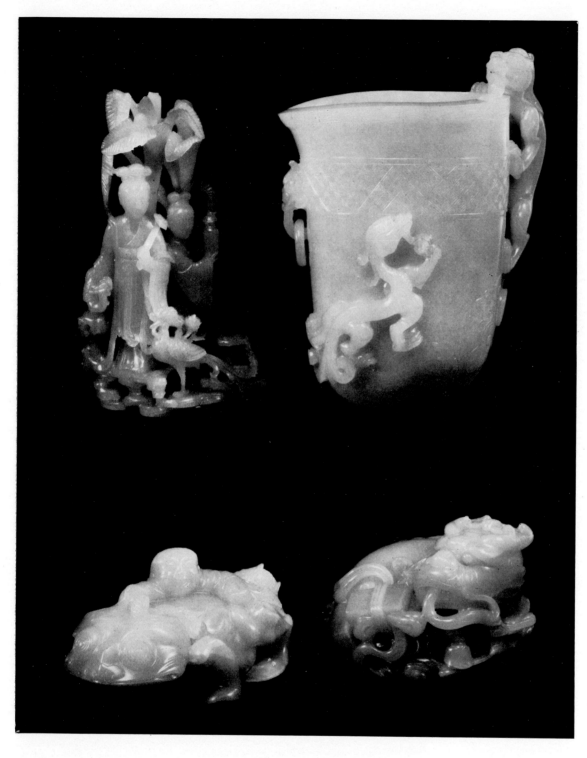

Four fine examples
of 18th-century
jade carving

Top left: two court
ladies
6½ in. (16 cm.) high
950 gns. ($2593)

Top right: a rhyton
6¼ in. (15 cm.) high
1900 gns. ($5187)

Bottom left: Liu Hai
and his three-legged
tadpole
5 in. (13 cm.) long
2000 gns. ($5460)

Bottom right:
Recumbent ch'i-lin
4 in. (10 cm.) long
2200 gns. ($6006)

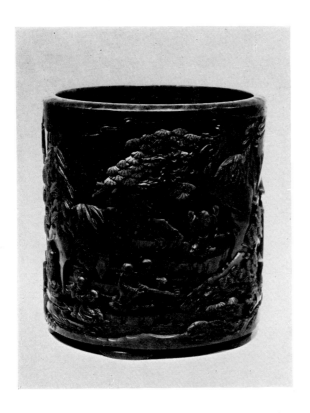

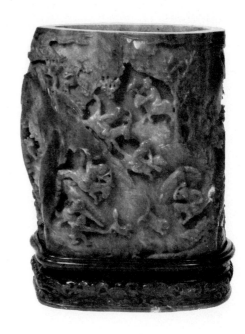

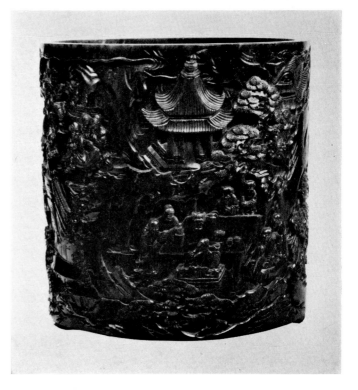

Three 18th-century jade brushpots carved in crisp relief with idealized scenes of everyday life

Top left: Small deep spinach-green jade brushpot carved with the date 1776, 6¼ in. (16.5 cm.) high
Sold 7.2.72 for 3400 gns. ($9282)

Top right: Irregular shaped brushpot, the subject carved from the russet 'crust' of the boulder
6 in. (15 cm.) high, on a shaped pierced spinach-green stand, both early 18th century
Sold 5.6.72 for 4000 gns. ($10,920)
From the collection of Dr Eric Vio

Bottom right: Brilliant spinach-green jade brushpot carved with the Eighteen Lohan on mountain terraces
7½ in. (19 cm.) high, K'ang Hsi
Sold 18.10.71 for 5800 gns. ($14,920)
From the collection of the Rt Hon Lord Margadale of Islay, TD, brought back after the sacking of the Summer Palace, Peking

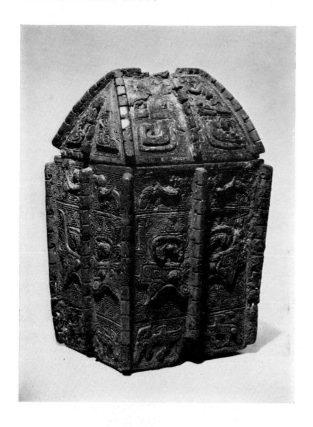

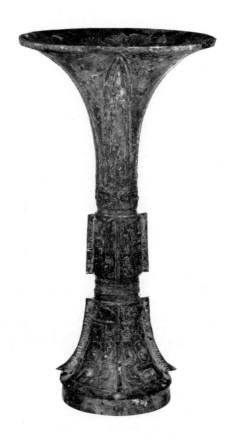

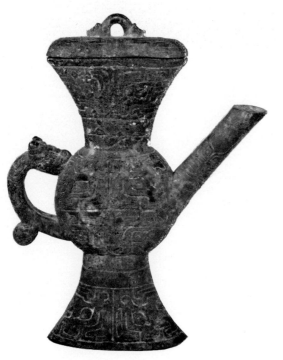

Top left: Fine archaic bronze fang-i, first phase, Shang dynasty
Sold 29.11.71 for 4700 gns. ($12,079)
From the collection of Georg L. Hartl

Top right: Finely cast archaic bronze Ku
11¾ in. (30 cm.) high, Shang dynasty
Sold 5.6.72 for 7000 gns. ($19,656)
Sold in these rooms March 29, 1939 for 92 gns.
From the collection of Mrs Guy Ridpath

Bottom left: Rare archaic bronze ewer and cover
9¾ in. (23 cm.) high, Chou dynasty
Sold 5.6.72 for 3000 gns. ($8190)

Massive cloisonné-
enamel incense-burner
and cover
37¾ in. (96 cm.) diam.
56 in. (142 cm.) high
Ch'ien Lung
Sold 18.10.71 for
1100 gns. ($2827)
From the collection of
the Rt Hon Lord
Margadale of Islay, TD
From the Summer
Palace, Peking

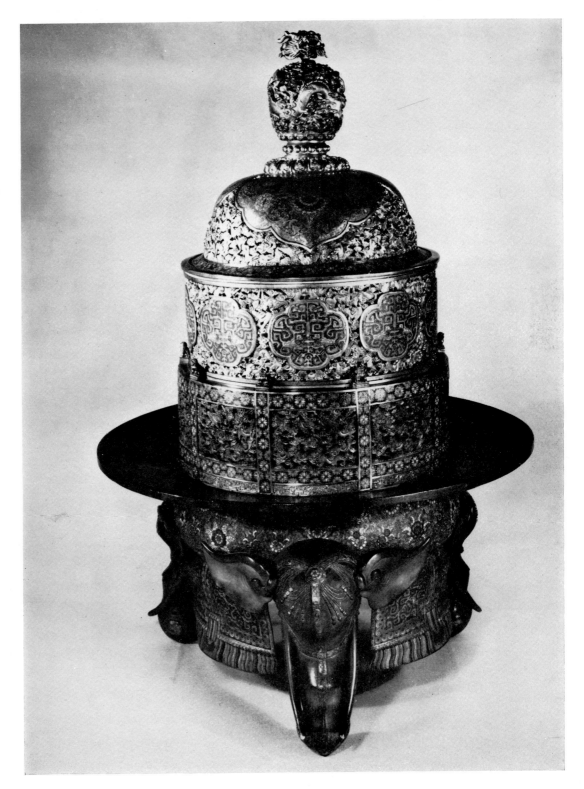

A fourteenth-century wine jar

The fourteenth-century Chinese wine jar (illustrated opposite) was found by Anthony Derham, one of our Oriental works of art directors, in a collection on the Continent only as a result of a request for a new valuation for insurance. At the time, it was being used as an umbrella stand. In fact, however, it is the third known example of a group of audaciously experimental works, the two other vases being in Peking, and in the Percival David Foundation, London.

Although by 1350 porcelain as a material held few secrets from the kiln masters at Ching-tê-chen, large or elaborately potted pieces which succeeded must have been thought of as triumphs and the group into which this wine jar falls must have been the work of one of the most daring kilns. The technicalities involve luting together a heavy slab base, a two-part body thick enough to have panels cut into it (during the 'leather' hardness stage of drying) and a short neck; then sticking small pre-moulded flowers and leaves on short stalks into the recessed panels, and the final double surrounds of 'sugar icing' beading. To succeed in all these processes is extraordinary enough, but in addition throughout a long firing any serious fluctuation in a temperature, which was controlled by the opening of 'draught' doors, could not only cause a total collapse, but would certainly affect the colour of either the underglaze copper red flowers or the cobalt blue decoration. It is only when all these considerations are borne in mind that we can appreciate the difficulties of a jar firing so well.

It is hardly surprising that such a rare and desirable object should achieve a world record price, but even so 210,000 guineas ($573,000) – more than has ever been given before for any work of art other than a painting – brought loud applause.

Highly important mid-fourteenth century underglaze red-and-blue wine jar, height 13½ in. (34.3 cm.), base diam. 6¾ in. (17.2 cm.), neck diam. 5¾ in. (14.7 cm.), max. diam. at shoulder 12¾ in. (32.5 cm.) Sold 5.6.72 for 210,000 gns. ($573,300)
A world record auction price for any work of art other than a picture

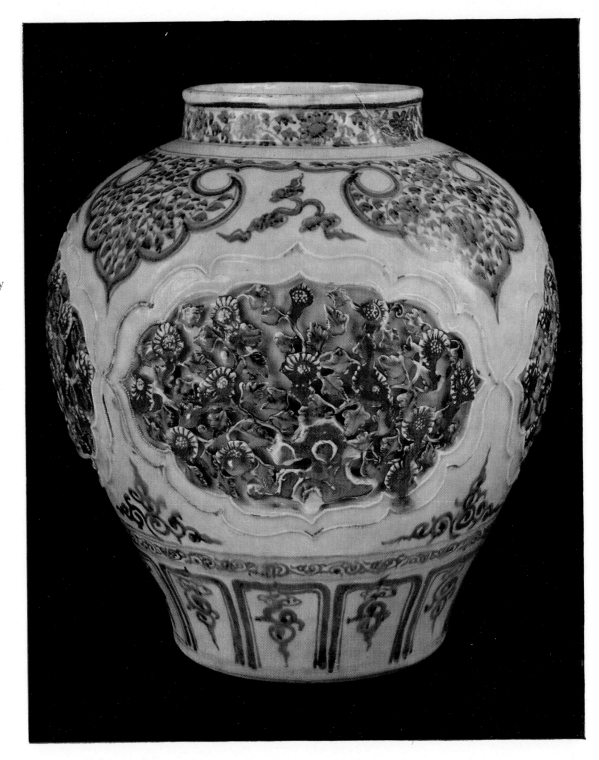

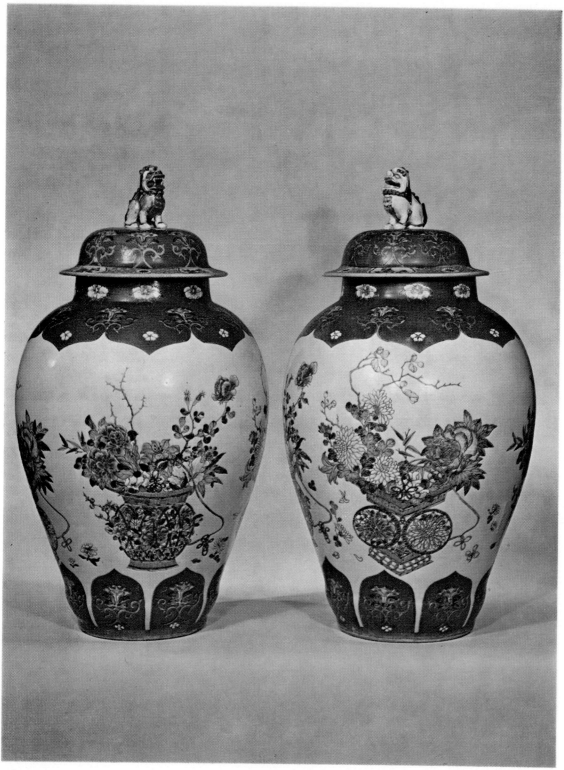

Important pair of
famille rose ruby-
ground vases and
covers
25 in. (63.5 cm.)
high, Yung Cheng
Sold 18.10.71 for
3600 gns. ($9261)
From the collection
of the Rt Hon
Lord Margadale of
Islay, TD

Top left: Important glazed buff pottery oviform jar
14¾in. (37.5 cm.) high
T'ang dynasty
Sold 29.11.71 for
13,500 gns. ($34,728)

Top right: Fine small San Ts'ai glazed moulded white pottery pilgrim flask
6¼ in. (16 cm.) high
T'ang dynasty
Sold 5.6.72 for
3200 gns. ($8736)

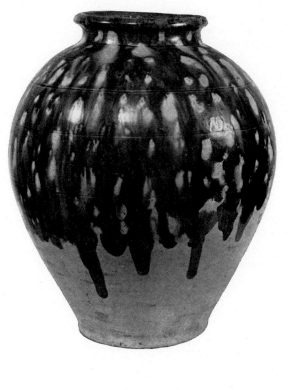

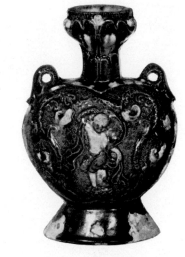

Bottom left: One of a pair of Huang Huali high-standing rectangular altar-coffers (men-hu-ch'u)
27 in. (69 cm.) wide
Late 17th century
Sold 5.6.72 for
2000 gns. ($5460)

Bottom right: One of a rare pair of fine early Huang Huali armchairs (fou-shou-i)
42 in. (106.5 cm.) high
Late 16th century
Sold 5.6.72 for
1900 gns. ($5187)

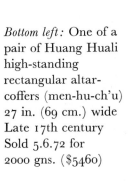

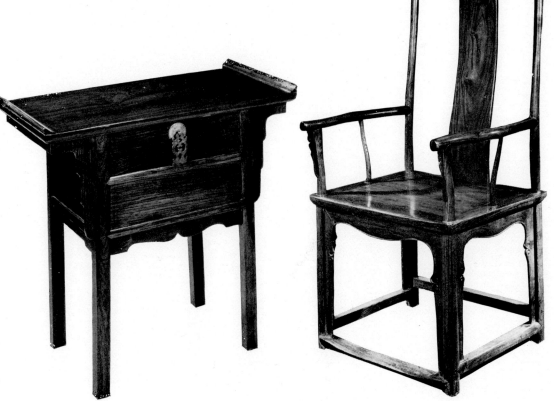

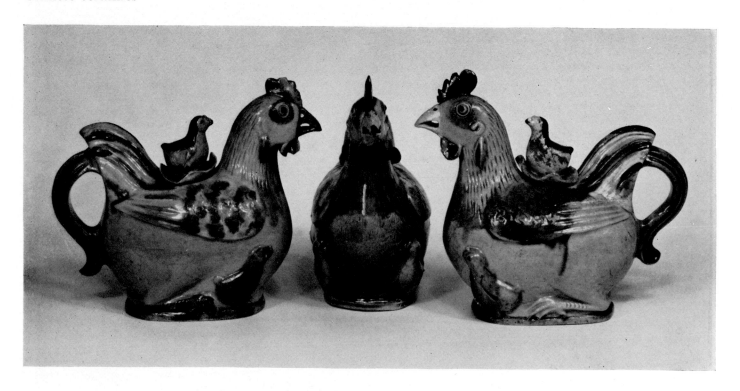

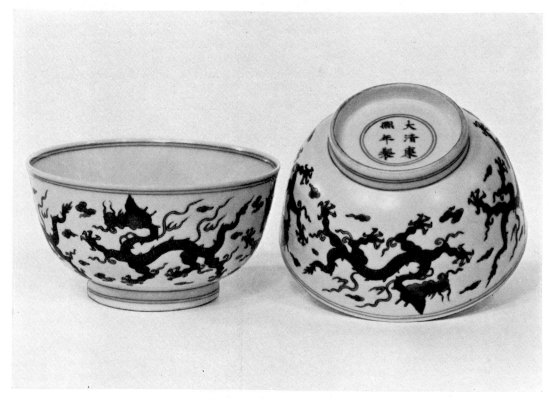

Top: Pair of famille verte chicken wine ewers and covers
6 in. (15 cm.) long
K'ang Hsi
Sold 1.11.71 for
1600 gns. ($4112)

Top centre: One of a pair of famille verte chicken wine ewers and covers
6 in. (15 cm.) long
K'ang Hsi
Sold 1.11.71 for
1600 gns. ($4112)

Pair of fine green-dragon bowls
5½ in. (14 cm.) diam.
K'ang Hsi
Sold 5.6.72 for
1800 gns. ($4914)

Rare Ming yellow and blue small circular saucer-dish
8½ in. (21.5 cm.) diam.
Ch'eng Te
Sold 5.6.72 for 3700 gns. ($10,101)

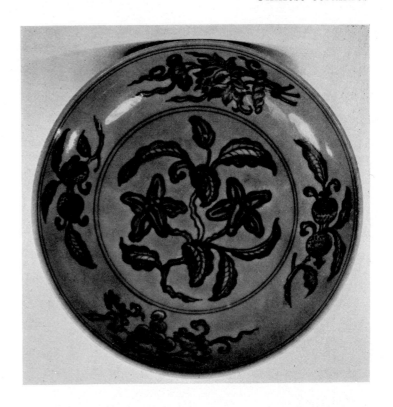

Pair of rare Ming celadon barrel-shaped garden seats
17 in. (43 cm.) high
15th century
Sold 5.6.72 for 3600 gns. ($9828)

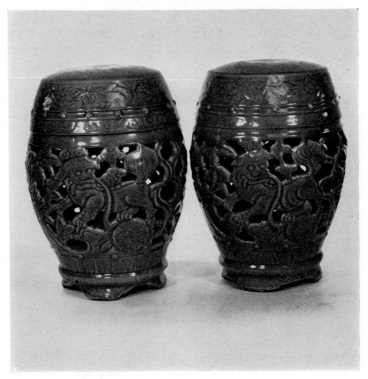

Fine and large Honan deep bowl, 11½ in. (29 cm.) diam. Southern Sung dynasty. Sold 5.6.72 for 3400 gns. ($9282)

Fine carved Ting yao shallow dish 10½ in. (27 cm.) diam., Northern Sung dynasty Sold 5.6.72 for 4800 gns. ($13,104)

Fine early Ming blue and white shallow dice bowl 10¼ in. (26 cm.) diam., Hsüan Tê. Sold 29.11.71 for 5200 gns. ($14,196)

14th-century blue-and-white cup stand 7¾ in. (19.5 cm.) diam. Sold 5.6.72 for 1800 gns. ($4914)

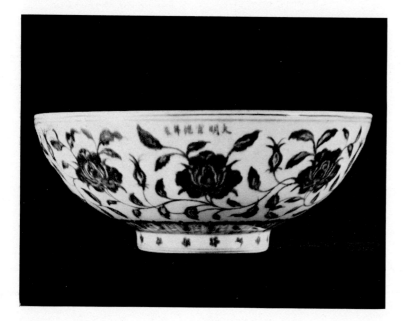

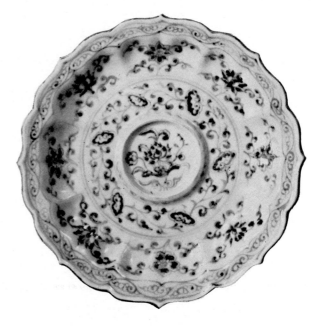

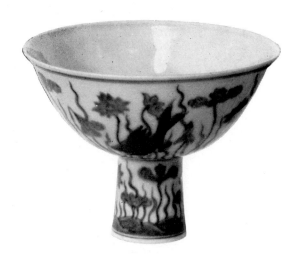

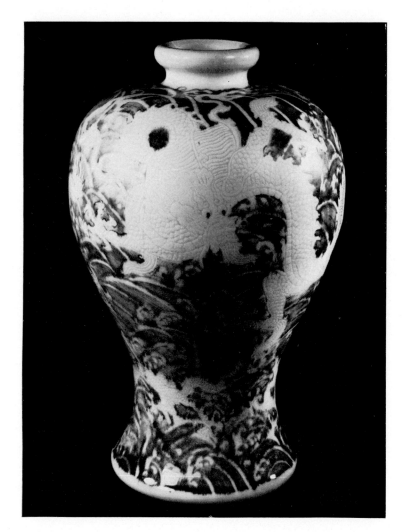

Two fine and typical examples of 18th-century porcelain, taking both their form and decoration from early Ming dynasty originals

Mei-p'ing with incised dragons on an underglaze red ground
13½ in. (34 cm.) high
Painted with the six-character mark of the early 15th-century emperor Hsüan Tê, but Yung Chêng
Sold 1.11.71 for 2000 gns. ($5140)

Rare underglaze red-and-blue stem cup
6¼ in. (16 cm.) diam.
Yung Chêng
Sold 5.6.72 for 2800 gns. ($7644)

The change in taste for later Chinese porcelain

BY ANTHONY DU BOULAY

On 18th October 1971, and 5th June this year, Christie's sold further portions of the famous collection formed by Alfred Morrison of Fonthill. The collection was one of the first of real importance to be formed in the West which included porcelain and enamel made for the Chinese as opposed to the European market. This happened as a result of the sacking of the Summer Palace of the Chinese Emperor in 1860. Lord Loch of Drylaw returned to London in that year with a quantity of packing cases of pieces he had acquired and which he sold to Alfred Morrison for a comparatively small sum of money. In addition to these Morrison bought from the leading London dealers of the period, as the collection had to be filled out with the type of porcelain that was then popular and remained so until the second world war. These were large garnitures of vases and beakers, mandarin jars and enormous cloisonné enamel jardinières.

The majority of the porcelain bought from Lord Loch comprised bowls and vases elaborately decorated in famille rose enamels on coloured grounds with turquoise (foreign green) glazed interiors and bases. A typical piece was the openwork revolving vase sold for 720 guineas ($1966), referred to by Honey as 'miracles of misapplied skill'. Up to last year porcelain of this kind was viewed in the West with deep suspicion, but the provenance and date of acquisition of the Morrison pieces, allied to their extraordinary quality and of course the recent change in fashion, gave confidence to the new generation of collectors who paid previously unheard-of prices.

Perhaps the finest of all the pieces was the pilgrim flask (see illustration opposite). Among the larger pieces fashionable in the nineteenth century were the two pairs of vases (see illustration page 296), the first being sold in October for 3600 guineas ($9261) and the second in June for 5800 guineas ($15,834). The difference in price was not due to any great rise during the intervening nine months, but to the vagaries of the saleroom and enthusiasm between two collectors on the second occasion.

The majority of the mandarin jars besides being more difficult to place in the modern interior had suffered the assaults of housemaids and others in the hundred years they had been in the house, and the only perfect example, a rare famille verte vase, fetched the good price of 2800 guineas ($7644).

Excluding the jade brushpot, (see illustration page 291), about a third of the October sale consisted of cloisonné and Canton enamels. Though there was nothing like the famous Hsüan Tê cloisonné enamel jar and cover sold for 7000 guineas ($19,110) in 1965, there were a number of interesting eighteenth-century pieces. The most important of these was the magnificent, though unwieldly, incense-burner (see illustration page 293). Other interesting prices were the 900 guineas ($2457) paid for a pair of massive fish bowls and 580 guineas ($1583) for another similar. It must be mentioned that this last had probably been bought from Henry Durlacher in 1866 for £660. A pair of Canton enamel garden seats fared somewhat better over the years, fetching 360 guineas ($983) despite some extensive chips, as against the 100 guineas also paid in 1866.

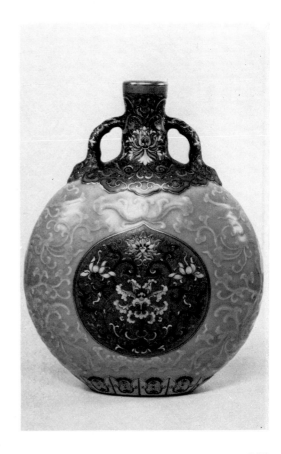

Brilliantly moulded and enamelled famille rose pilgrim flask, from the Summer Palace, Peking
10½ in. (26 cm.) high
Ch'ien Lung
Sold 18.10.71 for 3600 gns. ($9261)
From the collection of
the Rt Hon Lord Margadale of Islay, TD

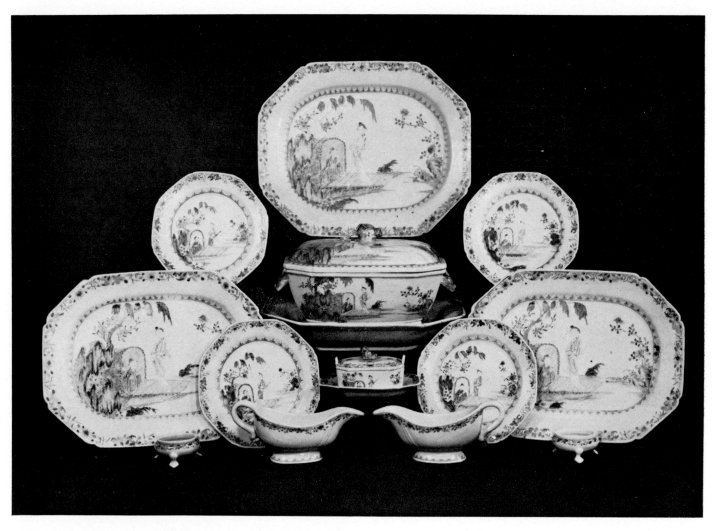

Fine famille rose dinner-service
Ch'ien Lung
Sold 20.3.72 for 4800 gns. ($13,104)

Rare large famille rose figure of
an elephant
23 in. (58 cm.) high
Ch'ien Lung
Sold 20.3.72 for 12,500 gns. ($34,125)
From the collection of
Mrs James de Rothschild

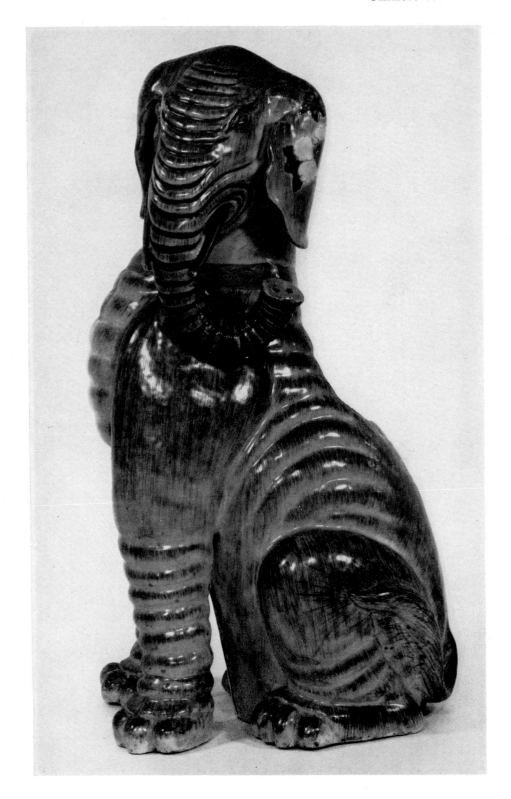

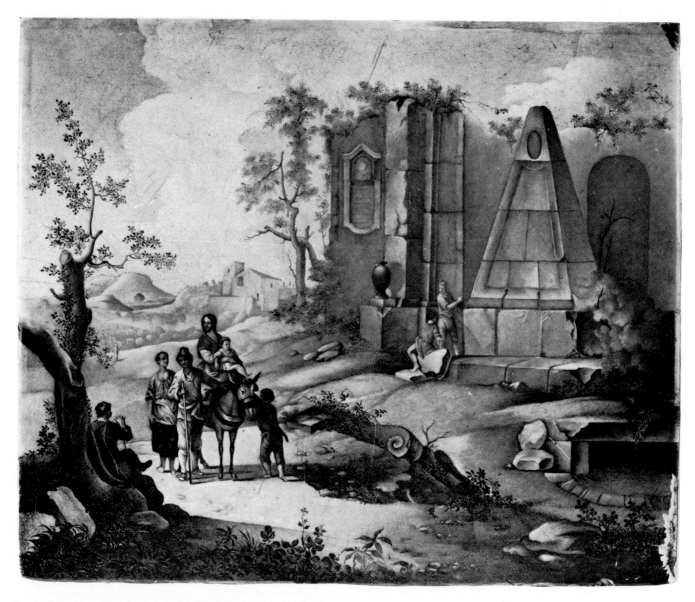

Rare Canton enamel plaque painted with a romanticized scene of the Flight into Egypt
In the style of Nicholas Berchem, 15 × 12 in. (38 × 30 cm.)
Ch'ien Lung
Sold 7.2.72 for 1000 gns. ($2730)
From the collection of the late Lady Margaret Oudendyk

One of four large 18th-
century Canton enamel
lunettes painted with
hunting scenes
Sold 24.5.72 for £1266
(L. 1,900,000) at the
Salone Margherita, Rome

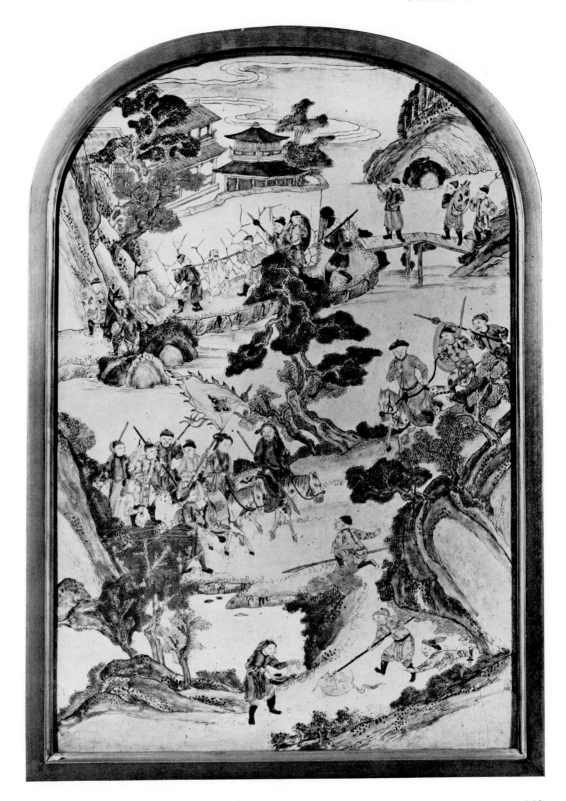

 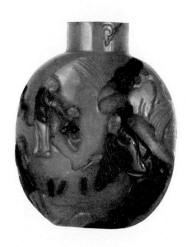

Right: Very fine Soochow School grey agate bottle carved with immortals in a landscape
Sold 15.11.71 for 1000 gns. ($2570)

Left: Soochow School grey agate bottle carved with figures
Sold 3.7.72 for 850 gns. ($2142)

As a result of increased knowledge over the last few years, prices for certain groups of snuff-bottles have risen considerably. The most important of these groups are those bottles from the Soochow School of carving. As the name implies, this school worked in Kiangsu province between 1780 and 1860. It specialized in the carving of grey agate, using all the dark brown inclusions of the stone in the decoration. Other schools did use the inclusions, but the trade mark of the Soochow School is the brilliant technical perfection of the majority of examples. No other school is so consistently excellent. Small oval-shaped bottles with flat bases were favoured and the majority are not very well hollowed. Other characteristics can be seen in the stylized carving of folding rocks, clouds, pines and streams.

Left: Grey and brown agate bottle, the fish with 'eyeball' inclusions
Sold 3.7.72 for 340 gns. ($857)

Centre: Dark brown agate bottle with lighter inclusions carved with a bird on a branch
Sold 8.5.72 for 280 gns. ($764)

Right: Grey and brown agate bottle carved with the moon and pines
Sold 3.7.72 for 520 gns. ($1310)

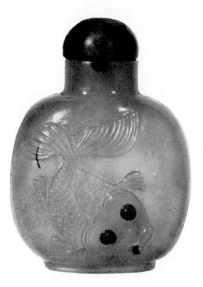 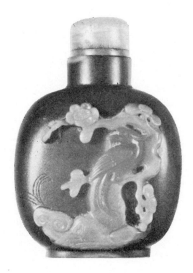 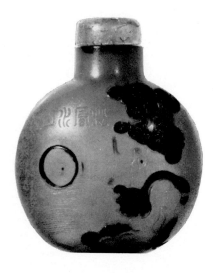

JAPANESE
AND TIBETAN
WORKS OF ART

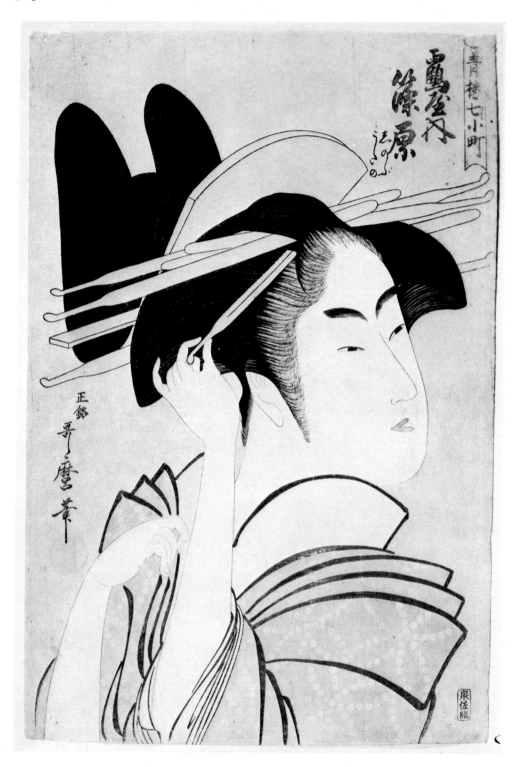

Fine oban tate-e 'large head'
portrait of Shinohara of Tsuruya
From the series Seiro Nana
Komachi, by Utamaro
Sold 25.1.71 for 680 gns.
($1821)

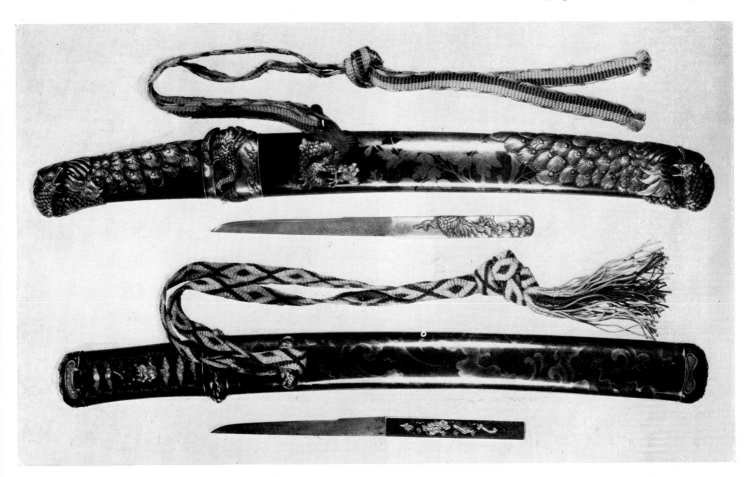

Top: Superbly mounted aikuchi tanto, the lacquer scabbard decorated in
gold and black lacquer, the silver mounts carved with peacocks
Signed Ishiguro Masayoshi (1781–1851), the fine blade signed
Yamato Daijo Fujiwara Masanori, mid-17th century
Length 11¾ in. (30 cm.)
Sold 6.6.72 for 3800 gns. ($10,374)
Finely mounted aikuchi tanto, the lacquer scabbard decorated in gold
lacquer, the shakudo mounts carved and inlaid in gold with dragons
The blade signed Kaneura, mid-16th century
Sold 6.6.72 for 1300 gns. ($3549)

Fine oval iron swordguard carved and inlaid in copper and gold with a carp
in a stream, signed Natsuo
Sold 16.11.71 for 800 gns. ($2056)

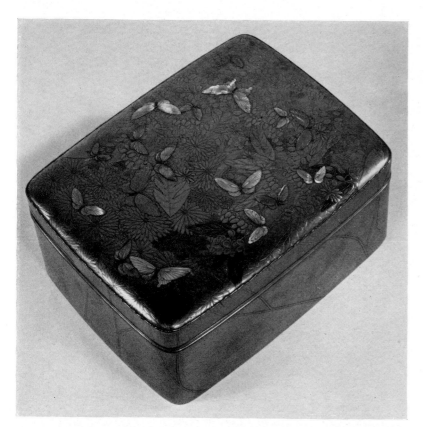

Extremely fine ryoshi-bako decorated in various
techniques of gold lacquer and inlaid in aogai
Unsigned, 19th century
9¼ × 7¼ × 3¾ in. (23.5 × 18.5 × 9.5 cm.)
Sold 6.6.72 for 1000 gns. ($2730)
From the collection of Mrs J. Monkman

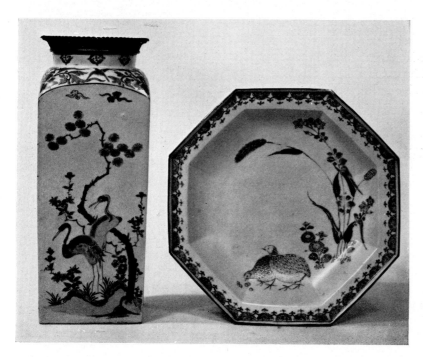

Left: One of a pair of Kakiemon vases
11½ in. (29 cm.) high
17th century
Sold 14.3.72 for 1600 gns. ($4368)

Right: One of a pair of Kakiemon dishes
9¾ in. (22.5 cm.) high
17th century
Sold 14.3.72 for 600 gns. ($1638)

Fine quality brown-laced Do-Maru
The sixteen-plate helmet signed
Haruta Mitsusada
16th century
Sold 2.5.72 for 1500 gns. ($4095)

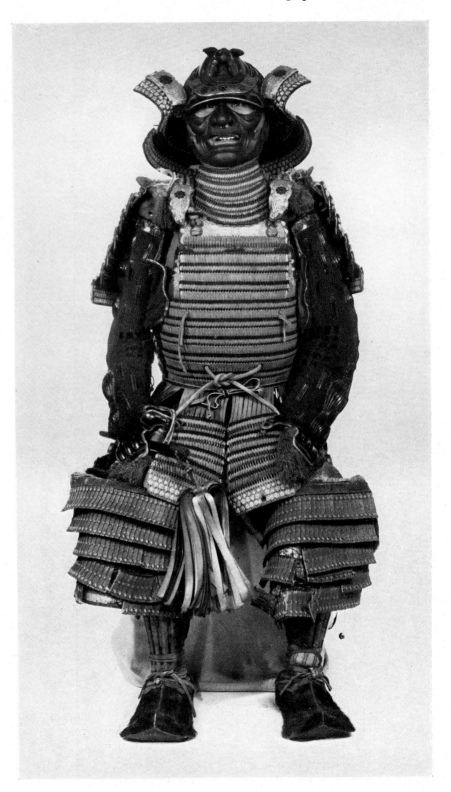

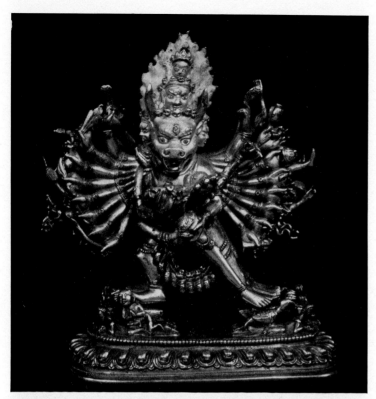

Fine Tibetan bronze group of Vajrabhairava and his Sakti
4¾ in. (12 cm.) high
17th century
Sold 4.7.72 for 780 gns. ($1966)

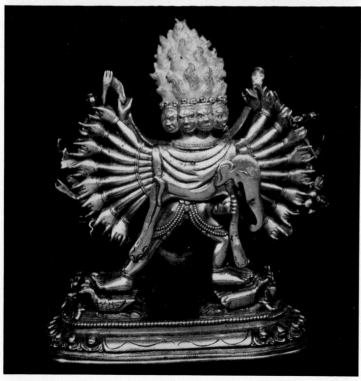

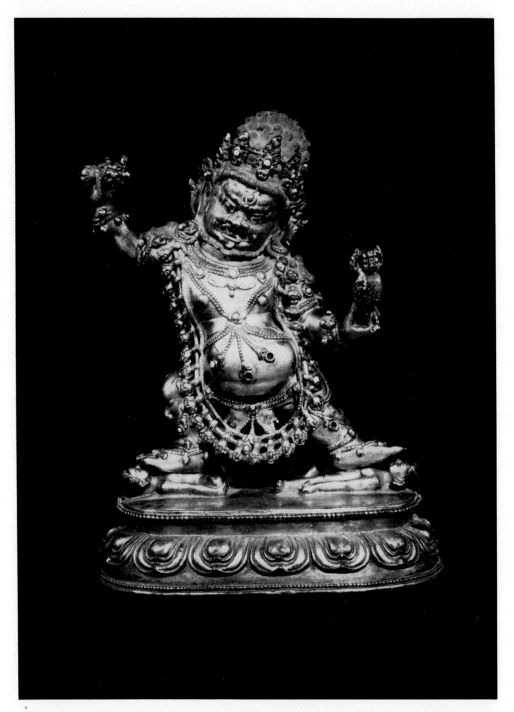

Fine Tibetan gilt bronze figure of the Yi-dam Samvara, $5\frac{3}{4}$ in. (14.5 cm.) high
16th century
Sold 4.7.72 for 750 gns. ($1890)
From the collection of the late Lt-Col F. M. Bailey

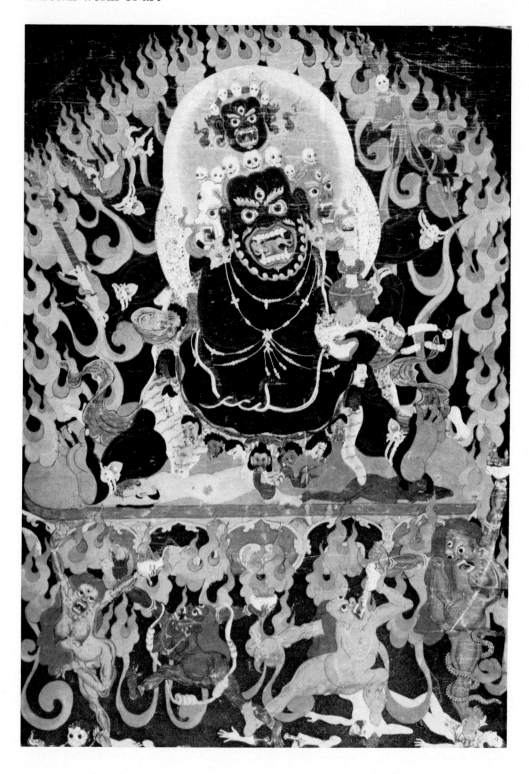

Fine Tibetan Thanka, with a
ferocious figure of Mahakala
30 in. (76 cm.) high
18th century
Sold 8.11.71 for 440 gns.
($1131)
From the collection of
A. C. Stubbs, Esq

Fine Tibetan Thanka, showing a
Mahasiddha (Sorcerer)
50 in. (127 cm.) high
17th century
Sold 8.11.71 for 580 gns.
($1491)
From the collection of
Milton Gendel, Esq

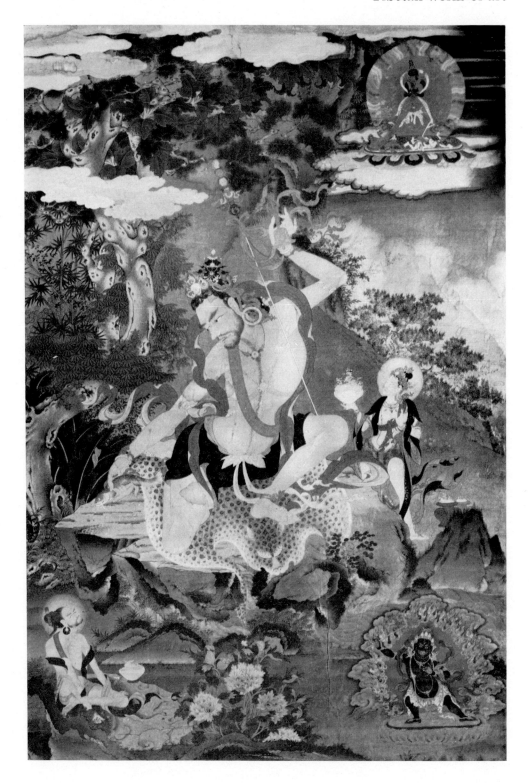

Central heating and works of art

BY JOHN HERBERT

Central heating, which is such a boon in many homes today, can in time cause a panel picture to warp and go 'bang', or a piece of furniture to split down the sides unless proper precautions are taken. This is somewhat ironic when one thinks that hundreds of such works survived the journey from their country of origin, some of them two hundred years ago or more, before sophisticated packing materials were invented and when forms of transport were still comparatively primitive.

The most vulnerable works of art to central heating are panel paintings, modern wood sculpture, furniture, particularly those decorated with veneers, miniature portraits and other works of art painted on ivory, like tryptychs, Japanese and Chinese lacquer, icons and leather bindings; in fact any work of art of an organic nature.

The damage done to these works of art is caused not simply by heat, but by the moisture being taken out of the atmosphere abruptly. The change in relative humidity levels causes the materials to expand or contract at different rates, depending on whether the heating is being turned on or off. A sudden cold snap, or an electricity failure due to an industrial dispute, can do as much damage as the perfectly human reaction of wanting to turn the heating full on when one returns home after a holiday.

Mr. Arthur Lucas, chief restorer at the National Gallery, explains it very simply: 'It's when man steps in that one gets into trouble. When cool air is heated it will expand; however, as there is only the same amount of moisture for a greater volume of air, the relative humidity will drop. It is the latter conditions which cause the most damage in winter time, especially in modern buildings with very efficient central heating. The basic need in a room where there are works of art is to have a small excess of humidity in order to induce the moisture back into the object. The typically Victorian room with its potted plants, heavy drapes and clutter of furniture was perfect because they were all compensating each other.'

In the case of pictures the dangers of central heating apply to a comparatively small group, namely works on panel. These can warp to an extraordinary degree; on one occasion Rubens' *Château de Steen* in the National Gallery split with a loud report. Even in the days of Van Eyck the risk of a panel contracting and expanding through a

Rubens' panel of
Chapeau de Paille
showing splits at bottom
and down right hand side
where the artist added
two pieces of wood to the
original work

By courtesy of the National Gallery

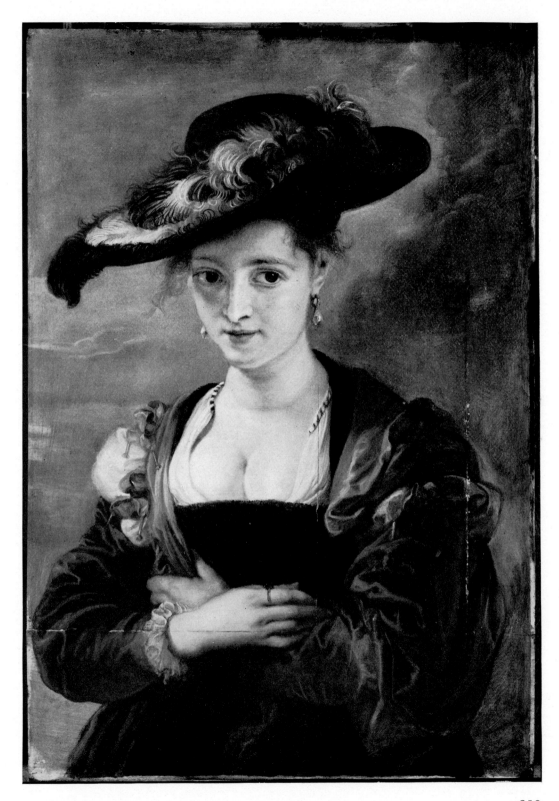

change in temperature levels was known, because many artists sought to control the humidity by applying a balancing layer of gesso or chalk. Sometimes the damage caused to many works was as much the fault of the artist as the heating (although naturally not 'central' in those days). Rubens was often at fault because having started on a picture he would decide to enlarge it, and add pieces of wood which ran contrary to the grain of the original panel. Not unnaturally large cracks appeared where the wood was expanding in different directions (see illustration on page 319 of Rubens' *Chapeau de Paille* in the National Gallery with cracks on the right hand side and bottom of the picture where the picture was enlarged).

Damage can also be done by bad conservation. In the 'thirties the correct protection for a panel picture was considered to be a 'cradle'. This process consisted of gluing strips of wood to the back under pressure and in the same direction as the grain. In each slat a number of slots was cut, so that transverse slats could be put through them which were movable and ran across the grain of wood. The theory was that the transverse slats kept the panel flat, but being movable enabled it to expand and contract within limits.

This method of restoration or protection is by no means foolproof. Mr Lucas says that by locking the movable part of the panel, the pressure comes in an uneven manner when the panel warps, and in the end produces a 'washboard' similarity. The modern technique is to flatten the panel by means of moisture – literally putting wet rags underneath it so that it contracts. The next step is to plug and glue the crack. Then the whole of the back is sealed with wax resin and balsa wood (running with the grain of the picture). This process is designed to stop the moisture getting out not only from the front but also the back of the panel, and is basically a more thorough version of what the masters did in the old days.

Apart from a panel warping and eventually cracking, contraction of the panel can cause the paint to lift off and form blisters. Sometimes if the warping is considerable these blisters may break. If a panel starts to blister it should be laid flat on the ground and an expert restorer sent for. It should never ever be dusted.

Turning to veneered furniture, Norman Bromelle, Keeper of Conservation at the Victoria & Albert Museum, says that this is particularly prone to damage from central heating because it produces long spells of low relative humidity during the winter. The 'carcase' or main body of the piece which may very likely be made of pine or oak will often contract to a different extent than the kingwood, sycamore or maple veneers which cover it. In time this differential expansion and contraction will cause the veneers to split (see illustration opposite) and become detached. Metal inlays, such as ormolu or brass, being unaffected by humidity changes can buckle.

The only reason why so much fine furniture is still in reasonably good condition is

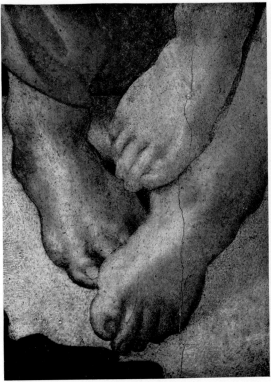

that it has in the past generally stood in large country houses where modern central heating has not been installed. Consequently the average temperature during the winter was lower and the humidity higher. The presence of curtains and furnishings also helped in buffering the atmosphere against rapid humidity changes.

The converse is the liking of Americans for a much higher temperature in their homes than the British, and thus many years ago a more general installation of central heating. This naturally put French furniture, which in the 'twenties and 'thirties had become very popular, at risk. Pieces suffered to such an extent that collectors were chary of buying it and prices at auction dropped considerably. I hasten to add that thanks to modern research this unhappy situation no longer obtains, and in the last thirteen months Christie's have sold two of the only four pieces of French furniture ever to fetch over £100,000 ($240,000).

To show how important it is to keep the atmosphere moist, it is worth recalling the sale in 1958 by Christie's for £35,700 ($107,100) of a superb Louis XV marquetry writing table made by J. F. Oeben, which remained a world record price for a piece of furniture for many years. The table came from the collection of the 2nd Baron Llangattock and had been stored in a garage – albeit a well-built one – for the whole of the war. It emerged from its dust-sheets and seclusion in virtually perfect

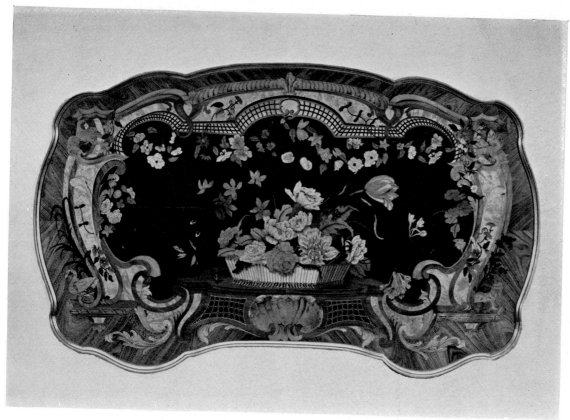

The top of the
Louis XV table from
the Llangattock
collection which
survived the war in a
garage, and was sold
by Christie's in 1958
for £35,700
($107,100)
The marquetry was in
virtually perfect
condition

condition. Today if it is in the same state it will probably be worth about £140,000 ($336,000).

To protect such beautiful objects it is necessary to simulate the Llangattock garage atmosphere by installing a humidifier to add moisture where required and a hydrometer to warn of changes in humidity. In extreme cases a panel picture should be placed in a 'shadow box' which hermetically seals it and damps off the moisture changes between day and night and summer and winter. Examples of these can be seen in the Rubens room in the National Gallery. I need hardly say, however, that this and other forms of restoration to panels, miniature portraits, and other works of art of an organic nature, should only be undertaken by real experts.

Within the space available it is impossible to do more than touch on the problems raised by central heating. Equally well it is only fair to say that if the precautions mentioned above are taken and, also the advice of the National Heating Consultancy, collectors should be able to sleep well in their beds without being woken by the occasional loud report.

ENGLISH, FRENCH AND
CONTINENTAL
FURNITURE,
CLOCKS, WORKS OF ART,
MUSICAL INSTRUMENTS,
ORIENTAL RUGS
AND TAPESTRIES

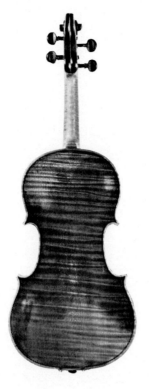
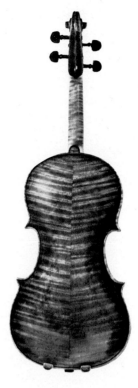

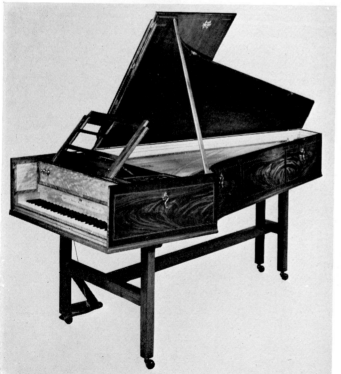

Top left: Italian violin, by Joseph Gagliano, 1763
Length of back 14 in. (35.6 cm.)
Sold 23.3.72 for 1200 gns. ($3276)
From the collection of Miss Penelope Howard

Top centre: French violin, by J. B. Vuillaume, 1823
Length of back 14 in. (35.6 cm.)
Sold 28.10.71 for 1100 gns. ($2827)
From the collection of Mrs H. G. Leyson Cooney

Top right: Italian violin, by David Tecchler, 1719
Length of back 14 in. (35.6 cm.)
Sold 23.3.72 for 4200 gns. ($11,466)

Fine George III mahogany single-manual harpsichord
By Jacob and Abraham Kirckman, 1785
89 in. (226 cm.) long, 37½ in. (95 cm.) wide
Sold 11.11.71 for 2200 gns. ($5654)

Right: One of a pair of George I gilt gesso mirrors
60½ × 31 in. (154 × 79 cm.)
Sold 25.5.72 for 1,400 gns. ($3,822)
From the collection of Sir James Younger, CBE, JP

Bottom left: Early George III giltwood overmantel
In the style of Ince and Mayhew
54 × 79 in. (137 × 201 cm.)
Sold 11.11.71 for 3500 gns. ($9015)

Bottom right: One of an important pair of George II giltwood frames
With contemporary Venetian School paintings
55 × 57 in. (140 × 145 cm.)
Sold 16.3.72 for 9000 gns. ($24,570)

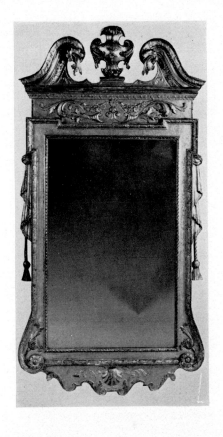

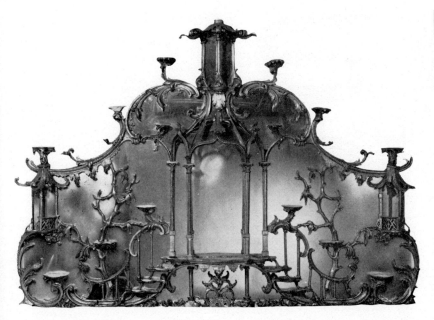

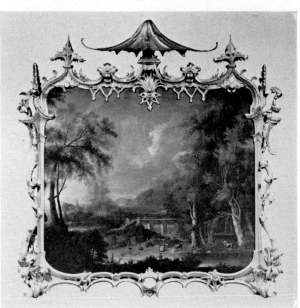

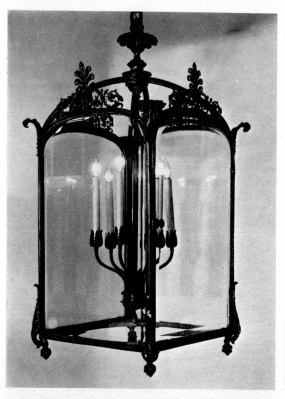

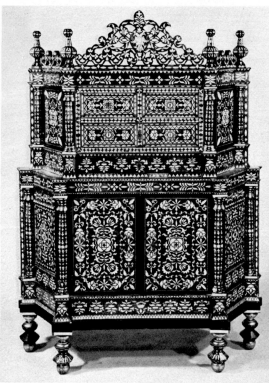

Top left: George III
gilt metal hall lantern
48 in. (122 cm.) high
Sold 25.5.72 for
1200 gns. ($3276)
From the collection
of The Hon Michael
Astor

Top right: One of a
pair of Spanish
mother-of-pearl, and
tortoiseshell cabinets
48 in. (122 cm.) wide
Sold 25.11.71 for
1200 gns. ($3084)
From the collection
of Mrs James de
Rothschild

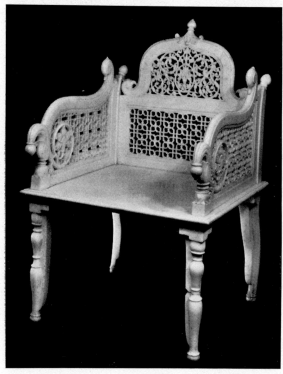

Bottom right: English
Serpent by T. Key
The bell mount
engraved
Coldstream Guards
Total length 82 in.
(207.5 cm.)
Circa 1815
Sold 28.10.71 for
210 gns. ($540)

Bottom left: Four
Indian white marble
throne chairs
From the collection
of The Rt Hon
Lord Margadale of
Islay, TD
Sold 1/2.11.71 for
1500 gns. ($3855)
on the premises at
Fonthill House
Tisbury, Wiltshire

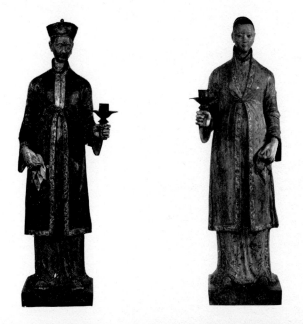

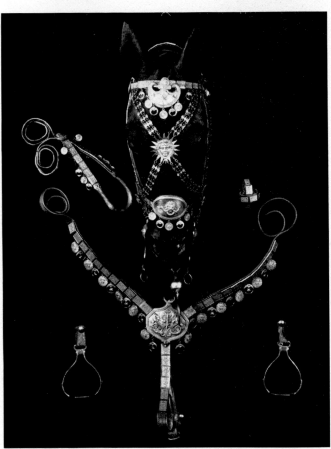

Top left: Pair of Regency polychrome plaster chinoiserie figures in the Brighton Pavilion taste
39 in. (99 cm.) high
Sold 11.11.71 for 2000 gns. ($5140)

Bottom left: Empire ormolu harness
In the 'Turkish' manner
Sold 23.3.72 for 1900 gns. ($5187)
From the collection of Countess Monica Esterhazy

Centre: Rare boxwood treble recorder
Length $19\frac{3}{4}$ in. (50.3 cm.) German, *circa* 1700
Sold 28.10.71 for 650 gns. ($1,671)
From the collection of
the late Herr Hans Eltzbacher

Bottom right: Pair of George III girandoles
$31\frac{1}{2} \times 17\frac{1}{4}$ in. (80 × 44 cm.) Irish, *circa* 1785
Sold 3.2.72 for 3200 gns. ($8568)
From the collection of Lord Bruntisfield

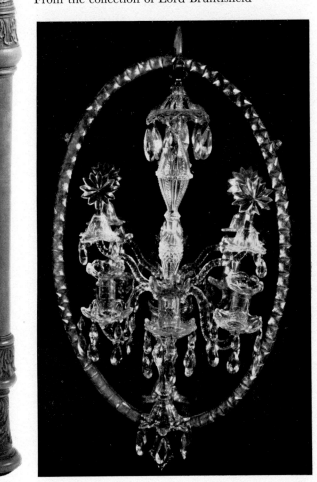

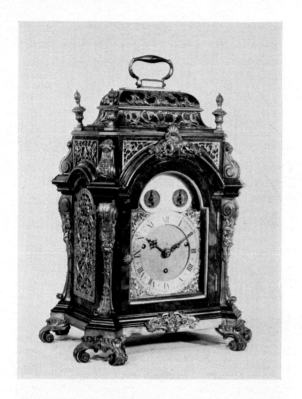

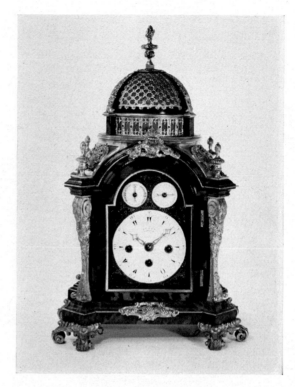

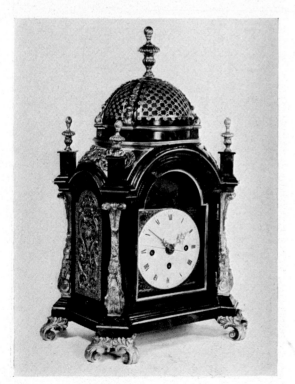

Top left: George III ormolu-mounted
tortoiseshell table-clock
By Francis Perigal, Royal Exchange
14½ in. (37 cm.) high
Sold 6.7.72 for 2600 gns. ($6552)
From the collection of
the late Sir Henry Sutcliffe-Smith

Top right: George III ormolu-mounted
tortoiseshell mantel-clock
Made for the Turkish market
By Henry Borrell, Exchange, London
16 in. (41 cm.) high
Sold 16.3.72 for 2100 gns. ($5733)

Bottom left: George III ormolu-mounted
tortoiseshell musical automaton bracket-clock
By William Story, London
16½ in. (42 cm.) high
Sold 9.12.71 for 2900 gns. ($7105)
From the collection of Dr Pierre Loup

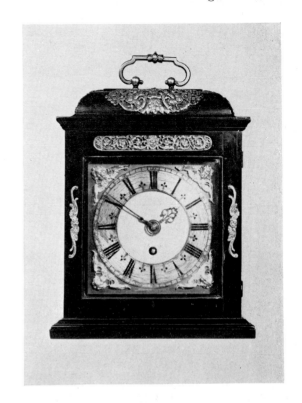

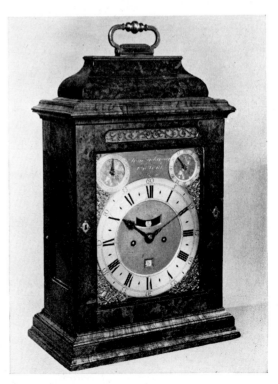

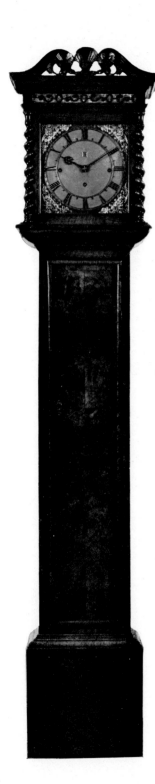

Top right: Ebony bracket-clock
By Joseph Knibb
13½ in. (34 cm.) high
Sold 6.7.72 for 2600 gns. ($6552)
Sold by The Red Cross Society
(Suffolk Branch)

Bottom right: George I burr walnut bracket-clock
By Daniel Delander, London
21 in. (51 cm.) high
Sold 9.12.71 for 2100 gns. ($5145)

Left: Important walnut longcase-clock
By Joseph Knibb
77 in. (195.6 cm.) high
The hood 16½ in. (42 cm.) wide
Sold 16.3.72 for 16,000 gns. ($43,680)

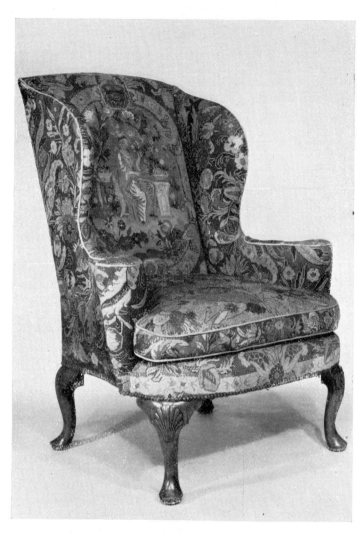

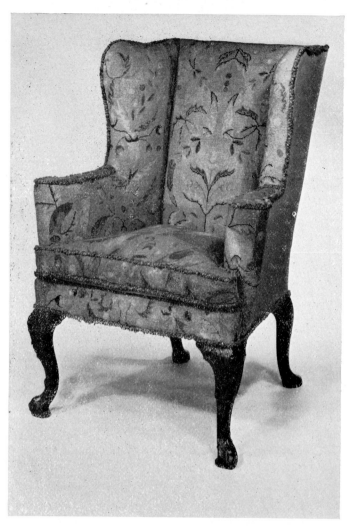

George I needlework and walnut wing armchair
Sold 25.5.72 for 1050 gns. ($2867)

George II small mahogany wing armchair
Sold 6.7.72 for 850 gns. ($2142)
From the collection of the late Miss C. A. Moore

Near right: One of a set of ten George III painted and gilt open armchairs
Sold 25.5.72
for 3200 gns. ($8736)
From the collection of the late Sir Nicholas and Lady Sekers

Far right: One of a set of six Regency parcel-gilt simulated rosewood open armchairs
Sold 25.5.72
for 1400 gns. ($3822)
From the collection of Rivers Carew, Esq

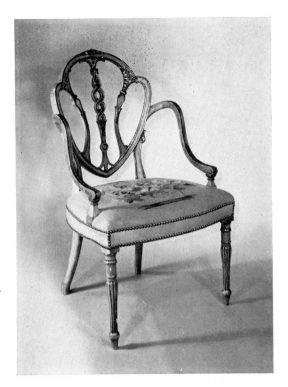

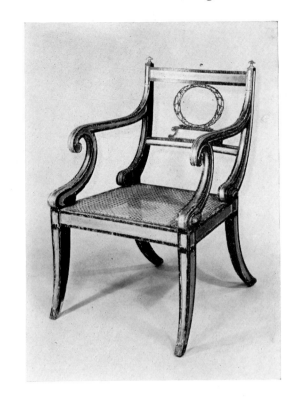

Near right: One of a set of seven George II mahogany dining chairs
Sold 11.11.71
for 2000 gns. ($5654)
From the Metropolitan Museum of Art, New York

Far right: One of a set of six George III mahogany open armchairs in the French manner
Sold 11.11.71
for 3600 gns. ($9261)

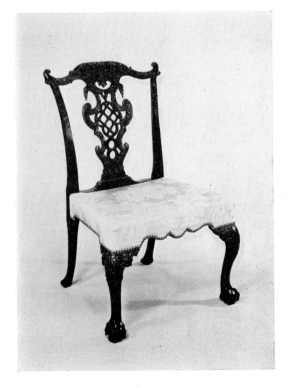

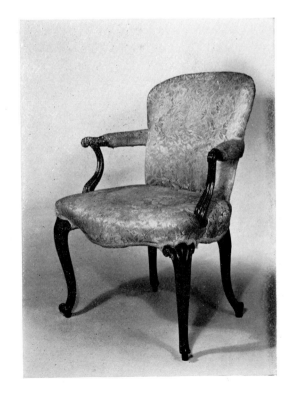

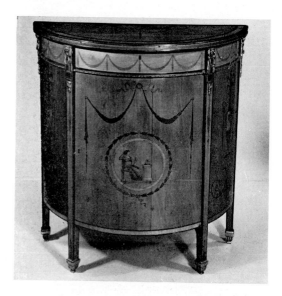

One of a pair of George III satinwood semi-circular side cabinets
32 in. (81 cm.) wide
Sold 11.11.71 for 4500 gns. ($11,565)

Important late George III inlaid satinwood serpentine commode
70 in. (178 cm.) wide
Sold 25.5.72 for 6500 gns. ($17,745)

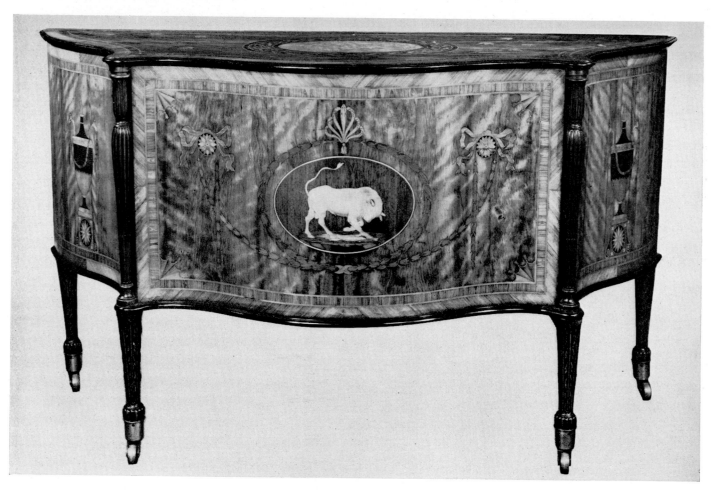

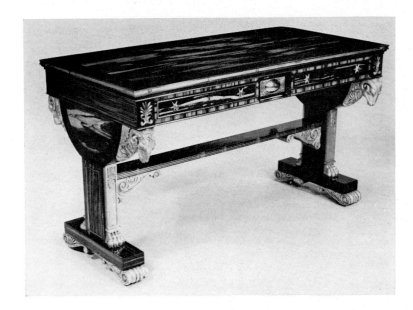

Important Regency calamander wood, giltwood and ebony writing table
In the style of George Smith
$52\frac{1}{4} \times 26\frac{1}{2}$ in. (133×67 cm.)
Sold 25.5.72 for 4800 gns. ($13,104)

Right: Regency rosewood dwarf cabinet, in the Southill manner
42 in. (107 cm.) wide
Sold 3.2.72 for 2200 gns. ($5890)
From the collection of Grace, Countess of Dudley

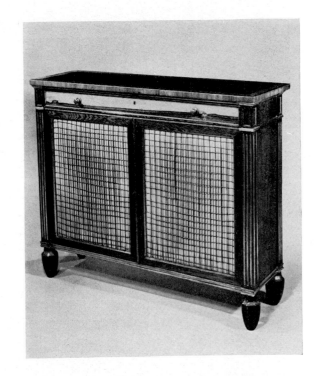

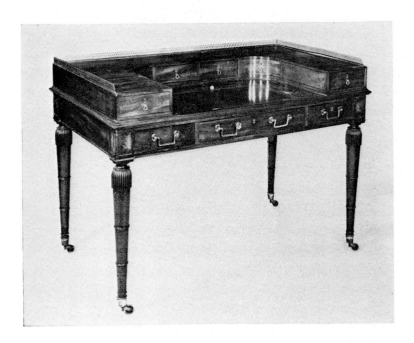

Regency mahogany Carlton House writing table
53 in. (135 cm.) wide
Sold 9.12.71 for 2200 gns. ($5654)
From the collection of the late Major J. R. Abbey

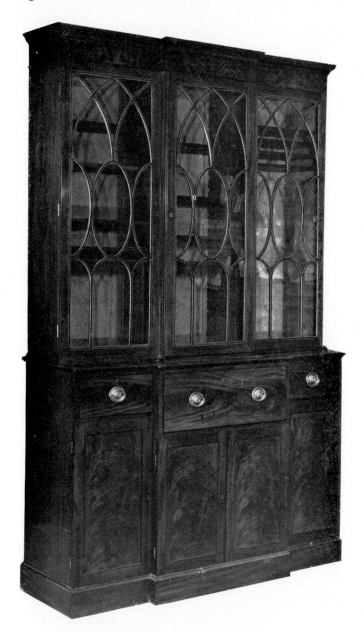

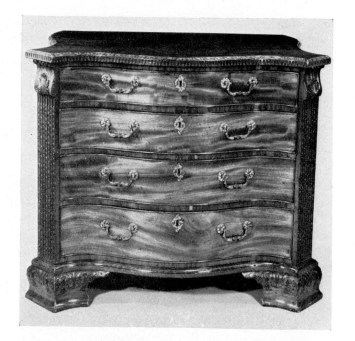

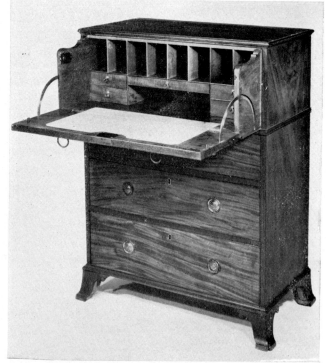

Top: One of a pair of Regency mahogany secretaire bookcases
66¼ in. (168 cm.) wide, 102 in. (259 cm.) high
Sold 11.11.71 for 2300 gns. ($5911)
From the collection of the late Captain H. E. Rimington-Wilson
Top right: Early George III mahogany serpentine commode
39 in. (99 cm.) wide. Sold 11.11.71 for 2600 gns. ($6688)

George III mahogany small secretaire chest, attributed
to Chippendale Haig & Co, 29¼ in. (74.4 cm.) wide
Sold 9.12.71 for 1400 gns. ($3598). From the collection
of Mrs Home Robertson of Paxton, Berwickshire

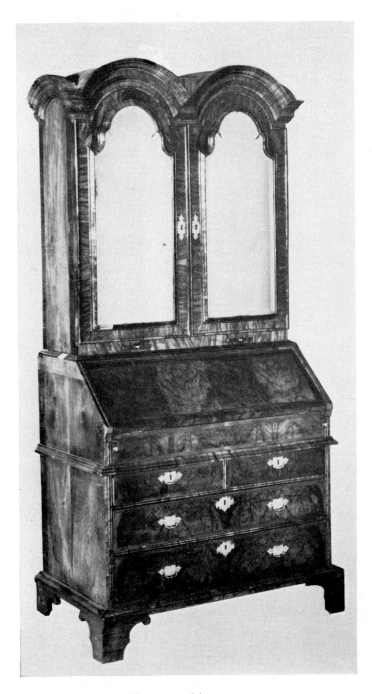

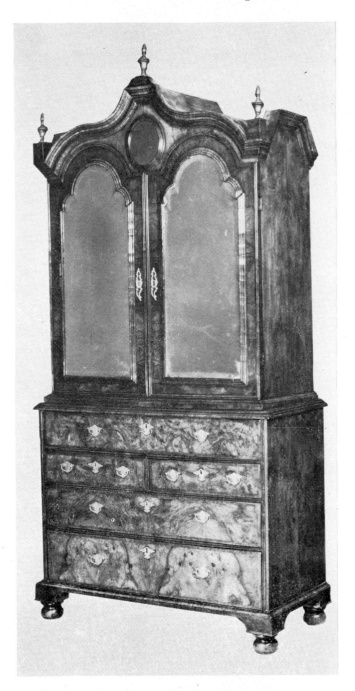

Queen Anne walnut bureau cabinet
39 in. (99 cm.) wide, 81½ in. (207 cm.) high
Sold 16.3.72 for 1600 gns. ($4368)
From the collection of the late Ernest Thornton-Smith, Esq

Queen Anne walnut secretaire cabinet
44 in. (112 cm.) wide, 90 in. (229 cm.) high
Sold 25.5.72 for 2800 gns. ($7644)
From the collection of Charles Pretzlick, Esq

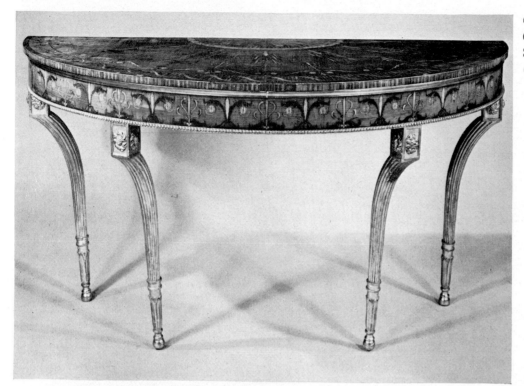

George III marquetry side table
64½ in. (164 cm.) wide
Sold 11.11.71 for 3000 gns.
($7710)

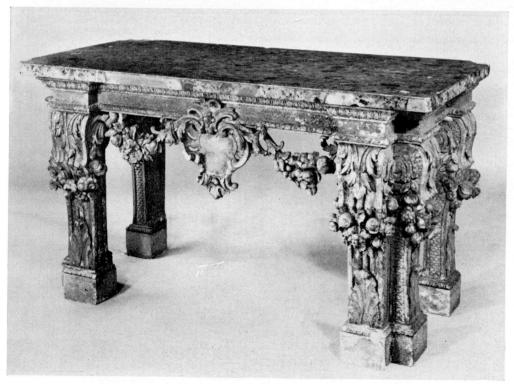

Early George II giltwood
side table
In the style of William Kent
60¼ in. (153 cm.) wide
Sold 16.3.72 for 3600 gns.
($9828)

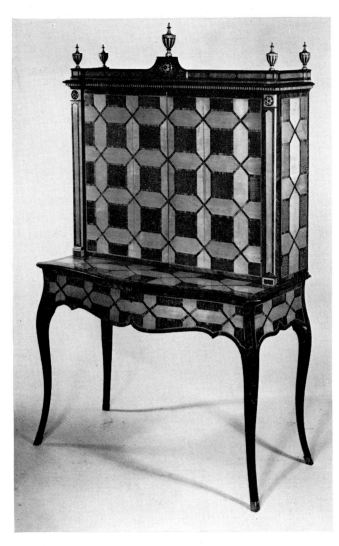

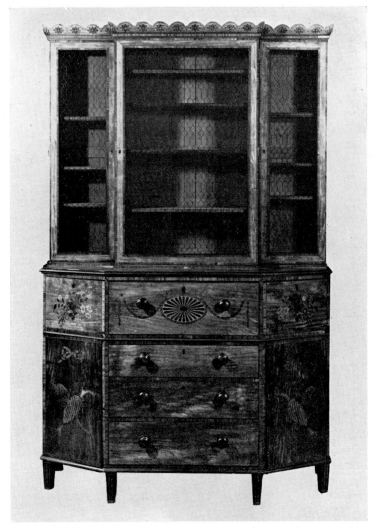

George III parquetry secretaire cabinet
44½ in. (113 cm.) wide, 73 in. (186 cm.) high
Sold 11.11.71 for 3800 gns. ($9775)

Fine George III satinwood secretaire bookcase
52¾ in. (134 cm.) wide
Sold 9.12.71 for 7000 gns. ($17,150)
From the collection of the late Hon. Lady J. D. Cochrane, CBE

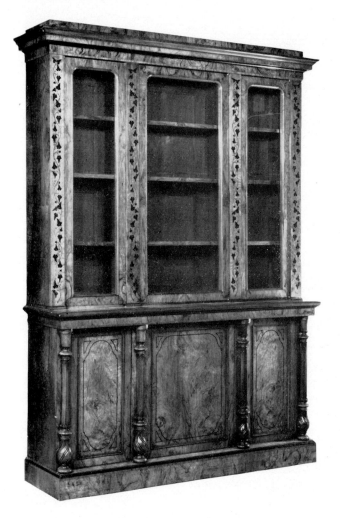

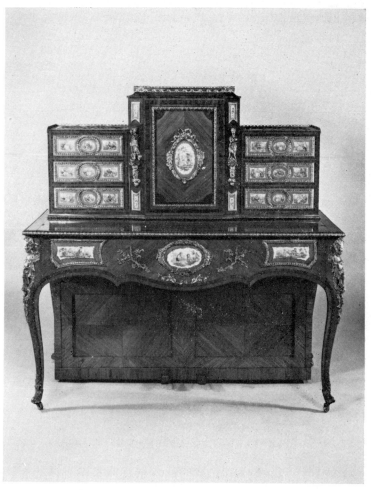

One of a pair of walnut bookcases
62½ in. (159 cm.) wide
Circa 1840
Sold 13.7.72 for 850 gns. ($2142)
From the collection of Lady Maxwell

Tulipwood salon piano in the Louis XV style
By John Broadwood & Sons
57 in. (145 cm.) wide, 58¼ in. (148 cm.) high
Circa 1860
Sold 13.7.72 for 1800 gns. ($4536)

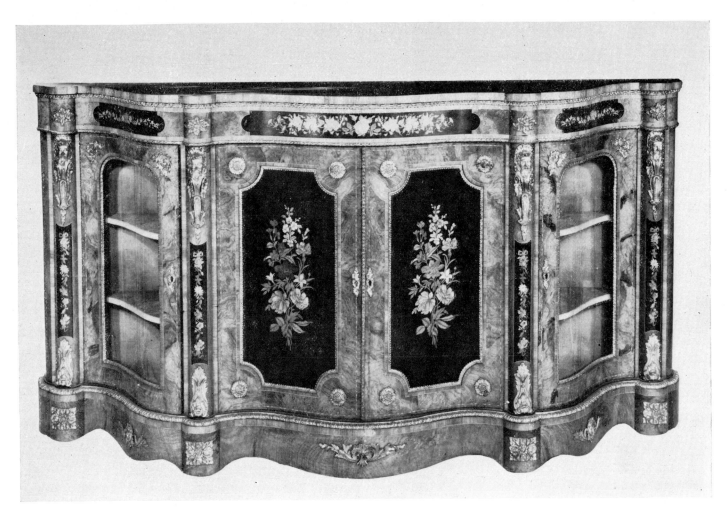

Walnut and marquetry dwarf cabinet
87 in. (221 cm.) wide
Circa 1860
Sold 13.7.72 for 1400 gns. ($3528)
From the collection of Mrs M. Freeman

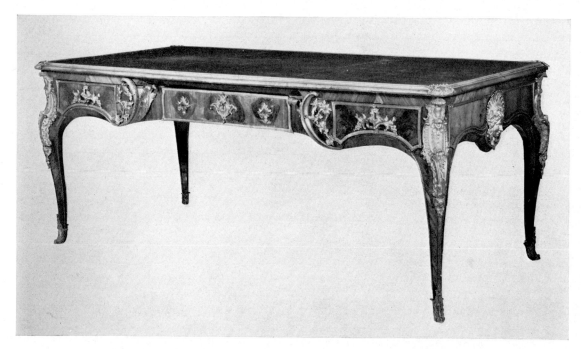

Important early
Louis XV kingwood
bureau plat,
By Bernard (II)
Van Risenburgh
$83 \times 38\frac{1}{2}$ in.
(211×98 cm.)
Stamped twice
BVRB and once
with initials FL
Sold 23.3.72 for
24,000 gns. ($65,520)
From the collection of
The Dowager
Viscountess Galway

Interesting origins BY HUGH ROBERTS

The two tables illustrated here, one so characteristically English, the other so unmistakably French, share an interesting and unusual link – in each case noted in our catalogues for the first time – in the person of the little-known English architect and furniture designer John Vardy (d. 1765).

Mr Theodore Dell and Mr Peter Thornton first noticed the very close resemblance between the bureau plat by B. V. R. B. and that forming the subject of Vardy's drawing in the RIBA, dated *circa* 1745, which is inscribed 'J. Vardy delin. at Mr. Arundale's.' This inscription has hitherto been understood to mean that the table was an unexecuted design by Vardy himself in the French manner, and as such, in very marked contrast to his other known furniture designs. The 'Mr Arundale' had already been identified with Richard Arundell, MP, Surveyor of the King's Works, for whom Vardy designed a new house in 1746. Further enquiry showed that he was in fact the first Lord Galway's brother-in-law and that on Arundell's death his property, including the table of Vardy's drawing, passed to his nephew by marriage, the second Lord Galway, in whose family the piece has always remained. Since it is clear that Vardy can only have drawn the table a short time after its acquisition by Arundell, a revealing light is cast both on the scope of contemporary interest in fashionable furniture designs outside England, and on English patronage of a style of

George II giltwood
side-table designed
by John Vardy
72 in. (183 cm.) wide
Sold 25.5.72 for
3000 gns. ($8190)
From the collection
of the Hon Michael
Astor

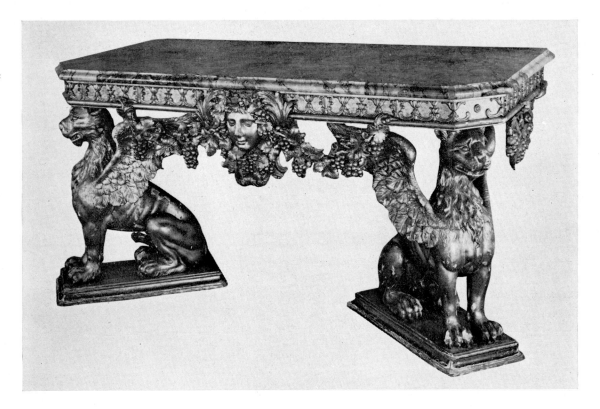

furniture which was new even in Paris and virtually unknown to English cabinet-makers.

The second table, giltwood with a Siena marble top, was known until recently only from a drawing by Vardy in the British Museum dated 1758 (one of a group connected with the furnishing of Spencer House, Green Park, of which Vardy was also the architect), where it is shown beneath an elaborate pier-glass inscribed 'Two Tables and Two Glasses at each end of Great Dining Room and Parlour'. Hitherto it had been uncertain whether any furniture was actually made to these designs, but if, as seems likely, the designs were executed, the furniture did not remain in situ beyond 1786 when the second Earl Spencer ordered a new pair of console tables from the *marchand-mercier* Daguerre in Paris to stand in the position intended by Vardy for the original tables and mirrors. At the same time the Parlour was altered under Henry Holland's supervision and Vardy's furniture must have been removed. The subsequent history of this suite is unknown.

Apart from the pieces mentioned here, little has come to light which can be confidently linked with known Vardy drawings. The piecing together of the early history of these two tables therefore marks an interesting addition to the documentation of an important but still shadowy English eighteenth-century furniture designer.

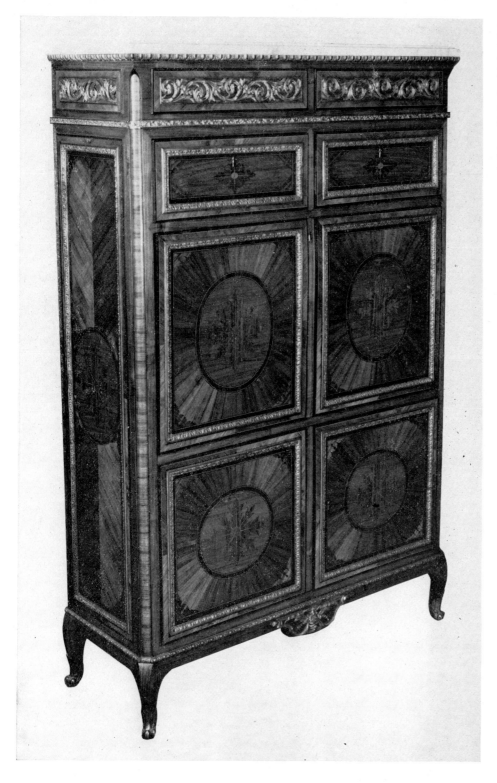

One of an important pair of
Louis XVI tulipwood upright
cabinets
By M. Carlin
40½ in. (103 cm.) wide
Stamped M. Carlin and J. Pafrat
Sold 23.3.72 for 25,000 gns.
($68,250)
From the collection of
the late Mrs Derek FitzGerald

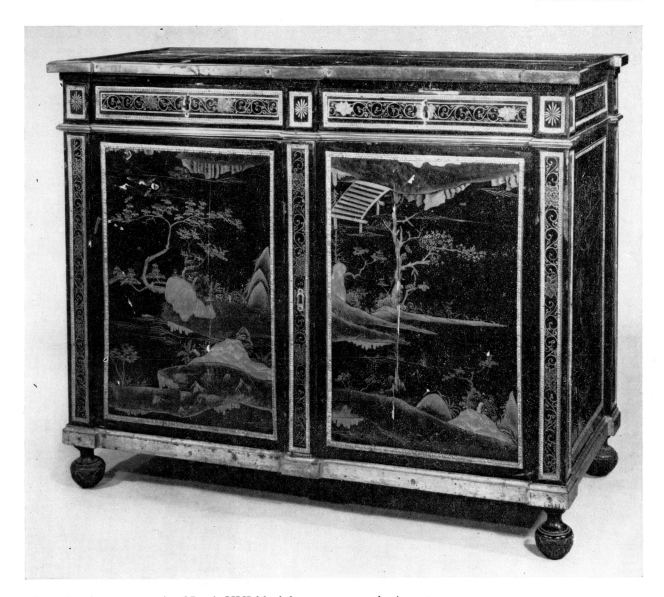

One of an important pair of Louis XVI black lacquer commodes à portes
By M. B. Evalde
46 in. (117 cm.) wide, 36½ in. (93 cm.) high
One commode stamped M. B. Evalde
Sold 23.3.72 for 18,500 gns. ($51,505)
From the collection of the Duca della Grazia

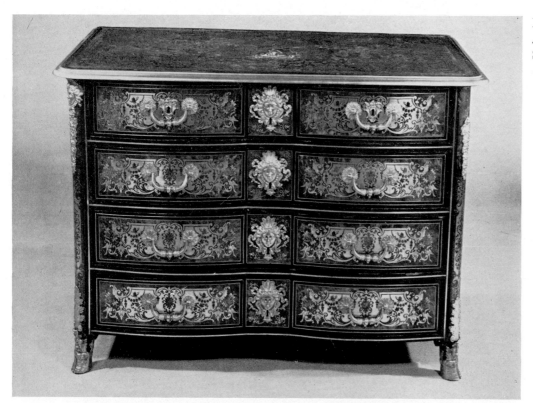

Louis XIV Boulle commode
46½ in. (118 cm.) wide
Sold 23.3.72 for 3800 gns.
($10,374)

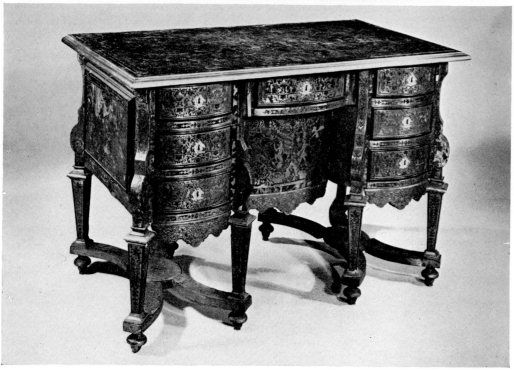

Louis XIV Boulle bureau
mazarin
47½ in. (121 cm.) wide
Sold 2.12.71 for 2000 gns.
($5140)

Louis XV marquetry table de toilette
By P. A. Foulet
36¼ in. (92 cm.) wide
Stamped P. A. Foulet and JME three times
Sold 29.6.72 for 5000 gns. ($13,020)
Sold on behalf of the Trustees of Lord
Hillingdon

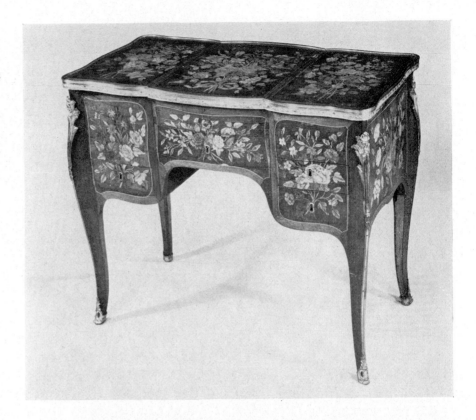

Régence kingwood parquetry commode à
portes
By Migeon
44 in. (112 cm.) wide, stamped Migeon
Sold 2.12.71 for 4000 gns. ($9788)
From the collection of Mrs James de
Rothschild

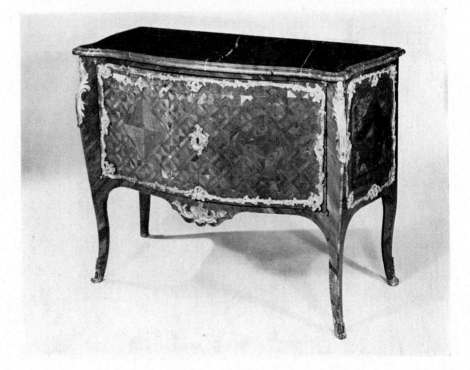

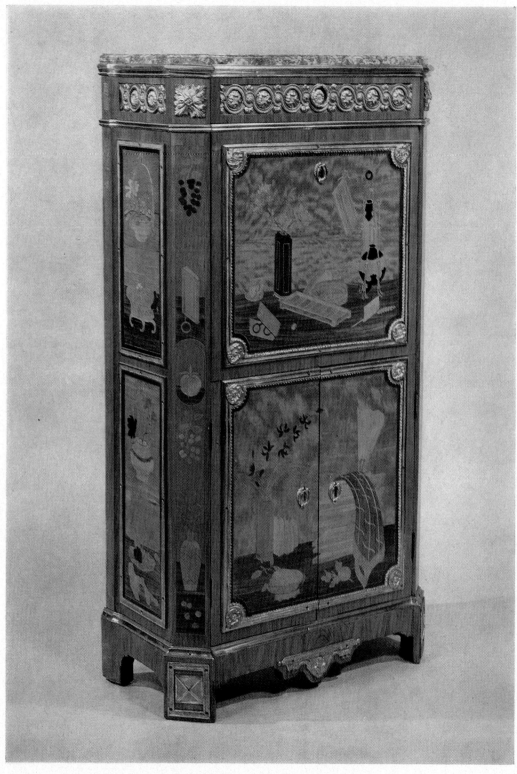

Important Louis XVI
marquetry secretaire à
abattant by R.V.L.C.
26¾ in. (68 cm.) wide,
50¾ in. (129 cm.) high
Stamped R.V.L.C. and
JME
Sold 29.6.72 for 32,000 gns.
($83,330)
From the collection of
the Hon Lady Salmond

Louis XVI demi-lune marquetry commode
By C. Topino
38½ in. (98 cm.) wide
Stamped C. Topino and JME
Sold 29.6.72 for 8000 gns. ($20,832)
Sold on behalf of the Trustees of Lord Hillingdon

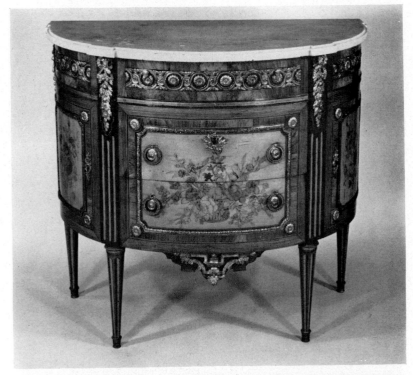

Louis XVI marquetry commode
By G. Dester
37¾ in. (96 cm.) wide
Stamped G. Dester and JME
Sold 29.6.72 for 5500 gns. ($14,322)
Sold on behalf of the Trustees of Lord Hillingdon

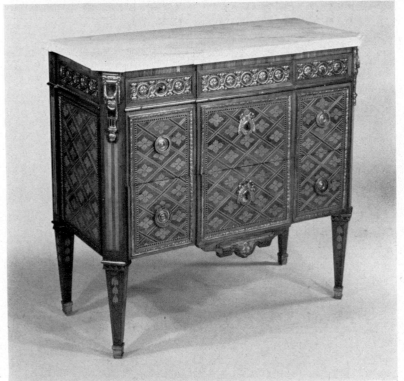

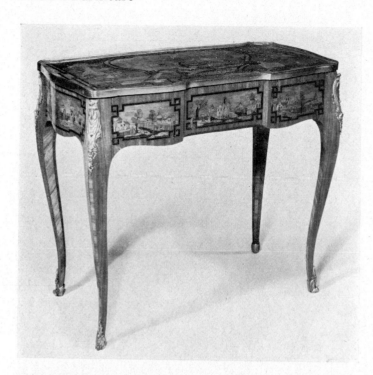

Fine Louis XV marquetry table à écrire
32¾ in. (83 cm.) wide
Sold 2.12.71 for 10,500 gns. ($27,011)

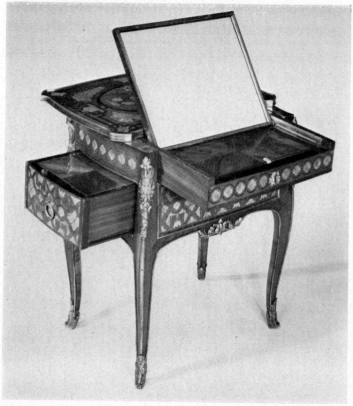

Important Louis XV marquetry table à toilette, in the
manner of R.V.L.C.
22¾ in. (57.8 cm.) wide
Sold 23.3.72 for 22,000 gns. ($60,060)
From the collection of the late Mrs Derek FitzGerald

Louis XIV marquetry bureau
mazarin
In the manner of A. C. Boulle
45 in. (114 cm.) wide
Sold 29.6.72 for 4000 gns.
($10,416)

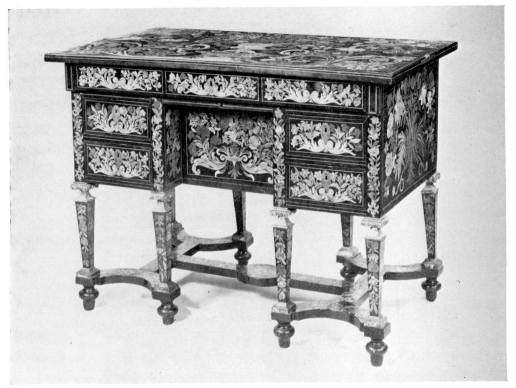

Louis XIV marquetry bureau
mazarin
In the manner of A. C. Boulle
76 in. (193 cm.) wide
Sold 29.6.72 for 8500 gns.
($22,134)
From the collection of
Mr and Mrs John Balfour
Removed from Balbirnie
Markinch, Fife

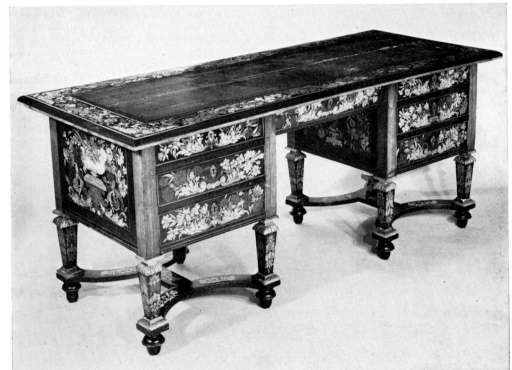

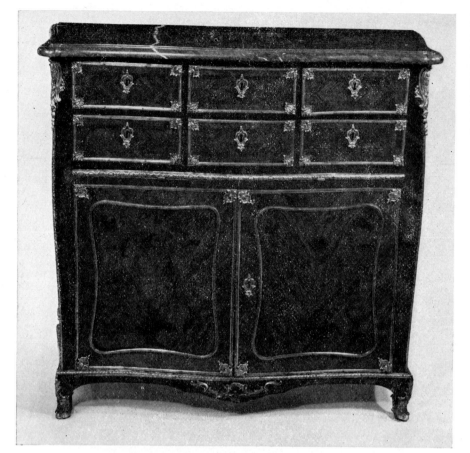

Louis XV kingwood and marquetry
meuble d'appui
By J. F. Dubut
38½ in. (98 cm.) wide
Stamped J. F. Dubut and JME
Sold 23.3.72 for 8500 gns. ($23,205)
From the collection of
the late Mrs Derek FitzGerald

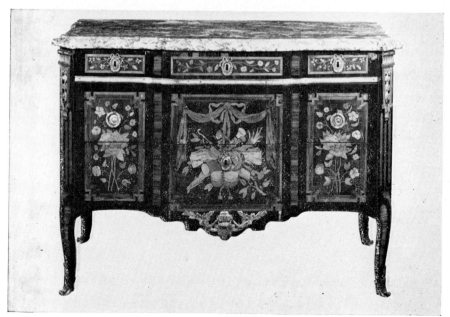

Transitional marquetry commode
51½ in. (130 cm.) wide
Branded twice with a shield of three
crosses between initials J.G.
Sold 2.12.71 for 4000 gns. ($9766)
From the collection of
Mrs Gaby Salomon of Buenos Aires

Louis XV kingwood bureau plat
64 × 34 in. (163 × 86 cm.)
Sold 2.12.71 for 5200 gns. ($13,377)
From the collection of
Mrs James de Rothschild

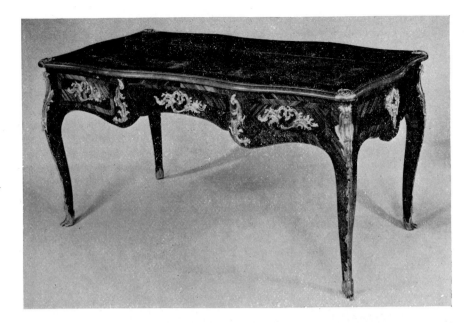

Important Louis XVI mahogany parquetry
bureau plat
By J. H. Riesener
64 × 31½ in. (163 × 80 cm.)
Stamped twice J. H. Riesener
Sold 29.6.72 for 20,000 gns. ($51,080)
Sold on behalf of the Trustees of
Lord Hillingdon

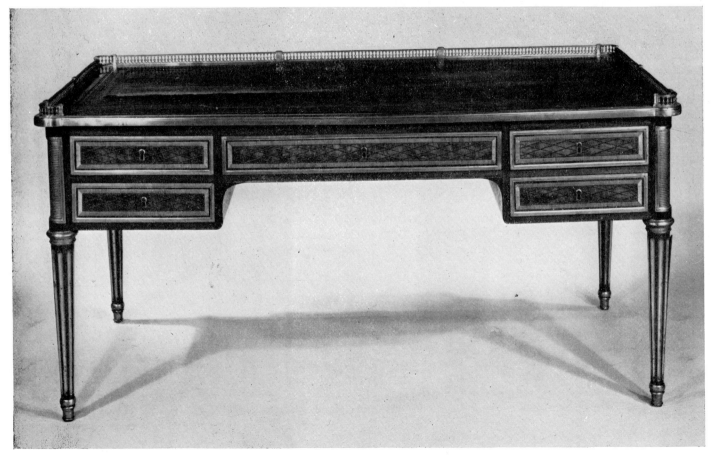

Latz

This table, which bears the interlaced V's of the Versailles Palace mark, probably passed into the collection of the Dukes of Sutherland in 1838, since an account dated December 11th of that year relating to purchases made by Thomas Jackson for the 2nd Duke of Sutherland records that a Library table, probably to be identified with this piece, was bought by Jackson for the then considerable sum of £1000 from G. Gunn of 65 Rue Amelot, in Paris.

J. P. Latz (*circa* 1691–1754), to whom this bureau plât is attributed, practised as an *ébéniste privilégié du Roi* and therefore was never officially received *Maître* by the Paris guild. He is known to have worked for the Kings of Prussia and Saxony but hitherto no furniture by or attributed to Latz and linked with the French Crown has come to light.

Dolphin mounts of the kind seen on this table are traditionally associated with furniture made for the Dauphin and occur identically on a small number of other important pieces, notably a desk in the collection of the Earl of Rosebery and on a bureau by Latz decorated with dolphins and fleurs-de-lis – which, it has been suggested, might have belonged to Marie-Josephe of Saxony, Dauphine of France.

The attribution of this table is strengthened by comparison with the stylistically similar also unstamped desk (no. F112) in the Wallace Collection, which in a recent article in the *Cleveland Museum of Art Bulletin* was ascribed to Latz. The same article also notes that since Latz worked outside the guild he was not obliged to stamp his work, and was possibly not anxious to do so in any case since at least until 1749 he was illegally making his own mounts. This meant that he was not confined to or dependent on the mounts generally available to Parisian *ébénistes*, from which it may be concluded that the repetition of mounts on Latz's signed and unsigned pieces serves to confirm attributions to him made on the basis of the general style of the pieces.

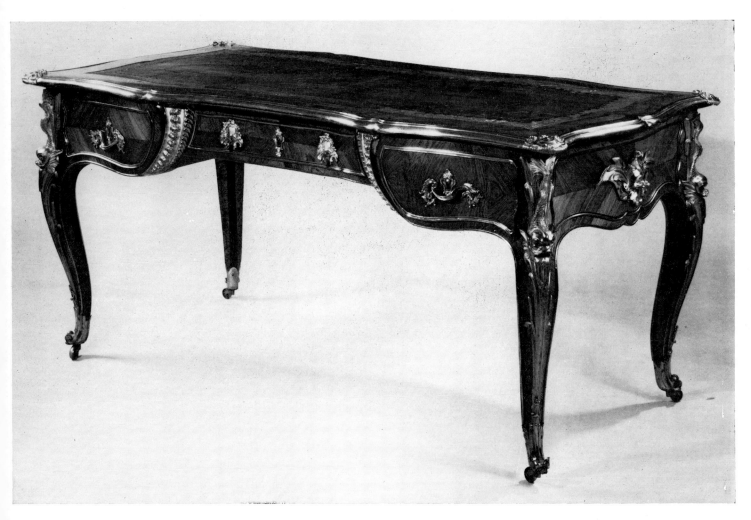

Important Royal kingwood bureau plat, attributed to J. P. Latz
69¼ × 34 in. (176 × 86.5 cm.), with the painted conjoined V mark of the Palace of Versailles
Sold 29.6.72 for 18,000 gns. ($46,890)
From the collection of the Countess of Sutherland

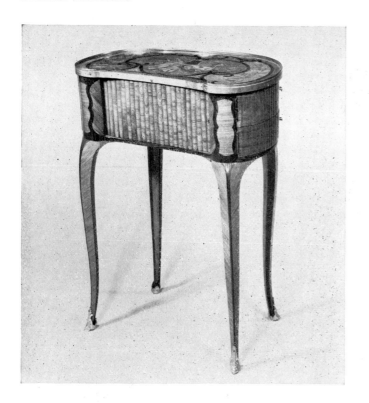

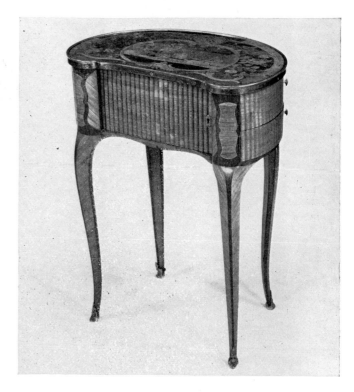

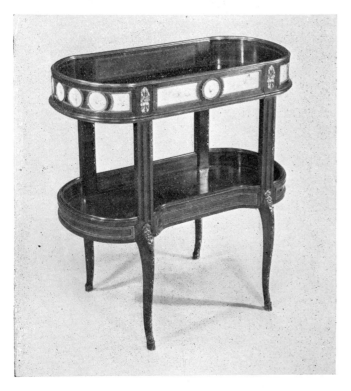

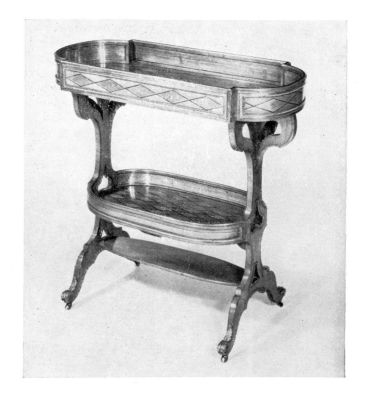

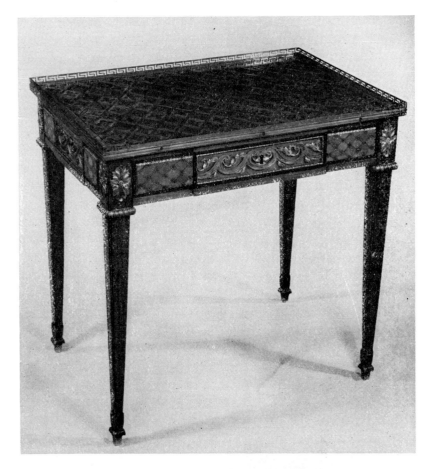

Opposite:

Top left: Louis XV marquetry table à rognon
21¾ in. (55 cm.) wide
Sold 2.12.71 for 3000 gns. ($7710)

Top right: Louis XV tulipwood and marquetry
table à rognon
22 in. (56 cm.) wide
Sold 29.6.72 for 4000 gns. ($10,416)
Sold on behalf of the Trustees of Lord Hillingdon

Bottom left: Louis XVI mahogany tricoteuse
Mounted with Sèvres plaques
26¾ in. (68 cm.) wide, branded twice with a
crown
Sold 29.6.72 for 3000 gns. ($7812)
Sold on behalf of the Trustees of Lord Hillingdon

Bottom right: Louis XVI parquetry tricoteuse
By M. Carlin
29½ in. (75 cm.) wide, stamped M. Carlin JME
Sold 29.6.72 for 4500 gns. ($11,718)
From the collection of Mr and Mrs John
Balfour, removed from Balbirnie, Markinch, Fife

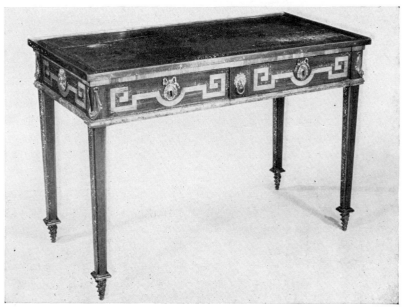

Top right: Louis XVI marquetry table à écrire
27 in. (68.5 cm.) wide
Sold 23.3.72 for 4800 gns. ($13,104)
From the collection of the late Mrs Derek
FitzGerald

Bottom right: Inlaid amaranth table à écrire
By R. Dubois who continued to use his father's
stamp
43¾ in. (114 cm.) wide, stamped I. Dubois
Sold 29.6.72 for 10,000 gns. ($26,040)
Sold on behalf of the Trustees of Lord Hillingdon

French furniture

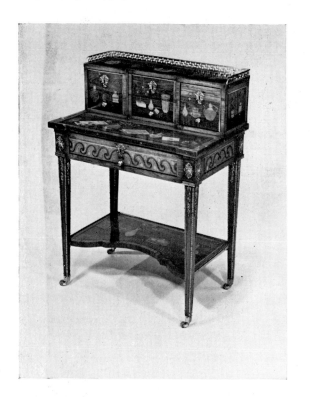

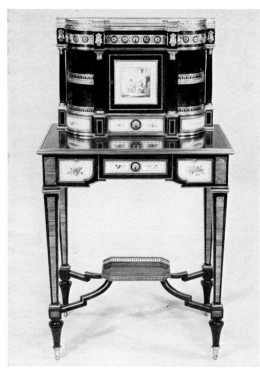

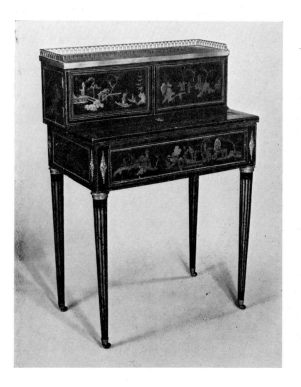

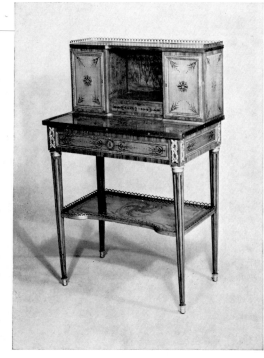

Top left: Louis XVI marquetry bonheur du jour By P. H. Mewesen $25\frac{3}{4}$ in. (65.5 cm.) wide Stamped P. H. Mewesen and JME Sold 29.6.72 for 4000 gns. ($10,416)

Top right: Louis XVI porcelain-mounted mahogany bonheur du jour $25\frac{1}{4}$ in. (64 cm.) wide Sold 23.3.72 for 4200 gns. ($11,466) From the collection of the late Mrs Derek FitzGerald

Bottom left: Louis XVI black lacquer bonheur du jour By G. Cordié 28 in. (71 cm.) wide Stamped G. Cordie with the JME poinçon partly obliterated Sold 2.12.71 for 2200 gns. ($5684)

Bottom right: Louis XVI bois clair and marquetry bonheur du jour By R. Lacroix $25\frac{3}{4}$ in. (65.5 cm.) wide Stamped twice R. Lacroix and once with the JME poinçon Sold 2.12.71 for 3800 gns. ($9775)

Top left: Fine lacquered and giltwood
Flemish musical longcase-clock
By Giles de Beefe à Liege
96 in. (244 cm.) high
Second quarter 18th century
Sold 29.6.72 for 8000 gns. ($20,832)

Top right: Important Louis XV
kingwood equation regulator-clock
The movement by Samson Le Roy,
Paris, the case by B. Lieutaud
93 in. (236 cm.) high
Sold 2.12.71 for 7800 gns. ($20,065)
From the collection of Mrs Gaby
Salomon of Buenos Aires

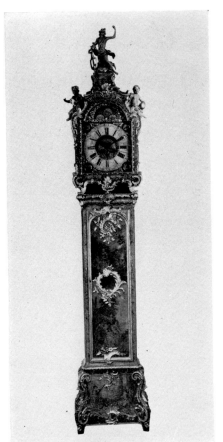
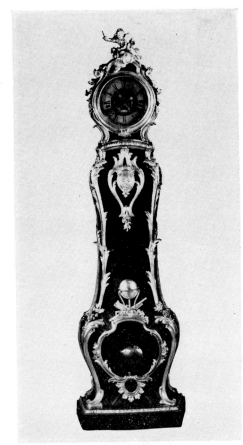

Bottom left: Pair of Louis XVI
ebony, ormolu and brass corner
cupboards
By J. Dubois
29 in. (74 cm.) wide, 37¾ in. (96 cm.)
high, stamped I. Dubois, one with
JME poinçon
Sold 23.3.72 for 9500 gns. ($25,935)

Bottom right: One of a pair of Louis
XV black lacquer encoignures
By J. Desforges
32½ in. (82.5 cm.) wide, each stamped
twice DF
Sold 29.6.72 for 6800 gns. ($17,701)

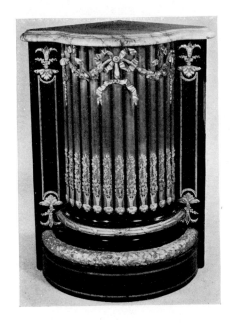
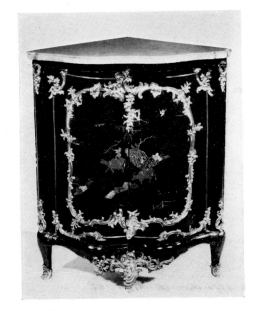

French chairs

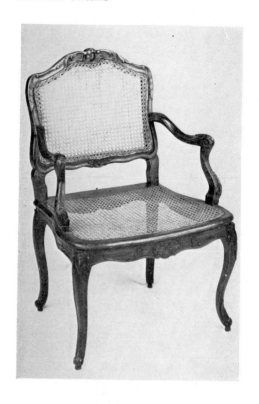

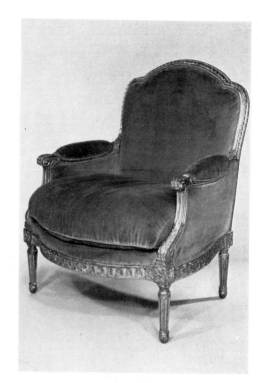

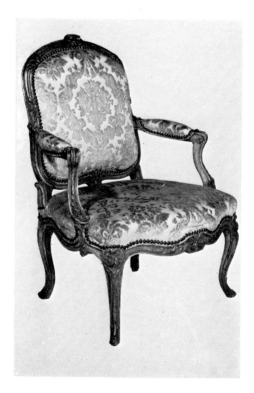

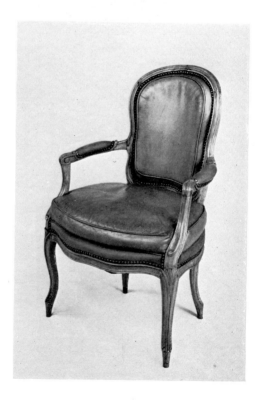

Top left: One of a set of six Louis XV beechwood and cane panelled fauteuils
By C. F. Drouilly, stamped C. F. Drouilly and JME
Sold 27.9.71 for 3300 gns. ($9000)
From the Dodge collection, sold on the premises at Rose Terrace, Grosse Pointe Farms, Michigan, U.S.A.

Top right: One of a pair of Louis XVI giltwood bergères
One chair stamped IM
Sold 29.6.72 for 3800 gns. ($9895)
From the collection of Mrs Ronald Tree

Bottom left: One of a set of six Louis XV fauteuils
By J. Lebas, each chair stamped I. Lebas twice
Sold 2.12.71 for 8000 gns. ($20,580)

Bottom right: One of a set of four Louis XV waxed walnut fauteuils
Sold 27.9.71 for 1830 gns. ($5000)
From the Dodge collection
Sold on the premises at Rose Terrace, Grosse Pointe Farms, Michigan, U.S.A.

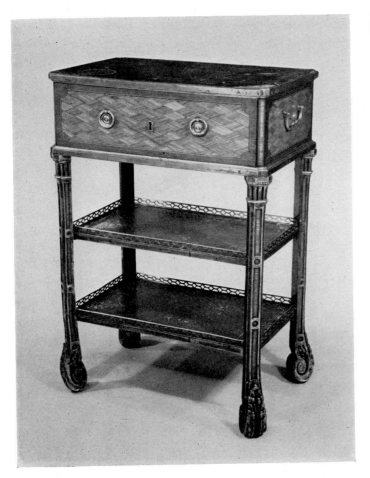

Louis XVI kingwood and parquetry étagère
19½ in. (49.5 cm.) wide
Sold 29.6.72 for 14,000 gns. ($36,460)
Sold on behalf of the Trustees of Lord Hillingdon

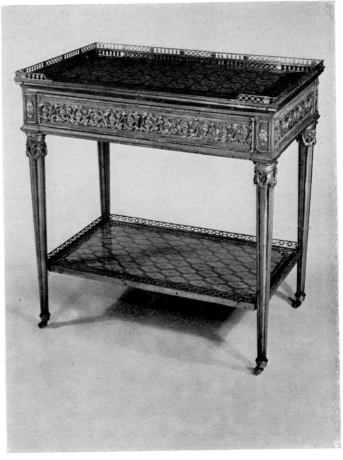

Louis XVI marquetry table à écrire
By P. Roussel
30 in. (76 cm.) wide, stamped P. Roussel
Sold 29.6.72 for 6000 gns. ($15,624)
Sold on behalf of the Trustees of Lord Hillingdon

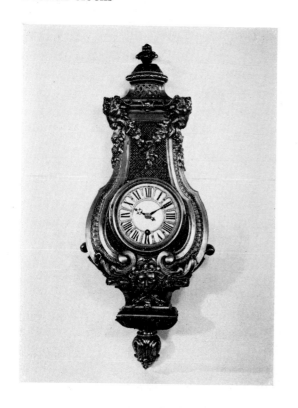

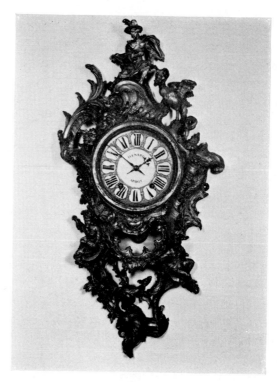

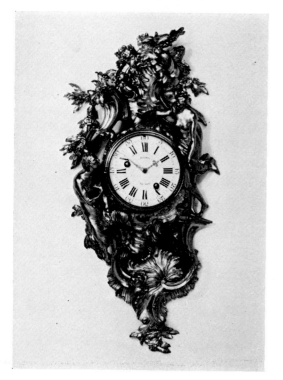

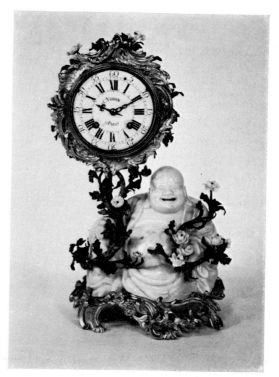

Top left: Louis XVI ormolu cartel-clock 28 in. (71 cm.) high Sold 29.6.72 for 3800 gns. ($9895) Sold on behalf of the Trustees of Lord Hillingdon

Top right: Louis XV giltwood cartel-clock Signed on the backplate Hénard à Paris, No. 199 33½ in. (85 cm.) high Sold 2.12.71 for 1300 gns. ($3341)

Bottom left: Louis XV ormolu cartel-clock, Striking movement by Julien le Roy 24¾ in. (63 cm.) high Stamped with the crowned 'C' poinçon in several places Sold 29.6.72 for 2200 gns. ($5729) From the collection of Mr and Mrs John Balfour, removed from Balbirnie, Markinch, Fife

Bottom right: Louis XV ormolu and porcelain clock Signed Charles Voisin à Paris 13½ in. (34 cm.) high Sold 29.6.72 for 4000 gns. ($10,416) From the collection of Mrs Stewart Sargent

Top left: One of a pair of Régence ormolu candelabra 20 in. (51 cm.) high Stamped with the crowned 'C' poinçon Sold 2.12.71 for 2000 gns. ($5140)

Top right: One of a pair of Louis XVI ormolu table candelabra, after J. D. Dugourc 22½ in. (57 cm.) high Sold 2.12.71 for 2600 gns. ($6688)

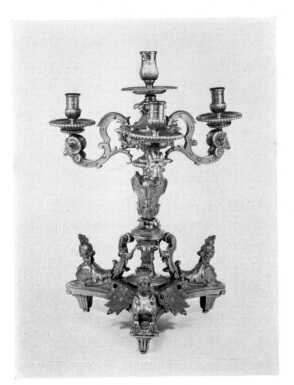

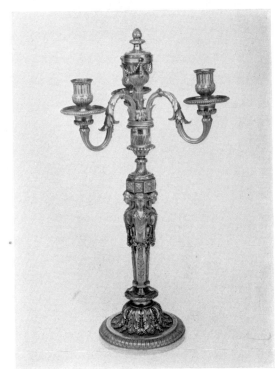

Bottom left: One of a pair of Louis XV ormolu and porcelain openwork candlesticks 9¾ in. (25 cm.) high Sold 23.3.72 for 1100 gns. ($3003)

Bottom right: Important pair of Louis XVI ormolu candlesticks By Etienne Martincourt 11½ in. (29.1 cm.) high, the bases stamped Martincourt Sold 23.3.72 for 4800 gns. ($13,104) From the collection of the late Mrs Derek Fitzgerald

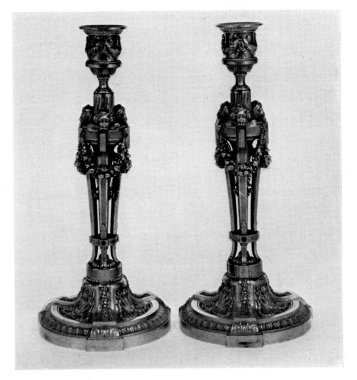

Plácido Zuloaga

BY ANTHONY COLERIDGE

During the season under review we held a two-day sale for Lord Margadale of Islay of the remaining contents of Fonthill House, Tisbury, Wiltshire, among which were a large Spanish parcel-gilt and bronzed metal coffer by Plácido Zuloaga (see illustration) and a pair of two-handled damascened metal vases (see illustration) made by the same craftsman for Alfred Morrison, Lord Margadale's grand-father. These were of exceptional interest on account of three letters written by Zuloaga to Mr & Mrs Alfred Morrison from Eibar in 1868 and 1869 and an estimate which was sold with this Lot.

Plácido Zuloaga, born in Madrid in about 1833, the son of Eusebio Zuloaga (born 1808), was a most celebrated craftsman in metalwork, particularly in inlaid and damascened work. His father, who had won many prizes in international exhibitions and specialized in making pieces in damascened steel and iron, had his workshops at Eibar in Guipuzcoa and Madrid.

Plácido followed in his father's footsteps and after studying with Lienard in Paris, where he met Carpeau and Barye, he returned to Spain and worked with his father at Eibar. He finished his training in Dresden where he specialized in *damasquinado*. He won prizes at, *inter alia,* the Paris Exhibition of 1855, the Madrid Exhibition of 1856, the Philadelphia Exhibition of 1876 and the Paris Exhibition of 1878. The *Enciclopedia Espasa* records that in the 1878 Paris Exhibition he showed '*una gran bandeja* [tray] *labrada por Morrison de Londres*'. This tray is probably the one referred to in two letters written in French by Zuloaga to Mrs Morrison on 5 February 1868, and 27 July 1869. In the second letter he describes it as 'a piece that no one dared to make in times gone by because of the difficulty of construction'. In the third paragraph of this letter he continues, 'In the same case there is a drawing of two pieces which I am in the course of making in iron and I beg you to tell Mr Morrison that I have made a calculation and that I could make the pair inlaid with three metals like the large tray, except that they will be copper, gold and silver. I think that this will give a good effect and if Mr Morrison wishes it in silver only on a background of polished black, or completely in gold, this will make 2000 francs difference to the

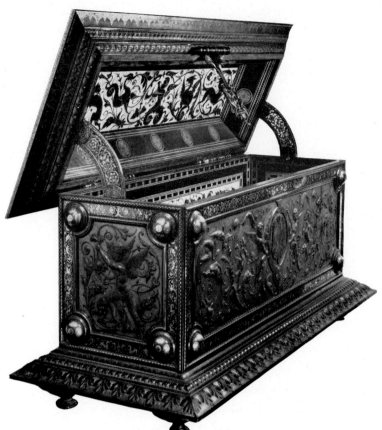

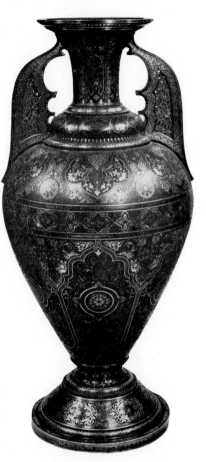

Left: Large Spanish parcel-gilt and bronzed metal coffer By Plácido Zuloaga 79 in. (121 cm.) wide 34 in. (86 cm.) deep Sold 1.11.71 for 3000 gns. ($7710)

Right: One of a pair of large Spanish two-handled damascened metal vases By Plácido Zuloaga 42½ in. (108 cm.) high Sold 1.11.71 for 450 gns. ($1157)

Both from the collection of The Rt Hon Lord Margadale of Islay, TD Sold on the premises of Fonthill House Tisbury, Wiltshire

price'. Enclosed with this letter was the following 'estimate of the two pieces in black polished iron, as in the drawing [not extant] which I have sent you

								£
No. 1 The above pieces inlaid with the ornament in gold								650
No. 2 ,, ,,	,,	,,	,,	,,	,, silver			500
No. 3 ,, ,,	,,	,,	,,	,,	,, copper, silver & gold			550
No. 4 ,, ,,	,,	,,	,,	,,	,, gold & silver			600'

The pair of vases (fig. 2) are in black polished iron inlaid with gold and silver and are presumably the ones referred to in this letter and estimate, as costing £600 (no. 4).

A third letter, dated 13 October 1868, is of great interest because in it Zuloaga offers to work solely for Alfred Morrison on account of the recent death of the former's father, Eusebio, and of current financial embarrassments.

Germanic furniture

BY PAUL WHITFIELD

One of the most fascinating aspects of the auctioneer's work is to observe the changes in fashion, sometimes rapid, but often imperceptible to start with, which in themselves determine and are determined by fluctuations in supply and demand.

In recent years one such noticeable change has been the increased demand for European furniture other than the finest Parisian examples, and in particular for Germanic furniture and works of art. Several factors seem to have contributed to this. First, probably, is an awareness on the part of collectors that it was not only France which produced magnificent furniture during the seventeenth and eighteenth centuries; a rather obvious point of view, it may be thought, but one which might have been considered heretical ten years ago. Second is the publication of several important scholarly works, including Dr Heinrich Kreisel's monumental three-volume *Die Kunst des Deutschen Möbels* – the third volume of which is still awaited, as is Dr Georg Himmelheber's book on the Biedermeier style, to be published simultaneously in England and Germany. A third factor is the great purchasing power of German collectors and museums, and a fourth the surprisingly large amount of furniture and works of art from Germany and its neighbours still in this country.

These four influences (and others besides) have created a strong demand. The great richness and regional variety to be found in German furniture are shown in four pieces sold by us this season. Eighteenth-century Germany was not a unified country, but consisted of a great number of independent states under both princely and episcopal rule, rivals in many ways, but generally united in their common admiration for the splendour of France. Interpretations of the style, however, show great differences from the astonishingly lush rococo of Potsdam and Munich to the traditional baroque forms of the South, which survived in the form of the 'Frankfurt' cupboard (see illustration, page 366) far into the eighteenth century. The bureau-cabinet (see illustration, page 366) is similar to an example at Schloss Berchtesgaden which was made for the Elector Palatine, Carl Theodor, in 1750.

Another bureau cabinet (see illustration, page 365) sold this season came from Austria, and was charmingly decorated in coloured penwork with pastoral scenes. Perhaps the

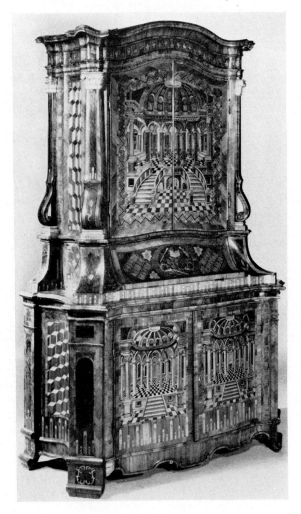

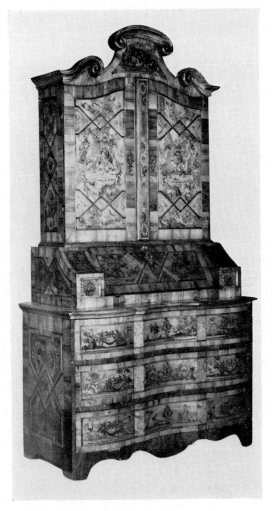

Important German walnut and marquetry
secretaire cabinet. 84 in. (213 cm.) high
51 in. (135 cm.) wide, *circa* 1760
Sold 25.11.71 for 6800 gns. ($17,493)
From the collection of Mrs James de Rothschild

Austrian walnut bureau cabinet
47 in. (120 cm.) wide, 88 in. (224 cm.) high
Mid-eighteenth century
Sold 10.2.72 for 3700 gns. ($10,001)
From the collection of Dr C. O. Harman

grandest piece of German furniture was a bureau cabinet (see illustration) from the collection of Mrs James de Rothschild which was sold for 6800 guineas ($17,493). Its sinuous outline and rich architectural perspective marquetry are characteristic of the important cabinet-making centre of Mainz, and the high price emphasizes again the importance attached by buyers to a distinguished provenance.

There is undoubtedly much Germanic furniture in this country although not all perhaps of the quality of the four pieces illustrated here, and we expect that future sales will continue to attract appreciative foreign buyers to London.

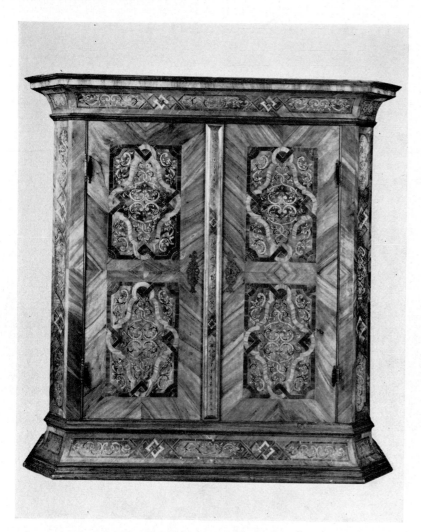

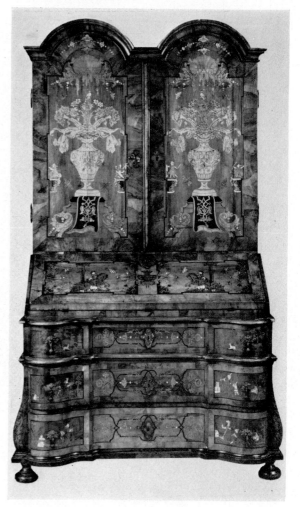

South German walnut and marquetry armoire
82 in. (208 cm.) wide
First half eighteenth century
Sold 25.11.71 for 1800 gns. ($4626)
From the collection of Mrs James de Rothschild

South German walnut and marquetry
bureau cabinet
46½ in. (118 cm.) wide, 84½ in. (214 cm.) high
Circa 1730
Sold 1.6.72 for 3400 gns. ($9282)

Important marquetry
secretaire
By David Roentgen
39¼ in. (99.5) cm.) wide
64½ in. (163 cm.) high
Circa 1780
Sold 29.6.72 for 26,000 gns.
($65,520), on behalf of the
Trustees of Lord Hillingdon

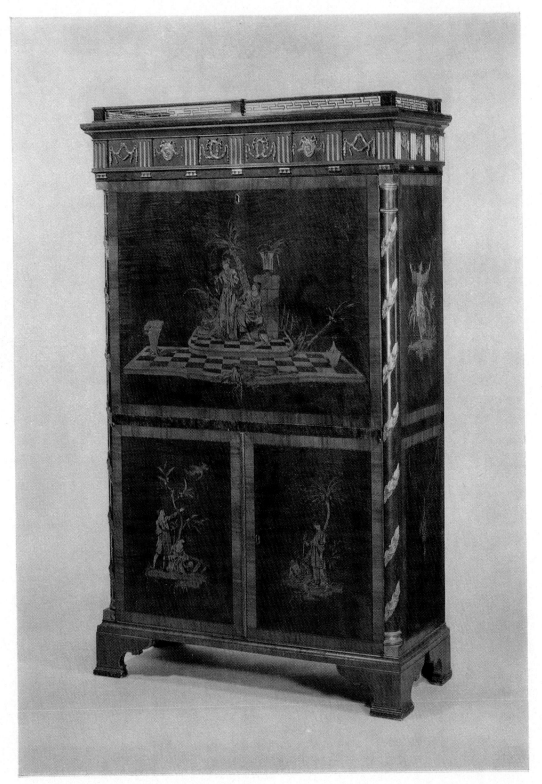

Roentgen

Among the many interesting pieces sent for sale this season by the Trustees of Lord Hillingdon was a rare group of furniture by the celebrated German *ébéniste*, David Roentgen. Roentgen, born in 1743 at Neuwied on the Rhine, where his father Abraham had established a furniture workshop a few years before, was one of the most outstandingly successful *ébénistes* of the second half of the eighteenth century, supplying in the course of a long life great quantities of extremely expensive furniture to most of the Courts of Europe. He employed a staff of over a hundred craftsmen and designers and as a result was able to stock extensive *depôts* at Neuwied and in Vienna, Naples and Paris. The latter opened in 1780 much to the annoyance of the French guild who, in a vain effort to exercise control, obliged him to become *Maître* in the same year. Parisian guild laws were not framed with such an international figure in mind and any effect they might have had was seriously diminished by the prestige of his semi-official status as *Ebéniste Mécanicien du Roi et de la Reine,* an office bestowed by Louis XVI who held Roentgen in high favour, and who with the French court spent nearly 1 million livres (about £40,000 in the money of the day) on Roentgen's furniture. Between 1783 and 1785 Roentgen made several journeys to St. Petersburg, and in the latter year Catherine the Great, his other important royal patron, recorded that 'David Roentgen and his two hundred cases have arrived at the right moment to satisfy my gluttony'. Many of the pieces ordered by Catherine are still in Russia, some remaining in the palaces for which they were made. Roentgen's far flung business empire suffered a fatal blow from the French revolution; his Paris warehouse was expropriated, his French clientèle vanished and his workshops at Neuwied were destroyed by the Republican armies. He died, almost ruined, in Wiesbaden in 1807.

The pieces of furniture shown here illustrate the characteristic features of the Roentgen style of *circa* 1780: restrained architectural forms, sparingly applied ormolu and pictorial marquetry of the finest quality. Among the specialists employed by Roentgen were the painter Januarius Zick and the mechanician Peter Kinzing. Zick seems to have been commissioned to make designs for the chinoiserie marquetry panels of the kind seen here on the secretaire and the card table. Kinzing's specialities included highly complicated concealed locking systems – a feature common to much Germanic

furniture – and cleverly contrived mechanical or moving fitments. Although the same features frequently recur on Roentgen's furniture – in particular the marquetry panels – there is seldom any hint of mass-production or poor quality; thanks to stringent control, the standard of workmanship, as these pieces from the Hillingdon Collection show, is generally of the very highest.

Marquetry games-table, by David Roentgen
37½ in. (94.5 cm.) wide
Circa 1780, the marquetry signed DR
Sold 29.6.72 for 2800 gns. ($7291). Sold on behalf of the Trustees of Lord Hillingdon

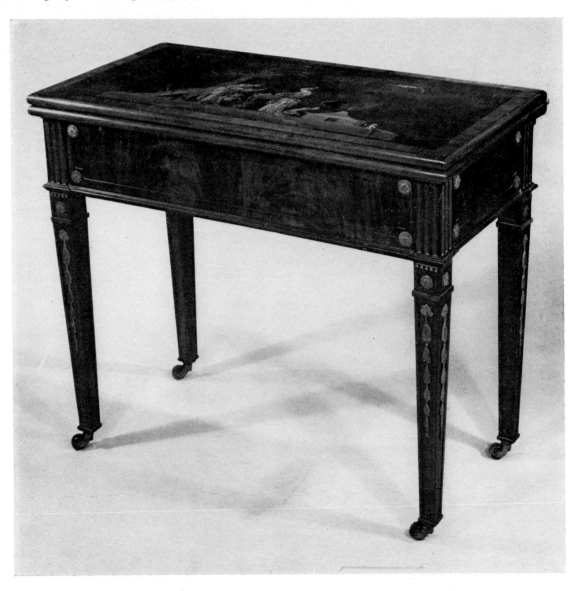

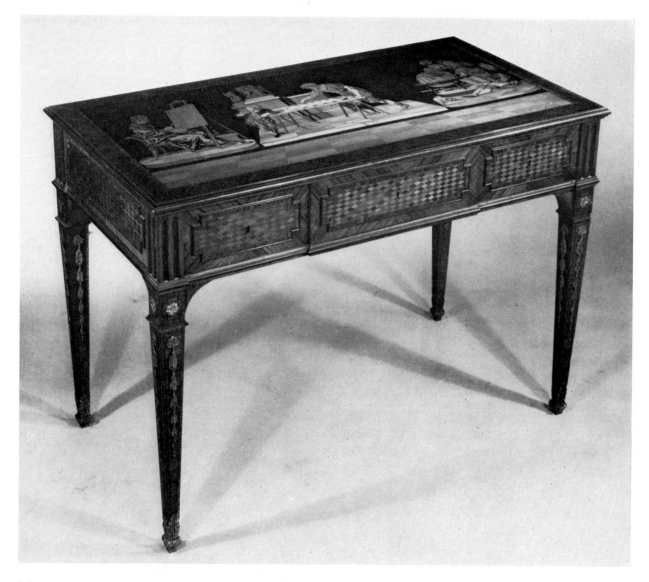

Marquetry rectangular table, the top with three panels from the Roentgen workshop
45½ in. (115 cm.) wide
Sold 29.6.72 for 3800 gns. ($9895)
Sold on behalf of the Trustees of Lord Hillingdon

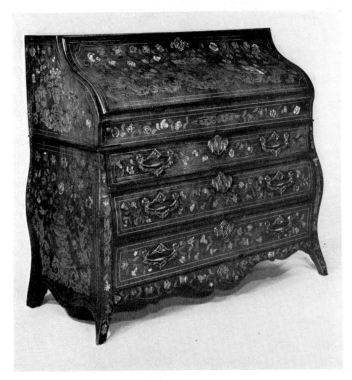

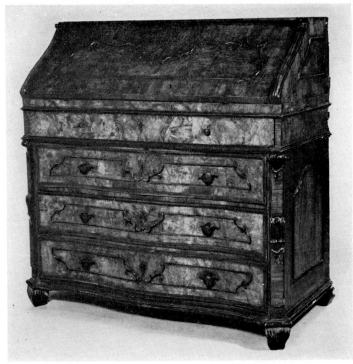

Dutch marquetry bureau of bombé form
47 in. (120 cm.) wide
Late 18th century
Sold 20.7.72 for 900 gns. ($2268)
From the collection of B. D. J. Walsh, Esq

North Italian walnut bureau
48 in. (122 cm.) wide
Mid-18th century
Sold 10.2.72 for 1150 gns. ($3139)

South German walnut and marquetry commode
48 in. (122 cm.) wide
Mid-18th century
Sold 25.11.71 for 2000 gns. ($5140)
From the collection of Mrs James de Rothschild

Left: Swedish kingwood parquetry bombé commode
47 in. (119.5 cm.) wide
Mid-18th century
Sold 20.7.71 for 650 gns. ($1638)

Bottom left: Flemish ebony and painted cabinet
44½ in. (113 cm.) wide
Sold 1.6.72 for 2200 gns. ($6006)

Bottom right: Large ebony and painted glass cabinet
70 in. (178 cm.) wide, 128 in. (325 cm.) high approx.
Late 17th century
Sold 1.6.72 for 1950 gns. ($5323)

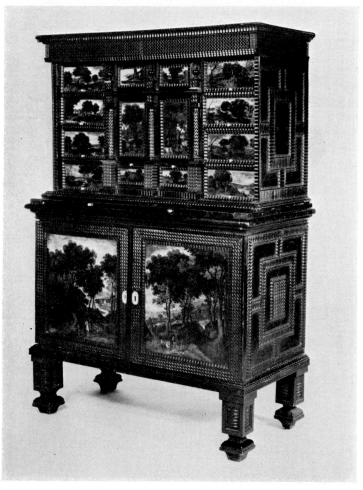

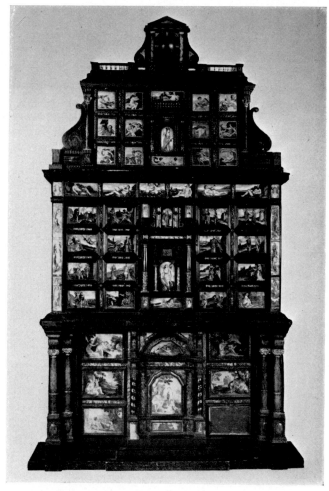

North Italian marquetry writing table of 'Bureau
Mazarin' type
51 in. (130 cm.) wide
Probably Turin, second half 17th century
Sold 25.11.71 for 3600 gns. ($9272)
From the collection of Mrs Gaby Salomon of Buenos Aires

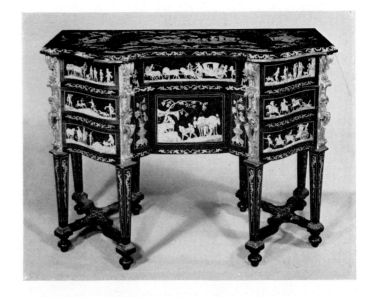

Fine Florentine pietra dura and ebony cabinet
49½ in. (126 cm.) wide
17th century, on English 19th-century stand
51 in. (130 cm.) wide
Sold 25.11.71 for 2200 gns. ($5654)

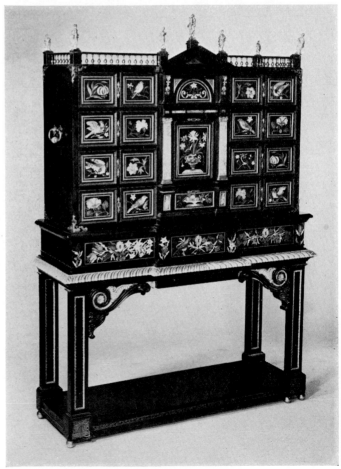

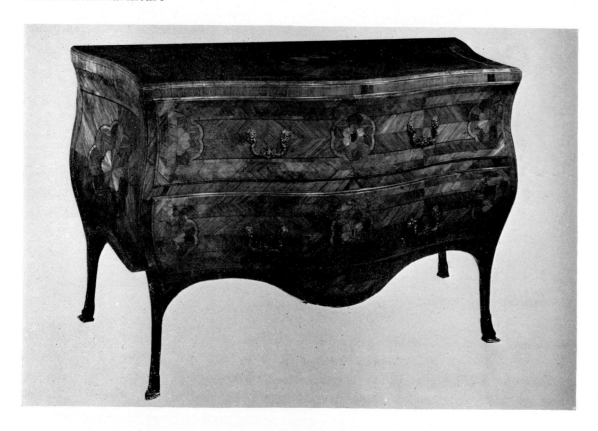

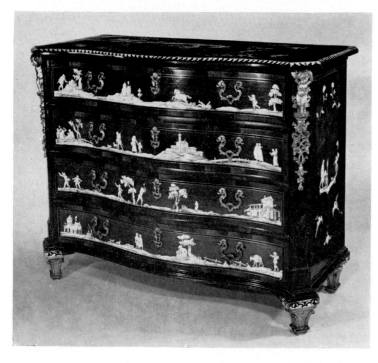

Top: South Italian kingwood
bombé commode
57½ in. (146 cm.) wide
Second half, 18th century
Sold 25.11.71 for 1200 gns.
($3084)

North Italian ivory inlaid
serpentine commode
53½ in. (136 cm.) wide
Circa 1730
Sold 27.4.72 for 2000 gns.
($5460)

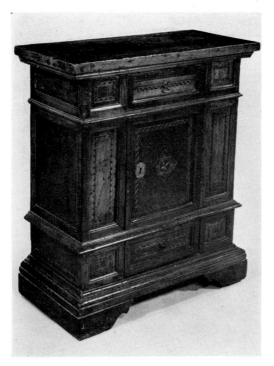

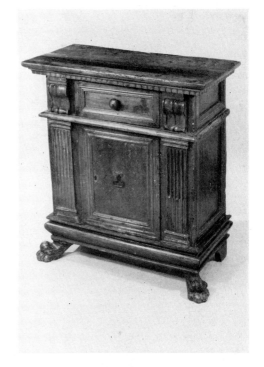

Italian walnut credenza
32 in. (81 cm.) wide
17th century
Sold 27.7.72 for 480 gns. ($1209)

Italian walnut credenza
30¼ in. (77 cm.) wide
17th century
Sold 4.5.72 for 500 gns. ($1365)

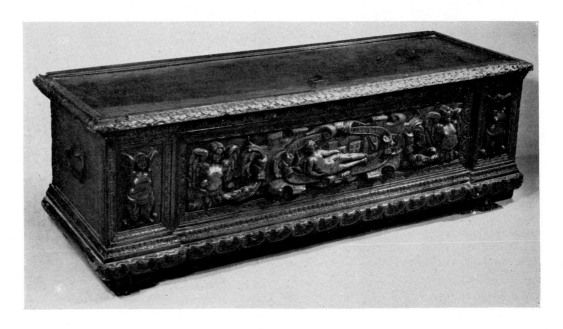

Italian walnut cassone
67 in. (170 cm.) wide
16th century
Sold 18.11.71 for 600 gns.
($1542)

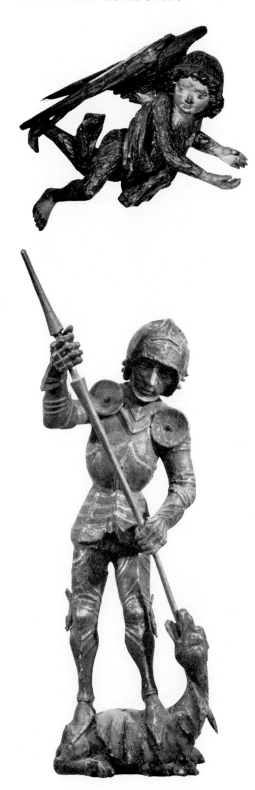

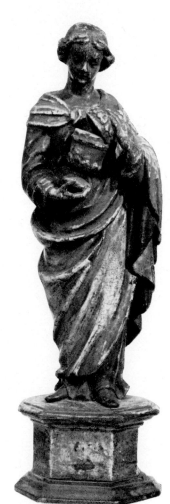

Top left and right: Pair of South German painted and gilded figures of flying angels
13 in. (33 cm.) wide
Circa 1500
Sold 20.6.72 for 1600 gns. ($3368)
From the collection of the late Dr Erich Alport

Far left: German painted wood figure of St George
20 in. (51 cm.) high
Late 15th century
Sold 20.6.72 for 750 gns. ($2041)

Painted wood figure of St Barbara
15¼ in. (39 cm.) high
Late 16th century, probably Flemish
Sold 20.6.72 for 500 gns. ($1365)
From the collection of Mrs James de Rothschild

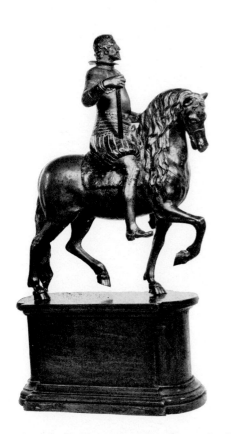

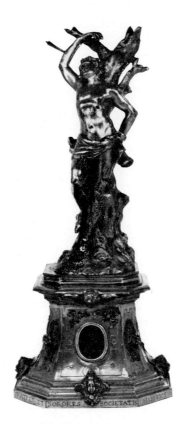

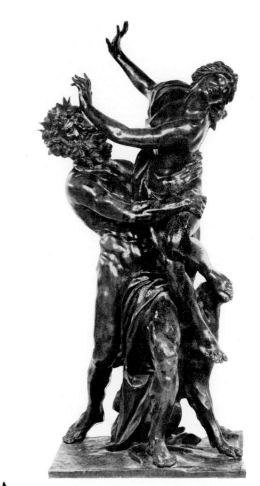

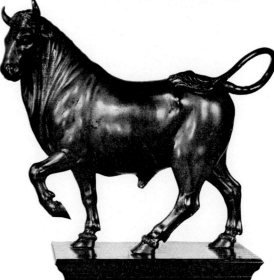

Top left: Bronze equestrian figure, in the manner of Susini
15½ in. (39 cm.) high, 17th century
Sold 20.6.72 for 2700 gns. ($7371)

Top centre: Copper gilt figure of the martyrdom of St Sebastian
17 in. (43 cm.) high
Probably South German
Sold 20.6.72 for 1800 gns. ($4914)

Top right: Bronze group of Pluto carrying off Proserpine, after
Bernini
30½ in. (77.5 cm.) high
Sold 1.2.72 for 2900 gns. ($7760)
From the collection of Mrs Gaby Salomon of Buenos Aires

Right: Bronze model of a bull, from the Bologna-Susini
workshop
9¼ in. (23.5 cm.) high, 10¾ in. (27.4 cm.) long
Sold 1.2.72 for 1600 gns. ($4284)
From the collection of Lt-Col A. Joyce

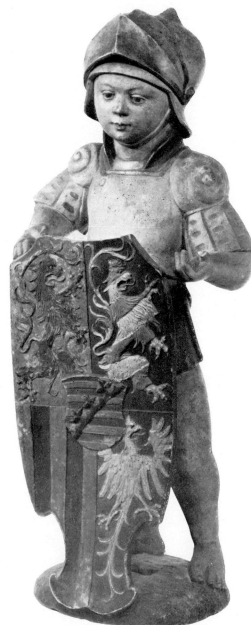

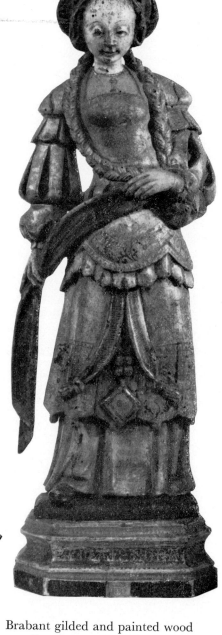

One of an important pair
of Venetian celestial and
terrestrial globes
By Vincenzo Coronelli
Total height 68½ in.
(174 cm.), circumference of
globes 130 in. (330 cm.)
1692/3 or 1699
Sold 23.3.72 for 6800 gns.
($18,564)

Important German solnhofer-stone
armorial supporter
19¾ in. (50 cm.) high
Second quarter 16th century
Sold 20.6.72 for 6500 gns. ($17,745)
From the collection of
Mrs James de Rothschild

Brabant gilded and painted wood
standing figure of the Virgin
16 in. (41 cm.) high
Malines, late 15th/early 16th century
Sold 20.6.72 for 2500 gns. ($6825)
From the collection of
Mrs James de Rothschild

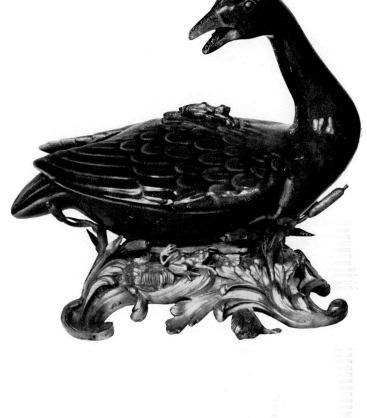

Right: One of a pair of Louis XV ormolu-mounted
turquoise porcelain ducks
9 in. (23 cm.) wide
Sold 2.12.71 for 7500 gns. ($19,293)

Bottom left: One of a pair of Louis XV ormolu-
mounted late Ming bowls and covers
11 in. (28 cm.) wide, the ormolu stamped with the
crowned C poinçon, the porcelain with green leaf mark
Sold 29.6.72 for 14,000 gns. ($36,460)
From the collection of Mrs James de Rothschild

Bottom centre: One of a pair of Transitional
ormolu and Meissen porcelain candelabra
16½ in. (42 cm.) high
The porcelain with blue crossed sword marks
Sold 29.6.72 for 3500 gns. ($9114)
Sold on behalf of the Trustees of Lord Hillingdon

Bottom right: Meissen porcelain and
Louis XV ormolu table ornament
14½ in. (37 cm.) high
Sold 23.3.72 for 3400 gns. ($9282)
From the collection of the late Mrs Derek FitzGerald

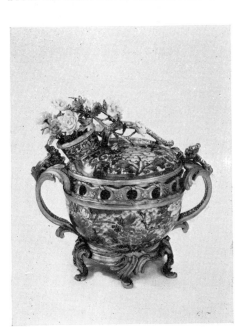

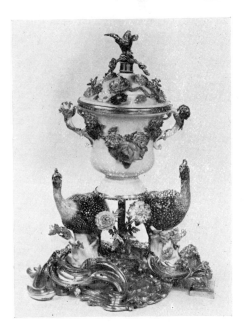

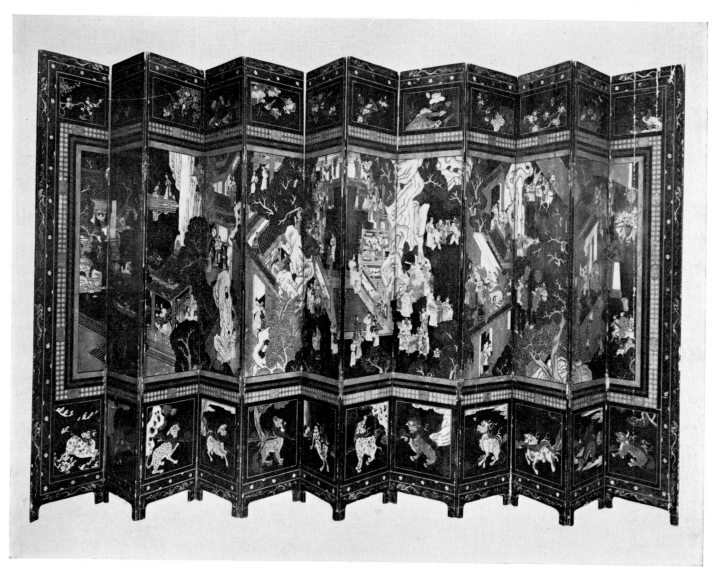

Chinese coromandel lacquer screen of twelve leaves
Each leaf 108 × 17 in. (274 × 43 cm.)
Ch'ien Lung
Sold 25.5.72 for 2600 gns. ($7098)
From the collection of The Hon Michael Astor

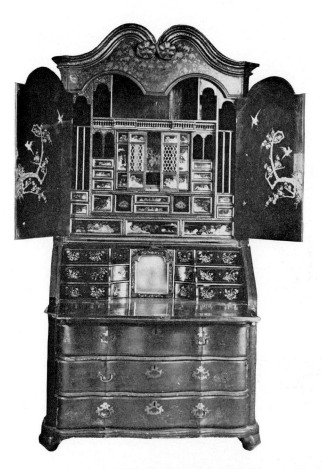

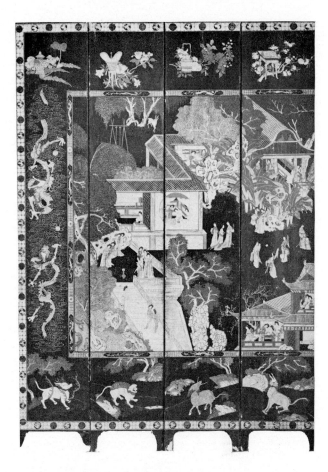

Top left: Chinese export lacquer bureau-bookcase
46 in. (117 cm.) wide, 89 in. (226 cm.) high
Second half of the 18th century
Sold 25.5.72 for 1300 gns. ($3549)

Top right: Four leaves from an important Chinese twelve-leaf coromandel lacquer screen
Each leaf 9 ft. 8 in. (294 cm.) high, 20½ in. (52 cm.) wide
First half of the 18th century
Sold 1.11.72 for 6000 gns ($15,420)
From the collection of The Rt Hon Lord Margadale of Islay, TD
Sold on the premises at Fonthill House, Tisbury, Wiltshire

Bottom left: Chinese mirror painting
30 × 17½ in. (76 × 44 cm.)
Late 18th century
Sold 3.2.72 for 1600 gns. ($4284)
From the collection of Mrs Warwick Bryant

The furniture of the nomad

BY OLIVER HOARE

It has often been assumed that carpet designs circulated around the Near and Middle East in much the same way as did the new compositions of paintings in post-Renaissance Europe. The assumption has been used to explain many relationships in carpet design, such as the close similarity between Bergama rugs from Western Turkey and certain Kazak rugs from the Caucasus. It does, however, overlook the most fundamental characteristic of carpets, that they are above all a tribal art form, the furniture of the nomad and his only luxury. If similar designs appear in different and often distant areas, it is because of the tribal link and the fact that designs largely belong to tribal groups much like heraldic symbols.

One must remember that the Turkish tribes migrated in the eleventh century from Turkestan and Central Asia, through Persia and the Caucasus, into Turkey,

Antique Kashan
silk rug
7 ft. × 4 ft. 2 in
(2 m. 13 cm ×
1 m. 27 cm.)
Sold 23.3.72 for
1750 gns. ($4777)
From the collection
of
Bo Sallmander, Esq

Right: Tabriz silk
prayer rug
5 ft. 7 in. × 4 ft. 2 in.
(1 m. 70 cm. ×
1 m. 27 cm.)
Sold 23.3.72 for
1500 gns. ($4095)
From the collection
of Dr A. Sanderson

Far right: Antique
Kuba rug
12 ft. 9 in. × 5 ft. 1 in.
(3 m. 89 cm. ×
1 m. 55 cm.)
Late 18th century
Sold 29.6.72 for
1250 gns. ($3250)
From the collection
of Herr G. M. Gloor

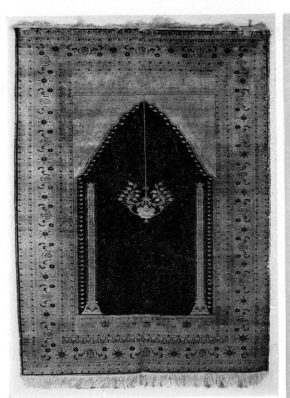

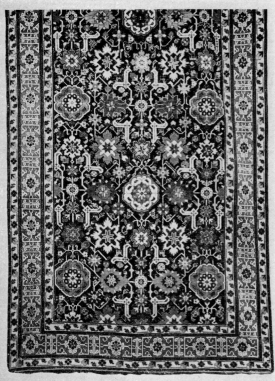

and thus, when a fifteenth-century carpet made in Turkey resembles a nineteenth-century Turcoman carpet made in the area of Bukhara, it is not that one has influenced the other in our sense, but that they are fundamentally the same, the genuine expression of the same ethnic group. Time works slowly among traditional tribal peoples; because these designs have an objective function which does not depend on the inspirational self-expression of an artist, they do not change.

Having said this, it is interesting to see where carpet design has departed from the tribal principle. Curiously, Persia is the villain of the piece, if one is considering the tribal integrity of the art form. It is debatable whether in fact the Persians ever made carpets before the very end of the fifteenth century. Certainly no example or even fragment exists, which is telling when one considers the numbers of earlier Turkish examples extant. If one turns for evidence to the Persian miniature paintings of the fourteenth and fifteenth centuries, carpets, whenever shown, have a distinctive Turkish look, and remembering that a large section of the population of Persia, then as now, was Turkish, and also remembering the basic tribal characteristic of these designs, it is not unreasonable to assume that these carpets were made by Turks.

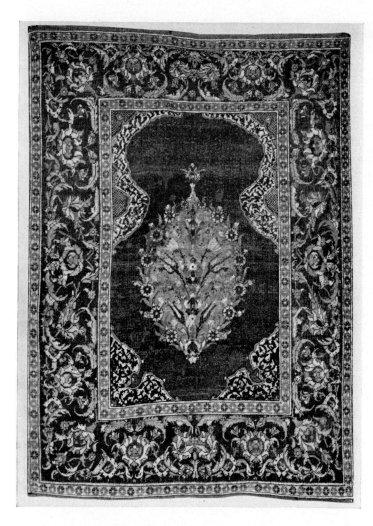

Ottoman prayer rug
5 ft. 10 in. × 4 ft.
(1 m. 77 cm. × 1 m. 22 cm.)
First half 17th century
Sold 29.6.72 for 2200 gns.
($5729)

Around the year 1500 a remarkable revolution took place in carpet design, which was unmistakably Persian and seems to represent the beginning of specifically Persian carpets. Its hallmark is the medallion-and-spandrels design – a central medallion with a quarter medallion in each corner – coupled with free floral forms so dear to Persians. This lay-out was to be found previously in illuminated manuscripts especially in the tooled leather bindings and illuminated frontispieces, and it is likely that the transfer to carpets took place as a result of painters being set the task of designing carpets by a royal patron. Thus the tribal uniqueness of the art form was lost in favour of new sophisticated designs from which the Persian tradition derives.

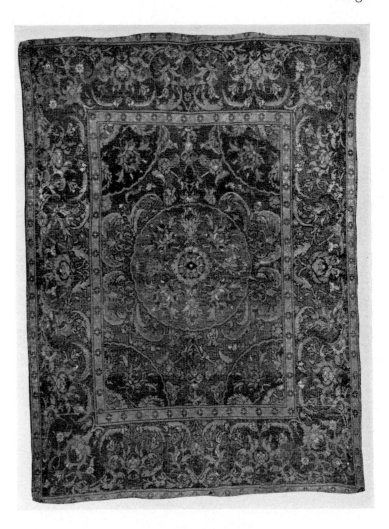

Ottoman rug
6 ft. 1 in. × 4 ft. 4 in.
(1 m. 85 cm. × 1 m. 82 cm.)
Mid-16th century
Sold 29.6.72 for 1400 gns.
($3646)

The carpet illustrated is an example of how this new concept of designing carpets took over. It was made in Cairo in the mid-sixteenth century in a manufacture set up by the Ottoman Sultan of Turkey after his conquest of Egypt in 1517. There were at that time frequent clashes between the Turks and the Persians, ruled since 1501 by the Safavid monarchs, and one notable Turkish success was the capture of Tabriz, the regional capital of Western Persia, in 1514. The town was looted and if as seems probable, carpets were among the loot, it may explain how suddenly the medallion and spandrels lay-out was being made in Cairo under Turkish patronage.

Tapestries

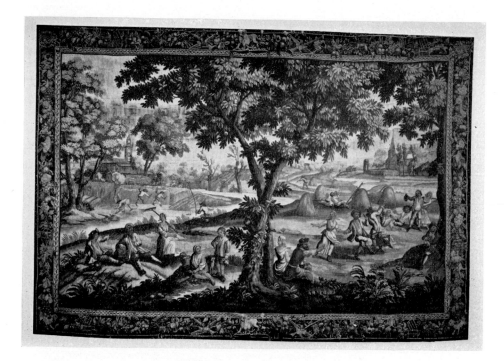

English tapestry of
The Harvesters, after Teniers
8 ft. 11 in. × 13 ft. 4 in.
(271 × 406 cm.)
Early 18th century
Sold 9.12.71 for 4800 gns.
($11,760)
From the collection of Sir
Thomas Pilkington, BT

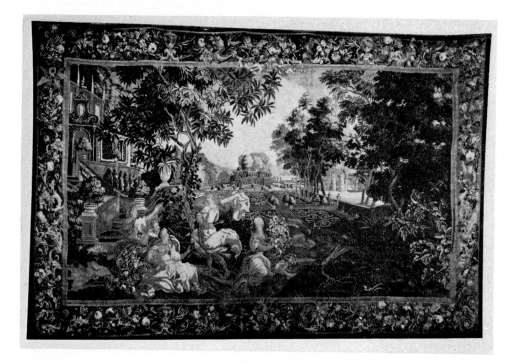

Brussels tapestry
10 ft. 10 in. × 16 ft. 10 in.
(330 × 515 cm.)
Circa 1700
Sold 2.12.71 for 2400 gns.
($6174)
From the collection of Sir
Thomas Pilkington, BT

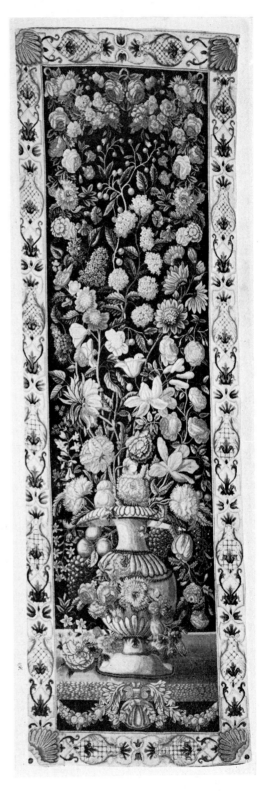

Top : Floral tapestry table cover
8 ft. 6 in. × 13 ft. 6 in. (257 × 412 cm.)
Probably English, *circa* 1690
Sold 25.11.71 for 2600 gns. ($6682)

Right : One of a pair of Louis XIV needlework hangings
9 ft. 10 in. × 3 ft. 1 in. (300 × 94 cm.)
Sold 29.6.72 for 5200 gns. ($13,540)

Rare Dutch tapestry table cover
8 ft. 5 in × 5 ft. 6 in. (257 × 168 cm.)
Mid-17th century, probably of Delft manufacture
Sold 25.11.71 for 5500 gns. ($13,621)

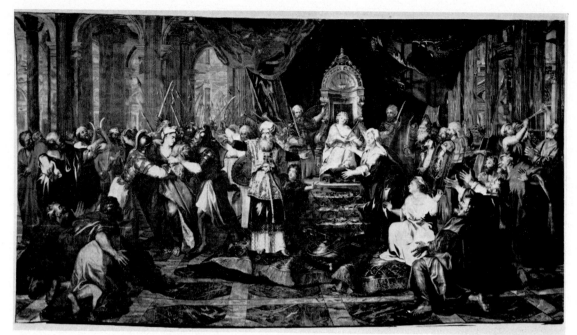

Gobelins Tapestry
By Jacques Neilson
Signed and dated
1781
11 ft. 8 in. ×
22 ft. 11½ in.
(355 × 700 cm.)
Sold 25.5.72 for
£3333 (L. 5,000,000)
in Rome in
association with
Gallery Salga

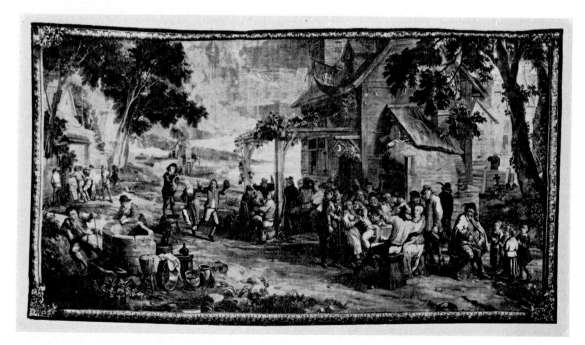

Brussels tapestry of
the Kermesse, after
Teniers
9 ft. 4 in. × 18 ft. 3 in.
(285 × 555 cm.)
Early 18th century
Sold 25.5.72 for
£5333 (L. 8,000,000)
in Rome in
association with
Gallery Salga

ARMS AND ARMOUR

Iron 24-pound cannon barrel from H.M.S.
Foudroyant, Nelson's flagship in the
Mediterranean
9 ft. 10 in. long, late 18th century
Sold 10.5.72 for 440 gns. ($1201)
Sold on behalf of The Foudroyant Trust

Silver-mounted Highland dress sword and
scabbard, the blade bearing the Radcliffe
coat-of-arms, and the Order of the
Thistle
33 in. (83.8 cm.) blade, the hilt and scabbard
mounts bearing Edinburgh silver hallmarks
for 1826, maker's mark TR
Sold 10.5.72 for 2200 gns. ($6006)
From the collection of Captain Sir Everard
Radcliffe, BT, MC

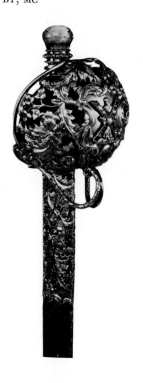

Right: Rare Scottish targe, 19½ in. (49.6 cm.) diam. Early 18th century. Sold 1.3.72 for 630 gns. ($1638) The property of the late Lord Glentanar, sold by order of the Hon. Mrs James Bruce

Bottom left: Spanish cup-hilt rapier with its companion left-hand dagger, 39½ in. (10.03 cm.) and 19½ in. (49.5 cm.) blades respectively, *circa* 1660 Sold 15.12.71 for 2200 gns. ($5654) Formerly in the collection of Samuel Rush Meyrick, BT

Second from right: Spanish left-hand dagger, probably by Francisco Perez of Toledo, late 17th century 22½ in. (57.2 cm.) overall, struck with three marks on the ricasso. Sold 15.12.71 for 560 gns. ($1439)

Far right: German seven-flanged steel mace, retaining traces of gilding, 24¾ in. (62.8 cm.), *circa* 1550 Sold 15.12.71 for 1350 gns. ($3470)

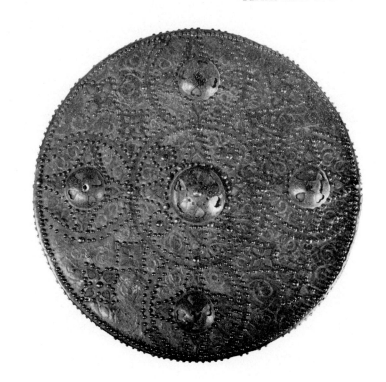

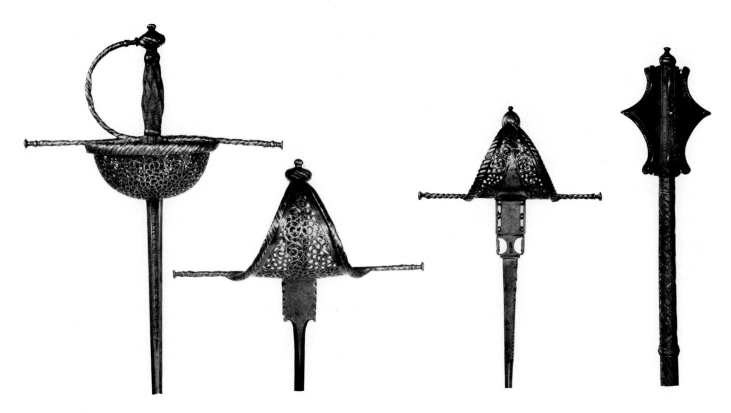

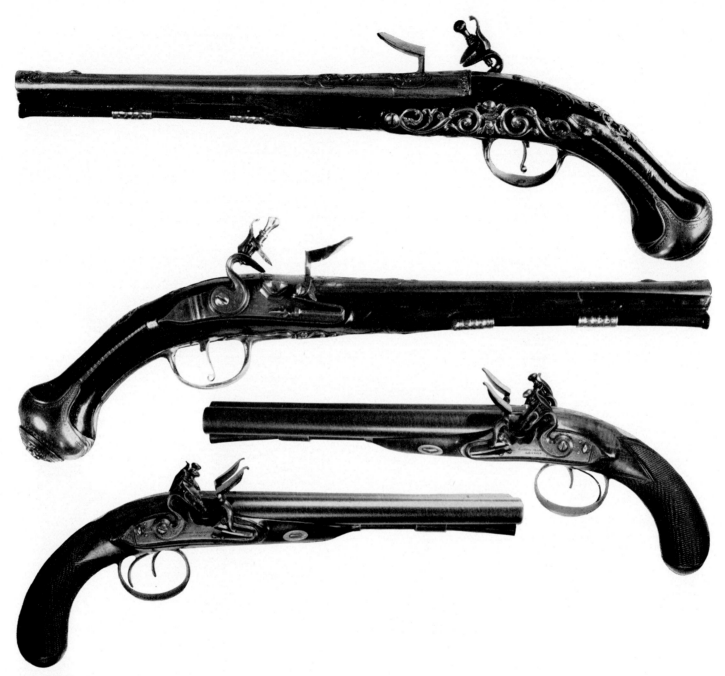

Top: Pair of Dutch flintlock holster pistols, with chiselled steel mounts by Penterman, Utrecht, *circa* 1700
20⅛ in. (51 cm.)
Sold 20.3.72 at Der Malkasten, Düsseldorf, for £1438 (D.M. 12,000)
Bottom: Cased pair of D.B. flintlock pistols
15½ in. (39.3 cm.), by Joseph Manton, London, *circa* 1803
Sold 10.5.72 for 1900 gns.

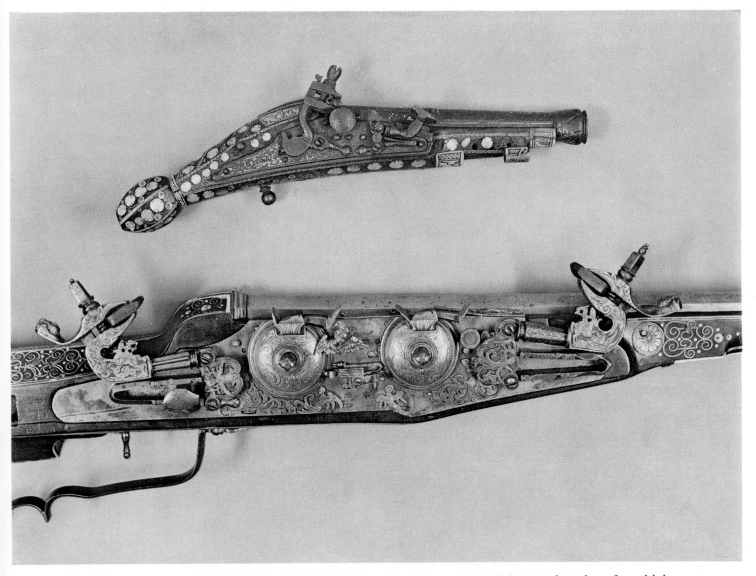

Top : Highly important English small snaphaunce pistol, the stock decorated with horn and mother-of-pearl inlay
Early seventeenth century. 11¼ in. (28.6 cm.)
Sold 27.10.71 for 10,000 gns. ($25,725)
From the collection of the late J. T. Hooper, Esq. Now in The Armouries, H.M. Tower of London

Bottom : Detail of an extremely fine Saxon wheel-lock super-imposed load, the lock with gilt mounts
Late sixteenth century, 43¼ in. (109.9 cm.) barrel struck with a mark, apparently a lion rampant within a shield
Sold 27.10.71 for 4800 gns. ($12,348)

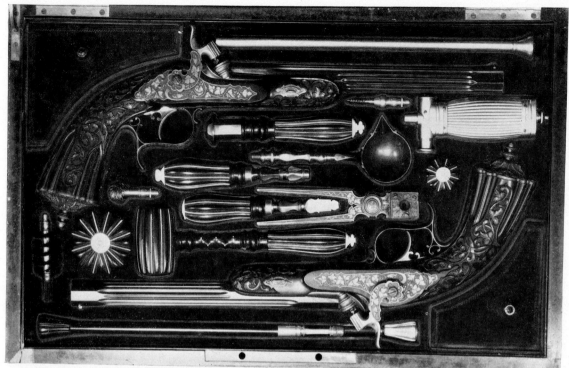

Cased pair of Belgian
percussion target
pistols
16½ in. (41.9 cm.)
Unsigned
Mid-nineteenth
century
Sold 10.5.72 for
1400 gns. ($3822)
From the collection
of Senor Carlos
Varela of Buenos
Aires

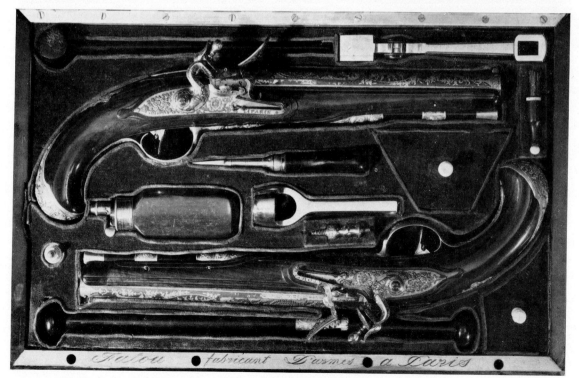

Cased pair of
flintlock silver-
mounted presentation
pistols
15 in. (38.2 cm.)
Signed Fatou, Paris
Dated 1818
Sold 21.6.72 for
2700 gns. ($7371)

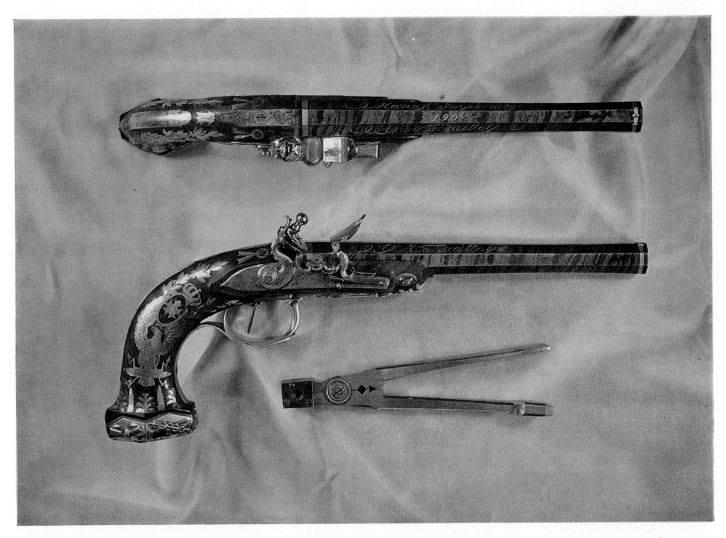

Cased pair of highly important French flintlock presentation pistols with silver mounts, bearing marks used up to 1809
By Nicolas Noël Boutet, Versailles
Sold 20.3.72 at Der Malkasten, Dusseldorf, for £15,587 (D.M. 130,000)
Traditionally given by Napoleon I to his brother Joseph Bonaparte on his being given the crown of Spain, probably in 1808

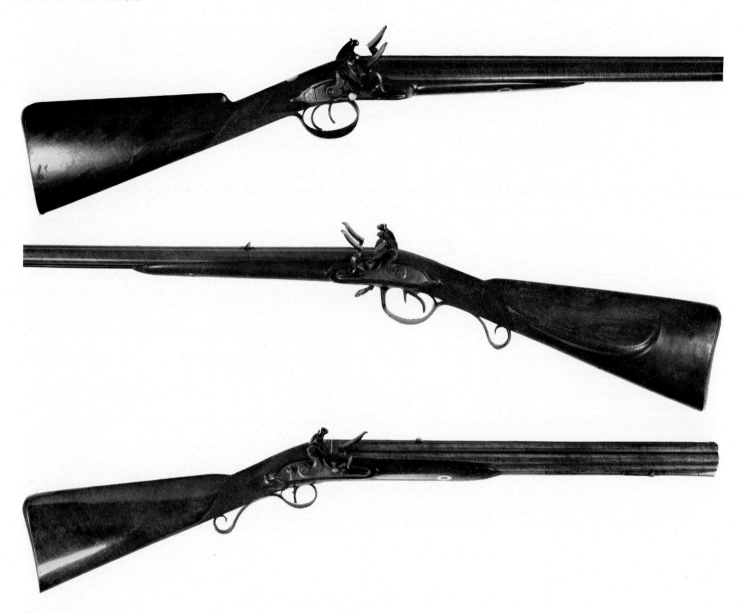

Top: D.B. flintlock fowling-piece, by Joseph Manton, London, *circa* 1815
30 in. (76.3 cm.) barrels. Sold 21.6.72 for 1250 gns. ($3412)
From the collection of Lt.-Col. M. P. De Klee

Centre: Royal D.B. flintlock combined fowling-piece and rifle, by Durs Egg, London, early nineteenth century
31½ in. (80 cm.). Sold 27.10.71 for 1200 gns. ($3084)
Made for the Duke of Cambridge, Viceroy of Hanover

Bottom: Very rare flintlock seven-barrel goose rifle, by Henry Nock, London, Gunmaker to His Majesty, late eighteenth century
20 in. (50.8 cm.) barrels
Sold 27.10.71 for 1450 gns. ($3727)

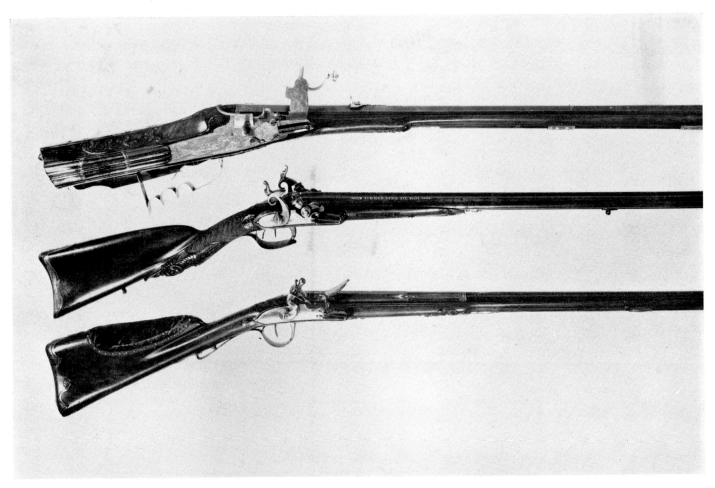

Top: Austrian wheel-lock sporting rifle with gilt mounts, by Franz Weyrer of Vienna, *circa* 1730
33 in. (83.8 cm.) barrel. Sold 10.5.72 for 1700 gns. ($4641)

Centre: Rare French D.B. sporting gun with fulminate locks on the Forsyth principle, by Le Page, Paris, dated 1815
32 in. (81.4 cm.) barrels. Sold 10.5.72 for 950 gns. ($2593)

Bottom: Very fine French flintlock fowling-piece, by Puiforcat, Paris, *circa* 1760/70
36 in. (91.4 cm.) barrel. Sold 10.5.72 for 1000 gns. ($2730)

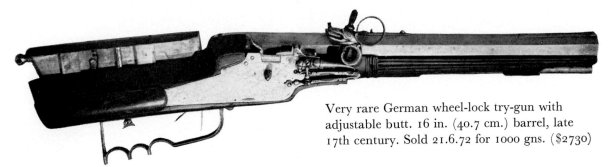

Very rare German wheel-lock try-gun with
adjustable butt. 16 in. (40.7 cm.) barrel, late
17th century. Sold 21.6.72 for 1000 gns. ($2730)

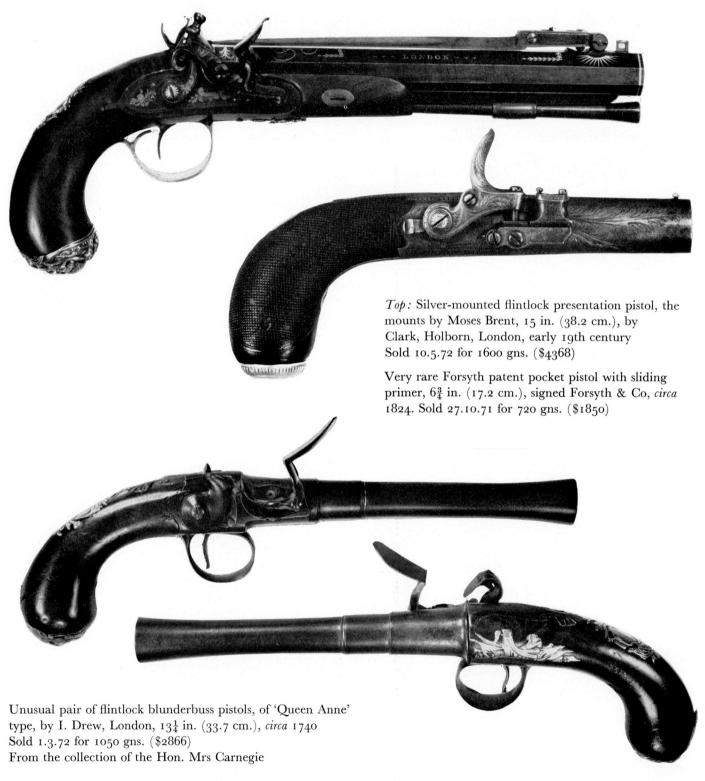

Top: Silver-mounted flintlock presentation pistol, the mounts by Moses Brent, 15 in. (38.2 cm.), by Clark, Holborn, London, early 19th century
Sold 10.5.72 for 1600 gns. ($4368)

Very rare Forsyth patent pocket pistol with sliding primer, 6¾ in. (17.2 cm.), signed Forsyth & Co, *circa* 1824. Sold 27.10.71 for 720 gns. ($1850)

Unusual pair of flintlock blunderbuss pistols, of 'Queen Anne' type, by I. Drew, London, 13¼ in. (33.7 cm.), *circa* 1740
Sold 1.3.72 for 1050 gns. ($2866)
From the collection of the Hon. Mrs Carnegie

Modern sporting guns

BY CHRISTOPHER BRUNKER

Modern sporting guns became an established feature of our arms sales in 1971. We arranged to take on the sale of sporting guns, which had previously been the speciality of Knight Frank and Rutley, when they closed their salerooms in 1970. The *entente* between the two firms has been celebrated in a joint stand at the Game Fairs of 1971 and 1972, and the success of the transition has been proved in sale results. Proceeds from the sale of modern firearms at Christie's in 1971 were forty per cent higher than at K.F.R. in 1970. The annual rise in prices may account for part of this increase, but there remains evidence of an expansion which has been maintained in 1972.

Our sales in 1971 included an average entry of thirty modern sporting shotguns, which has risen to thirty-seven in 1972. Though the numbers may not seem great at first sight, I calculate that since January 1971 our sales have accounted for about eighty per cent of the guns auctioned in London, and an even higher proportion of the guns that I would class as 'best' quality.

The principle demand is for sporting shotguns for use. All guns of quality and most guns in good order are acceptable for sale. There is a more limited market for modern rifles and pistols, many of which are not suitable for our sales. In the context of our arms sales, 'modern' encompasses most firearms made since the mid-nineteenth century. This is because firearms law applies, in practice, to all breech-loading, gas-tight cartridge firearms irrespective of age or obsolescence. Some early breech-loading firearms, which we term 'vintage' for convenience, have become collectors' items, but none is exempt from legal restrictions. The law affects the possession, sale and acquisition of firearms in two particular ways, Registration and Proof.

REGISTRATION OF FIREARMS

Registration concerns the certificates and procedures involved in possessing or acquiring modern firearms. Shotguns require a Shot Gun Certificate and all other firearms require a Firearm Certificate. Both types of Certificate are issued by the police. Shot Gun Certificates are normally issued readily and cover any number of unspecified shotguns. Firearm Certificates are more difficult to obtain

and they give restricted authority to possess or acquire specified firearms (e.g. rifles and pistols) and associated items (e.g. ammunition and silencers).

Procedures vary according to the transaction:

(a) *Selling*—the appropriate certificate should be presented with any firearm delivered for sale, but this is not essential. No firearm can be returned, however, unless the owner presents a valid certificate on collection. Details of our special Conditions of Acceptance for modern firearms are available on request.

(b) *Buying*—it is permissible to bid for firearms without holding a certificate, but no firearm may be collected until the required certificate is presented. Notes in the catalogue indicate the type of certificate needed.

(c) *Overseas Clients*—foreign certificates are not valid in the United Kingdom. However, overseas visitors (who have been in the U.K. for not more than thirty days in the previous twelve months) may import or acquire a shotgun without a certificate. This applies only to shotguns; other firearms require a valid certificate or must be handled by a recognised shipper. Advice on shipping, including Import and Export Licences, is available on request.

PROOF OF FIREARMS

Proof is the statutory testing of a firearm to show that it is safe for normal use, and no firearm may be sold unless it bears the valid marks of a recognized Proof House. Several European countries have proof standards recognized by agreement in this country. The exceptions include the pre-war proofs of Austria and Germany, which are no longer valid. It is also worth noting that all American firearms are regarded as unproved, unless they have been proved since importation. The various rules and marks may seem complex and mysterious, but they are relatively easy to learn. More difficult is establishing whether the marks on a particular firearm are still valid. As with hallmarks, the validity of proof is not diminished by time, but if a gun is altered, deliberately or accidentally, in a way that weakens it beyond prescribed limits, it becomes out of proof. To tell whether this has occurred, a gun must be carefully gauged and inspected. A set of gauges, as used by us, could cost as much as a good gun and technical viewing requires experience.

A common cause of a shotgun's becoming out of proof is the enlargement of its bores beyond the limit allowed by its present proof gauge. Oversize bores are usually the result of reboring, as when pitting has been lapped-out or dents raised. The removal of metal in this way may leave the barrels too thin to permit further repairs or to withstand re-proof. Where it is felt that barrels are

beyond repair or re-proof, the stock, action and fore-end of the gun may still be sold.

Where appropriate, we can submit firearms to proof prior to sale at the owner's risk and expense. The risk is that a firearm may be damaged or destroyed at proof, which involves the weapon's being fired with an excess load, and no compensation is payable. In certain circumstances, the Proof Master may grant, at his discretion, a Certificate of Exemption from Proof. These certificates are seldom issued for firearms for which ammunition is obtainable, however.

Certain defects may have to be put right before a firearm is accepted for proof. Most shotguns require some preparation and typical faults are dents and bulges in the barrels, pitting in the bores and looseness in the jointing of the barrels to the action. Where work is necessary, we can obtain a gunmaker's estimate.

Every gun sold at Christie's is examined by us and our findings are checked, as a precaution, by a leading firm of gunmakers. In doing this we act primarily for the seller, but our findings and opinions may also assist buyers, who are invited to consult us.

The following examples, taken from sales in our 1971–72 season, are representative as a whole. However, condition and other factors varied from gun to gun, and parallels between a particular example and a gun of similar type, make and age, may not apply. All these guns were nitro proof, double-barrelled and hammerless. Barrel and chamber lengths are shown thus, '28/2½ in'.

Detail of one of a pair of 12-bore sidelock ejector guns by J. Purdey, built in 1935
Sold 19.7.72 for 4000 gns. ($10,080)

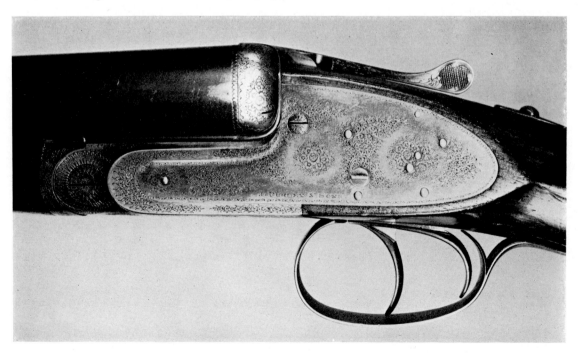

Sidelock Ejector Guns

	GUINEAS
ATKIN (H) 12-bore, No. 1450, 29/2½ in.	700
BOSS 12-bore, No. 5959, selective S/T, 28/2½ in.	1100
BOSS 12-bore over-and-under, No. 8824, S/T, 30/2¾ in.	2100
CHUBBS 12-bore, No. 10101, 27/2¾ in.	500
CHURCHILL (EJ) 12-bore 'Imperial XXV', No. 4879, 25/2½ in.	550
EVANS (W) 16-bore, No. 11966, 28/2½ in.	520
EVANS (W) 12-bore, No. 13944, plain finish, 30/2½ in.	300
HOLLAND & HOLLAND 12-bore 'Badminton', No. 20299, 28/2½ in.	550
HUSSEY (HJ) 12-bore 'Imperial', No. 14004, 28/2¾ in.	550
LANG (J) 12-bore, No. 18648, 28/2¾ in.	850
MARTIN (A) 12-bore, No. 18219, 28/2½ in.	440
PURDEY (J) 12-bore, No. 21753, 28/2½ in.	1250
PURDEY (J) 12-bore, No. 17494, 30/2½ in.	850
RICHARDS (W) 12-bore, No. 11134, 28/2½ in.	700
SCOTT (W & C) 12-bore 'Premier', No. 77394, 30/2½ in.	550

Pairs of Sidelock Ejector Guns

	GUINEAS
EVANS (W) 12-bore, Nos. 17222/3, 26/2½ in.	2500
GRANT (S) 12-bore, Nos. 7977/8, 29/2½ in.	1600
GRANT (S) 12-bore, Nos. 7990/1, 30/2½ in.	1200
HOLLAND & HOLLAND 20-bore 'Royal', Nos. 29465/6, S/T, 28/2½ in.	1550
HOLLAND & HOLLAND 12-bore 'Badminton', Nos. 32310/1, central-vision, 26½/2½ in.	1100
HUSSEY LTD 12-bore, Nos. 14555/6, 29/2½ in.	850
LANG (J) 12-bore, Nos. 14670/1, S/T, 28/2½ in.	1000
LANG (J) 12-bore, Nos. 15228/9, detachable locks, 29/2½ in.	1400
POWELL (W) 12-bore, Nos. 10946/7, 28/2½ in.	1250
PURDEY (J) 12-bore, Nos. 24697/8, 28/2½ in.	4000
PURDEY (J) 12-bore, Nos. 25271/2, 30/2½ in.	2000
PURDEY (J) 12-bore, Nos. 18923/4, cast-on, 30/2½ in.	1900
WESTLEY RICHARDS 12-bore 'Model A', Nos. 17496/7, selective S/T, 28/2½ in.	950
WILKES (J) 16-bore, Nos. 8133/4, 28/2½ in.	950
WOODWARD (J) 16-bore over-and-under, Nos. 6636/7, 28/2½ in.	2100

Boxlock Ejector Guns

	GUINEAS
ADSETT (T) 12-bore, No. 6966, 25/2½ in.	340
ARMY & NAVY 12-bore, No. 72490, plain finish, 28/2½ in.	220

Boxlock Ejector Guns (continued) GUINEAS

BLANCH (J) 12-bore, No. 4223, 30/3 in.	170
BLAND (T) 12-bore, No. 18085, 27/2½ in.	300
CHURCHILL (EJ) 12-bore 'Utility XXV', No. 6401, cast-on, 25/2½ in.	320
CHURCHILL (EJ) 12-bore 'Utility XXV', No. 4183, 25/2½ in.	300
CHURCHILL (EJ) 12-bore 'Crown XXV', No. 3017, 25/2½ in.	370
CHURCHILL (EJ) 12-bore 'Regal XXV', No. 4508, 25/2½ in.	250
CHURCHILL (EJ) 20-bore, No. 4968, plain finish, 25/2½ in.	280
COGSWELL & HARRISON 12-bore over-and-under, No. 69712, 30/2½ in.	320
COGSWELL & HARRISON 12-bore, No. 45756, 30/2½ in.	170
CRUDGINGTON (IM) 12-bore trap model, No. 35, 30/2¾ in.	200
FORD (W) 12-bore, No. 20302, central-vision, 28/2½ in.	230
HELLIS (C) 12-bore, No. 2929, 28/2½ in.	250
HOWELL (W) 12-bore (no number), 26/2½ in.	280
LANCASTER (C) 20-bore 'A. & W. Special', No. 12808, 28/2½ in.	300
LANG (J) 12-bore, No. 17992, 27/2½ in.	300
WATSON BROS 20-bore, No. 8551, 28/2½ in.	260
WEBLEY & SCOTT 12-bore, No. 115101, plain finish, 28/2½ in.	130
WESTLEY RICHARDS 12-bore, No. 17565, detachable locks, selective S/T, 30/2¾ in.	580

Pairs of Boxlock Ejector Guns

CHURCHILL (EJ) 12-bore 'Utility XXV', Nos. 5529/30, 25/2½ in.	850
EVANS (W) 12-bore, Nos. 4277/8, 30/2½ in.	380
POWELL (W) 12-bore, Nos. 10895/6, plain finish, 29/2½ in.	320
RUSSELL HILLSDON 12-bore 'Royal Counties', Nos. 3753/4, one cast-on, 26/2½ in.	800
TOLLEY (J & W) 12-bore, Nos. 84007/7A, 28/2 in.	600
WESTLEY RICHARDS 12-bore, Nos. 16153/4, selective S/T, damascus barrels, 28/2½ in.	620

Boxlock Non-Ejector Guns

ARMSTRONG & CO 20-bore, No. 23517, barrels by J. B. WALKER, 28/2½ in.	90
BAKER (F.T.) 4-bore, No. 7800, side-lever, 38¾/4 in.	680
GREENER (WW) 12-bore 'Facile Princeps', No. 58175, 30/2¾ in.	190
GREENER (WW) 10-bore 'Facile Princeps', No. 57290, 31/2⅞ in.	280
RICHARDS (W) 8-bore, No. 9415, 36/3¼ in.	320
WILD (T) 12-bore, No. 10432, 32/3 in.	80

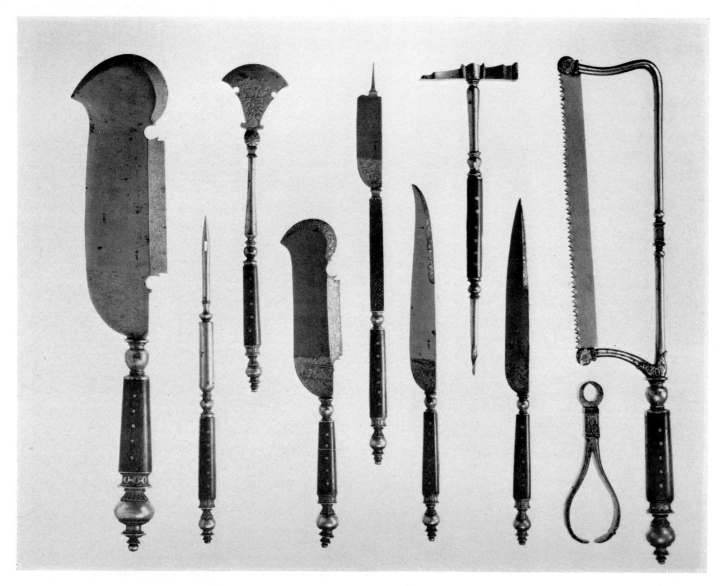

Set of South German surgical instruments, one piece dated 1569.
Sold 20.3.72 at Der Malkasten, Düsseldorf, for £1438 (D.M. 12,000)

WINE

The wine year

BY MICHAEL BROADBENT, MW

The 1971–72 season has seen a marked increase in the price of fine wine and a broadening of our international activities. We have continued to break more price records and set further precedents, the most significant being the publication of *Christie's Wine Review*.

The pattern of sales

We have followed our now customary pattern of specialized sales held weekly, with breaks around Christmas and Easter, throughout the season.

Out of a total of 30 wine sales (compared with 31 last season), 6 have been Fine Wine; 6 Bordeaux; 3 Vintage Port & Sherry; 5 End of Bin; 1 Hock & Burgundy, and 4 Overseas sales (including Dublin). In the absence of any monumental trade sales the five Christie–Restell sales at Beaver Hall have provided a useful outlet which City buyers clearly find convenient. The specialized Burgundy and Hock sales are being phased out, the better quality wines going into Fine Wine sales and run-of-the-mill wines into End of Bin and City sales. Certainly the price of good burgundy has improved measurably, but whether this is because of the Fine Wine context or the increasing appreciation of the previously undervalued fine Burgundies is hard to say.

In addition to the London based sales we have held one wine auction in Dublin, one in association with a firm of French auctioneers in Vosne-Romanée and have conducted two sales in America.

Overseas Wine Activities

This season has seen the extension of our international wine auction activities.

Dublin, 12 October, 1971. Sale total: £14,253. ($37,057)

Our first ever wine auction in the Irish Republic was held in conjunction with an old established firm of family wine merchants, FitzGerald, Findlater & Co. Ltd. The catalogue was made up of wine from various private and trade sources, the biggest parcel being the remaining contents of the cellars of the former and renowned Jammet's Restaurant.

Sakowitz, Houston, Texas, 4 November, 1971. Sale total: $23,000 (£8800)
Sakowitz is the largest and most successful group of family owned speciality stores in the United States. In common with the better class department stores in this country, they have flourishing wine departments and these new annual auctions manage to combine a genuine sale of rarer wine with some useful promotional activity.

The first Sakowitz wine sale in October, 1970, was arranged by a firm of New York auctioneers. For their second sale, they decided to call in Christie's and the Head of the Wine Department flew to Texas to conduct the sale.

The Belin Sale, Vosne-Romanée, 5 December, 1971. Sale total: NF 120,000 (£9000)
In conjunction with a firm of Dijon auctioneers we disposed of the very fine cellar of the Restaurant Belin, a two-rosette establishment at Montbard. The sale, held in the Caves Municipaux at Vosne-Romanée in the heart of Burgundy's Côte d'Or, was well attended and prices were high despite the swingeing TVA (VAT) and other taxes which had to be paid by the French buyers.

The Fourth Heublein Premiere National Auction of Rare Wines. New York 23 May, 1972. Sale total: $260,335 (£100,130).
Heublein's and Christie's pioneered the first American wine auction in 1969. This year's, the fourth, was the largest and most successful to date.

By now the teamwork on both sides is almost effortlessly smooth and although we have reservations about the effect engendered by some of the somewhat artificially high prices, on balance we consider this monumental promotion usefully stimulates a high degree of interest in wine and, incidentally, in the auction medium.

Mr Alexander C. McNally, Heublein's wine manager, once again arranged the sale and the head of Christie's wine department advised and conducted the auction itself which this year took place in the Vivian Beaumont Theatre at the Lincoln Center, New York.

Amongst many high prices a new world record was established by a New York wine merchant who paid $9200 (£3540) for a jeroboam of Mouton-Rothschild, vintage 1929. The vendor was one of Christie's most distinguished private clients.

As a result of these overseas activities we are attracting more and more buyers and sellers, clients who either send wine to London for sale, or instruct us to sell their stocks still lying in their own cellars.

Buyers range from Australia, Switzerland and almost all parts of the United States.

Inflationary demand in the wine market

Throughout the season the cumulative effects of the marked international upsurge of interest in fine wine has been felt. It is not just the rampant enthusiasm of the Americans, for the demand has also been growing in Western Europe and, a very recent phenomenon, in Japan. As the output of the hard pressed top growth vineyards is naturally limited, the increasing world demand can have only one effect. The result is of course higher prices for new vintages at source followed by the frantic search for maturer wines and the consequent price rise of old wines.

The only 'unnatural' and disturbing influence is the unknown level of demand for speculative purposes only.

'Christie's Wine Review'

Despite the delay in publication, due to a printing go-slow and other factors, we can report that this entirely new venture, the first of its sort, has been well received and is already more than just self-supporting.

Wine is totally unlike works of art which are mainly 'one-off's'. We are dealing with an article of multiple production whose quality variations are dependent initially on geographical origin and the sum total of natural yearly climatic variations; and finally, upon its age and condition. The selling price is a reflection of this combination of quality and the quantity available. Over a period of time a pattern emerges and it is this which, in effect, we report in the Price Index section which occupies exactly one half of the Review.

The prices section is preceded by articles about historical wine auctions, current market trends and vintage comments and assessments.

It is our intention to publish the Wine Review annually, containing an index based on the highest and lowest prices obtained on the open market (not just Christie's) during each preceding calendar year.

Highlights of the London sales season

One of the best sales of the season followed the removal of the contents of the cellar of the Queen's Garden Restaurant, The Hague. Visitors to the Park hotel will have to make do now with a less de luxe ambience and less rare wines following the owner's decision to concede victory to spiralling costs. A very attractive and varied collection, mainly of Bordeaux and Burgundy, realized £21,000 ($50,400).

Individual prices follow a pattern, the centre being held by first growth claret fringed by the better known lesser growths and fine burgundy, both of which have increased markedly over the past few months. Following the successful and highly priced 1970 vintage, other prices, particularly of mature and negotiable vintages,

Pre-phylloxera claret
from Sir William
Gladstone's cellar
at Fasque

Left to right:
Léoville 1864
(28 bottles £1165—
$3029)
Léoville-Lascases 1871
(12 bottles £198—
$515)
Lafite 1871
(32 bottles £1505—
$3913)
Pichon-Longueville,
Lalande 1875
(8 bottles £250—
$650)
Gruaud-Larose 1875
(6 bottles £160—
$416)

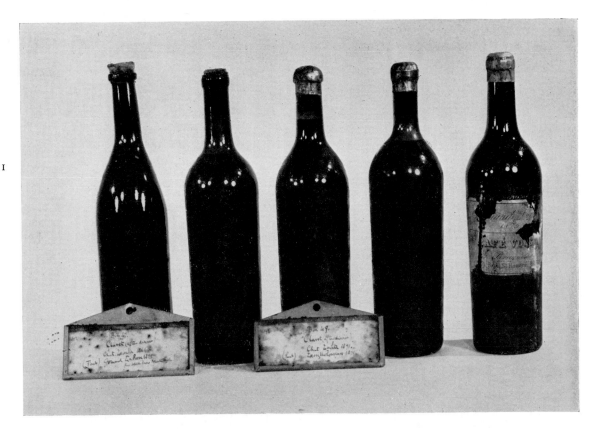

have soared, and even the previously sluggish 1960 and 1963 vintage ports have at last 'taken off'.

So many record prices have been achieved that as successful sale succeeds sale we have stopped noting them as such. Some examples of the seasonal highs follow (prices being £ per dozen bottles):

PORT – Cockburn, 1927 £94 ($243), Croft 1908 £78 ($203), Dow 1912 £82 ($213), Fonseca 1948 £88 ($229), Graham 1917 £86 ($224), and 1955 £60 ($156), Martinez 1908 £70 ($182), Quinta do Noval 1931 £130 ($338), Taylor 1935 £100 ($260), and 1945 £100 ($260).

CLARET – Lafite 1858 £200 ($520) per magnum, 1865 £410 ($1066) per double magnum, 1874 £155 ($403) per magnum, 1924 £230 ($598) per dozen, 1945 £280 ($728), 1961 £250 ($650), Margaux 1934 £195 ($507), Latour 1934 £220 ($572), 1945 £240 ($624), Mouton-Rothschild 1961 £270 ($702), Petrus 1961 £350 ($910).

BURGUNDY – Romanée-Conti 1961 £310 ($744), Richebourg 1955 £200 ($520).

SAUTERNES – Yquem 1945 £105 ($273)

The highlight of the entire season was the sale of rarities from Sir William Gladstone's cellar at Fasque in Scotland. The discovery of this cellar was the nearest

thing we on the wine side will ever come to a 'Tutankhamun'. The wines were mainly laid down by the first and second baronets (respectively father and eldest brother of the great Liberal Prime Minister). Certainly nothing was added after 1914.

All the great mid-century vintages of port were represented, magnums of the 1834 fetching £98 ($255) each, forty bottles of the 1837 realized a total of £590 ($1534), and three dozen bottles of the 1851 £835 ($2171).

Old claret sold well, twenty-eight bottles of 1864 Léoville in perfect drinking condition realized £1165 ($3029), and two dozen and eight bottles of Lafite 1871 (in immaculate condition) brought in £1505 ($3913), as illustrated on the previous page.

Roughly fifty cases of beautifully preserved old wine was sold for £7233 ($18,806).

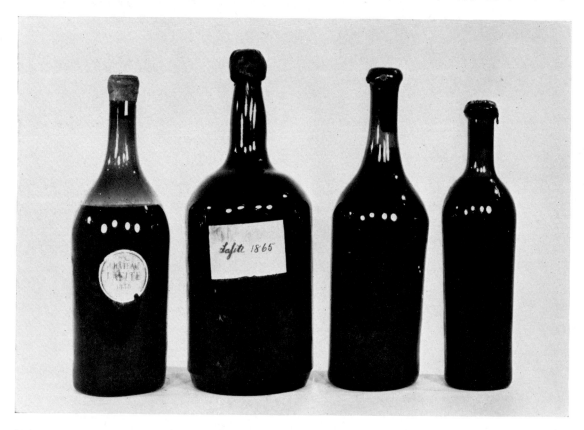

Pre-phylloxera Lafite

Left to right:
Magnums of 1858 £190 ($494) and £200 ($520) each
(ullaged sample shown to illustrate label)
Double magnum of 1865 £410 ($1066)
Magnum of 1874 £155 ($403)
Bottles of 1874 £26 ($68) each

Wine Press and 'Relics'

Our first major sale of wine trade relics and collectors' pieces formed the afternoon portion of the Fine Wine sale on April 27th.

An extremely rare French wine press (see illustration below) dated 1784 was bought by the Peter Stuyvesant Foundation for the Stellenbosch Wine Museum. The price paid was £2700 ($7020). Also in the sale were silver wine labels, a collection of rare seventeenth- and eighteenth-century Acts and 'Ordonnances' related to wine, and prints and drawings on the subject – all assembled by the late André L. Simon. A Vintners' Inventory dated 15 October 1663, in the form of a scroll manuscript 700 cm. long realized £74. ($194). Perhaps the biggest surprise of the sale were the extremely high prices made by sets of old corkscrews (see illustration page 412), six early patented examples fetching a total of £346 ($900).

An extremely rare old wine press
£2700 ($7020)

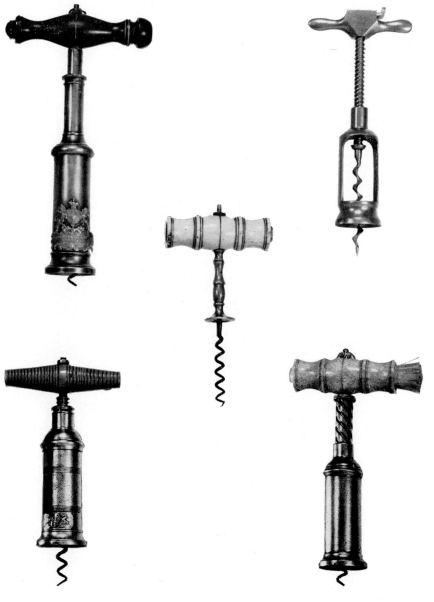

Part of a collection of early patented corkscrews
Sold 27.4.72 for: *top left* £84 ($202); *top right* £64 ($154); *centre* £64 ($154); *bottom left* £20 ($48); *bottom right* £42 ($103)

DOLLS, FANS
AND DRESSES

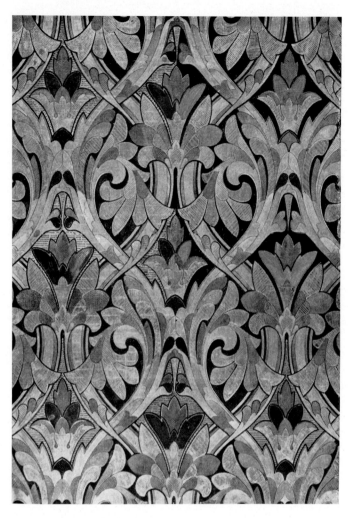

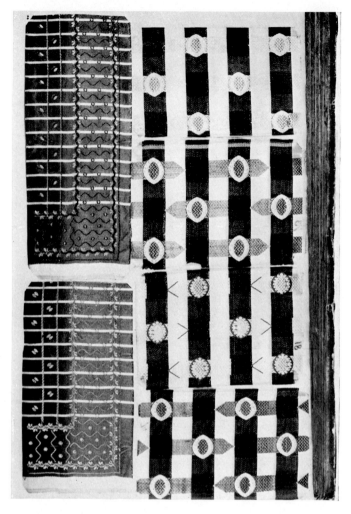

Stanhope, by Owen Jones, a design for silk
Circa 1870–74
$25\frac{1}{2} \times 18\frac{1}{4}$ in. (65 × 46.3 cm.)
Sold 10.7.72 for 260 gns. ($655)
From the Archive of Warners of
Braintree Ltd.

Six 18th-century samples of waistoat material, from a
pattern book inscribed '1786 Maze & Steer, Fancy
Vestings and Handkerchief Goods'
English, dated 1786–1789
Sold 10.7.72 for 1800 gns. ($4536)
From the Archive of Warners of
Braintree Ltd., Silk Weavers of Spitalfields and Braintree
Now in the Victoria and Albert Museum

The Warner Archive

BY SUSAN MAYOR

A new departure, or rather the return to an eighteenth-century practice for Christie's, was the sale of the Warner Archive on the 10th July. Unlike the sale of weaver's goods held in the 1780's which were sales of stock lengths, this sale consisted of pattern books of other firms from 1750–1900, eighteenth-century French designs and Warner's own production records and designs.

The principal buyer was the Victoria and Albert Museum which was successful in purchasing most of the eighteenth-century pattern books including five of the notable firm of Batchelor, Ham and Perigal 1768–1833, a book of waistcoat samples by Maze and Steer 1786–1789 and a French order book possibly the book confiscated by the Customs in 1764 as contraband. These will be invaluable for the dating of costume. While they were at Christie's a waistcoat came in that could be dated to the summer of 1789, instead of the blanket 'circa 1790' and, happily, it followed the pattern book to the V. & A.

Many designers were at the sale and bought several of the nineteenth-century pattern books, although museums bought a number, including those of Stone & Kemp, a big mid-nineteenth-century weaving house, one of whose books went for 400 guineas ($1008) to the V. & A., who also paid 1600 guineas ($4032) for the seventeen volumes of Warner's own handloom production records from 1884–1930. As there were 112 nineteenth-century pattern books it was pleasing to see that the supply did not exceed the demand and designers are still influenced by earlier forms.

A book *Clouds and a few satin flounces* of 1792 which went for 650 guineas ($1638) could have been a haberdasher's pattern book for ties in 1972 and a shell pattern of 1848 was the obvious inspiration of Herbert Woodman's *Morecombe* of 1937 with each being true to the taste of its time. In the other eighteenth-century pattern books are samples that could have passed as new in all decades of this century.

Another extremely important part of the sale was the group of sixty-six designs from Galy Gallien of Lyons, twenty-three of which were dated from 1761–1771. These appear to be the only dated French silk designs known and as rare as the eighteenth- and early nineteenth-century point papers, technical designs used by the

weavers in setting up their looms and almost always used as waste paper. The former were purchased mainly by the V. & A. and the latter were bought by the V. & A. and Colefax and Fowler, the interior decorators. The Science Museum bought some of the Dye books that came originally from Edmund Potter and Co.'s Calico Works at Dinting Vale near Glossop in Derbyshire.

The final fifty-five lots were devoted to Warner's themselves who have closed down their mill at Braintree a hundred years after they were founded in 1870 at the bottom of the silk slumps by Benjamin Warner who saw the only hope of survival was in producing fine designs for the English taste. The wheel has turned and the designs he commissioned from Owen Jones, Talbert, Godwin and others have found favour again. Jones's design 'No. 28' fetched 340 guineas ($856), his Sicily and Stanhope 260 guineas ($655) each, and A. H. Mackmurdo's Bexley 360 guineas ($807) for two versions. Even the best designs of the 'twenties and 'thirties fetched good prices as designers competed with museums, three designs by Albert Swindells of 1926–34 fetching 32 guineas ($77).

The Victoria and Albert Museum was able to buy almost all they wanted as the result of an appeal to those interested in textiles. The decision to offer the property for sale at auction was amply justified as it generated the urgency that made it so successful.

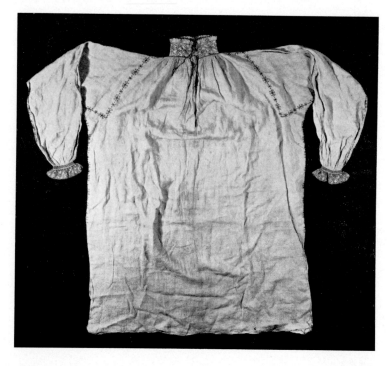

Extremely rare Tudor young man's shirt, embroidered in blue cross-stitch at the collar, cuffs and seams
16th century
Sold 3.5.72 for 850 gns. ($2230)
From the collection of Colonel J. Anderson-Wilson

Carved and painted
wooden doll
10 in. (25 cm.) high
Circa 1805
Sold 17.7.72 for 95 gns.
($238)

China doll, dressed
à la Turque
7½ in. (19 cm.) high
Circa 1860
Sold 17.7.72 for 60 gns.
($151)

Poured wax child-doll
by Charles Marsh
21 in. (54 cm.) high
Circa 1865
Sold 17.7.72 for 65 gns.
($163)

Bisque boy bathing-doll
8½ in. (19 cm.) high
Circa 1890
Sold 17.7.72 for 32 gns.
($83)

From the collection of
the late Miss E. G.
Hastelow, sold on
behalf of the Guide
Dogs for The Blind
Association

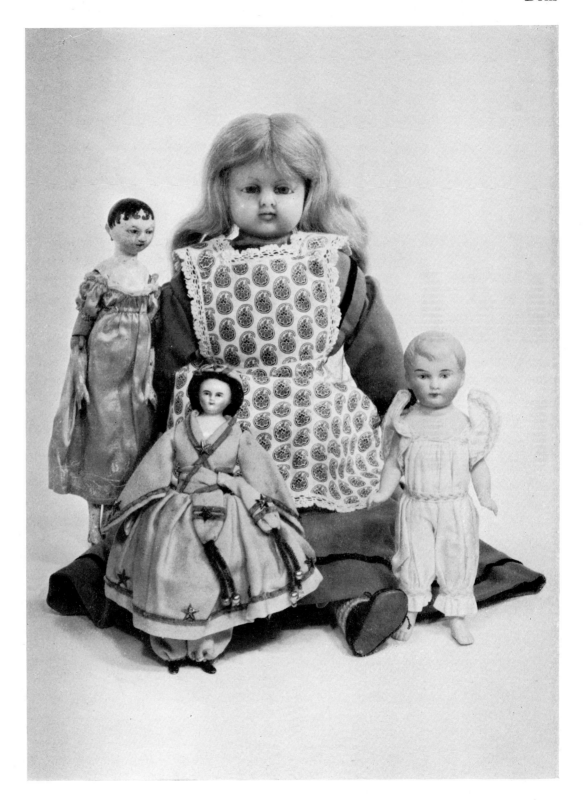

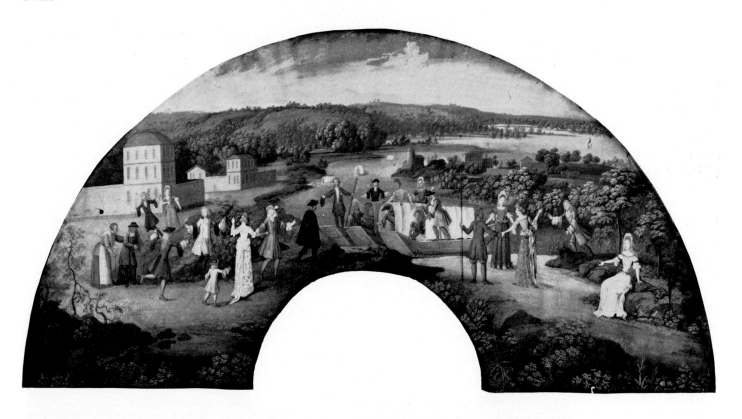

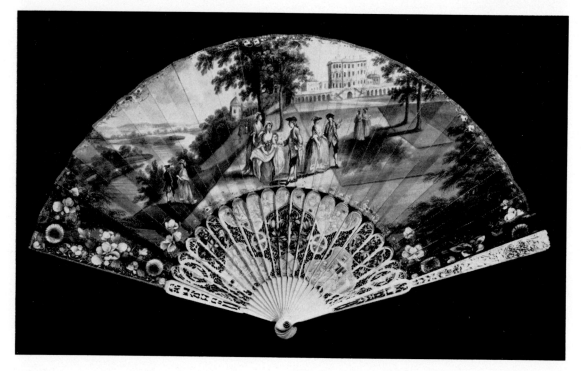

Top: Fan leaf
20 in. (51 cm.) wide
Dutch, *circa* 1680
Sold 3.5.72 for
230 gns. ($628)

English topographical
fan, the paper leaf
painted with figures
before Cliveden
House, Taplow,
Bucks
10 in. (25 cm.) wide
Mid-18th century
Sold 3.5.72 for
180 gns. ($491)
(see opposite)

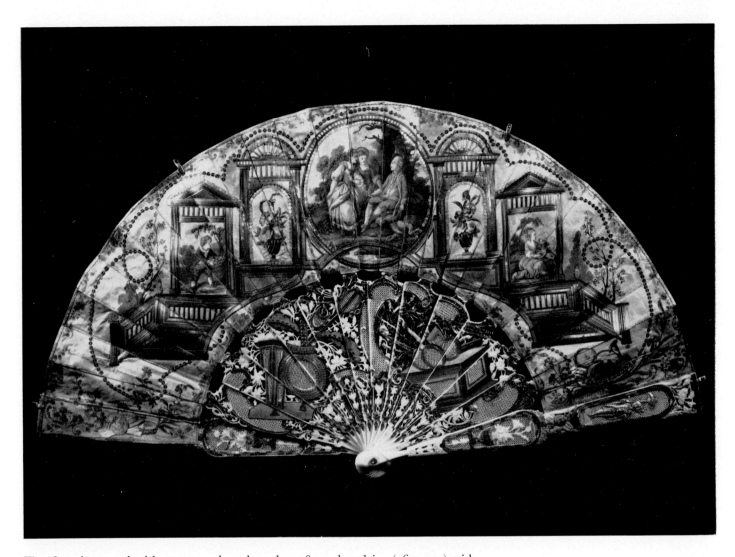

Fine fan, decorated with straw-work and mother-of-pearl. 10½ in. (26.5 cm.) wide
German, *circa* 1760
Sold 21.2.72 for 220 gns. ($601)

The fan illustrated bottom left was probably painted by Joseph Goupy for a member of the Court of Frederick, Prince of Wales, who took Cliveden from 1739 to 1751. Joseph Goupy, the fan painter, was cabinet painter to the Prince of Wales in 1736 and art teacher to the Princess and the infant Princes. English topographical fans are extremely rare. The 'Goupy' fans in the Schreiber collection are Italian and the 'Canaletto' fan of 'St James's Square', formerly in the Walker collection, is not topographical

Rare six-cylinder revolver box mandoline expréssion by George Baker & Co., Geneva, playing thirty-six tunes
29 in. (73.5 cm.) wide, cylinders 13 in. (33 cm.)
Sold 21.2.72 for 1500 gns. ($4095)
From the collection of Mrs D. Scott

Postage stamps, philately and postal history

BY ROBSON LOWE

The auction season which has finished will be remembered for a long time for several reasons. There were two sales the like of which had not been seen before, and the number of original 'finds' which thrilled both those who had the pleasure of writing the catalogues and the fortunate buyers.

Perhaps the most popular collection was that formed by the late Julius P. Steindler. The first part was a collection of the old German States which was sold in Basle and realised nearly £90,000 ($234,000). Among the highlights were four Brunswick letters bearing bisected stamps which realised over £16,000 ($41,600), and the front of a Prussian letter bearing a half and a whole 2 silbergroschen went for £3500 ($9100).

The second Steindler auction was a collection of the stamps issued by private shipping companies which brought another £90,000 ($234,000). Letters carried by the Danube Steam Navigation Co. fetched £29,000 ($75,400), two Suez Canal letters of 1868 realized £2850 ($7410) and £1650 ($4290), the last having been previously sold under the hammer for £40 ($104) in 1937. The Hamburg–Amerika Packet Company's letters fetched over £7500 ($19,500) and a faded 10 cents rose produced by the Royal Mail Steam Packet Company went for £500 ($1300). This was the first time that an auction had been held of such stamps and the handbook catalogue, which included a history of each service, is already a philatelic bibliophile's treasure.

Other collections sold through our Basle rooms included the Palais France, the Steindler Italian States, an unused European collection formed by Dr James K. Senior of Chicago, French Antilles formed by Robert G. Stone of Fairfield, Pa. and a reference collection of the forgeries made by the late Jean de Sperati.

The most valuable collection sold through London was the China formed by the late Warren G. Kauder of Orange, N.J. which filled three days and surprised everyone by realising over £150,000 ($390,000). While one expected the consular post offices and the classic issues to be popular, this was the first time that there had been a notable study of the stamps of the People's Republic for sale under the hammer. A change in the policy of the United States government helped, for the collecting of these stamps ceased to be a crime and became permissible only a few

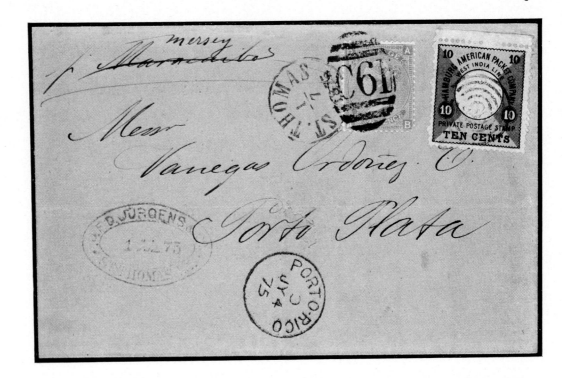

Hamburg-Amerika
Packet Company.
The cover passed through
Porto Rico where the 4d.
stamp was cancelled 'C61'.
A rare combination cover
which realized £650 ($1560)
in the Steindler 'Shipping
Companies Stamps' sale

months before the sale. Buyers came from all over the world, the Japanese being particularly successful, but the largest buyer from America unfortunately perished in an air crash later in the month so that once more, a valuable section of this collection must come on the market again before long.

Another collection which proved to be an innovation was the Revenue, Railway and Telegraph stamps formed by Dr Albert E. Thill of California. Nearly seventy years had elapsed since a serious study of these stamps came up for sale, for by 1914 the number of collectors interested had dwindled to a few who were usually regarded as eccentrics. In the event there were over three hundred bidders and the sale brought over £27,000 ($70,200).

There were many other fine specialized studies sold during the season including Roland King-Farlow's Faröe Islands, R. C. Agabeg's New Zealand, Charles Symes' Sarawak, Raymond Baldwin's Pacific Islands and Roy Boucher's Sydney Views, for each of which a special catalogue was published.

And now for a brief comment on hidden treasure.

Discoveries in family letters have provided excitement. While it is common for the marvellous rarity to realize £10,000 ($26,000), often a season will go by when no casual vendor drops in at 50 Pall Mall with something that they found among grandfather's papers. Too often, the discovery turns out to be of little value.

During last season there have been over a dozen 'finds'. A dossier of some sixty

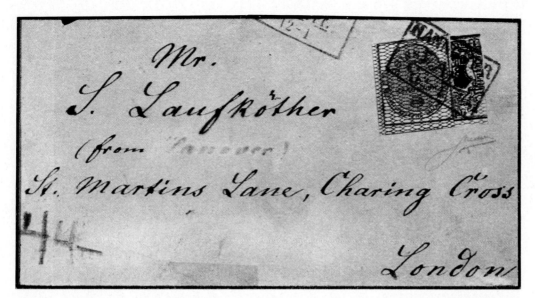

Hanover. A bisected $\frac{1}{30}$ Thaler used with a 3pfg This is believed to be a unique cover and realized £7000 ($16,800) in the Steindler 'German States' sale

letters written in Antigua between 1770 and 1830 fetched £2800 ($7280). A 1909 letter in its original envelope from Tristan da Cunha, written by one school-girl to another in Pontefract described her life on the island:

'*The* (sic) *that grow on our island are Daises Geranium Buttercup Roses – we do our work first and then we play*'

Tattered and grubby from its travels (it had been taken by a passing tramp steamer and put in the post office at Sydney), this human memento went for £170 ($447).

In a mixed lot from an Italian owner we found a Great Britain 1867 10d. plate 2 (plate 1 is *vin ordinaire*) which made £2200 ($5720).

In a collection of little importance, the Bournemouth office discovered five examples of the '*Houses of Parliament Post Paid Two Pence*' envelopes which were in use from 16th January to 5th May 1840. Only three examples of these envelopes had been known previously and the last to appear in auction some two years ago realized £140 ($364). The writer was Edward Barnes, M.P. for Leeds, and the letters were addressed to his son and had passed into the collection of one of his descendants. The five envelopes fetched £3075 ($7995) – a record for British postal stationery.

In a damaged envelope addressed to the Countess Bertrand aboard HMS *Bellerophon* at Plymouth in 1815, an unknown letter to Napoleon was found. His Imperial Majesty was told that £16,000 had been transferred to America so that he could live in comfort until he could be restored to the glorious throne in France. He must refuse to go to the rat-infested island and demand to be sent to the States.

Alas for the plans, the Post Office had marked the envelope, *Gone to St. Helena*; £500 ($1300) worth of romance discovered by curiosity.

The total auction turnover for the year was £1,450,000 ($3,770,000).

VINTAGE CARS, MODELS AND STEAM LOCOMOTIVES, PHOTOGRAPHS AND PHOTOGRAPHICA

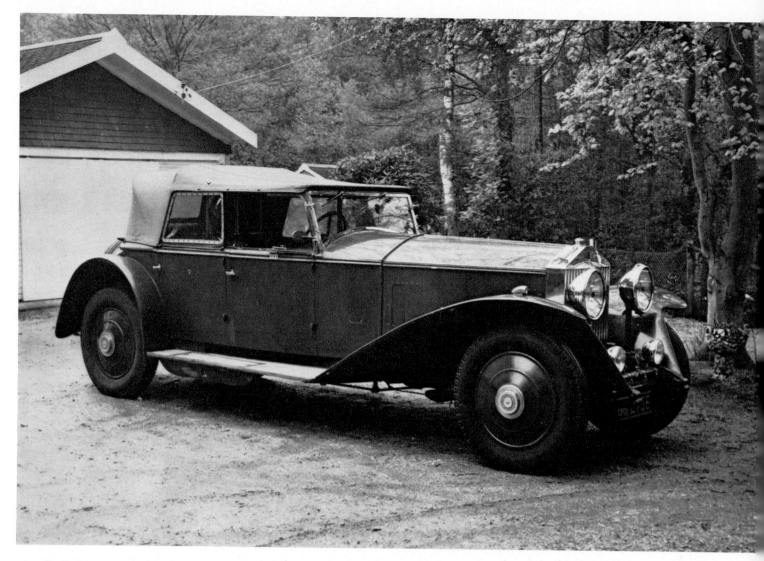

1930 Rolls Royce Phantom II Four-door Sports Tourer. Registration number GG 2755. Coachwork by Barker
Sold 13.7.72 for £15,000 ($36,000) at the Palace of Beaulieu to mark the opening of Britain's first National Motor Museum
From the collection of M. N. Mavrogordato, Esq

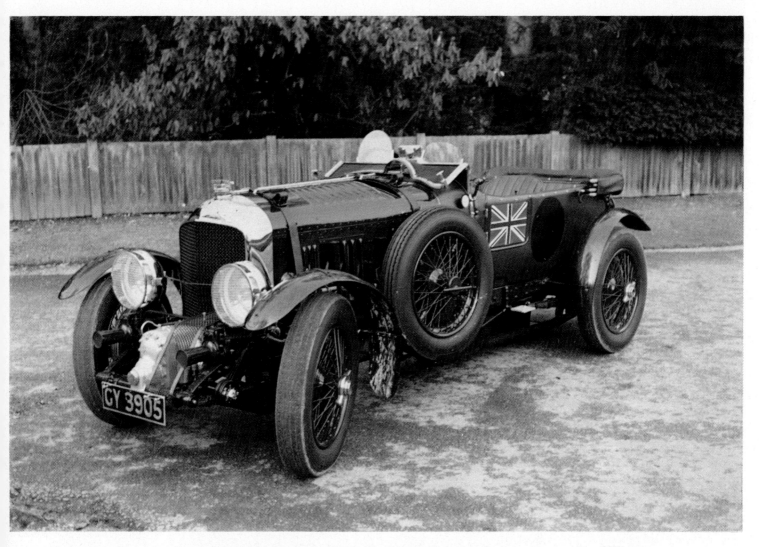

1931 Bentley 4½-Litre Supercharged Birkin-Paget Team Replica Four-seater. Registration number GY 3905
Sold 13.7.72 for £17,000 ($40,800) at the Palace of Beaulieu
From the collection of Wing-Commander Richard Seys, DFC, AFC, RAF (Retd.)

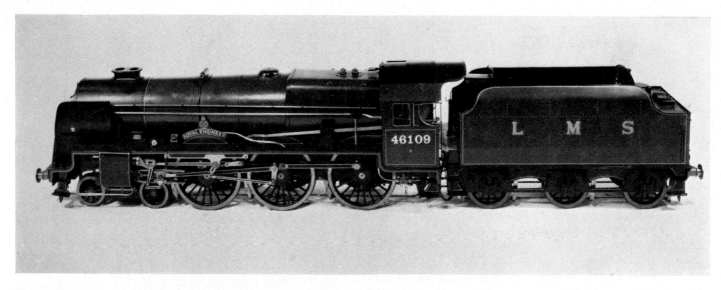

Exhibition quality 5 in. gauge model of the London, Midland and Scottish Railway rebuilt Scot locomotive and tender No. 46109, 'Royal Engineer', built by K. Elsworth, Solihull
Sold 26.7.72 for 1200 gns. ($3004)

Fine quality 1⅛ in. scale, 3½ in. gauge model of the 0–4–4–0 narrow gauge Garrett locomotive No. 7
Built by A. W. G. Tucker of Bramall, Cheshire
14 in. high × 51 in. long (35.5 × 129.5 cm.)
Sold 17.11.71 for £1500 ($3855)

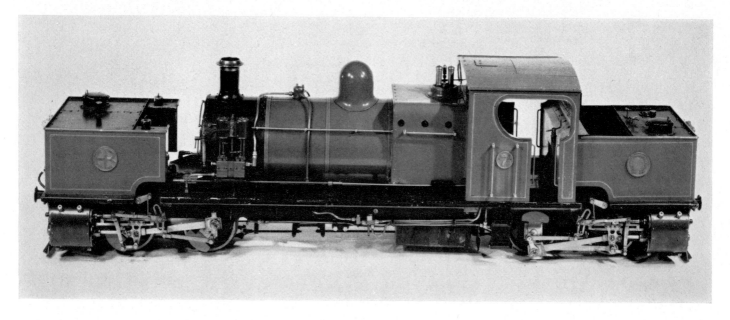

Well-built 2 in. scale model of a single-cylinder, two-speed, four-shaft, general purpose agricultural traction engine built by B. Parsons St Columb
24 × 37½ in. (61 × 94 cm.)
Sold 26.7.72 for 600 gns.
($1512)

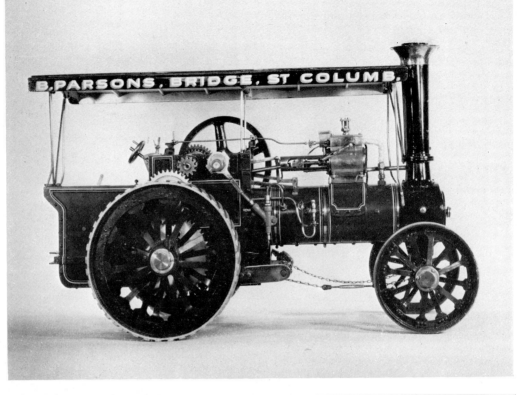

Fine quality 2 in. scale model of a twin-cylinder undertype Sentinel Steam Wagon
13 in. (33 cm.) high
34 in. (86 cm.) long
Sold 17.11.71 for 750 gns.
($1928)

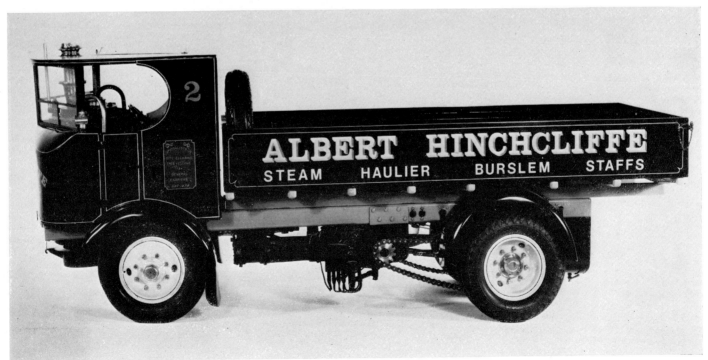

Models

Rare, fine quality 1 in. scale model of a
twin-cylinder single-speed, chain-driven, steam
fire engine of *circa* 1905
Built by A. M. Tyrer, Hastings
8½ in. (21.5 cm.) high, 14 in (35.5 cm.) long
Sold 17.11.71 for 1600 gns. ($4112)

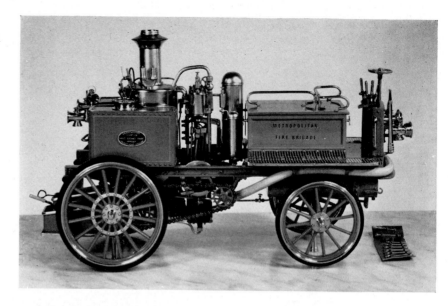

Fine model of the first-class battleship
Asahi, which was built by John Brown
and Co. Ltd, Sheffield and Clydebank, for
the Imperial Japanese Government
54 × 108 in. (137 × 274.5 cm.)
Sold 26.7.72 for 2400 gns. ($6048)

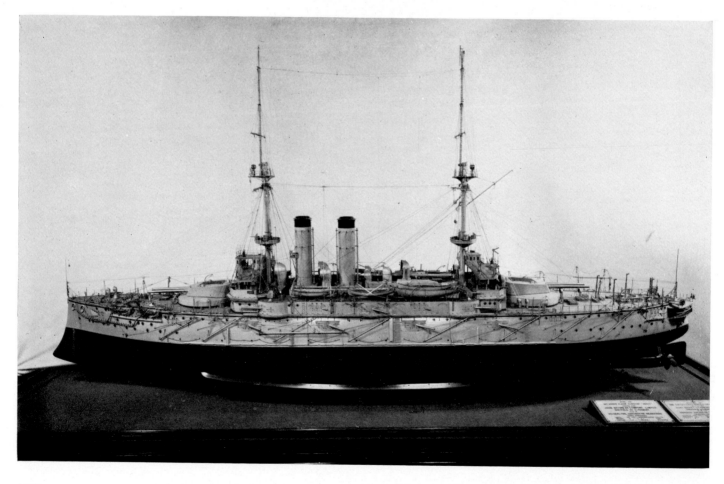

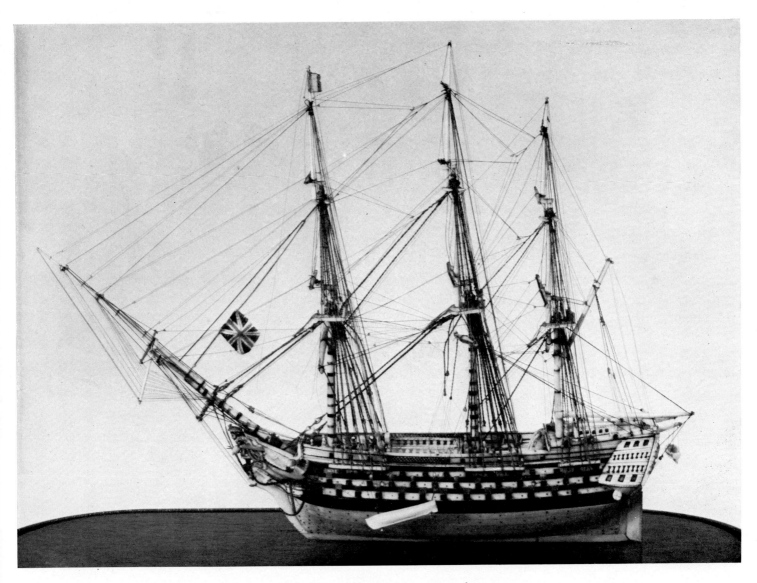

French prisoner-of-war bone-and-horn model of a one-hundred-gun man-of-war
9½ × 12½ in. (24 × 32 cm.)
Sold 26.7.72 for 1300 gns. ($3276)

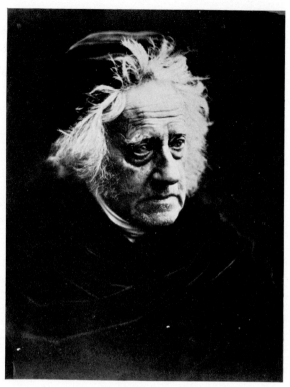

Top left: Half-plate studio camera
By James Sinclair & Co., London
Sold 13.7.72 for £110 ($264.60)

Top right: JULIA MARGARET CAMERON:
Portrait of Sir John Herschel
Signed, inscribed and dated April 1867
$12\frac{5}{8} \times 10$ in. (32.1 × 25.5 cm)
Sold 13.7.72 for £273 ($655.20)

Bottom left: FRANK MEADOW SUTCLIFFE:
A group of girls standing in a country lane
holding hands. Initialled and numbered 297
Sold 13.7.72 for £63 ($151.20)

Sales of photographs and photographica

BY CHRISTOPHER WOOD

Following the sale last year of a collection of photographs by Julia Margaret Cameron, this season we were able to hold our first sale devoted entirely to photographs and photographic equipment Although the total was a modest £3700 ($8887) by comparison with other sales, there was no shortage of keen bidders, and we hope in future to have two sales of this type every season.

Among the photographic prints and albums, the top price of £388 ($931) was for an interesting album of American Indians, mostly of the Ute tribe, who fought for their land from 1868 to 1881, when they were moved to a reservation in Utah. There were also prints by the ever-popular Julia Margaret Cameron. A wonderfully craggy and lined face of Sir John Herschel made £273 ($655), and an album of reduced photographs, containing small prints of many of Mrs Cameron's best known works, made £336 ($809). Prices for other prints by Cameron ranged from about £15 to £100 ($36 to $240).

The main feature of the sale was a group of ninety photographs by the great Whitby photographer F. M. Sutcliffe (1853–1941). These made a total of just over £650 ($1560), and were divided into thirty-four Lots. A delightful group of girls standing in a ring holding hands made the top price of £63 ($151). The photographs varied widely in date, ranging from about 1880 to 1912. The early ones made the highest prices, averaging about £20 ($48) each, and the later ones sold for smaller sums.

Another new departure for Christie's was the inclusion of twenty-three Lots of cameras and other photographic equipment. The outstanding item was a half-plate studio camera by James Sinclair and Co, in superb condition with its original case with lens and plate holders. This made £110 ($264). In future our cameras will be catalogued by Mr Edward Holmes, a well-known collector and writer on the subject, who is now our consultant in this field.

Christie, Manson & Woods

LONDON 8 King Street, St James's, SWIY 6QT
Telephone 01–839 9060 *Telegrams* Christiart London SW1 *Telex* 916429

Our companies and Agents Overseas

AMERICA Robert Waley-Cohen
Christie, Manson & Woods (USA)
867 Madison Avenue, New York 10021, NY
Telephone (212) 744 4017 *Cables* Chriswoods, New York *Telex* New York 620721
LOS ANGELES: Mrs Barbara Roberts
450 North Roxbury Drive, Beverly Hills, California 90210 *Telephone* (213) 273 0550 *Telex* Beverly
Hills 674 858

SWITZERLAND Anthony du Boulay, Dr Geza von Habsburg, Hans Nadelhoffer
Christie, Manson & Woods (International), SA
8 Place de la Taconnerie, 1204 Geneva
Telephone Geneva 24 33 44 *Cables* Chrisauction, Genève *Telex* Geneva 23634

GERMANY Dr Geza von Habsburg, Baroness Olga von Fürstenberg
Christie, Manson & Woods KG
Alt Pempelfort 11a, 4 Düsseldorf
Telephone 36 42 12 *Cables* Chriskunst Düsseldorf *Telex* Düsseldorf 7599

AUSTRIA Baron Martin von Koblitz
c/o Christie's Geneva Office, (private address) Burgelsteinstrasse 4, 5020 Salzburg
Telephone Salzburg 23 3 44

ITALY Christie, Manson & Woods (Internazionale) SA
Via Margutta 54, Rome 00187 *Telephone* 679 2289
FLORENCE: Dr Louisa Nicholson
Via Laura 70, Florence *Telephone* 26 02 74

FRANCE Princesse Jeanne-Marie de Broglie
68 Rue de l'Université, 75 Paris VIIe *Telephone* 544 16 30

CANADA Mrs Laurie Lerew
Christie, Manson & Woods (Canada) Ltd
1115 Sherbrooke Street West, Montreal, 110 P.Q.
Telephone (514) 842 1527 *Cables* Chriscan, Montreal

ARGENTINA Señor Cesar Feldman
Studio, Libertad 1271, Buenos Aires *Telephone* 41 1616 or 42 2046

AUSTRALIA SYDNEY: John Henshaw
Christie, Manson & Woods (Australia)
298 New South Head Road, Double Bay, Sydney 2028 *Telephone* 36–7268 *Cables* Christiart, Sydney
MELBOURNE: Christie, Manson & Woods (Australia)
The Joshua McClelland Print Room, 81 Collins Street, Melbourne, Victoria 3000
Telephone 63–2631 *Cables* Christiart, Melbourne

SCOTLAND Sir Ilay Campbell, BT, Cumlodden Estate Office, Furnace by Inverary, Argyll *Telephone* Furnace 206
(Edinburgh Office) 68 Charlotte Square, Edinburgh EH4 4DV *Telephone* 031 226 7148

WEST COUNTRY R. L. Harrington, Esq
Pencuil, Polvarth Road, St Mawes, Cornwall *Telephone* St Mawes 582

Table of prices paid at auction over £250,000

27.XI.70	Velazquez	*Juan de Pareja*	£2,310,000	Christie's
25.VI.71	Titian	*Death of Actaeon*	£1,680,000	Christie's
16.XI.61	Rembrandt	*Aristotle contemplating the bust of Homer* ($2,300,000)	£821,400	Parke-Bernet
19.III.65	Rembrandt	*Portrait of Titus*	£798,000	Christie's
9.X.68	Renoir	*Le Pont des Arts* ($1,550,000)	£645,833	Parke-Bernet
1.XII.67	Monet	*La Terrasse à St Adresse*	£588,000	Christie's
25.II.70	Van Gogh	*Le Cyprès et l'arbre en fleur* ($1,300,000)	£541,667	Parke-Bernet
5.V.71	Van Gogh	*L'Hôpital de St Paul à St Rémy* ($1,200,000)	£500,000	Parke-Bernet
27.VI.69	Rembrandt	*Self portrait*	£483,000	Christie's
6.VII.71	Renoir	*Le pêcheur à la ligne*	£483,000	Christie's
30.VI.70	Seurat	*Les poseuses* (Small Version)	£430,500	Christie's
25.VI.71	Van Dyck	*Four negro heads*	£420,000	Christie's
25.VI.71	Boucher	*The fountain of love* and *The bird catchers* (a pair)	£420,000	Christie's
27.VI.69	Tiepolo	*An allegory of Venus entrusting Eros to Chronos*	£409,500	Christie's
25.II.70	Van Gogh	*Le laboureur, Arles* ($875,000)	£364,000	Parke-Bernet
3.XII.69	Rubens	*The rape of the Sabines* (a pair)	£350,000	Sotheby's
8.XII.71	Frogonard	*Anne François D'Harcourt, Duc de Beurson*	£340,000	Sotheby's
25.VI.71	Rembrandt	*Portrait of the artist's father*	£315,000	Christie's
6.VII.71	Renoir	*Mademoiselle Georgette Charpentier*	£315,000	Christie's
26.XI.71	Bellotto	*Ponte delle Navi, Verona*	£315,000	Christie's
16.XI.61	Fragonard	*La Liseuse* ($750,000)	£312,500	Parke-Bernet
21.X.71	Rousseau (Le Douanier)	*Paysage Exotique*	£299,000	Parke-Bernet
14.X.66	Cézanne	*Maisons à l'Estaque* ($800,000)	£285,000	Parke-Bernet
19.VII.72	Gainsborough	*The Gravenor Family*	£280,000	Sotheby's
24.VI.59	Rubens	*The Adoration of the Magi*	£275,000	Sotheby's
5.XII.69	Bassano	*Flight into Egypt*	£273,000	Christie's
30.VI.70	Monet	*Bords de la Seine, Argenteuil*	£252,000	Christie's

Acknowledgements

Christie's are indebted to the following who have allowed their names to be published as purchasers of works of art illustrated on the preceding pages. The figures refer to the page numbers on which the illustrations appear

Galerie Anne Abels, 133

Arthur Ackermann & Son Ltd, 55 (top)

Thos Agnew & Sons Ltd, 59, 61, 63, 84 (bottom), 86 (top), 87 (top), 88 (top), 98 (bottom right), 109 (top), 123, 141 (right)

Albany Gallery, 94 (bottom)

Alexander & Berendt Ltd, 356 (bottom right)

Mr & Mrs James W. Alsdorf, 137 (right)

A. Amor, 269 (both)

The Antique Gun Shop, Birmingham, 394 (top)

The Antique Porcelain Company of London and New York, 260, 268 (right), 283

The Armouries, H.M. Tower of London, 395

Art Gallery of South Australia, 111

L'Arte Antica, 106 (top), 107

Asprey & Co Ltd, 209 (top right), 336 (top)

Mrs E. Assheton-Bennett, 185 (left), 190 (left)

H. Baer, 265, 366 (left), 371 (bottom right), 377 (top centre)

Dr N. C. Baskett, 158 (bottom)

Baskett & Day Ltd, 62, 72, 76 (top), 81 (top right), 84 (top), 88 (bottom), 89 (bottom), 92 (bottom), 98 (top right), 101 (both), 110 (bottom), 140 (top)

A. E. Bayliss Esq, 429 (top)

Leslie M. Berker Esq, OBE, 191 (top)

Mrs M. A. Berlioz, 344 (top)

Ernst Beyeler, 125

N. Bloom & Son Ltd, 181 (right), 183

Bluett & Sons, 299 (top)

C. G. Boerner, 105 (right)

Boghallens Antikvariat, 242 (right)

Martin Breslauer, 254

Brod Gallery, 29, 70

Claus von Bulow, 60

H. Calmann, 75, 79 (top), 80 (right)

Chichester Antiques Ltd, 358 (bottom left)

Ciancimino Ltd, 316, 317

William Clayton Ltd, 306

J. Close Esq, 390 (left)

The Coldstream Guards 326 (bottom right)

P. & D. Colnaghi & Co Ltd, 36 (bottom), 82 (bottom), 85 (top), 105 (left)

A. Cook, 326 (top left), 380, 381 (top left)

D. M. Collins Esq, 326 (top right)

Richard Courtney, 330 (left)

Peter Dale Ltd, 393 (bottom)

Gordon A. Dando Esq, 428 (top)

Bernard Danenberg Galleries, 155 (bottom)

William Darby Esq, 140 (bottom), 144 (left), 150 (top left)

Major Dawnay, 271 (bottom left and top right)

Deakin & Ward Ltd, 333 (top left)

J. de Haan & Son Ltd, 334 (left)

Paul Delplace, 221 (centre right)

John Didcock Esq, FRGS, FRSA, 227 (bottom centre)

Mr Joseph Dollinger, MD of New York, 227 (bottom right)

D. Drager, 167 (centre)

Michel Dumez-Onof, 375 (bottom)

Dr Eisenbeiss, 24, 26, 28, 119, 122, 223 (bottom), 233 (bottom right), 376 (top), 378 (left)

Meijer Elte, 251

Eskenazi Ltd, 297 (top right)

Richard L. Feigen, 137 (left)

The Fine Art Society Ltd, 99 (bottom), 144 (right), 146

H. M. Fletcher, 253 (left)

French & Co Inc, 349 (both), 350 (bottom), 360 (top left), 361 (bottom right)

Frost & Reed Ltd, 145 (bottom)

C. G. Fry, 206 (top right), 207 (top left and centre)

Garrard & Co Ltd, 199 (right)

L. Gertler Esq, 145 (top)

Christopher Gibbs Ltd, 297 (bottom right), 331 (bottom left), 376 (left)

Arthur Gilbert Esq, 373 (bottom)

Helen Glatz, 298 (top), 304

A. & F. Gordon, 366 (right), 339

Richard Green (Fine Paintings) Ltd, 52, 65, 138, 139, 148 (top)

John Hadfield Esq, 265

John Hall, 270 (top left and centre)

Harrods Fine Art, 378 (centre)

Harvey & Gore, 197 (top right)

Haslam & Whiteway Ltd, 414 (left)

J. B. Hayward & Son, 390 (right)

G. Henderson Esq, 35

G. Heywood Hill, 243, 244

Hirano Tatsuo, 292 (top right), 300 (top left)

Henry C. Hofheimer, 266 (left)

House of China, 288 (bottom)

How of Edinburgh Ltd, 181 (left), 182 (bottom), 184, 186 (top left), 188 (left)

The Governor & Company of the Bank of Ireland, Dublin, 218 (top right)

Nico Israel, 252

Jellinek & Sampson, 265

G. P. Jenkinson Esq, 391 (bottom)

C. John, 384, 385, 386 (top)

Oscar & Peter Johnson Ltd, 102

W. Keith Neal Esq, 396 (centre), 398 (top)

Richard Kenneth, 350 (bottom)

Baron Martin von Koblitz, 365 (left), 376 (bottom right)

Koopman, 198 (left), 203 (left), 218 (bottom left)

Lambeth Arts Ltd, 151

D. S. Lavender, 214

Raymond Le Brun, 387 (bottom left)

Ronald A. Lee, 227 (centre), 329 (left), 357 (top left), 391 (top)

The Leger Galleries Ltd, 27 (top), 38, 43, 56, 85 (bottom), 90 (top), 91, 99 (top)

Leggatt Brothers, 21, 55 (bottom), 93, 209 (left)

Limner Antiques, 207 (bottom), 208 (top right)

Little Winchester Gallery, 156

Littlecote Antiques, 375 (top right)

London Gallery Ltd, 310, 311, 312, 313

Thomas Lumley Ltd, 178, 182 (top), 186 (right), 196 (right), 202 (right)

Lumley Cazalet Ltd, 112

Dr Hendrik G. Luttig, 158 (top)

MacConnal-Mason & Son, 53 (bottom)

G. McKinley Ltd, 236 (bottom)

Maggs Brothers Ltd, 253 (right)

Manning Galleries Ltd, 98 (bottom left)

S. Marchant & Son, 303, 312 (bottom)

Marlborough Fine Art, 126 (bottom), 130

The Merchant Taylors Co, The Costume Society & Viscount Boyd of Merton, 414 (right)

Harry Michaels Esq, 80 (left)

Max Moller N.V., 324 (top left)

The Lord Montagu of Beaulieu, 427

Hugh M. Moss Ltd, 298 (bottom), 308

S. Moss Ltd, 292 (bottom left), 300 (bottom left)

Meyrick Neilson of Tetbury Ltd, 328 (bottom left)

Herr A. Neuhaus, 213 (bottom)

George Ortiz, 234 (right)

J. Ost Esq, 356 (top right)

Frank Partridge & Sons Ltd, 187 (top), 194 (bottom left and centre), 327 (top left), 329 (bottom left), 343, 347 (bottom), 354 (top left), 356 (top left), 359 (bottom right), 367, 379 (bottom left)

Peerage Antiques, 270 (bottom right)

Perez (London) Ltd, 383 (right)

S. R. Perren, 176 (left)

Phillips & Harris, 293

S. J. Phillips Ltd, 166, 180 (right), 185 (right), 186 (top right), 189, 191 (bottom), 197 (bottom), 204, 218 (top left), 220, 221, 222, 225 (right)

T. H. Porter Esq, 397 (top)

Bernard Quaritch Ltd, 246

Redburn (Antiques) Ltd, 334 (bottom right)

H. J. Ricketts Esq, 432 (top right)

Acknowledgements

Mr & Mrs Henry Riseman, 286 (left)
James Robinson Inc, 190 (top)
T. Rogers Esq, 278 (bottom)
Roland, Browse & Delbanco, 141 (left)
Bertram Rota Ltd, 255
Miss M. Routh, 417
Mrs K. E. Rumball, 355 (top)
H. Sabet Esq, *frontispiece*, 342, 357 (bottom left), 359 (right),
 379 (bottom right)
C. A. B. St George Esq, 336 (bottom)
J. M. E. Santo Silva, 180 (left)
Chas. J. Sawyer, 100
Scarsbrick & Bate Ltd, 330 (right)
Mrs Scharf, 79 (bottom), 98 (top left)
M. Seymour Ltd, 165, 169, 171
H. Shickman Gallery, 33, 109 (bottom)
S. J. Shrubsole Ltd, 187 (bottom), 193, 200
The Norton Simon Foundation, 19
E. E. Simmons Esq, 270 (bottom left and top right)
Mrs H. W. Skrine, 66
Duncan Smith Esq, 338 (right)
John Sparks Ltd, 290 (bottom left and right)
Edward Speelman Ltd, 44, 54, 71, 82 (top)
Spink & Son Ltd, 95–97, 198 (bottom right),
 286 (right)
E. Swonnell (Silverware) Ltd, 198 (top right)

Yvonne Tan Bunzl, 77
Temple Gallery, 230, 232
Tilley & Co (Antiques) Ltd, 263 (top), 266 (right)
Arthur Tooth & Sons Ltd, 116
Charles W. Traylen, 242 (left), 246 (left), 249
M. Turpin, 381 (right), 328 (top right),
 331 (bottom right)
J. & E. D. Vandekar, 305
Herr R. Vater, 276 (top left)
Victoria & Albert Museum, 416, 418 (top)
Vigo-Sternberg Galleries, 386 (bottom), 387 (top left)
Waddington Galleries Ltd, 149 (right)
B. Warwick, 289, 290 (top left and right)
R. Weiner Esq, 324 (top centre)
J. Weitzner Esq, 27 (bottom)
R. J. Wigington Esq, 394 (bottom)
Winifred Williams, 262, 263 (bottom), 268 (left)
W. H. Willson Ltd, 188 (right)
Windsor & Eton Fine Arts Co Ltd, 53 (top)
R. W. Winter Esq, 428 (bottom)
Ian Woodner Esq, 76 (bottom)
Charles Woollett & Son, 206 (top centre), 208 (top left),
 335 (right)
Douglas J. Wright Ltd, 300 (bottom right)
Yoshi Gallery, 114
Peter Emmanuel Zervudachi—Galerie du Lac, 129

Index

Abbott, John White, 83
American paintings, 155–157
Antiquities, 235–238
Arms and Armour, 389–398
Arpo, Guariento, 19
Australian paintings, 152–154

Barbieri, Giovanni Francesco, Il Guercino, 21, 72, 73, 75
Bastida, Joaquin Sorolla y, 126
Beccafumi, Domenico, 20
Beckmann, Max, 133
Belloto, Bernardo, 22
Bianco, Baccio di, 79
Blake, Peter, 149
Blake, William, 101
Bloemaert, Abraham, 81
Bonington, Richard Parkes, 87
Books and Manuscripts, 239–258
Boscoli, Andrea, 81
Boucher, François, 39
Boudin, Eugene, 118, 126
Boyd, Arthur, 153
Boys, Thomas Shotter, 87
Brancusi, Constantin, 128–130
Braque, Georges, 110
Burne-Jones, Sir Edward Coley, BT, 99

Callot, Jacques, 106
Cambiasco, Luca, 81
Canal, Giovanni Antonio, Il Canaletto, 24, 26, 27
Cantarini, Simone, 79
Carlevarijs, Luca, 23
Carr, M. Emily, 154
Cars, veteran and vintage, 426–427
Ceramics, Chinese, 287–308
Cézanne, Paul, 137

Clayssens, Pieter II, 29
Conder, Charles, 140
Constable, John, 64
Copley, John Singleton, 54
Corot, Jean Baptiste Camille, 123
Cotes, Francis, 93
Cotman, John Sell, 90
Cox, David, 86
Cozens, John Robert, 84
Cross, Henri Edmund, 127

Daniell, Samuel, 94–97
Daniell, Thomas, 94–97
Drawings, Old Master, 69–82
 English, 83–102
Dreschler, Johann Baptiste, 52
Dresses, 416
Dolls, 417
Dürer, Albrecht, 105, 106

English paintings, 51–68
 drawings and watercolours, 83–102
Ensor, James, 109

Fans, 418–419
Fielding, Anthony Vandyke Copley, 88
Foujita, Tsughouharu, 130
Fragonard, Jean-Honoré, 38
Francia, François Louis Thomas, 85
Franconian School, 28
French School, 40
Furniture, English, 324–343
 French, 344–363
 Continental, 364–381

Index

Gertler, Mark, 145
Girtin, Thomas, 84
Glass, 285–286
Guardi, Francesco, 25
Guns, modern sporting, 399–403

Hearne, Thomas, 88
Heem, Jan Davidsz de, 43
Hockney, David, 149
Hornel, Edward Atkinson, 142
Hoyte, John Clarke, 158
Hunt, William Holman, 89
Hunter, Leslie, 143

Ibbetson, Julius Caesar, 92
Icons, 230–232
Impressionist paintings, 113–137
 prints, 110–112

Jade, 288–291
Japanese works of art, 309–313
Jewellery, 159–176
John, Augustus, 147
Johnson, Eastman, 155

Kauffman, Angelica, 92
Klimt, Gustav, 136
Krieghoff, Cornelius, 155

La Thangue, Henry Herbert, 144
Lombard, Lambert, 32
Lowry, Laurence Stephen, 148

Manet, Edouard, 122
Mantegna, School of, 107

Marieschi, Michele, 27
Medals, 228–229
Meissen porcelain, 274–282
Millais, Sir John Everett, 66, 67
Miniatures, 206–209
Models, 428–431
Modigliani, Amadeo, 116
Moerenhout, Josephine Jodocus, 53
Monet, Claude, 119
Moore, Henry, 150–151
Moses, Anna Mary Robertson, 156
Munnings, Sir Alfred, 138, 139
Murillo, Bartolomé Estéban, 37

Nash, John, 144
Nolde, Emil, 134–137

Objects of art, 205–238
Old Master paintings, 17–44
 drawings and watercolours, 69–82
 prints, 104–109
Orchardson, Sir William Quiller, 68

Palmer, Samuel, 62
Pars, William, 85
Pascin, Jules, 131
Peale, Rembrandt, 157
Photographs, 432
Picasso, Pablo, 112, 124, 125, 137
Pistols, 392, 395
Porcelain, English, 260–271
 Continental, 274–284
Poynter, Sir Edward John, BT, 99
Primaticcio, Francesco, 76

Prints, Old Master, 104–109
 Impressionist and modern, 110–112

Rembrandt, Harmensz van Rijn, 70, 105
Reni, Guido, 77
Renoir, Pierre-Auguste, 111, 115
Reynolds, Sir Joshua, 59, 60
Ribera, Jusepi di, 76
Romney, George, 56, 98
Rosetti, Dante Gabriel, 86, 100
Rouault, Georges, 132
Rugs, 382–385
Russell Flint, Sir William, 145

Schelfhout, Andreas, 53
Sculpture, 150–151
Serres, Dominic, 83
Seymour, James, 55
Sickert, Walter Richard, 141
Signorelli, Luca, 75
Silver, English, 176–199
 Continental, 202–204
 American, 200–201
Sisley, Alfred, 120, 121
Snuff-bottles, 308
Snuff-boxes, 210–217
South African works of art, 158
Soutine, Chaim, 114
Stamps, 421–424
Steam locomotives, 428–430
Steen, Jan, 36
Strang, William, 146
Streeton, Sir Arthur Ernest, 153
Stubbs, George, 109
Swords, 390–391
 Japanese, 311

Tapestries, 386–388
Thornhill, Sir James, 98
Tibetan works of art, 314–317
Tiepolo, Giovanni Battista, 80, 104
Tiepolo, Giovanni Domenico, 104
Tiepolo, Lorenzo, 104
Toulouse-Lautrec, Henri de, 110
Troy, Jean François de, 44
Turner, Joseph Mallord William, 89, 91

Van der Heyden, Jan, 33
Van der Neer, Aert, 35
Van de Velde, Esaias, 78
Van de Velde, William II, 82
Van Goyen, Jan, 34
Van Leyden, Lucas, 31
Van Ostade, Adriaen, 71
Van Wouw, Anton, 158

Wadsworth, Edward, 148
Watches, 225–227
Watteau, Jean-Antoine, 108
Watts, Frederick William, 65
Wells, Albert Goodwin, 102
Whistler, James Abbott McNeill, 140
Wilkie, Sir David, 98
Wilson, Richard, 53
Wine, 405–412
Wyck, Thomas, 78

Yeats, Jack Butler, 142

Zuccarelli, Francesco, 182
Zuccero, Federico, 77

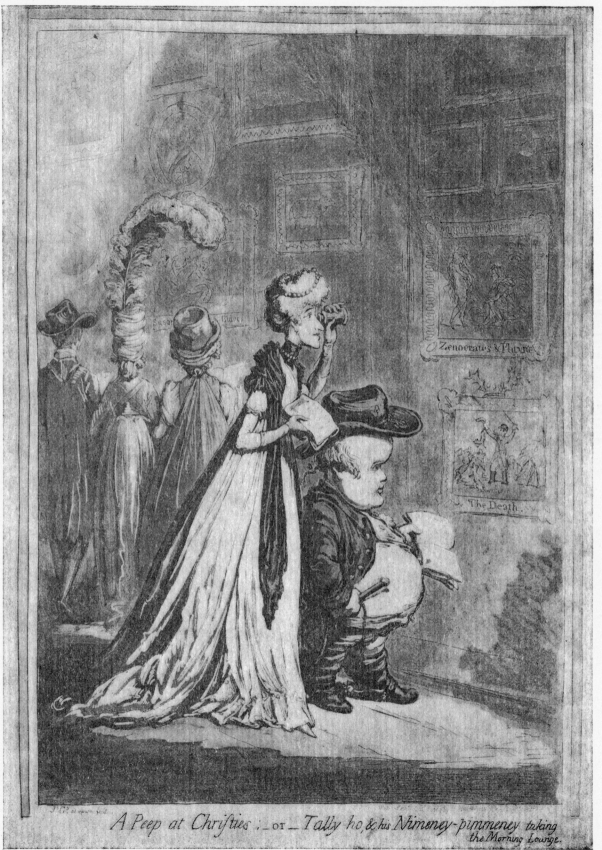

A Peep at Christies; — or — Tally ho & his Nimeney-pimmeney taking the Morning Lounge.